IMAGING CHILDHOOD

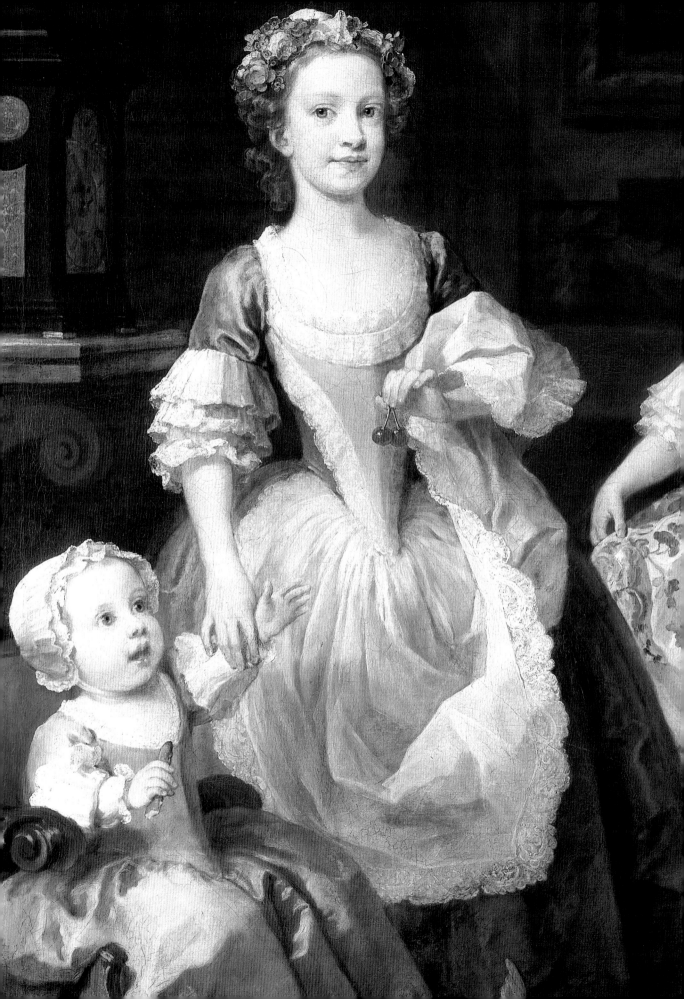

Imagining Childhood

Erika Langmuir

Yale University Press New Haven & London

Designed by Sally Salvesen
Typeset in Monophoto Bembo
by SNP Best-set Typesetter Ltd., Hong Kong
Printed in China through Worldprint

Library of Congress Cataloging-in-Publication Data
Langmuir, Erika.
 Imagining childhood / Erika Langmuir.
 p. cm.
 Includes bibliographical references and index.
 ISBN 0-300-10131-7 (alk. paper)
 1. Children in art. 2. Childhood in art. I. Title.
 N7640.L36 2006
 704.9'425 – dc22 2006006485

HALF-TITLEPAGE
detail from *Beter stil gestaen*, Emblem XXI, Roemer Visscher, *Sinnepoppen*, fig. 102

TITLESPREAD
detail from William Hogarth, *The Graham Children*, London, National Gallery, fig. 56

PAGE vi
Francisco Goya, *Childish Rage*, Madrid, Prado Museum, fig. 131

To my daughter
Valerie Clare Langmuir

2.

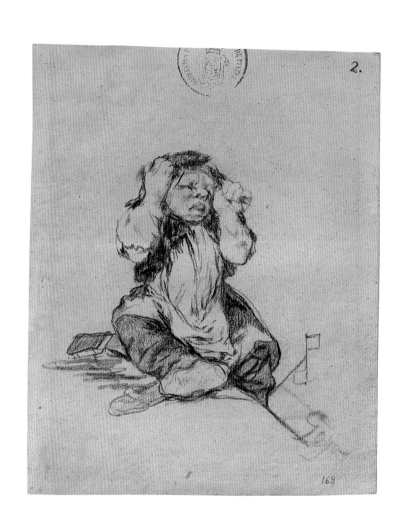

168

Contents

Acknowledgements

The origins of this book date back to 1980, when I taught a class in *Images of Childhood*, an interdisciplinary contextual course in the School of Cultural and Community Studies at the University of Sussex. Brainchild of the psychologist John Sants, the course was heavily biased towards the nineteenth and early twentieth centuries; the only art historian on the team, I perversely focused on classical Greece and Rome. I am grateful to my former colleagues for their tolerance, to my students for their interest, and to Dorothy Scruton for heroically seeking out illustrative material.

If Sussex prompted my interest in concepts of childhood, it was the Warburg Institute of the School of Advanced Study, University of London, that sustained it. Having first arrived there as a Junior Fellow in 1968, like many others I have found continuing inspiration and help in the generous company of its past and present staff (most particularly Elizabeth McGrath) and fellows, and in the peerless resources of its library and photographic collection. As the footnotes testify, this book could not have been written elsewhere.

Sally Salvesen of Yale University Press galvaniseed me into reviving a long-dormant and seemingly doomed project, and I am most grateful for her unfailing encouragement. Patricia Williams and Jean Liddiard also deserve special thanks, as does Neil MacGregor, whose lucid writing style I have long tried to emulate, and who gave up precious free time to read and comment on the typescript. Needless to say, remaining errors are solely my own.

Lastly, and most of all, and as ever, I record my loving gratitude to Charles McKeown, partner in work as in life.

INTRODUCTION

Mainly about parents

Quelqu'un pourrait dire de moi que j'ai seulement fait ici un amas de fleurs étrangères, n'y ayant fourni du mien que le filet à les lier.[1]

STYLISHLY POISED 'BETWEEN ROCOCO AND ROMANTICISM',[2] two illustrations from an eighteenth-century German almanac contrast parental attitudes to children (figs. 1, 2).[3] Designed as a critique of contemporary mores, these prints by the painter-etcher Daniel Chodowiecki are also indebted to ideas and artistic models from the past, and have in turn influenced later art. At once timely and timeless, they serve to introduce the scope and aims of this book, which draws heavily on detailed research by others to make more general conclusions about images of children throughout the history of Western visual culture.

As the book's title is meant to suggest, making images of children presupposes an idea, or ideal, of a 'state of childhood' distinguishing children from adults. Part of this mental construct corresponds to simple observation – most children are smaller than most adults, for example. Other components, however, such as the traditional association of childhood with spring, depend less on perception than on the collective imagination. Imagining childhood, as well as informing the representation of actual children, has also made it possible to create an imagery of childhood itself.

Not obviously an artistic genre like 'landscape' or 'still life', the imagery of childhood nonetheless shares some features of such pictorial categories: perennially reinterpreting traditional themes even when seeming to record ambient reality; ignoring or distorting aspects of reality as they conflict with tradition, but perhaps revealing the deeper reality of human feelings for our own and others' childhood.

This is a book by an art historian, not a social historian nor a historian of ideas. It is not, however, written from a professional concern for the medium, attribution, provenance, technique, style, or quality of 'works of Art',[4] but by a viewer specialised in some areas and dilettante in many, interested in the origins, functions, significances or effects of images – sometimes of the same image as it migrates from one age or milieu to another. Although what follows is a survey, it does not pretend to be comprehensive. The themes proposed here do not always coincide with historically important moments and movements that have been the subject of period-based studies more focused on change than on continuity. The reverse is true of this book.

As an aid to literacy and a means of instruction, almanacs have always been among the most popular products of the printing press. Since the 1750s, French almanacs had led the field in transmitting the ideas of the Enlightenment to a widening bourgeois readership; in 1770, the first two modern German almanacs were published in explicit imitatation of the Paris *Almanach des Muses* for 1765.

From 1770 until his death in 1801, Chodowiecki was the artist most closely identified with German almanac production. He contributed no fewer than 1275 prints to these yearly publications, tirelessly illustrating current affairs, scientific vogues and literary texts. He is best remembered, however, for his witty depictions of contemporary urban life and fashions, especially those designed for the *Göttinger Taschenkalender*, the Göttingen Pocket Almanac, in the years 1778 to 1783, under the editorship of the celebrated physicist, mathematician, littérateur and satirist, Georg Christoph Lichtenberg.

Like his Swiss contemporary Johann Kaspar Lavater, Lichtenberg propounded a theory of physiognomy. Lavater's *Physiognomische Fragmente*, published in 1775–78, deduced innate character from the shape of people's heads and profiles. In his rival theory of 'pathognomy', Lichtenberg affirmed that facial features resulted from

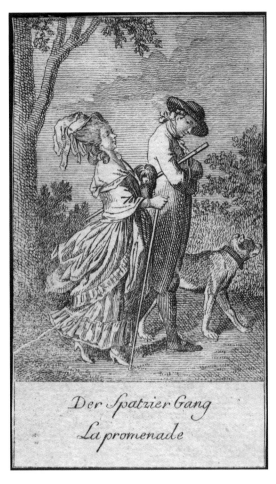

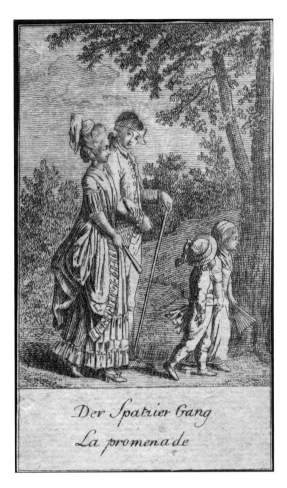

1 Daniel Nikolaus Chodowiecki, *Der Spatzier Gang, La Promenade, Affectation*, Plate 7, *Nature et Affectation, Göttinger Taschenkalender*, 1779; J.H. Bauer, no. 559

2 Daniel Nikolaus Chodowiecki, *Der Spatzier Gang, La Promenade, Nature*, Plate 8, *Nature et Affectation, Göttinger Taschenkalender*, 1779; J.H. Bauer, no. 560

habitual feelings and behaviour. Expressions, gestures and postures – that 'universal language . . . so clear that through it elephants and dogs learn to understand man' – left their marks on the face and body, making it possible to recognise 'the libertine, the miser, the peasant etc.'.

Lichtenberg initiated his editorship of the Göttingen Almanac by including in it his own pathognomic treatise, with apposite etchings by Chodowiecki. The artist had already provided the images to Lavater's work, and was known for his own psychological acuity; Lichtenberg called him the 'draughtsman of the soul'. Following Lichtenberg's instructions, he was to depict 'the same young man and the same young woman, according to the two diverse kinds of life they might undertake, so that their history can be read more in their physiognomies than through their actions'.[5] The Göttingen Almanac proved a runaway success from its very first edition.

For the years 1779 and 1780, Lichtenberg chose a topic of great concern to a late eighteenth-century readership: the contrast between Nature and Affectation.[6] Commenting on Chodowiecki's prints, Lichtenberg stresses that the subjects were drawn from the artist's own 'treasure of observations' of daily life.[7] Published with captions in German and French, the first, 1779 series included: *Instruction; The Conversation; Prayer; The Promenade; The Bow; The Dance.* Figures 1 and 2 reproduce Chodowiecki's plates 7 and 8, *Der Spatzier Gang* or *La Promenade*.[8]

Plate 7 (fig. 1) shows Lichtenberg's young man and woman out walking in parkland. He is accompanied by a mastiff; she carries a long-haired lap dog. In Plate 8 (fig. 2), the same pair stroll arm in arm behind two children holding hands.

Lichtenberg's heavily ironic French commentary may be roughly translated as follows:

> Even if there were no other sign by which to recognise the young man in plate 7 (who seems a little the worse for drink and harassed by the hunt) than his *almost* foreign appearance, you would still know that he was German. The German Production on his right, who has been associated to him through marriage, doesn't seem to suit him nearly as well as the creature of English origin on his left, which he has chosen himself.
>
> The couple in the eighth plate bring their children out with them, while the couple in the seventh, by contrast, take their Dogs, whom they seem to hold as dear. Indeed, what would children do there? Least of all would they learn to cultivate tender feelings. Which is why, while father and mother go for a walk, the children will be better and more speedily taught on far more soft-hearted promenades accompanying the man servant and the housekeeper, or the tutor and the French governess.[9]

Plate 7 ridicules affected behaviour: the slouching young man's hat and clothes are possibly more English than German, his overdressed wife smiles coquettishly as she shimmies by his side; they love their foreign pets more than their own children. This was surely intended, and viewed, as a topical critique of current fashions. Yet Chodowiecki's pictorial contrast between exotic affectation and homegrown naturalness echoes a passage written over a millennium earlier, by the Greek historian and essayist Plutarch (*c.*AD 45–*c.*120).

The third series of Plutarch's *Parallel Lives* (or *Lives of The Noble Grecians and Romans*, as Sir Thomas North entitled his English translation of 1579) includes the biographies of men famous for public virtues. These exemplary lives are introduced with the following vignette:

> The emperor Augustus once caught sight of some wealthy foreigners in Rome, who were carrying about young monkeys and puppies in their arms and caressing them with a great show of affection. We are told that he then asked whether the women in those countries did not bear children, thus rebuking in truly imperial fashion those who squander upon animals that capacity for love and affection which in the natural order of things should be reserved for our fellow men.[10]

In the *Life* of Solon (*c.*640/635–*c.*560 BC) that concludes the Greek biographies in this series, Plutarch identifies the motive for the behaviour Augustus castigated – and which, according to the author, was as prevalent in his own time as in the seventh and first centuries BC. It is fear of loss, the unbearable pain of watching one's children die, that misdirects natural human affection to animal surrogates.[11]

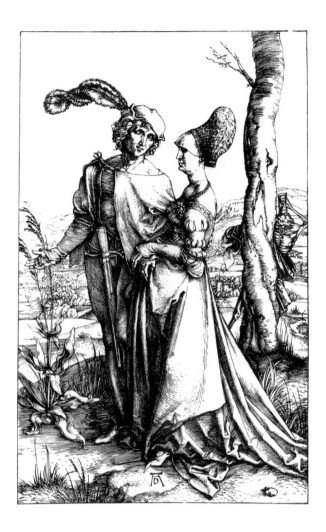

3 Albrecht Dürer, *Young Couple Threatened by Death ('The Promenade')*, engraving, *c*.1494–8; Bartsch 94

There is no hint of Plutarch's psychologising in either Chodowiecki's images or Lichtenberg's commentary, nor indeed any indication that they recalled Plutarch at all. Yet the correspondence between the eighteenth-century German prints and the ancient Graeco-Roman texts is as striking as it is surprising – too striking to be pure coincidence.

We need not, however, try to establish a direct link between the two. That Chodowiecki had read Plutarch is probable but not necessary. Many of Plutarch's vivid anecdotes and aphorisms, both in the *Lives* and in the essays collected as *Moralia*, had long entered Western thought, and some lodge there today, among people who have never heard of Plutarch, nor even know the Roman tragedies that Shakespeare based on his more spectacular *Lives*. The ancient writer's views on children continued to exercise a powerful influence on parents, professional educators, artists and their viewers almost until our own time.

The equation of natural affection with love of children, and of unnatural coldness with a fondness for pet animals, now seems commonplace, even a stereotype of the English national character.[12] It has become a cultural *topos* which, consciously or unconsciously, influences our views on parental attitudes. Yet if Chodowiecki the

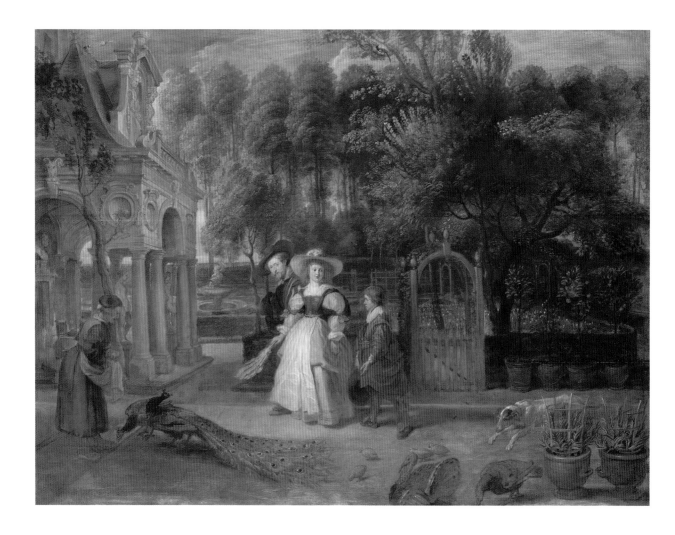

observer of contemporary mores was affected by a literary *topos*, Chodowiecki the draughtsman is most likely to have relied on models from the visual arts.

The couple strolling in parkland, a favourite motif of eighteenth-century European art, has a distinguished lineage. Ultimately traceable to medieval and Renaissance antecedents, notably Dürer's celebrated engraving of the 1490s showing fashionable young lovers threatened by Death lurking behind a tree (fig. 3),[13] the eighteenth-century version is directly descended from Peter Paul Rubens's reprise of the motif shortly after 1630 and his second marriage, to the young Hélène Fourment. In addition to several allegorical pictures of *The Garden of Love* – showing elegant young couples propelled by cupids into the gardens of Venus/Juno, goddess of love, marriage and fertility – he seems to have painted himself with Hélène and Nicholas (Rubens's youngest son by his much loved first wife, Isabella Brant, who had died in 1626)[14] walking in his own luxuriant garden, tended by an old woman; Hélène wears a rustic straw hat and a gardener's apron (fig. 4).[15] The picture may have been intended to allude not only to the Garden of Love but also to the ancient myth of Vertumnus and Pomona, in which the god of fertility Vertumnus, pleading his cause disguised as an

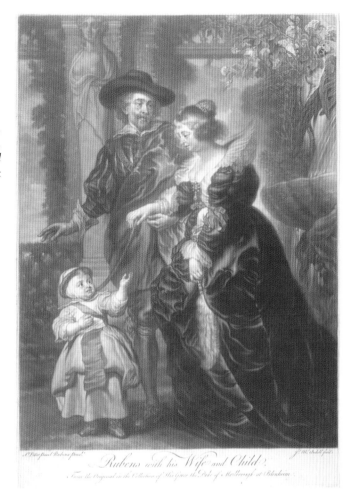

4 Peter Paul Rubens, *Peter Paul Rubens, Hélène Fourment and Nicholas Rubens ('The Walk in the Garden'), c.*1630, Munich, Alte Pinakothek

5 James McArdell, after Peter Paul Rubens, *Rubens with his Wife and Child,* mezzotint

old woman, wins the heart of Pomona, goddess of gardens, orchards and ripening fruit[16] – much as Rubens, at the advanced age of fifty-three, had won the love of sixteen-year-old Hélène.

A year or two later, Rubens painted what I believe to be the direct prototype of Chodowiecki's image of natural parental affection.[17] The picture seems to be the earliest family portrait of its kind in the whole of Western art. The Flemish painter's fame would ensure that it entered the general artistic repertory. In truth, Rubens shows only one toddler out strolling with her parents, with her mother holding her leading reins; she is probably his and Hélène's first child, Clara-Johanna. Chodowiecki could not have seen the original, which in 1706 was taken from Brussels to Blenheim Palace, but is most likely to have studied the mezzotint engraving made of it in England by James McArdell (fig. 5).[18]

Assuming, as I think we can from comparing Figures 2 and 5,[19] that Chodowiecki adapted the McArdell/Rubens composition, how conscious would he have been of the freight of associations just outlined – and how many of these can we read back into his little almanac illustration?

There can be no doubt that ideas of Nature, conjugal love and fruitfulness are intrinsic to Chodowiecki's image. The couple show no disparity in age, so we can surely eliminate the poignancy of an allusion to Vertumnus and Pomona. We can however less easily dismiss the lurking figure of Death in Dürer's seminal print, Figure 3, for although it is nowhere explicit in Rubens's imagery, the themes of youth, love, flowers and fruit are inseparable from melancholy notions of transience and mortality. Is it too fanciful to say that Chodowiecki's little children walk in the shadow of death – or, conversely, that by replacing Death, they in some way ensure their parents' survival?

The association with Death may be inappropriate to the theme of the 1779 Göttingen Almanac, but if we take a longer view, it seems legitimately evoked by an image of such complex antecedents.

Chodowiecki continued to be greatly admired in Germany throughout the nineteenth century.[20] The influence of the 'natural' parents' unaffected *Promenade*, Figure 2, can, I believe, be discerned in a key work of German Romantic art: Philipp Otto Runge's full-length portrait of his own parents (fig. 6).[21] The picture dates from 1806, when a trading blockade imposed after the French invasion of Germany had bankrupted Daniel, Runge's elder brother and chief support, forcing the painter to take refuge in his parents' home. Two preliminary studies for the work depict the elderly couple strolling, arm in arm, in the garden in front of their house and shipyard in Wolgast. Despite their seeming realism, these compositions rely on the conventions of eighteenth-century English portraiture that had influenced Jens Juel, Runge's teacher at the Academy of Copenhagen.[22] To the final version of the painting, however, Runge added the portraits of his own first-born child, Otto Sigismund, and the boy's older cousin Friedrich, son of the artist's brother Jacob. The consequent resemblance to Chodowiecki's etching[23] points to the picture, originally undertaken as a mere 'exercise' in painting, having assumed a deeper significance for the artist.

Capturing a likeness had never ranked high in Runge's artistic ambitions. Since 1802 he had been obsessed with a complex allegorical cycle, the *Four Times of Day*,[24] originally designed as mural decoration but ultimately meant to be the focus of a total art work (*Gesamtkunstwerk*) involving architecture, poetry and music. He continued elaborating the project throughout his short life, correlating Morning, Midday, Evening and Night with flowers – for Runge the most evocative of natural forms – colours, seasons and the stages of existence. Characteristically, his descriptions of his great work reconcile a cyclical world view, indebted to classical Antiquity, with Christian beliefs inherited from his fervently Lutheran parents:

> Morning is the limitless enlightenment of the universe. Day is the limitless realisation of creature life which fills the universe. Evening is the limitless annihilation of existence, reverting to the beginnings of the universe. Night is the limitless depth of belief in God's eternal existence.[25]

The rampant vegetation in the foreground of the artist's family portrait signals that this painting had also been colonised by Runge's preoccupation with the *Times of Day*

6 Otto Runge, *The Artist's Parents,*
1806, Hamburg Kunsthalle

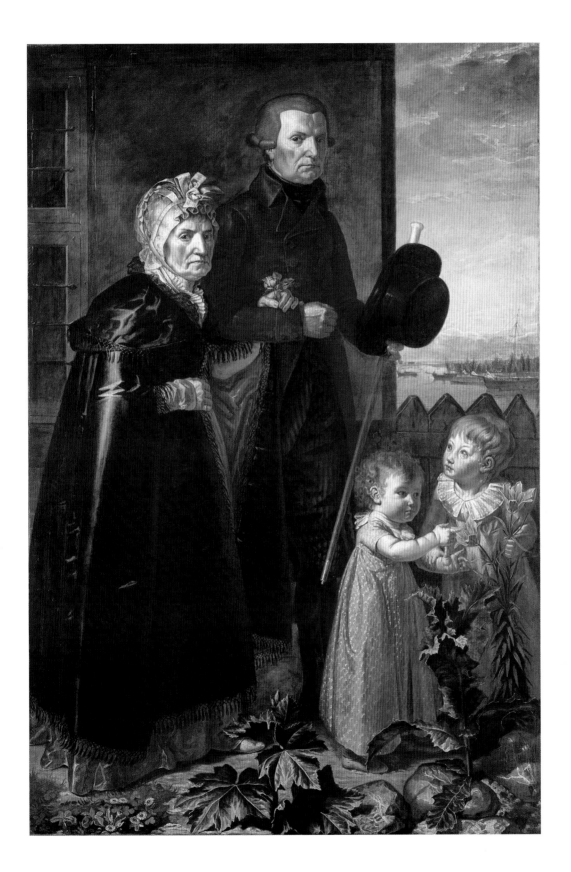

cycle. In general, the artist's flower symbolism is individual and hermetic; even his friends doubted it could become a universally understood code.[26] At times, however, he also relied on tradition, and there is no reason to doubt that the love token of a rose in his mother's hand, as in countless poems from Antiquity onwards, is also a reminder of transience, the brevity of earthly life. The rank henbane growing between stones in the foreground is a deadly poison; Runge's design for *Night* similarly contrasts organic with inorganic nature. Of all the plants in the painting, however, the most conspicuous is the orange lily – *Feuerlilie* ('fire lily') in German[27] – to which Otto Sigismund is pointing and Friedrich tries to call his grandparents' attention. Lilies, often in combination with the naked figures of babies, symbolise morning and day, light and the life force in Runge's *Times of Day* – and now these same associations are carried over to the real children in the portrait.[28]

By adopting the schema of Chodowiecki's etching, Runge asserts that the family group he depicts is guided by Nature; natural affection propels the generations along the path of life. The grandparents' life has nearly run its course towards night, yet night's 'limitless depth of belief in God's eternal existence' ensures the unbroken continuation of Nature's cycle. The lives of these old people portrayed by their painter-son will be perpetuated in their grandchildren, symbolised by the fire lilies and the light that herald a new day.

Runge's paintings, not least the robust portraits of his own and other people's children, consistently equate childhood with the Life Force, a new dawn, Revelation itself. In Robert Rosenblum's happy phrase, he views children 'as mysterious vessels of primitive energy through which nature's most awesome secrets could be intuited.'[29] It is not coincidental that the artist himself had been a sickly child, and was to die of consumption at thirty-three, only four years after this work was completed.

The 'long view' of Chodowiecki's prints exemplifies filiation typical of images, and why their relationship to reality is complex and unpredictable. Whatever the specific circumstances of its creation, even the most naturalistic portrait of a child or a family depends on inherited conventions, in the same way that a still-life painting is a response to a pictorial tradition before being, say, the record of new cultivars of cabbages.

In the many years since the publication of Philippe Ariès's *L'Enfant et la vie familiale sous l'Ancien Régime*,[30] critics have repeatedly refuted his contention, largely based on a survey of visual images, that childhood was not perceived as a distinctive stage of life until the modern period. Yet many have fallen into one of the very errors of which Ariès is rightly accused. Citing historical, literary or archaeological evidence disproving his thesis, they have nevertheless often continued to adduce images of children as unmediated reflections of contemporary attitudes and actual conditions, without due attention to the relative autonomy of art and the persistence of cultural *topoi*.[31]

A recent example is all the more striking because the artist himself seems to have exploited the gap between the public's and his own familiarity with artistic tradition. In the second volume of an excellent series on the history of the European family,[32] there appears a reproduction of William-Adolphe Bouguereau's *Indigent Family*, exhibited as *La Famille indigente* at the Paris Salon of 1865 (fig. 7).[33] After a description of the picture, the extended caption continues,

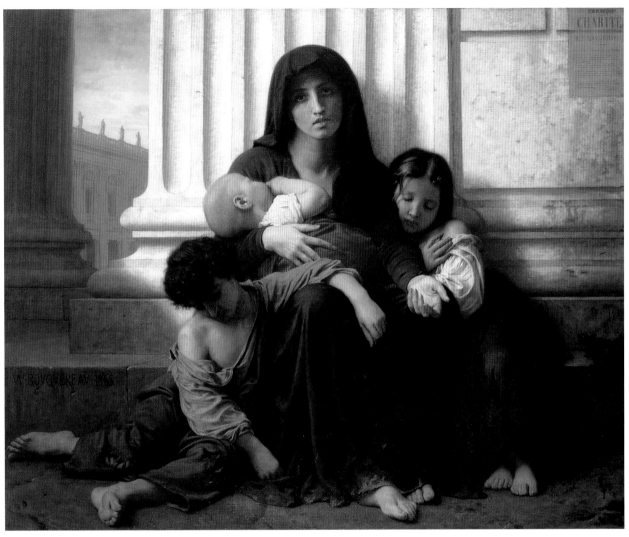

7 William Bouguereau, *La Famille Indigente*, 1865,
Birmingham, City Museum and Art Gallery 11.97

Painted prior to the days of public welfare programs for mothers and children, the image shows that alms and religious charity were virtually a mother's only recourse. With three children, this woman might have qualified for some charitable aid programs, but these would, most likely, have supplied only aid in kind and would probably have been insufficient. In portraying the close attachment of mother and children, the separation of family members appears all the more undesirable.[34]

There is no reason to doubt the historical accuracy of this information. But the painting was not social reportage and a call to action, as was obvious to the contemporary critics who rebuked the artist for insufficient realism:

'Doesn't that family have all it needs? Good and beautiful clothes, all new, and furthermore of silk!'

'M. Bouguereau can teach his pupils how to draw; he will not teach the rich how, and how much, people around them suffer.'[35]

The clue to the picture's ambiguities is provided by the inscription, disguised as a poster affixed under the portico of the Parisian church of the Madeleine that shelters the figures (though the background shows the Campidoglio in Rome). This notice announces a sermon on charity to be preached by the celebrated Père Lacordaire;[36] the only easily legible word is CHARITÉ.

The theological virtue of Charity, according to Saint Paul greatest of the trio Faith, Hope and Charity (I Corinthians 13:13), and termed 'mother of all the virtues' by the Church Fathers, was first personified as a mother nursing two children in fourteenth-century Italian church sculpture.[37] Versions of this iconography soon ousted earlier representations. For many centuries, artists and poets[38] throughout Europe depicted Charity as a mother of three or more children, one of them still at the breast.[39]

Bouguereau would have seen an allegorical painting of this kind by Andrea del Sarto (1486–1530) at the Louvre;[40] he also owned an engraving after the picture (fig. 8).[41] It has always been recognised that he freely adapted the Renaissance master's composition in numerous studies for his own overtly allegorical paintings of Charity, exhibited at the Salons of 1859, 1874 and 1878,[42] although oddly varying the number of children from two to five. What seems to have escaped notice is that he also used it as the basis for the *Indigent Family* of 1865.[43]

A product of academic training and beneficiary of the Prix de Rome in 1850, Bouguereau was a committed champion of an art seeking ideal Beauty and Truth, rooted in classical Antiquity, the Italian Renaissance and Poussin, as these were understood in conservative French Catholic circles under the Second Empire.[44] In the early 1860s, however, the magniloquent religious and mythological canvases that constituted Bouguereau's '*soutien de la grande peinture*', his 'support of the Grand Manner',[45] lost sales to innovations of 'anecdotal fantasy', particularly popular with the rich English and American collectors who now flocked to buy French art. His dealer, Durand-Ruel, having arranged for Bouguereau's work to be marketed through a London gallery, the artist was forced to betray his high calling, though even in the cloying scenes of familial love that made his fame abroad he never abandoned academic ideals and procedures. Between 1864 and 1869, perhaps adding ballast to his new popular repertoire, Bouguereau also turned to the 'miserabilist' subjects that had moved the public to tears in the 1830s and 1840s. *Indigent Family* was his first essay in the genre; it demonstrates quite precisely the artist's conflicting aims. The title under which he exhibited the canvas is anecdotal, and the picture was obviously realised from carefully chosen live models.[46] Beneath this modern cloak, however, Bouguereau smuggled into the Salon his continued allegiance to academic *grande peinture*, subduing the topical to the timeless, the particular to the universal, and eschewing ugliness for Beauty.

Could Bouguereau, a genuinely compassionate and charitable man, also have intended the image of a destitute mother, captioned CHARITY, to signify that it is the poor who practise that virtue rather than the rich? Though the picture itself may prompt this reading, it is not supported by the biographical evidence.

A plausible alternative interpretation, however, is suggested by Thomas

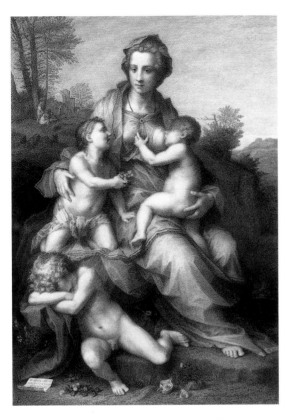

8 ?Danguin, after Andrea del Sarto,
Charity

9 Richard Banks Harradan, after Thomas Gainsborough,
Charity sympathising with Distress, 1801, mezzotint
(Gainsborough's House, Sudbury)

Gainsborough's *Charity Relieving Distress* of 1784, reproduced in mezzotint in 1801
(fig. 9).[47] The composition shows charity being dispensed by the servant of a stately
house to a beggar woman with five children. This partly bare-breasted figure, how-
ever, herself personifies Charity (a fact that seems to have escaped the picture's orig-
inal critics, although Gainsborough's beggar woman is loosely modelled on *Charity*,
one of the emblematic 'Virtues' designed by Sir Joshua Reynolds for New College
Chapel, Oxford). Her gift to the rich – providing the opportunity for benevolence –
is far greater than the alms they give. The picture's religious dimension is underlined
by the white dove hovering above the principal group, in a clear reference to the Holy
Spirit:[48] it is Christian Charity which is being depicted under the appearance of a
scene from everyday life. Without necessarily demonstrating any direct influence from
Gainsborough to Bouguereau, the spiritual gift of the poor to the rich may also be
the underlying message of the latter's painting.

Overlooked examples of the role of tradition in works of art, Bouguereau's *Indigent
Family* and Runge's *Portrait of the Artist's Parents* also anticipate one of the findings of
this study. Images of children, with or without carers, lend themselves readily to alle-
gorisation. In the process, they may acquire not merely divergent but contrasting
'universal' meanings: in Runge's work, children exemplify the Life Force; in the

iconography of the Virtues, they represent the weak and needy recipients of Charity's bounty. Pointing to an age-old *sentiment de l'enfance*, such images also demonstrate its inherent ambivalence.

It is not my intention in this book to pursue the argument with Ariès – that battle has long been won, though not all specialists in the modern period may have noticed.[49] My aim is almost the reverse of his: not primarily to deduce attitudes to childhood from pictorial evidence, but to examine the imagery of childhood for what it tells us about the uses of images. For if we look beyond the art of art galleries to consider amulets, cult, votive and funerary objects, devotonal or didactic prints, book illustration and decoration – in short, virtually every kind of visual representation – from Antiquity until the recent past, we find that images of or alluding to childhood have been commissioned, purchased, viewed and otherwise utilised by a wider segment of the population than any others, and particularly by women, otherwise under-represented as patrons or artists.

Rates of child mortality, how childhood has been defined by age, children actually nurtured or abused, educated or exploited, play their part in this story, but evidence of the condition of children from socio-historic sources is not central to my account.[50] Because, as shown by the few examples mustered in this introduction, Western art has long been cosmopolitan, local circumstances will be cited only as they are pertinent to the fashioning of particular works. Literary texts will be adduced only rarely. The absence of stylistic analysis in these pages represents a deliberate choice. Representing children schematically, as 'miniature adults', does not signify perceiving them in this way. Such stylistic traits are not normally a matter of choice, but symptomatic of a general condition of visual art at a given time in a given place, and/or of individual competence. Exceptions may be depictions of the Christ Child, where stylistic archaisms can be introduced deliberately in order to symbolise the holy infant's divine nature, and children's dynastic portraiture, designed to contradict future princes' childish nature.

I have resisted the temptation to include the numerous Asian, African and Amerindian images of children that have come to my attention while researching this book;[51] their context is too unfamiliar for me to do them even summary justice. Focusing exclusively on the Western tradition emphasises the continuity of that tradition – but also reflects the limitations of my training and energies. I can only hope that readers find the following pages a stimulus to casting their own nets more widely.

PART I

THE VULNERABLE CHILD

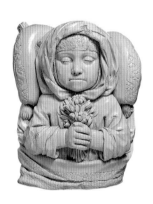

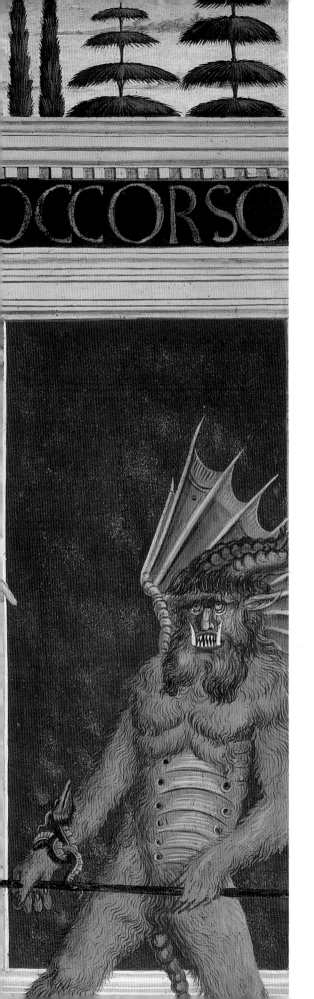

OCCORSO

CHAPTER I

Protection

In the twentieth century, parents began to see the world as a dangerous place for their children and their children prey to its many dangers. 'The idea of the vulnerable child, which replaced earlier convictions about children's sturdiness, reflects an anxious century,' he writes. 'More anxious than before? Quite probably. Oddly anxious, all things considered? Without a doubt.'[1]

THIS QUOTATION, FROM A RECENT book on childcare in America, can only provoke an old-fashioned exclamation of disbelief: 'Tell that to the marines!'

The evidence for high rates of child mortality in pre-industrial societies – and until recently in industrial societies as well – is overwhelming. Children's all-too real vulnerability to natural, accidental or violent death has left a deep imprint on visual culture. Since earliest Antiquity, innumerable artefacts have recorded parents' efforts to protect children from danger, their desire to mourn and commemorate the dead when such efforts have proved unavailing, and their need for consolation. Some images, conversely, depict hapless children's wilful murder by adults – in the Christian era most often deployed to evoke pity for the innocent victims.

The mortal dangers that infants and young children run in daily life, and their need of extraordinary protection, are vividly recorded in the fourteenth-century altarpiece

10 Simone Martini, *Beato Agostino Novello* altarpiece,
*c.*1324, Siena, Pinacoteca Nazionale

by Simone Martini that once surmounted the altar-tomb of the Blessed Agostino Novello in the church of Sant'Agostino, Siena (fig. 10).[2] Its five compartments, now deprived of their side frames and pinnacles, show four posthumous miracles of Blessed Agostino, with in the centre his likeness in the habit of the Eremitani, an order of Augustinian friars, claiming descent from Saint Augustine of Hippo (AD 354–430) but actually formed in 1256 out of several groupings of Italian hermits. Agostino Novello is portrayed in the wilderness of the hermitage, its silence broken only by angelic conversation and the song of birds, lovingly depicted by the artist.[3] A former jurist, he holds in his hands a bound copy of the *Constitutiones* he drafted for the lay order running Siena's Hospital of Santa Maria della Scala.[4] He is thus characterised as a contemporary who successfully combined the contemplative and the active life, in emulation of the Augustinians' supposed founder-saint and his immediate successors, the bearded hermits pictured in the roundels on either side of the arch.[5]

Late in life, Agostino Novello retired to the hermitage of San Leonardo al Lago near Siena, but he had earlier spent decades in Rome at the papal court, rising to be the pope's confessor. After his death in 1309, the Eremitani began an energetic campaign to have him canonised and venerated as a patron saint of Siena. By 1324, his body had been handsomely entombed in their church within the city. It is likely that the front of his wooden altar-tomb was decorated with scenes from his life, now lost, which formed a predella to the altarpiece. Since he had performed no miracles while alive, the major arguments for his elevation to sainthood are pictured on the surviving panels.

In 1329, his local cult having been sanctioned by the bishop, the beatified friar was invoked by Siena's General Council as the city's advocate at the celestial court.[6]

Later that year, however, the Council, wishing to abstain from participating in all the wearisome processions marking the feast-days of Siena's patron saints, conducted a poll of the latter's popularity. Agostino Novello collected the lowest number of votes. This is the background to the imagery of the altarpiece commissioned from Simone.

The four narrative compartments were designed in the form of votive images dedicated to Christ or the saints in thanksgiving for prayers granted.[7] Three of the four describe in minute detail Agostino's miraculous rescues of children from everyday mortal dangers.[8] They are set in contemporary Siena, easily recognisable by any of the original viewers.

Outside a gate to the city, a toddler is attacked by a savage dog;[9] his mother rushes to pick him up while a younger woman beats the animal off with a stick, but the child's face has already been terribly mauled, one eye dangling out of its orbit. A Super Hero in friar's tunic, Blessed Agostino swoops down from the skies, his hand extended in blessing. The child is now safe and sound; the women and two male passers-by pray in gratitude.

The scene below takes place in one of the city's narrow alleyways. A small boy was sitting on a little bench inside a jerry-built wooden loggia projecting from the first-floor of his house. The plank he was kicking has given way, and the boy has fallen out. His helpless mother shrieks and tears her hair. But before the child's body smashes on the ground, Agostino breaks its fall with his blessing, and retrieves the plank. Male passers-by help the boy, safe though shocked, to his feet; two of them give thanks.[10]

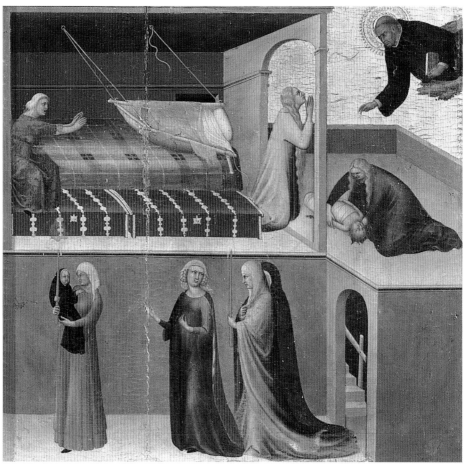

11 Simone Martini, *Beato Agostino Novello* altarpiece, detail of fig. 10,
Child Falling out of his Cradle – 'The Paganelli Miracle'

The final miracle, and the only one documented in Agostino's hagiographies,[11] unfolds within a bedroom, on a terrace and in the street (fig. 11).[12] A nursemaid has been rocking the hammock-like cradle of the swaddled infant son of Margherita and Miguccio Paganelli. One of the ropes by which the cradle hangs from the ceiling has frayed; the baby, ejected onto the terrace, lies still and pale, blood pouring from his fractured skull. His mother, in pink, prays for help to Blessed Agostino; his grand-mother Nera (appropriately draped in *nero*) gathers up the pathetic nursling, vowing that if he lives she will bring him to the Beato's altar dressed as an Augustinian friar. Agostino does not disappoint; once again he zooms to the rescue. In the foreground the grateful women process, coiffed and composed on their way to church, with the happy infant 'friar' clutching one of the wax candles to light in thanksgiving at Agostino's altar-tomb.

Nera's promise harks back to the custom, finally abolished in 1439, of offering chil-dren as oblates to a monastery or convent with the lifelong obligation of conventual vows. Here, the Augustinian habit becomes the visible sign of the child's dedication to his protector saint (neatly blurring the distinction between the Blessed Agostino

Novello and Saint Augustine).

The Eremitani who commissioned the altarpiece from Simone were well aware that, despite his involvement with Santa Maria della Scala, Agostino Novello had spent most of his life away from the city. To enlist public sympathy in his cause would require an exceptional effort of public relations. We can presume that sermons were said outlining the friar's merits, but imagery has a more powerful capacity for arousal.[13] The solemn rites with bell, book and candle at the altar would magnify the painting's impact on the faithful.

The division of the panel into one large standing 'image' and smaller side 'stories' had been introduced some hundred years earlier in altarpieces of Francis of Assisi, the mendicant friar canonised within two years of his death, and the first saint in Italy to be honoured with cult images.[14] While Simone Martini used the central likeness to stress Agostino's ecclesiastical credentials, the 'stories' flanking it had to demonstrate his efficacy as patron-protector of the laity. The commis-

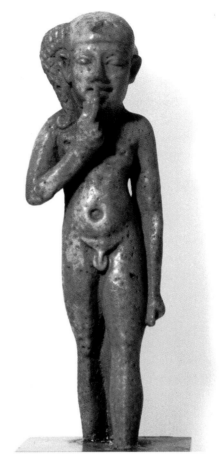

12 *Horus-the-Child,* amulet, London, British Museum

sioning friars would have required from the artist scenes of the utmost legibility, the greatest emotional impact and the widest possible appeal. No doubt the recorded Paganelli miracle inspired the two analogous incidents depicted by Simone, but it seems highly significant that three scenes out of four show the miraculous rescue or resurrection of a child. The Augustinian spin doctors evidently decided that no other topic would seem more urgent, be closer to the hearts of laymen and women, or of greater significance for the community. That Simone's painting failed to gain wider popularity for Blessed Agostino Novello only demonstrates that even in fourteenth-century Siena spin doctors did not always get their way.

Despite its vivid topicality, the altarpiece belongs to a category of image with an especially long and poignant history. The baby-friar of the Paganelli miracle exemplifies generations of vulnerable infants placed under the protection of supernatural beings with whom they are in some sense identified.

One of the earliest of these entities is the god Horus-the-child of Pharaonic Egypt, later known by the Greek name Harpocrates (fig. 12).[15] Like all children of either sex, he is represented in Egyptian art with adult proportions, but naked, and with a tress

of hair looped behind his ear.[16] More specific to him is the conventional, though originally well-observed, infantile gesture of an index finger in the mouth.[17]

This is not the place to unravel at length the complexities of ancient Egyptian religious beliefs: accretions of local cults and foreign imports, transmitted by oral tradition and through texts from different periods. Broadly speaking, these beliefs were directed at preventing chaos, and maintaining the cosmic order mirrored in the governance of the state. The god Horus is one prototype of the living earthly king. When portrayed in temples, palaces and funerary art as a falcon-headed man, or simply a falcon, he personifies various deities: a sky god; a solar god whose two eyes represent the sun and the moon; a warrior god, victor in the battle against evil and avenger of his murdered father Osiris; a god of the netherworld who ushers the dead into the presence of Osiris, supreme judge and quintessential deity of resurrection, and testifies to the successful completion of the various trials mortals must undergo to ensure a happy afterlife in Osiris's realm.[18]

adult Horus [handwritten margin note]

As in any culture, however, there was a more domestic side to Egyptian religion. In daily life, the fierce falcon god Horus gave way to frail little Horus-the-child.

The most widely diffused Egyptian myth describes Horus as the son of Isis and Osiris, the divine king murdered and dismembered by his evil brother Seth. Conceived after Isis had recovered Osiris's scattered body parts and bound them up in bandages (thus inventing mummification), the infant was hidden by his mother in the papyrus marsh of the Nile Delta, a border area between divine and human spheres. Sheltered from the malign Seth, Horus would grow up to contend with him successfully for his father's throne. But Horus-the-child remained 'in his basic role, forever a child, a point of reference and prototype for all future children.'[19]

When Isis was forced to leave him alone in the papyrus thicket, the fragile Horus-the-child suffered from hunger, fevers, stomach ache, the pains of dentition, scorpions, snakes, hookworm, and even attempted rape by Seth. He was foolish, reckless and the only divine being recorded to have suffered a nightmare.[20]

By identifying their mortal children with this vulnerable yet indestructible infant deity, Egyptian mothers could extend to them the supernatural protection that the mother goddess Isis offered her own offspring. Surviving medico-magical spells read, 'My arms are over this child – the arms of Isis are over him, as she puts her arms over her son Horus'; 'You are Horus, you have awoken as Horus. You are the living Horus. I drive out the illness which is in your body and the pain which is in your limbs'.[21] Amulets – effigies small enough to be worn as personal ornaments – of the archetypal mother goddess suckling her child are found on mummies from the thirteenth century BC onwards.[22]

Egyptians were of course not the only ancient people to produce apotropaic representations of a nurturing mother. The motif is also a striking and persistent feature of Greek art. A celebrated monumental group of Eirene with Ploutos – allegorical figure of Peace, mother of Wealth – by the fifth-century BC sculptor Kephisodotos, known through a Roman copy now in Munich, was at one time regarded as the earliest example of an intimate grouping of mother and infant, but is in fact only a late exemplar (fig. 13).[23] Thousands of statuettes known collectively as *kourotrophoi*, literally 'nursing mothers of boys' or 'child-nourishers', have been excavated in Greek settlements around the Aegean and the Mediterranean Seas. The oldest date from the

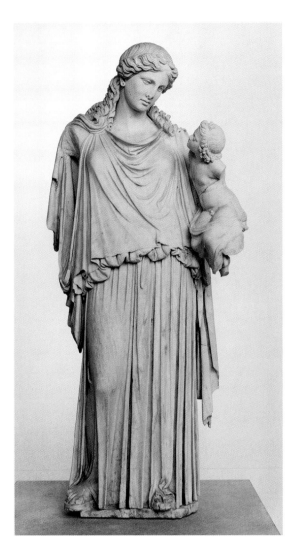

13 Roman copy after Kephisodotos, or Cephisodotus, the Elder, fl. *c.*400 BC, Munich, Staatliche Antikensammlungen

Bronze Age, *c.*3000 BC, and the latest from the Hellenistic period, a span of over three thousand years.[24] Some could be worn as amulets. Placed in graves, they represented maternal protection in the world beyond; in sanctuaries, they might be votive tokens of gratitude for the birth of a healthy child, or reflect the dedication of children to the *kourotrophos* who would care for them as she did for her own divine offspring. Whereas in Egypt she is primarily identified with Isis, and her solar aspect Hathor, virtually any goddess in the Greek pantheon could be represented in this nurturing role: not only Eirene, but also Ge, the earth goddess; Hera, wife of Zeus; Athena, protector of the city of Athens; even the virgin Artemis, goddess of the moon. Perhaps the most fervent *kourotrophic* cult was that of Demeter and Persephone. When her adolescent daughter Persephone or Kore ('maiden') was ravished by the god of the Underworld and taken there to be his wife, the lamenting Demeter searched for her in all the world, finally succeeding in bringing her back among the living for part of each year.[25] Like the myth of Isis, the tale of Demeter, goddess of agriculture, and her

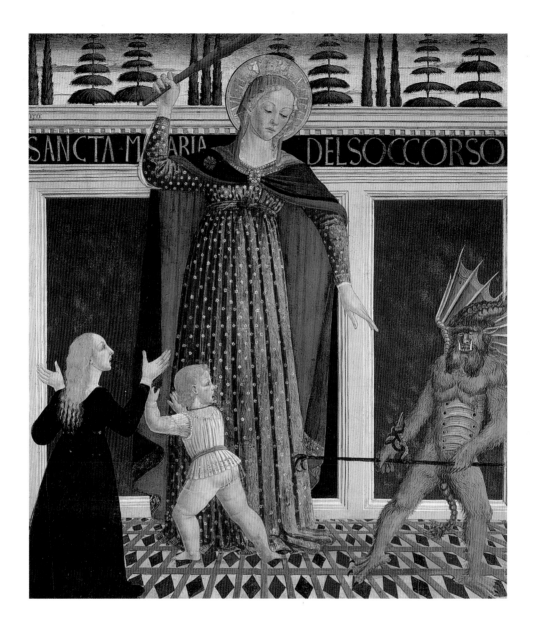

daughter Persephone, queen of the Underworld, conflates the notions of death and fertility, maternal love and regeneration – and paves the way for the allegorical interpretation of childhood as the springtime of human life.

It hardly needs stressing that the ubiquitous imagery of the Virgin and Child, that once presided over every Christian home, church and place of burial, resumes the millennial tradition of Isis and other pagan *kourotrophoi*. Like them, Mary protects adults as well as children: countless votive pictures show her rescuing from harm those who pray, or are prayed for, to her; in her aspect as the *Madonna della Misericordia*, when she is normally represented without the infant Jesus, she may compassionately shelter entire religious orders, confraternities or communities under her cloak. Yet her primary role as protector of children is never in doubt, though rarely as explicit as in the robust

14 Anonymous Florentine,
15th century; *Santa Maria del Soccorso*,
Florence, Church of Santo Spirito

15 Egyptian *cippus*, *Horus-the-child as
Saviour*, after 600 BC; London, British
Museum, EA 60958

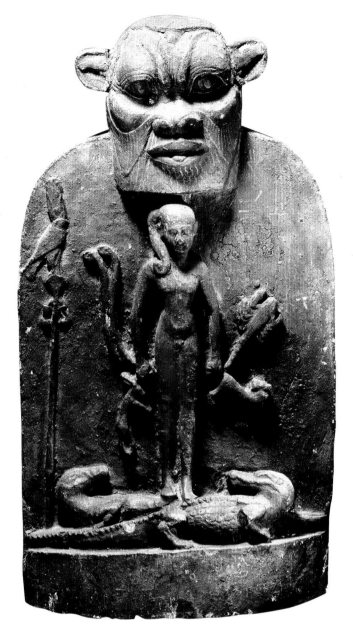

image by an unknown fifteenth-cen-
tury Florentine, the *Sancta Madonna del
Soccorso* (fig. 14).[26] A devil threatens a
naughty toddler. The boy's distraught
mother implores the help of the
Mother of God. Mary comes to the res-
cue, driving the devil away with a club.
The mortal baby clings to her cloak;
like those who take refuge beneath its
ample folds in the imagery of the
Misericordia, he in a sense replaces her
own holy Child. We are reminded of
the ancient Egyptian invocations, cer-
tainly quite unknown to the Christian
artist, in which the ailing child is iden-
tified with Isis's son, little Horus.

Turning again to ancient Egypt, we
find that Horus-the-child, through
amulets such as the one shown in Figure 12, might be even more efficacious than his
mother in protecting living children from the dangers he himself survives, notably
snake bites and the stings of scorpions. The most highly protective of artefacts was the
cippus, a plaque on which Horus-the-child is shown standing on crocodiles, holding
snakes, scorpions and other biting and stinging creatures in his outstretched arms (fig.
15).[27] Above him rises the head of the beneficent dwarf deity Bes, associated with
sexuality, childbirth and the family, but also with warding off snakes from the house.
Magic spells are engraved on the flat surfaces. Such plaques or 'Horus stelae' became
popular in the eighth century BC and were still in use under Roman rule in the fourth
century AD. While some were small enough to be worn, others, mainly made of stone,
were set up in temple precincts; water poured over them absorbed their magic and
could be drunk as further protection or cure.

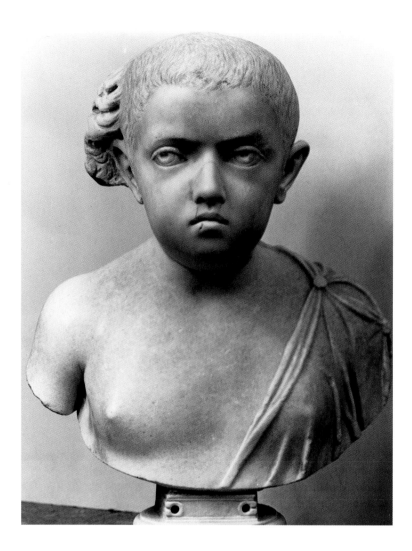

16 Roman bust portrait of unknown boy with 'side-lock of youth' demonstrating dedication to Isis, Petworth House, West Sussex

In his aspect of pest exterminator, Horus-the-Child was known as 'the saviour'. Conquering the noxious beings that endangered children's lives, he enabled living children to overcome them in turn. When the cult of Isis enraptured the Roman world between the fourth century BC. and the fourth century AD, as an oriental 'mystery' religion that became Christianity's greatest rival,[28] its adepts placed their young children under the goddess's protection; the youngsters' identification with Horus-the-child, under his Greek name of Harpocrates, was proclaimed through the Egyptian 'sidelock of youth', recorded in numerous Roman portrait busts (fig. 16).[29] The many amulets of Harpocrates excavated in Herculaneum and elsewhere show the little god wearing his sidelock and finger to mouth, seated on a lotus flower, the Egyptian plant *par excellence*.[30]

Hardly a period of Western culture does not reflect the impulse to ensure infants' and young children's survival through amulets and charms, distinctive clothing or hairstyles that place them under supernatural protection. Painted vases from fifth-century BC. Attica depict crawling babies and toddlers wearing strings of amulets across

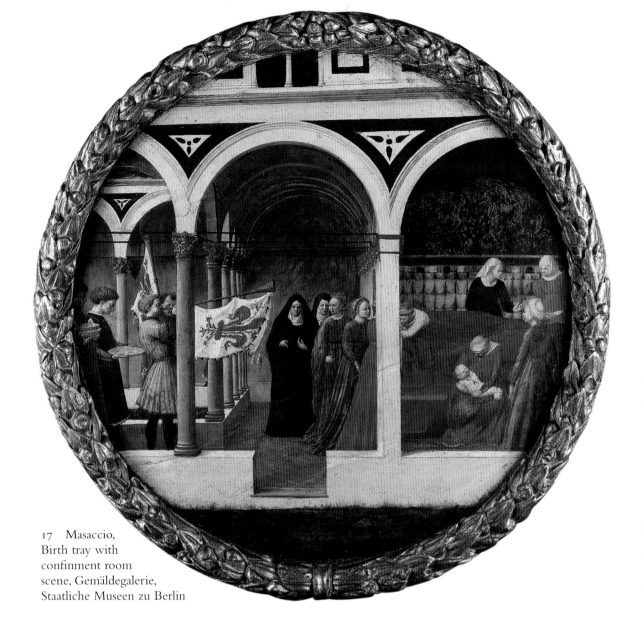

17 Masaccio,
Birth tray with
confinment room
scene, Gemäldegalerie,
Staatliche Museen zu Berlin

their chests;[31] amulets hang about the necks of swaddled infants in Etruscan (and many other) votive sculptures.[32] The custom persists through the Christian era. *Deschi da parto* or 'childbirth trays', presented to Italian Renaissance brides and newly delivered mothers, picture babies with apotropaic coral necklaces or pendants.[33] A fifteenth-century birth tray by the great Masaccio – atypical only in having been painted by a very major artist – depicts, in true-to-life detail according to contemporary accounts, a prosperous confinement-room scene in Florence (fig. 17).[34] Only the architecture is fictive, designed like a stage set for the benefit of spectators. The mother, attended by midwives, has been safely delivered of a child; the celebrations suggest it is a boy. Swaddled and be-coralled, he now lies in a nurse's arms. Five women visitors, two of them nuns, enter the room, heralded by trumpeters blowing horns sumptuously draped with the red Florentine fleur-de-lys. Behind the trumpeters, two male servants bring a box of sweetmeats and a childbirth tray, presumably similarly decorated.

In many fifteenth-century Italian paintings, even altarpieces, the Christ Child himself is shown with a coral amulet.[35] This imagery had always seemed to me surprising. What need does the incarnate God have of good-luck charms? What occult powers can they summon that are greater than his own? I now think such images have a different rationale. Like Horus-the-child, the Infant Jesus remains forever a deity identified with children, and the more closely he is depicted as a real child, the better can actual children be identified, or identify themselves, with him. The notion is enshrined in a famous passage from the *Rule for the Management of Family Care*, written in 1403 by the Florentine Dominican reformer Giovanni Dominici. His first precept for bringing up children 'for God' is

> to have paintings in the house, of holy boys, or young virgins, in which your child when still in swaddling clothes may delight as being as himself, and may be seized upon by the like thing, with actions and signs attractive to infancy. And as I say for paintings, so I say of sculptures. The Virgin Mary is good to have, with the child on her arm and the little bird, or the pomegranate in his fist. A good figure would be Jesus suckling, Jesus sleeping on his mother's lap, Jesus standing politely before her, Jesus making a hem and the mother sewing that hem. In the same way he may mirror himself in the holy Baptist, dressed in camel skin, a small boy entering the desert, playing with birds, sucking on the sweet leaves, sleeping on the ground. It would do no harm if he saw Jesus and the Baptist, the little Jesus and the Evangelist grouped together, and the murdered innocents, so that fear of arms and armed men would come over him. And so too little girls should be brought up in the sight of the eleven thousand virgins, discussing, fighting, praying. I would like them to see Agnes with the fat lamb, Cecilia crowned with roses, Elizabeth with many roses, Catherine on the wheel, with other figures that would give them love of virginity with their mother's milk, desire for Christ, hatred of sins, disgust at vanity, shrinking from bad companions, and a beginning, through considering the saints, of contemplating the supreme saint of saints.[36]

There are many noteworthy features in this recommendation, not least that little girls should be enticed by art to emulate female saints, but not the Virgin Mary, that supreme Christian role model of femininity;[37] 'discussing, fighting' are put on a par with 'praying'. The friar and his readers confound our post-Victorian expectations by not being averse to female feistiness. While he does not state so explicitly, Dominici clearly imagines Agnes, Cecilia and the others pictured as children (though this could never have been true of 'Catherine [martyred] on the wheel'), while the Virgin remains an adult *kourotrophos*.

If by danger we mean such things as scorpions or falling out of the cradle, Dominici's rule for using paintings and sculpture in the home is irrelevant to our theme. But the friar, in addition to the threat posed to children by 'arms and armed men' (to be discussed below), had in mind the spiritual danger of growing up – or dying – without God. In this sense, the paintings and sculptures of holy infants that we find so attractive in the art of the Early Florentine Renaissance[38] are all apotropaic images for the safety of children.

As is well known, a child's baptismal name may also place her or him under the special protection of a supernatural being;[39] many images record this special relationship. A little-known example is the 1596 portrait of two little Medici 'princes' by Cristofano Allori (fig. 18).[40] It shows the children of the Grand Duke of Tuscany,

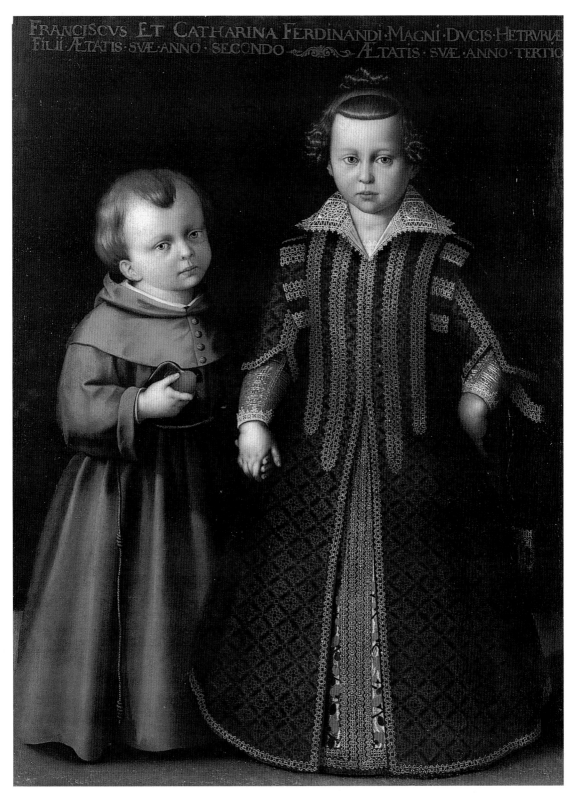

FRANCISCVS ET CATHARINA FERDINANDI MAGNI DVCIS HETRVRIÆ
FILII ÆTATIS SVÆ ANNO SECONDO ÆTATIS SVÆ ANNO TERTIO

18 Cristofano Allori, *Francesco & Caterina de'Medici*, 1596, Florence, Palazzo Pitti

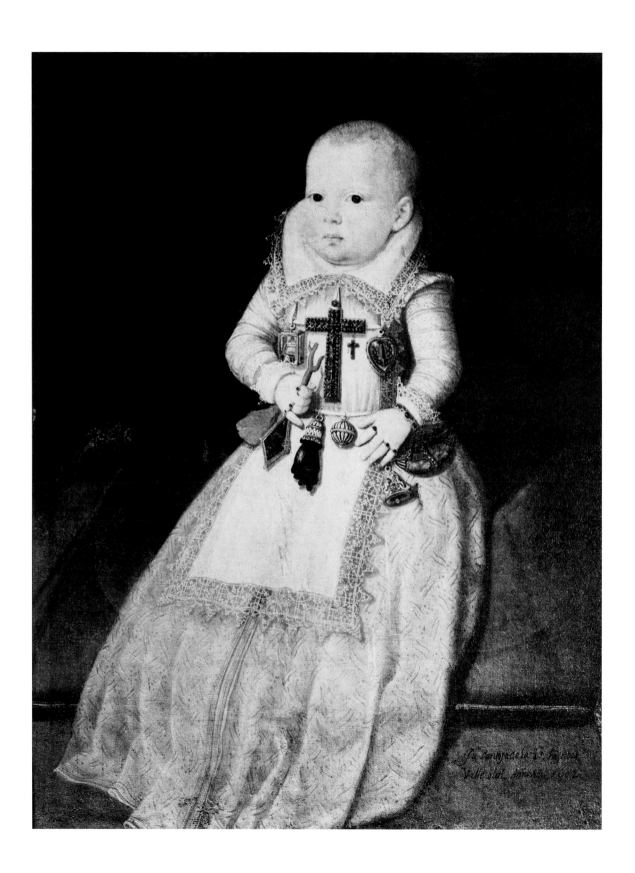

The Vulnerable Child

Ferdinando I de'Medici, and his wife Cristina of Lorraine: Caterina, aged three, and Francesco, aged two. The little boy, christened after the much-loved saint of Assisi, wears the habit of the order of mendicant friars founded by Francis in 1209; the grand-ducal wardrobe accounts record the actual 'dress of friarly grey serge' given to him by his mother.[41] Caterina, there being no female costume specifically associated with her name saint, is turned out in a fashion '*alla spagnola*', in the secular style of the Spanish court.

Francesco's habit neatly combines the sacred with the practical. Like the Augustinian dress of the Paganelli infant miraculously rescued by Beato Agostino Novello and immortalised by Simone Martini, it demonstrates the child's dedication to his saintly protector. In actual construction, however, it is like the petticoats that used to be worn by little boys before they were breeched. The resemblence is not casual. To stress the humility and obedience of monks and friars, their sexual inno-cence, their frugality and laborious life, the third-century founders of religious orders deliberately chose a hooded short tunic, the *cucullus*, as their distinctive dress. This gar-ment, worn since classical Antiquity by bare-legged little boys, slaves, shepherds and peasants, had been the humble dress of the most vulnerable section of the population.[42] Demonstrating his own baptismal link to a powerful patron saint, the Franciscan habit of little Francesco, cherished heir to one of the greatest principates of Europe, unintentionally also reflects a lasting association of dependent infancy with the socially marginalised and powerless.

This chapter ends, however, with a princely portrait of a child that illustrates in par-ticularly sumptuous form the persistence of apotropaic practices and their association with Christian belief (fig. 19).[43] It shows little Anne of Austria, eldest daughter of King Philip III of Spain and his wife Margaret of Austria, and future Queen of France. The baby, only a few months old, holds a branch of coral. At her waist hang bells, a horn, a rattle and a jet hand making an apotropaic gesture. The large cross suspended on her chest, and the objects flanking it, are reliquaries, including one containing a relic of her name saint, Saint Anne, mother of the Virgin Mary. I have not been able to dis-cover what the relics were thought to be – whether fragments of the True Cross or other Instruments of Christ's Passion, of clothing, personal belongings or of the bod-ies of the Virgin and Saint Anne – but their presence here signifies that not only emblems, but also rare and costly 'authentic' material remains, were recruited to safe-guard their Catholic Majesties' little daughter from harm. Sister of the future Philip IV of Spain, Anne survived to marry Louis XIII of France. Some half a century after this portrait was painted, a far greater Spanish court artist, Velázquez, would depict her sickly little nephew, Prince Philip Prosper, wreathed in amulets that, however, proved ineffectual to save him (fig. 144).

Most readers will have seen images of children placed under supernatural protec-tion – portraits of infants and toddlers with coral teething rings or whistles, baptismal photographs, photographs of Catholic boys and girls at their first communion, or even

19 Juan Pantoja de la Cruz, *La Infanta Ana de Austria, hija de Felipe III*
(*The Princess Anne of Austria, daughter of Philip III*), signed and dated 1602;
Real Patronato de las Descalzas

in the white and sky blue of dedicatees to the Virgin Mary. The list is endless. In the small sample presented in this chapter, I have touched upon amulets, votive and funerary statuettes and monumental cult sculpture, altarpieces, domestic devotional images, 'childbirth trays' designed to encourage or celebrate procreation, portraits – artefacts ranging in date from the Bronze Age to the 1800s. Whatever their primary function, all testify to the perennial perception of childhood as an especially vulnerable stage of life, and the desire to enlist superhuman aid in its protection.

CHAPTER 2

Innocent victims

WHEN NO PROTECTION AVAILS, CHILDREN DIE. More prone than adults to illness and accident, they are also more vulnerable to violence inflicted by others; this too is recorded in images. While the imagery of maternal love is normative, that of infanticide is highly selective and always tendentious.

Texts of every kind make it clear that exposure of the newborn – whether through economic necessity, social imperative or because they were sickly or malformed – was widespread throughout classical Antiquity. Rather than being officially accepted into the family, the unwanted infant was taken to some distant place and abandoned at the mercy of wild beasts and the elements. Most exposed children must have died; surprising large numbers were found and raised, normally as slaves. For fear of ritual pollution, active infanticide seems to have been avoided, except in rare cases of 'monstrous births' and in war (see below); it was, however, repeatedly legislated against, which suggests that it was practised.[1] Archaeological evidence seems to substantiate reports, in the Bible and other sources, of child sacrifice in Carthage and its dominions as late as the second century BC.[2]

These dark realities are barely reflected in visual imagery. Greek art depicts exposure and infanticide only as they occur in myths (though that is frequently); elegant vase paintings, many reflecting scenes from the plays of Greek tragedians, illustrate the stories of Kronos eating his newborn children;[3] the exposures of Oedipus, of baby Perseus with his mother Danae, of the twins Aeolus and Boeotos; Jason's and Medea's sons slaughtered by their mother.[4] With the exception of the foreign witch, Medea, who in Euripides' famous drama kills her own beloved children to wreak a terrible vengeance on her faithless husband,[5] the culprits in these mythical tales are normally the children's own fathers, ill-omened rulers fearful of being supplanted by their sons. Despite the abundance of cruel and murderous step-mothers in folk tales – such as those collected in the seventeenth century by Charles Perrault, or in the nineteenth by the Brothers Grimm – infanticidal women have left comparatively few traces in later European imagery. At about the same time as the virtue of Charity was first personified as a nurturing mother in Italian art, the vice of Cruelty was likened to a woman killing a child: Ambrogio Lorenzetti's 1338–9 fresco of *Bad Government*, in Siena's Palazzo Pubblico, shows Cruelty, enthroned next to Avarice and Vainglory, holding a serpent in one hand and choking a struggling baby with the other; some years later, Giovanni del Biondo's altarpiece of Saint Zenobius in Siena Cathedral represents Cruelty sinking her teeth into a child's naked body.[6] Although I am not aware of any similar subsequent depictions, the tradition must have been known to Cesare Ripa, who repeats the description verbally in his much reprinted handbook of allegorical imagery, the *Iconologia*, explaining it by saying that 'a great effect of cruelty is killing someone who does no one any harm'.[7]

More often, mothers who kill their children are depicted as motivated not by cruelty but by some external agency perverting their true nature. A fifteenth-century fresco in Rome shows women disposing of illegitimate offspring – 'the result of rape', says a later inscription – in the Tiber; the scene is part of a cycle that explains and exalts the salvific function of a foundling hospital (see below, pp. 49–54). An analogous reforming intention motivated Hogarth's famous eighteenth-century cautionary engraving of *Gin Lane* (fig. 20),[8] depicting the dehumanising effects of alcoholism. Like Chodowiecki's *The Promenade: Affectation* and *Nature* (figs 1, 2), which they pre-

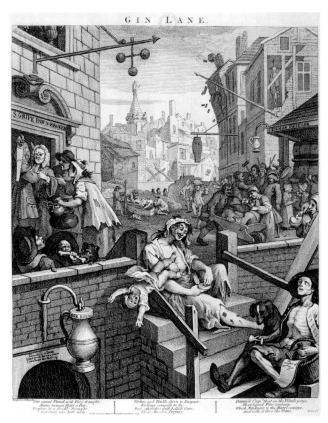

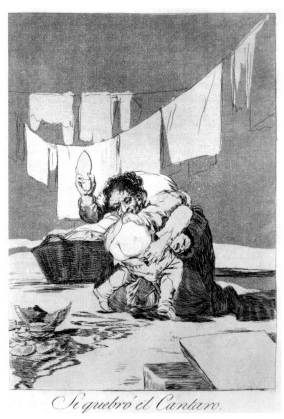

20 William Hogarth, *Gin Lane,* 1750/51, engraving, London, British Museum

21 Francisco Goya, *Si quebró el Cantaro,* aquatint, no. 25 in *Los Caprichos,* Madrid, 1799

date by nearly thirty years, the English artist's paired prints of *Beer Street* and *Gin Lane* also contrast natural and unnatural parental behaviour.[9] While the German artist's targets, however, were middle-class parents, the mother-and-child incident in the foreground of *Gin Lane* served as shock tactics in Hogarth's onslaught on the way of life of the London poor. Their traditional drink, weak beer, is shown to guarantee a sober, fruitful life. By contrast, addiction to cheap gin, first imported from the Low Countries by returning British soldiers, so debases human nature – 'Madness to the Heart conveys', says the caption – that a woman, forgetting she has been nursing a child, lets it fall from her arms to its death. A swaddled baby is being fed gin by its mother or nurse in the middleground, while in the distance, an infant lies crying on the ground besides its mother's coffin, and a drunken man brandishes a skewered baby in a grotesque parody of the Massacre of the Innocents (see below).

Seen in isolation, the aquatint of a mother savagely beating her son with the sole of a shoe for having broken a jug, by the Spanish artist Francisco Goya, appears more – and merely – realistic: a slice of brutal working-class life, in which the child is unlikely to lose his life (fig. 21).[10] The print, however, is twenty-fifth in an audacious series executed between 1796 and 1799, *Los Caprichos,* that remains Goya's most famous and influential work. Simultaneously satirical and surreal, it depicts vignettes

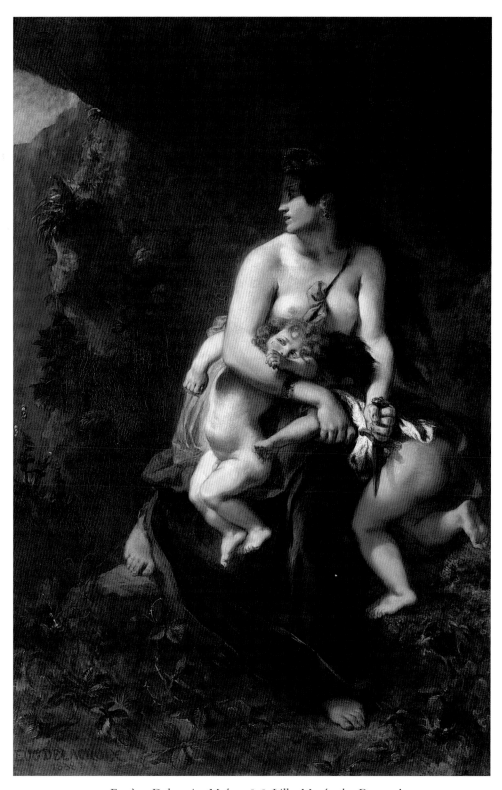

22 Eugène Delacroix, *Medea*, 1838, Lille, Musée des Beaux-Arts

of Spanish life alongside nightmares and hallucinations, and Spanish society itself as nightmarish and hallucinatory in comparison with its more enlightened European neighbours, mired in cruelty, ignorance and superstition: *The sleep of reason produces monsters*, reads the famous caption of print number forty-three.[11] In this context the mother's rage, as she claws and bites at the child's clothes to bare his flesh, appears more sinister and unnatural: the woman is a daylight forerunner of the hideous night-time witches, phantasmagoric versions of real-life procuresses and abortionists, who 'harvest' babies in a basket, perhaps to grind them into snuff, in print forty-five, '*It's juicy*', or offer them up to their master, the Devil, in print forty-seven.[12]

The murderous witch of ancient myth, Medea, reappears amongst the beautiful *femmes fatales* of nineteenth-century Romantic art in the work of the great French

23 Antoine Wiertz, *Hunger, Madness, Crime* (*Faim, Folie, Crime*), 1853, Brussels, Musée Wiertz

painter Eugène Delacroix. His first recorded mention of the subject dates from 1820, but his interest may have been further stimulated by Johann Simon Mayr's opera *Medea in Corinth*, inspired by Euripides' tragedy and premièred in Paris in 1823 with Madame Pasta, a singer much admired by Delacroix, in the title role. I reproduce the painting of 1838 (fig. 22),[13] for which numerous drawings and an oil sketch survive. The detail of the child awkwardly bundled under Medea's right arm may be derived from a figure in the foreground of a famous sixteenth-century engraving of the Massacre of the Innocents (fig. 28, pp. 43–4 below), of which Delacroix owned a copy. More unexpectedly, the composition echoes those of Leonardo da Vinci's *Virgin of the Rocks* in the Louvre, and Andrea del Sarto's *Charity* in the same museum (fig. 8).[14] The resemblance to the former, one of Western art's best-known icons of the Virgin and Child, is surely intended to point up the contrast between the Christian *kourotrophos* and the notorious pagan infanticide; knowingly or not, Delacroix also evokes the medieval tradition of Charity's antithetic vice, Cruelty – although Medea herself can be seen as a tragic victim of male cruelty, and is shown in flight from the avenging citizens of Corinth.

In 1853 one of the most eccentric Romantic artists, the Belgian Antoine Wiertz, created a more melodramatic and gruesome image of a filicidal mother, claiming, like Hogarth, social relevance, but probably influenced also by Goya's hag-ridden beauties and cannibal witches. His *Hunger, Madness, Crime* (fig. 23)[15] shows a pretty young woman, in an ample though ragged dress, sitting in a tumble-down peasant hovel with no food but turnips, the traditional attribute of famine. She laughs maniacally, brandishing a knife in one hand and clutching her hair with the other. One of her breasts is uncovered; the baby she has just been nursing lies shrouded in her lap. One of

24 Alessandro Allori (attr.),
*Beatus qui allidit parvulos suos
ad petram*, *c.*1590, Cassa di
Risparmio di Firenze

its plump little feet is sticking out of a cauldron in the fireplace, where the legs of a
chair are burning. Besides the turnips on the floor lies a paper with the headline CON-
TRIBUTION, evidently a record of charitable contributions distributed too
late or never.

 The strategy of these artists, like that of the Augustinian friars who in fourteenth-
century Siena commissioned Simone Martini's altarpiece of Beato Agostino Novello
(fig. 9), is based on the assumption that nothing mobilises viewers' emotions more
than a child coming to harm.[16] The image of a mother subverting her role as
kourotrophos is more horrifying still.

 Depictions of women killing children not related to them are even rarer than those
of infanticidal mothers. A unique sixteenth-century painting shows a Dominican *beata*
– almost certainly the Florentine Caterina de'Ricci (1522–89) – gravely dashing the
head of a naked infant on a block of stone; others, already dead, lie in a heap on the
ground (fig. 24).[17] The scene would be inexplicable were it not for the Latin inscrip-
tion carved in the stone, identified as the last verse of Psalm 136 (137 in the Hebrew
Bible and the Authorized Version).[18] This lament of exile begins with the memorable
verse 'By the rivers of Babylon, there we sat down, yea, we wept, when we

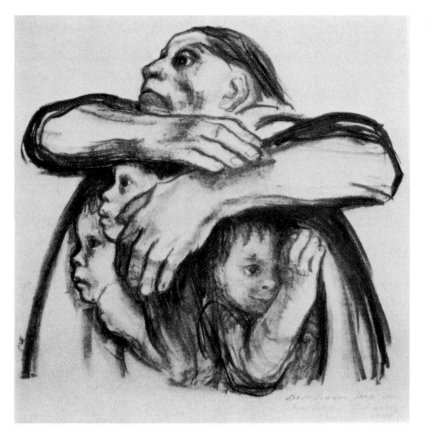

25 Käthe Kollwitz,
*Seed Corn Must not be
Ground*, lithograph,
1942

remembered Zion.' It ends with a vow of vengeance against the 'daughter of Babylon': 'Happy shall he be, that taketh and dasheth thy little ones against the stones.' The Authorized, Version's 'happy' misses the play on words of the Vulgate's Latin *'beatus'*, which means both 'blessed' and 'beatified', the Roman Church's first formal step in the process of sanctification. Caterina de' Ricci was an influential figure in Florentine religious life, intransigeant in her support for the Roman Church and notably intolerant of doctrinal deviation. We may suppose that the painting was commissioned, perhaps for the altar of the Dominican convent in Prato where she died, to mark Caterina's beatification and the doctrinal rigour that occasioned it; the unfortunate Babylonian infants must be seen as metaphors for heretical ideas. The imagery, not surprisingly, did not catch on. In the visual vocabulary of Western art, the 'woman infanticide', whether vengeful, brutalised or in allegorical guise, remains an oxymoron: a contradiction in terms.

The normative image of women as protectors of children is poignantly resumed in the last print made by the twentieth-century German socialist and artist, Käthe Kollwitz (fig. 25).[19] The lithograph dates from the war year 1942; its title, *Seed Corn Must not be Ground*, was taken by Kollwitz from a maxim in Goethe's *Wilhelm Meister*,

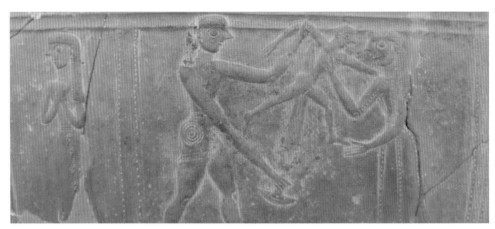

26 Relief panels of the 'Mykonos Pithos', metopes 14, 17,
7th century BC, Mykonos Museum, Cyclades

a book on the proper conduct of life, and one of the masterpieces of German litera-
ture. The print was designed – by a woman who had herself lost a son in action in
World War I – as a protest against the drafting of very young boys into the German
army; it could just as easily represent victims of German aggression, German victims
of Allied bombing, or the women and children in any genocidal war in history.
Implicit in the image is the contrary of the shielding mother: a threatening male
aggressor.

Armed men who slaughter children are, to a far greater extent even than abusive
fathers,[20] Western art's sombre mirror image of the *kourotrophos*. In representations of
war, women may, or may not, be massacred along with their offspring, but they are
always shown as victims alongside their children, being powerless to shield them.[21] It
is no coincidence that the Sorrows of the Virgin Mary, loving mother of her crucified
Son, are pictured by swords piercing her heart and body.

A seventh-century BC *pithos*, or large ceramic storage jar, from the island of
Mykonos in the Cyclades, is decorated with reliefs representing the massacre that fol-
lowed the Greek conquest of Troy (fig. 26).[22] The gruesome subject is recounted in
the *Iliad*, the eighth-century epic traditionally ascribed to Homer, and the reliefs share
the militaristic ethos of the poem, where the term *nepia tekna*, 'innocent children',
takes on a fearful significance. For Homer, *nepios*, 'innocent', does not mean 'guiltless',
but 'guileless', in its most pejorative sense: someone of limited perception, who can-
not reason or express thought in language, who is foolishly unable to foresee the con-
sequences of action, and who, unlike the warring heroes, understands neither battle
nor the design of the gods and is consequently doomed. It indicates, in short, some-
one like the women and 'innocent children' of conquered enemies.[23] The scenes on
the Mykonos Pithos show an infant spitted through the groin, another smashed head
down on the ground (the immemorial technique of infant murder, cited by the
Psalmist, see fig. 23) as his pleading mother is run through with a sword. The three-
figure groups are visual equivalents to the elaborately inventive Homeric descriptions
of violent death. They have been described as combining the 'titillation of ornamen-
tal horror with skilled figure variations ... a kind of witty ballet'.[24]

Although we admire the artful choreography of martial-arts films, and sanguinary comic strips have their many fans, we do not today normally countenance the use of such motifs as decoration, least of all on ceramics and in a domestic context.[25] But the Mykonos Pithos, and the ancient Greek vase paintings of child exposure and murder, show violence being perpetrated on exotic – that is, foreign *and* mythical – infants,[26] and the obtrusive stylistic conventions of these images serve further to distance the gruesome scenes from reality. Like present-day *kung fu* films and *manga* comics, but unlike classical Greek drama, which avoided showing violence, these visual depictions were probably always meant to evoke voyeuristic relish rather than moral reflection and cathartic release.

The exact contrary is traditionally intended by the innumerable depictions of the biblical Massacre of the Innocents, the distant heirs in Christian art of the Mykonos reliefs.[27]

The Massacre of the Innocents is recounted in the Infancy Gospel of St Matthew, chapter 2. After the birth of Jesus 'in the days of Herod the king', the Wise Men from the east, following the star, arrive in Jerusalem, asking 'Where is he that is born King of the Jews?'. Alarmed for his own reign, Herod learns of the prophecy that Christ would be born in Bethlehem; he sends the Magi to find the holy infant, ostensibly so that he too may adore him, but really in order to destroy him. The Magi, however, are warned by an angel in a dream not to return to the royal court after their Adoration of the Child. The enraged king orders all the male babies, 'from two years old and younger', of Bethlehem and its countryside to be killed – not realising that the Holy Family, equally forewarned, have already fled to Egypt.

Matthew's story of murder and Christ's miraculous escape parallels the account in Exodus of the rescue of an earlier saviour, Moses, from the massacre of Hebrew infants ordered by Pharaoh. It is a point of contact between the New Testament and the Hebrew Bible – and also of the biblical tales with the pagan myths in which a child predestined to greatness escapes death. Thus Zeus, in the best-known example, avoids being devoured by Kronos, whom he later dethrones.[28] For Matthew (2:17–18), the slaughtered babies of Bethlehem also fulfil Jeremiah's prophecy (31:15), in which Rachel's lament 'for her children ... because they are not' elicits God's consolation and promise of delivery. The infants massacred in Bethlehem, and their mothers' grief, authenticate Jesus's role as the Messiah foretold by the prophets; in turn, their significance in the Gospel is contingent on Christ's.

In time, the massacred infants acquired, as it were, a life of their own. During the Roman persecutions, they came to be identified as child-prototypes of all the Christian martyrs: 'An age not yet fit for battle was fit for the [martyr's] crown'.[29] Later theologians debated the nature of Original Sin, whether it could apply to 'innocent children', and whether there could be Christian baptism before the Baptism of Christ. (It was decided the massacred babies had been baptised in blood.) The very notion of childlike innocence was re-evaluated, and increasingly equated with guiltlessness, sexual innocence and celibacy. Christ had been incarnated as a newborn babe; he had later blessed 'little children . . . for of such is the kingdom of heaven/God' (Matthew 19:14; Mark 10:14; Luke 18:15). The doomed *nepia tekna* despised by Homeric heroes eventually became the 'Holy Innocents', role models for children and adults alike, exemplars of a fully Christian life.[30] By the fifth century,

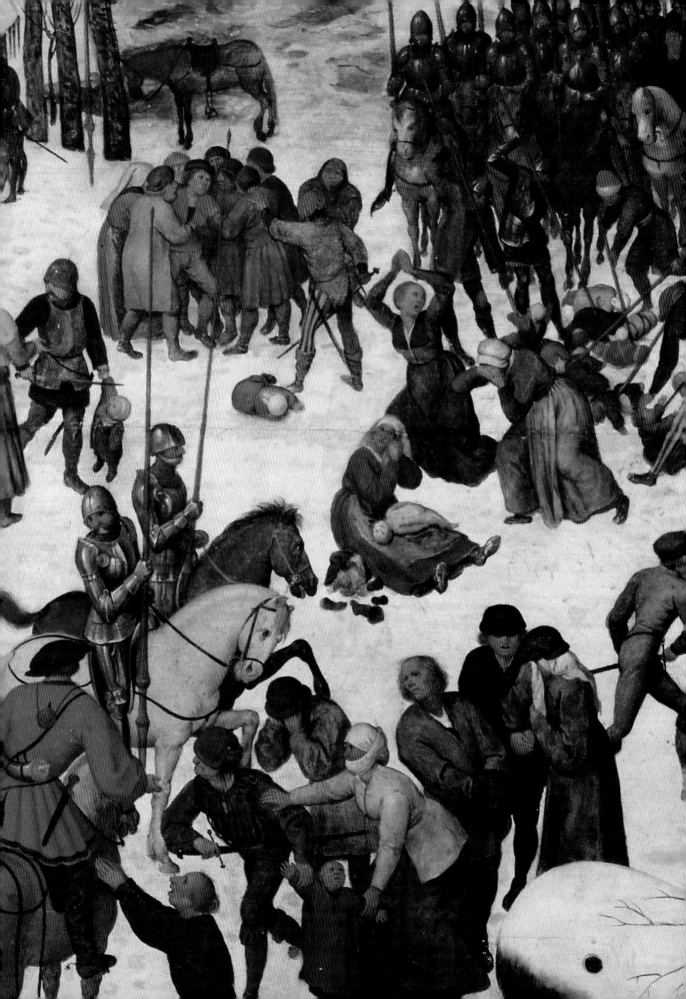

their massacre had entered the repertory of narrative art as part of the story of Christ's Infancy, a moral and visual counterpart to the the Magi's Adoration of the divine Child.[31] Herod's soldiers, usually shown wearing Roman armour, became the very type of benighted evildoers, bogey-men whose image could be used to teach good little children to fear 'arms and armed men', as advocated in Dominici's *Rule*.[32]

Between the fifth century and the present day, the Massacre of the Innocents has been depicted in stone on sarcophagi, pulpits and capitals; in bronze on church doors; in ivory on book covers; in manuscript illuminations on vellum, parchment and paper; in fresco, mosaic and *opus sectile* on church walls and floors; in tapestry; in tempera and in oils on altarpieces and chapel laterals.[33] These representations are designed to move viewers to terror and pity, to meditation on Christian values, but the very ubiquity and familiarity of the theme has also encouraged artists to use it for 'Mykonos'-like experiments in 'skilled figure variations', 'witty ballets' for collectors' pictures and prints. A famous and highly influential sixteenth-century virtuoso piece of this kind, a print by Marcantonio Raimondi after a composition by Raphael, is one of only four known to have been designed by the master specifically for engraving (fig. 28).[34] Judging by the number of surviving preparatory drawings, the print was important to Raphael; it has been suggested that the *Massacre of the Innocents* was to be his and Marcantonio's 'answer to both [Leonardo da Vinci's] *Battle of Anghiari* and [Michelangelo's] *Battle of Cascina*',[35] two never-completed, now lost, Florentine murals celebrated through drawings and engravings for their inventive choreography of violence. The insight is convincing only in part; closer rivals would have been the pioneering engravings of 'battles' by Antonio Pollaiuolo and Mantegna.[36] All four of these influential compositions, however, explore the furious passions of warring adult males (or, in the case of Michelangelo's *Battle of Cascina*, of men startled by an unforeseen attack) and Raphael may have chosen the subject of the Massacre of the Innocents, with its female and child victims, to demonstrate his own broader range. Instead of an imaginary Bethlehem, the background pictures the oldest bridge in Rome, the Ponte Fabricio or Quattro Capi leading to the Isola Tiberina, with modern buildings on either shore of the Tiber. The figures' dress ranges from the killers' total nudity (Raphael's tribute to his predecessors' obsession with male anatomy) through 'antique' to contemporary costumes; most of the women's faces resemble masks from ancient tragedy, and the children not in swaddling bands are represented as naked classical *putti*. Specific neither to the gospel narrative nor to a contemporary present, the anachronistic composition achieves iconic status as the antithesis of those gentle Madonna-and-Child paintings in which Raphael explores every variation on the theme of maternal and filial love. As curiously leached of affect as it is of blood, even this academic exercise, however, arouses in the viewer something of the traditional response to the subject when it is identified as the biblical Massacre of the Innocents.

Associated with centuries of Christian exegesis, yet also a decontextualised icon, the imagery of the Massacre became available to artists as a universal signifier of guilty aggression against guiltless victims. Pieter Bruegel the Elder's *Massacre of the Innocents* (fig. 29),[37] like most of his religious compositions, is set in a scontemporary Netherlands, and is carried out in a wintry Brabant village by troops in mainly contemporary armour. To what extent they are meant to resemble those despatched by

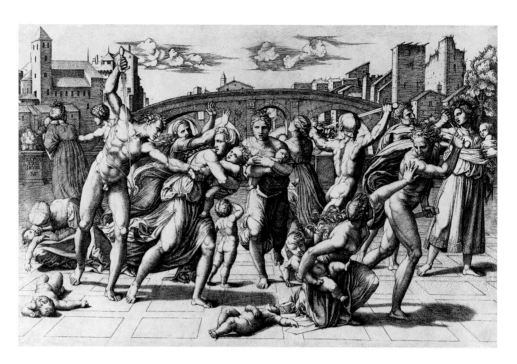

28 Marcantonio Raimondi, *Massacre of the Innocents*, second version, without fir tree. Engraving (Bartsch XIV.21.20), London, British Museum

29 Pieter Bruegel the Elder, *The Massacre of the Innocents*, c.1565–7, Vienna, Kunsthistorisches Museum

30 Pablo Picasso, *Guernica*, 1937, Madrid, Centro de Arte Reina Sofia

Philip II of Spain to quell Protestant 'heresy' and rebellion in his Netherlandish dominions has been much debated.[38] Whichever actual reality was evoked by the painting, however, Bruegel's transposition of the Bible story to familiar events invested the latter with the moral clarity and *gravitas* of the former.

Even a less explicit allusion to the theme could be equally effective. When Picasso painted *Guernica* for the Spanish Pavilion at the Paris World's Fair of 1937 (fig. 30),[39] seeking to rouse indignation at the town's bombing by Franco's German allies, and persuade liberal governments to intervene in the Spanish Republic's defence, he introduced the key motif of all Massacre pictures: a distraught mother weeping over the limp body of her baby.[40] She is the only principal character who does not appear in the first designs, and her final location in the picture was determined only after an unusual number of sketches and compositional studies. Yet she is the least ambiguous of all the figures in this great outcry of 'abhorrence of the military caste which [had] sunk Spain in an ocean of pain and death'.[41] The intent of Picasso's artful deformations and private symbols is not easily grasped;[42] it is this motif that most clearly guides viewers' responses.

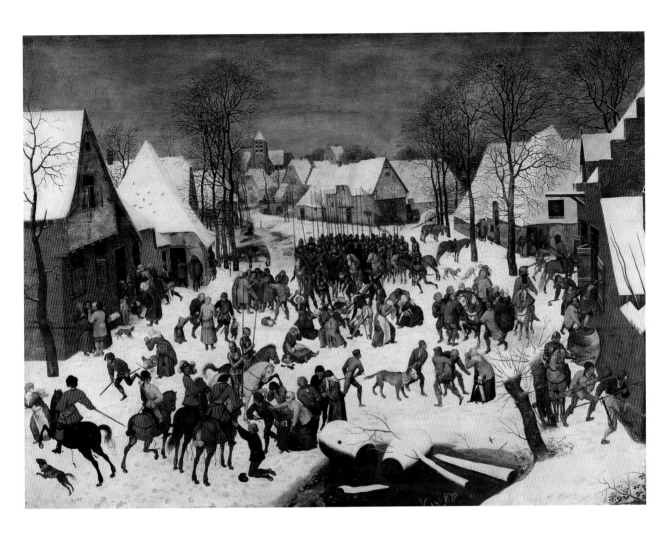

As we know, Picasso's appeal was in vain; *Guernica* records an artistic triumph and catastrophic political failure. The work may be the last occasion when a great painter recruited the imagery of the Massacre of the Innocents to an urgent contemporary cause, though documentary film makers and photographers have had all too many opportunities to carry on the tradition. Perhaps the earliest overt use of Massacre imagery as propaganda in another war – the civil war waged by church and state against infanticide – is documented by the first purpose-built hospital exclusively devoted to the care of foundlings, the fifteenth-century Ospedale degli Innocenti in Florence.

The reasons that had prompted the ancients to abandon unwanted babies did not disappear in the Christian era; now, however, it was a practice the Church condemned. Since neither sermons nor sanctions could prevent the indigent or the unmarried from disposing of infants, the early Church attempted to find homes for abandoned and orphaned children; medieval convents and hospitals took over the task.

The primary function of medieval hospitals was to shelter pilgrims and relieve poverty; nursing of the sick naturally followed, and some religious institutions specialised in caring for pandemic diseases such as leprosy or erysipelas, the dreaded 'Saint Anthony's fire'. In 1198, the year of his election to the papal throne, Innocent III rebuilt an eighth-century foundation for Saxon pilgrims to Rome, the Schola Saxonum, as a hospital additionally charged with taking in 'cast-out' children. He claimed to have had a dream, inspired by an angel, of newborn infants being thrown into the Tiber by their mothers; in actual fact, fishermen casting their nets in the river were finding the drowned corpses of infants. An energetic, autocratic man intent on imposing the spiritual authority and temporal power of the papacy, firstly on Rome and later over the whole of Europe, and the Middle East, Innocent must have viewed rampant infanticide as a particularly alarming symptom of the Eternal City's moral degradation and social anarchy. The new hospital was named Santo Spirito in Saxia (or Sassia), after the confraternity of the Holy Spirit – originally a French brotherhood – entrusted with its management.

In the 1470s Santo Spirito in Saxia was lavishly restructured and enlarged by Pope Sixtus IV.[43] The walls of the enormous Sistine ward built on the ruins of Innocent's hospital were decorated with frescoes recording the institution's history (Lower Wing, now the Sala Baglivi) and Sixtus's own life and achievements (mainly in the Upper Wing, now the Sala Lancisi). The original Latin inscriptions beneath these paintings are attributed to Sixtus's learned librarian, Bartolomeo Platina. The frescoes were restored in 1599; after a second intervention in 1650, when pictures and captions were mutilated by the addition of new windows, these texts were rewritten by a later humanist and papal librarian, Lucas Holstenius. Several more restorations followed: in 1733, 1850, 1938, and most recently in the 1990s, when the damaged and overpainted murals became once again legible, although by then their pictorial quality had been fatally compromised.[44]

The cycle begins with scenes of childbirth and infanticide. Platina's original inscriptions are recorded as describing 'cruel mothers' killing the 'progeny of guilty intercourse' (i.e. illegitimate children) by 'various means', and were supplemented with a medley of verses adapted from Isaiah, Chapters 13 and 14: 'Their children also shall be dashed to pieces before their eyes. And they shall have no pity on nursing

infants. Their eye shall have no compassion for their own children. For this reason a curse will devour the earth and few men shall be left.' The addendum implicitly equates contemporary Rome with ancient Babylon, and infanticide with God's vengeful curse that will depopulate the world.

A double vista of the river, with women casting babies into the water and fishermen bringing the bodies up in their nets, was painted on the short end wall facing the Tiber. Only fragments remain on either side, because in the eighteenth century these realistic scenes must have been judged too harrowing or too provocative, and a conventionally bland image of the Crucifixion in a fictive frame was substituted for most of the original work, to preside like an easel painting over the riverside entrance to the ward. Two later inscriptions, however, remain *in situ*; they alter the meaning of both Platina's and Holstenius's texts, toning down their vehement denunciations of 'cruel mothers'. It is not clear when these captions were written. The first avers that women, 'corrupted by clandestine lust' (translatable also as 'sexual defilement' or 'rape'), in various ways secretly kill the children who were its shameful signs. The second describes Innocent III in his concern earnestly supplicating God for advice on how to remedy so great an evil.[45]

The cycle continues with fishermen bringing their catch of dead babies to a horrified Pope, seated in full regalia on a faldstool. He is then pictured, still wearing the triple crown, asleep in bed while an angel directs him to build a foundling hospital on the site of the venerable Schola Saxonum. Platina's paraphrase of Isaiah 43:6 alluded to the hospital's mission of rescuing endangered children everywhere: 'I will say to the north wind, Give up; and to the south wind, do not hinder: bring back my sons from far, and my daughters from the ends of the earth.'

The Sistine fresco cycle at Santo Spirito in Saxia suggests that a foundling hospital was viewed – certainly in fifteenth-century, but probably also in twelfth-century Rome – as the surest antidote to mothers killing their illegitimate children. Only in captions composed at a later date was any blame attached to the babies' fathers for an evil crime that threatened society's present and future welfare.[46] The fifteenth-century paintings stress the religious dimension of Pope Innocent's original initiative, but draw no comparison between endangered contemporary infants and Herod's victims, the Holy Innocents.

A nod in that direction had however already been made some thirty years earlier in the imagery of Siena's general hospital, Santa Maria della Scala (so named because it faces the staircase, *scala*, leading up to the cathedral dedicated to Mary). Located on the Via Francigena (or Romea), the only road connecting medieval Rome with Spain, France, Flanders and Britain, Siena was an obligatory halt on the route of pilgrims to the Eternal City. Founded by the cathedral canons, its hospital became in time a rich and powerful civic institution; in addition to assisting pilgrims and the sick, it also assumed responsibility for the cast-off children of Siena and its countryside. It was staffed by a charitable confraternity whose statutes were later revised by Agostino Novello,[47] and for whom the friar designed distinctive garments.

In 1193 a papal bull granted Santa Maria della Scala autonomy from the cathedral authorities. In 1374, when the hospital had become the greatest owner of agricultural land in Siena and the city's banker, the civic authorities wrested from the clergy the right to nominate its rector. At the same time, not coincidentally, there grew up a tale

of the hospital having been founded by a layman, the Blessed Sorore, said to have been a humble ninth-century cobbler.

The legend of Beato Sorore was recounted in 1440–4 by a leading Sienese artist, Lorenzo di Pietro called 'il Vecchietta', as the first of a cycle of frescoes illustrating the hospital's history and its good works.[48] Like the Sistine paintings in Santo Spirito in Saxia, the Santa Maria della Scala murals decorated the hospital's largest ward, the *Pellegrinaio*.

Vecchietta depicted the prophetic *Dream of Sorore's Mother* (fig. 31).[49] Before giving birth to her son she was said to have dreamt of a ladder (also *scala* in Italian) rising from earth to heaven. Babies were climbing up the ladder to be received by the Madonna. In some unspecified way the dream predicted the charitable destiny of the future Beato.

The painting is as enigmatic as the dream itself. In the nave of a half-Gothic, half-Renaissance church, Sorore, in his humble white cap and grey workman's tunic,[50] kneels before the enthroned bishop recounting his mother's vision. Naked *putti* are climbing up the ladder to where Mary, attended by musician angels, reaches out to draw them up into Paradise. The story continues in the aisle on our right, where a child tugs on the bishop's robe as he places a coin in Sorore's hand to enable him to begin his great work. The cobbler tips his hat in thanks. Venerable elders, aristocratic youths and less exalted personages witness the event. The fictive reliefs above the side aisles of the church represent the Fall of Man – Adam and Eve with the Serpent – and two nude male figures, one with a club (Hercules personifying the virtue Fortitude?) and another holding a lamb and a small cross, the attributes of Saint John the Baptist, who is, however, not normally depicted naked and may here signify Christian Faith.

The babies climbing Mary's ladder, the *scala virtutis*, are equally difficult to interpret. Viewers have identified them with the souls of murdered or abandoned infants – but the logic of this interpretation is that the dead children have met a happier fate than those rescued by Sorore's foundation. More convincingly, the *putti* are seen as the martyred Holy Innocents, saintly patrons of children and protectors of the foundlings recovered in Santa Maria della Scala.[51]

However the mother's dream and Vecchietta's painting are read, their edulcorated allusion to the Murder of the Innocents lacks the stark imperative of the images of contemporary infanticide in Santo Spirito in Sassia.

At about the same time as Vecchietta and his collaborator Domenico di Bartolo were working in Siena, however, an altogether more direct analogy was being drawn in Florence between actual child murder or exposure and the Massacre of the Innocents.

Florence's abandoned children, like those elsewhere in Italy, had been cared for by general hospitals and religious orders since the late twelfth century.[52] From 1358, the Compagnia della Misericordia, a confraternity dedicated to the Seven Works of

31 Il Vecchietta, *The Dream of Sorore's Mother*, Siena, Santa Maria della Scala

Mercy,[53] appealed to public charity by displaying foundlings for three days on the covered porch of its headquarters, the Bigallo.[54] The hope was that they would attract adoptive parents before being put out to paid nurses. In 1386, by way of advertising the practice, Niccolò di Pietro Gerini and Ambrogio di Baldese frescoed an image of the *Captains of the Misericordia Entrusting Abandoned and Lost Children to the 'Mothers'* over the main entrance to the Bigallo's residence.[55]

Since 1294, however, the Florentine Republic had charged one of its most powerful guilds, the silk merchants' Arte della Seta, with primary responsibility for its abandoned children. Flushed with commercial success in the early fifteenth century, the Guild commissioned a new, central foundling hospital from the famous architect Filippo Brunelleschi. It became, as far as I know, the first purpose-built institution devoted exclusively to the rescue of unwanted infants, and was dedicated to Santa Maria degli Innocenti, Holy Mary of the Innocents, pictured as a Madonna of Misericord extending her protective cloak over the Holy Innocents and/or the foundlings.[56] A sixteenth-century processional standard (fig. 32),[57] shows the latter in various stages of swaddling, as toddlers, and as older children in the uniform of the Hospital with its distinctive badge.[58] The hospital's dedication boldly identified the *gettatelli*, deserted by their parents 'against nature's laws', with the Holy Innocents murdered by Herod.[59] From the high altarpiece of its church (fig. 33)[60] – an

33 Domenico Ghirlandaio, *Adoration of the Magi*, 1488,
Florence, Museum of the Ospedale degli Innocenti

34 Bernardino Poccetti,
*Massacre of the Innocents
and Scenes of the Life of the
Ospedale degli Innocenti*,
1610–12, Florence,
Ospedale degli Innocenti

Adoration of the Magi with the Massacre of the Innocents in the background, and two of the murdered babies kneeling in the foreground among the adoring Kings and next to Flo rence's patron saint, John the Baptist – to Andrea della Robbia's glazed terra-cotta roundels on its facade,[61] much of the hospital's imagery underlines the connection. Perhaps the most remarkable example of this is the fresco painted by Bernardino Poccetti for the women's refectory in 1610–12 (fig. 34).[62] A large mural in a small room, it shows the Virgin and Child in Heaven receiving the little souls of martyred Holy Innocents, crowned with flowers and carried up by angels from the Massacre taking place on earth, overseen by Herod and his counsellors. As if fleeing from the carnage, a cloaked woman hurries to deposit her swaddled infant in the Hospital.[63] She is preceded at the threshold by a woman in contemporary dress with two slightly older, naked children. Inside the building the kindly prioress, an elderly white-veiled matron, supervises wet-nurses cuddling and breast-feeding the *gettatelli*; two babies are accommodated head-to-foot in one cradle. On the picture's right, as if a counterpart of Herod on the left, Grand Duke Cosimo II de'Medici, accompanied by unidentified members of his entourage and the prior Roberto Antinori, himself a former *gettatello*, visits the hospital.[64] They are surrounded by girl foundlings in neat white coifs, reciting, or singing, from missals or hymnals. In the background Poccetti records the daily life of the foundling boys, kneeling at prayers besides the beds in their dormitory, in the classroom and in the refectory. During the recent restoration, the portraits of two lively little dogs, perhaps Grand Ducal pets, were found descending the fictive stairs that, serving as dadoes to the fresco on either side of an actual doorway in the wall, mediate between the viewers' space and that of the picture.[65]

The image is of a beneficent and orderly institution taking in and nurturing Florence's outcast children, and educating them to play a useful role in society;[66] through Poccetti's ingenious composition, it also presents itself as an effective, if anachronistic, antidote to the Massacre of the Innocents.

The Innocenti imagery most clearly symbolises the motives for the institution of foundling hospitals in Italy, and it may have been felt particularly appropriate to spell these out in detail to girls and women in their refectory. Poccetti's fresco pictures male authorities dissociating themselves from Herod's crime, while implicitly admitting the omnipresence of those culpable passions that drive women to betray their true nature, and threaten to turn all men into Herod. By rescuing the Christ Child's innocent surrogates, the hospital's benefactors expunge their own guilt and earn the forgiveness of Mary, Virgin, Mother and Bride – the ideal of womanhood so grievously outraged in the Massacre, so cruelly betrayed in contemporary society.

For reasons that are still disputed, the great foundling hospitals are particularly associated with Catholic Europe.[67] We would not expect the imagery of analogous later institutions in Protestant countries to feature the Virgin Mary, but the extent to which it concentrates on celebrating the work of the hospitals and their benefactors, managers and staff, while ignoring the guilty background of infanticide and child desertion, is striking. An early and outstanding example of such imagery is the anonymous Dutch portrait of *Hilleke de Roy and Four of her Orphans* dated 1586 (fig. 35).[68] Hilleke de Roy was the first matron of the Gorinchem orphanage, founded with a bequest in 1557/58; she was also the first person to register as a member of the city's Dutch Reformed Church (perhaps seen in the view through the window?) following

35 Anonymous, *Hilleke de Roy and Four of Her Orphans*, 1586, Gorinchem, Stichting Huize-Matthijs–Marijke

Gorinchem's capture by Protestant forces in 1572. The portrait shows her at the age of 76, combing the hair of one of her girl charges – an action emblematic of maternal care – while hearing one of the boy orphans read from an edifying text. The children are dressed in particoloured costumes, originating in the heraldic colours of servants' livery and guardsmen's uniforms, and signifying their status as orphans who 'must live by the kindness of others'.[69] The inscription upper left reads, in Dutch, 'I, Hilleke de Roy Aerts-daughter/have been mother to poor/abandoned orphans/for 29 years in this year of 1586'.

Presumably, the difference between foundling-hospital iconography in Catholic and Protestant countries is, at least in part and perhaps unconsciously, based on different views of the Works of Mercy: while in Catholic teaching good works are indispensable to redemption, for Protestants they are symptomatic of Grace already obtained; those predestined to be saved need not identify with guilty sinners, nor expiate their sins through charitable deeds. While the rich iconography of the Thomas Coram Foundling Hospital in London, founded in 1739 to alleviate the urgent problem of abandoned illegitimate infants, emulates the grand tradition of Italian hospitals

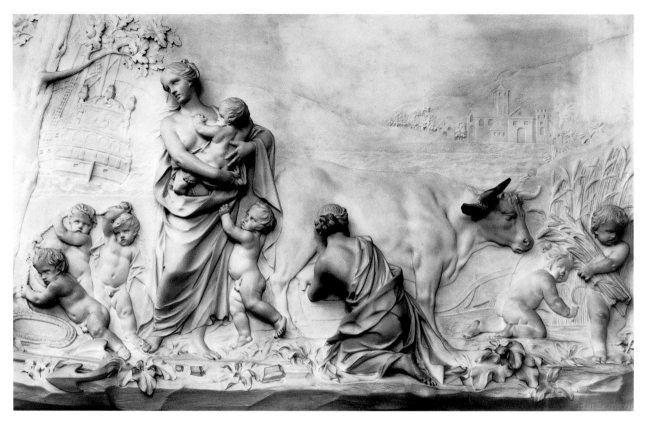

36 Michael Rysbrack, *Charity*, marble relief, 1746, London, The Foundling Museum

in its extensive use of motifs from the Bible, the self-congratulatory bias is evident even here.

An engraving by Samuel Wale shows the complex as it appeared in April 1749, a month before George Frederick Handel, the Hospital's famed musical patron, held his first benefit concert in the Chapel; allegorical statues of Fortune and Charity, placed respectively in front and to the left of the gate, illustrate the inscription, 'Which Fortune dooms but Charity compleats.'[70] Mainly through the efforts of William Hogarth, who in 1740 had executed Captain Coram's portrait,[71] and who became one of the Hospital's founding directors, the organisation also attracted the support of many visual artists.[72] In order to attract visitors and charitable donations, but also as a showcase for contemporary English art, Hogarth conceived the notion of ornamenting the Governors' Court Room with suitable subjects.

The sculptor Michael Rysbrack, elected 'Governor and Guardian' in 1745, offered a marble relief to go over the fireplace (fig. 36).[73] It is described by George Vertue, antiquarian, engraver and author of *Anecdotes of Painting*, who saw it in October 1746: 'Mr. Rysbrack has finisht his bass relief for the foundling hospital representing charity a woman embraceing of children – several others the boys coyling a cord or ship and anchor & the Girls, huswifrey and rural imployments milking the Cows etc.'[74] The effect today is faintly comical, the realistic cow, coiled rope and anchor

37 Francis Hayman, *The Finding of Moses*, 1746–7, London, The Foundling Museum

seeming at odds with the sculptor's idiom of white marble, naked *putti* and half-naked women in classical drapery, one crouching milking the cow, the other a standing per-sonification of Charity.[75] But there was nothing frivolous in Rysbrack's intentions. The relief is an allegory *all'antica* of the actual aims of the Hospital: to nurture England's outcast infants and train them for England's work in the Navy, on farms and in the home.

As Rysbrack worked in the solemn genre of allegory, so the painters showed their mettle in the highest pictorial genre, as then defined by art theorists, of History Painting, didactic narrative from literary sources, in which they were denied commis-sions by the preference of English collectors for Continental old masters. The subjects chosen were from Scripture. In 1746–7, Francis Hayman donated *The Finding of Moses* (fig. 37),[76] Hogarth *Moses Brought to Pharaoh's Daughter* (showing a later episode in the life of Moses as a child, choosing between Pharaoh's daughter and his 'nurse', in real-ity his birth mother), Joseph Highmore a *Hagar and Ishmael*, the Rev. James Wills the scene of Jesus blessing children, *Suffer the Little Children*.

In 1748 the biblical scenes were complemented with twelve landscape views of hos-pitals by other artists, including Gainsborough; portraits of the institution's officials and other works were donated in ensuing years. Thomas Coram's Foundling Hospital became the first public art gallery in England.[77]

Coram, a successful retired seaman and trader, and Hogarth, both childless, were sincerely horrified by the sight of babies deserted in the streets of London; all the contributing artists were moved to indignation and compassion. Yet the imagery of the Foundling Hospital's Court Room does little to evoke similar emotions from viewers.[78] Besides its stylistic remoteness and idyllic air, Rysbreck's allegory has the defects of its genre: its message must be laboriously deciphered. The biblical scenes similarly relate the present to the past only by inference. Viewers are expected to have read the Old Testament, and to grasp the relevance of the stories of Moses, history's first foundling, rescued by the charity of Pharaoh's daughter to become the future saviour of his people; and of Hagar, Abraham's concubine driven out by her child's father into the wilderness, where she is comforted by an angel. Even the significance of the fourth scene, that of Christ blessing the children from the Gospels of Mark (10:14–15) and Luke (18:16–17), is dependent on viewers' knowledge of the texts: 'Suffer [the] little children to come unto me, and forbid them not: for of such is the kingdom of God. [Verily I say unto you], Whosoever shall not receive the kingdom of God as a little child he shall not [shall in no wise] enter therein.'

Without the texts, image alone communicates little of what the Gospels enjoin: to follow Christ in welcoming little children, and to become like them in order to be saved. But in these passages it is neither their suffering nor sacrificial death but Christ's love for them, and their unquestioning trust in him, that make the little children suitable models of a godly life. In these sources, 'childlike innocence' has lost its lingering associations with Homeric doom and Herod's massacre; its depiction is free of both sadistic relish and a sense of guilt. In its imagery, the Hospital is shown not as a remedy for infanticide and a balm for guilty consciences, but as a successful means of forging good Christians and patriots out of foundlings and donors alike.

The break with Catholic tradition is documented in my final example from Coram's Foundling Hospital. The nineteenth-century taste for paintings of modern life bequeathed the institution perhaps its most endearing works. Their author, Emma Brownlow King, was brought up in the Hospital; her father, John Brownlow, had come there as a foundling, and rose to become Secretary from 1849 to 1872.

Emma Brownlow recorded four scenes from the life of girl foundlings in Coram's Hospital: *The Foundling restored to her Mother*, 1858, which includes a portrait of John Brownlow; *The Christening*, 1863; *The Sick Room*, 1864, and *A Foundling Girl at Christmas Dinner*, 1877.[79]

Although not conceived as a series, and donated to the Hospital by different owners at different times, the pictures tell a cheerful story with a happy ending: a newly respectable and prosperous mother reclaims the little girl she had earlier been forced to abandon. Walls hung with paintings, panelling and bed curtains, Christian ritual and appetising festive meals, set the cosy interiors of the Hospital apart from the streets teeming with destitute children, otherwise so popular in Victorian art. The artist even recoils from imagining death, for the sick little girl in the third painting is well cared for, with every prospect of recovery.

The Christening (fig. 38)[80] is shown taking place in the Hospital chapel. The children were christened on Sunday; they are carried in by older foundling girls, in uniforms resembling those of housemaids. Every baby had to have a sponsor; they are

38　　Emma Brownlow, *The Christening*, 1863, London, The Foundling Museum

here the gentlemen and lady on the right. The parson is the Reverend J.W. Gleadall, morning preacher at the Hospital.

Behind the infant being baptised, given a new name and a new start in life, is the altarpiece, Benjamin West's *Christ presenting a little Child*.[81] This was originally painted for the actor, playwright and art entrepreneur Charles Macklin's Bible, an exhibition of pictures of biblical subjects to be viewed like *tableaux vivants* by a paying public. Auctioned off after Macklin's death in 1797, West's painting was bought by four of the Coram's Governors, and presented to the Hospital to be placed over the altar of the chapel. Having restored his picture, West was elected a Governor of the Foundling Hospital in return.

West's *Christ presenting a little Child* replaced an *Adoration of the Magi* donated by its author, Andrea Casali, in 1750. The Italian-born painter had followed Catholic tradition in finding the subject of the *Adoration*, with its implicit allusion to the Massacre of the Innocents, suitable for the altar of a foundling hospital,[82] and it was a fundamental difference in attitudes, rather than a mere change in artistic taste, that prompted its removal.

Although British nineteenth-century art abounded in sentimental images of dead or dying children, it no longer pictured cast-out infants as potential victims of

39 William MacDuff,
Shaftesbury, or Lost and Found,
1862, London, Museum of
London

infanticide: it is the 'fallen woman' who in Victorian painting becomes the most
potent symbol of innocent suffering and undeserved death, usually by suicide, with
her illegitimate infant as mere attribute. Older abandoned, poor or orphaned children
are more often depicted as appealing to charity, or as its recipients, and being taught
the value of work and self-reliance.[83] In a painting of 1862 by William MacDuff
entitled *Shaftesbury, or Lost and Found* (fig. 39)[84] a virtuous little boy, member of Lord
Shaftesbury's 'Shoe Black Brigade',[85] draws the attention of a less fortunate pauper
friend to the great philanthropist's likeness in the window of the print publisher
Messrs. Graves. Below Shaftesbury's portrait is a print of Thomas Faed's *Mitherless
Bairn*, showing a cottage family taking in an orphaned child;[86] on the ground next to
the boys is a notice of a meeting of the Ragged School Union,[87] of which
Shaftesbury was president.

Twenty years later, the Anglophile French painter Jules Bastien-Lepage, having
decided, on what turned out to be his last visit to London, to depict *un type très anglais*,

40 Jules Bastien-Lepage, *Le Petit
Cireur de Bottes à Londres* (*The London
Bootblack*), 1882, Paris, Musée des Arts
Décoratifs

41 *Happy Tim*, from *Children's Delight*,
Boston 1889. Printed Books and Periodicals,
Winterthur Library, Winterthur, Delaware

hired as a model an actual Cheapside bootblack, identified by his livery and the brass
badge on his chest as a member of the Shoe Black Brigade (fig. 40).[88] Bastien-
Lepage's English hostess, the painter Dorothy Tennant (Mrs H.M. Stanley, later Lady
Stanley), described him as 'a restless, troublesome little fellow, and quite unconscious
of the honour done him', and the casual attitude in which he is posed seeks to pres-
ent him as the 'cheeky shoeblack' celebrated in the magazine *Punch* six months ear-
lier. Much influenced by her French guest, Lady Stanley herself became known as a
painter of pauper children; in her illustrations for *London Street Arabs*, London, 1890,
she records her preference for the 'happy-go-lucky urchin'.

American artists concurred with such optimistic, or hypocritical, portrayal of the
endangered child. Although readers on both sides of the Atlantic shed tears over the
descriptions by Charles Dickens, Charles Kingsley and others of the miserable lives
and deaths of little crossing sweepers and chimney sweeps, American society painters
such as G.F. Gilman, George Newell Bowers and D. Wilson were depicting 'street
urchins' as cheerful emblems of mischievous, energetic, entrepreneurial American
childhood. It is in this spirit that an illustration in *Children's Delight* (Boston, 1889)
presents the barefoot chimney sweep *Happy Tim* for the entertainment and instruc-
tion (probably even envy) of its more fortunate, though apparently less carefree, child
readers (fig. 41).[89]

Pace Bastien-Lepage, a different social programme informs much nineteenth-cen-

42 Anonymous, *Saint Vincent de Paul présidant une réunion des Dames de la Charité qui lui remettent leurs bijoux pour l'oeuvre des Enfants-Trouvés*, after 1729(?), Paris, Musée de l'Assistance Publique

tury French imagery of abandoned and orphaned children, which, as in Protestant countries, celebrates the founders and staff of foundling hospitals, in order, however, to propagandise the values of Catholic reform.

Foundling hospitals in France date from the mid-seventeenth century. Sometime after 1625, the priest Vincent de Paul (*c.*1580–1660, canonised 1737), a leading Catholic reformer and follower of Cardinal Bérulle, founder of the French Oratorians,[90] made charity fashionable, mobilising wealthy noblewomen to visit, feed and nurse the sick poor in their homes; eventually, peasant girls were also enrolled to assist these Ladies of Charity. In 1633, with his spiritual advisee the noble widow Louise de Marillac (canonised 1934), Vincent de Paul co-founded the socially all-inclusive lay order of the Sisters, or, as they came to be called, Daughters of Charity. The wealth of the Ladies also enabled him to establish hospitals, including, in 1638, and with a royal subsidy from the Queen, Anne of Austria, the Paris Oeuvre des Enfants-Trouvés for the care and education of orphans and foundlings (fig. 42).[91] This painting, by a now-unknown artist, purports to document the founding meeting, with the original nucleus of Ladies, some in widows' weeds, donating their jewels, and a Sister of Charity already caring for three well-swaddled infants in the foreground.[92] The aureole around Vincent de Paul's head suggests the picture was executed after 1729, to mark his beatification in that year; as in fourteenth-century Siena the artist relies on child-appeal to capture viewers' attention and sympathy for the new *beato*.

44 Isidore Pils, *La Mort d'une soeur de la charité*, 1850,
Paris, Musée d'Orsay

The Daughters of Charity of Saint Vincent de Paul was the earliest non-cloistered religious congregation of women devoted to charitable works, and by the twentieth century the Roman Catholic church's most populous women's institution. Anyone of a certain age who has been to a French hospital can call to mind their starched white coifs sailing majestically through wards and corridors.

In the 1830s and 1840s the problems of social welfare, and in particular of child abandonment, had again become acute, and propagandists for Catholic reform, such as the celebrated Dominican Père Lacordaire, were once more preaching charity in the name of Saint Vincent de Paul.[93] Among the Salon paintings of 'miserabilist subjects' were also those glorifying the work amongst the poor of Daughters of Charity and Catholic nuns. Isidore Pils submitted *The Death of a Sister of Charity* (actually, an Augustinian nun) to the Salon of 1850–1 (fig. 44),[94] and a related subject, *The Prayer in the Foundling Hospital*, to that of 1853. Both are set in the Hôpital Saint-Louis, which had become a centre for the treatment of skin and venereal disease where he himself had been a patient in the late 1840s. In addition to nuns, Figure 44 features indigent mothers and their ragged children mourning the dying sister; the companion painting shows children with shaven or bandaged heads, treated for scabies or ringworm.

45　Anonymous, *Saint Vincent de Paul et les soeurs de la charité*, 19th century,
Paris, Musée de l'Assistance Publique, M1862

Where Bouguereau's rare 'miserabilist' pictures emulated Raphael and the Italian
Renaissance,[95] Pils's realistic scenes of contemporary life recall works by Bartolomé
Murillo, seventeenth-century Spanish pioneer of the imagery of vagrant and beggar
children, and painter *par excellence* of charity being dispensed to the destitute.[96] But
the subject could also be approached in the cheerier and more unbuttoned mode of
Dutch seventeenth-century *genre*. The forgotten nineteenth-century painter of *Saint
Vincent de Paul and the Sisters of Charity* (fig. 45),[97] probably inspired by the image
reproduced in Figure 42, sentimentalised the dignified eighteenth-century narrative
of donation and foundation of the Enfants-Trouvés by showing the good saint bring-
ing a child he has just found to the newly established foundling home. In this charm-
ingly disordered, if not positively squalid, mock seventeenth-century environment,[98]
presided over by a painting of a Madonna and Child with saints, the sisters busy them-
selves cuddling, feeding and educating their charges. It is not the fate of abandoned
children that is deplored, but the human warmth, virtue and efficacy of practical
Catholic charity that are being celebrated and advocated.

By contrast, the lack of social programmes to relieve the plight of abandoned chil-
dren, and more particularly the catastrophic failure of charity by the rich and power-
ful, are the theme of the Spanish painter Joaquin Pallarés's *Abandonados*, painted in

46 Joaquin Pallarès, *Abandonados*, 1881, Museo del Prado no. 6738; deposited 1909 in the Instituto General y Técnico, Zaragoza; in 1983–4, in deposit in the Instituto 'Goya', Zaragoza

Rome in 1881 and bought for the Prado Museum in that same year by royal order (fig. 46).[99] Two ragged children have sheltered under the portico of a great house, whose door, emblazoned with a noble crest, remains resolutely shut as the sister tries to revive her dying, or dead, younger brother. The picture's rhetoric may be facile, the girl's charms a *fin-de-siècle* paedophile fantasy, but the reality Pallarés depicts remains bitter, and all too current in the 'global village' of our own time. No longer a theme for painters, such misery is now pictured in photographs, more often than not of African or Asian children – charitable organisation throughout the world finding that images of suffering childhood are still the most effective means of evoking public sympathy and support.

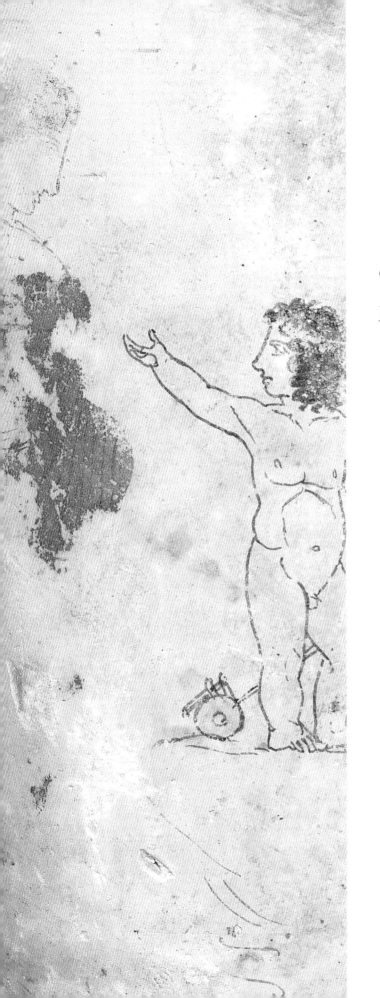

CHAPTER 3

Mourning and consolation

DESPITE THE HIGH INCIDENCE OF PURPOSEFUL exposure or infanticide, newborn babies and children throughout history have died mostly of natural causes. The death of the majority has gone unrecorded, but many have been memorialised with inscriptions and images that also commemorate, in socially mediated form, parental attitudes. Surprisingly often, grief is expressed on behalf of men as well as women, and although more boys than girls feature on funerary monuments – having been thought a greater loss to the future of family and state – significant numbers are dedicated to girls.

The precariousness of infant life in Ancient Egypt is suggested by a much quoted passage from one of the Egyptian 'wisdom texts', the *Instructions of Any*, composed sometime between 1550 and 1069 BC: 'Do not say, "I am too young to be taken", for you do not know your death. When death comes he steals the infant Who is in his mother's arms, Just like him who has reached old age.'[1]

We need not assume, however, that fatalistic resignation to infant death was the rule. It is instructive to read the text on an Egyptian funerary stele from the Late Period, 747–332 BC, dedicated to a little boy: 'Harm is what befell me When I was but a child! . . . I was driven from childhood too early! Turned away from my house as a youngster, Before I had my fill in it! The dark, a child's terror, engulfed me. While the breast was in my mouth!'[2] Since the *Instructions of Any* also recall that 'When you were born after your months, (your mother) was still yoked to you, her breast was in your mouth for three years', we may suppose the dead boy to have been a toddler, or only slightly older. What is probably new or exceptional here is not regret for an unfinished life or sensitivity to childish fear of the dark, but the fact that a stele was dedicated to such a young child.

Excavations of Egyptian burial and settlement sites from most periods, from the pre-dynastic through the pharaonic – such as Mostagedda, *c.*5500–4000 BC; Naqada, *c.*4000–3100 BC; Maadi, 3500–3100 BC; Kahun, 1880–1874 BC; Deir el-Medina, *c.*1550–1069 BC – have uncovered children's graves, and children's cemeteries, where the dead were buried in amphorae, baskets, boxes or coffins. Some well-furnished graves contained toys such as balls or skittles; those of stillborn infants tended to be bare even of amulets, with only small vessels filled with food for the underworld. Stillborn and dead newborn infants have also been found interred under the floors of private houses, sometimes two or three to a box, usually in chests made for other purposes such as storing clothes or toilet equipment.[3] One writer speculates that 'this may have been done in the hope that their spirits would re-enter their mother and be born again'.[4]

All this welter of children's graves was seldom, however, decorated with images. Although mummies of boys, some still wearing the sidelock of youth, have been found,[5] no child-specific imagery distinguishes their body-shaped wooden coffins. Startling though it is to see an infant's small mummy case painted and gilded in the semblance of the god Osiris, complete with upturned beard,[6] the convention is in reality no stranger than dressing a live boy in the tunic of his protective saint.[7] Eloquent as the silence of the dog in the night-time,[8] this *non*-alteration of adult funerary imagery testifies to continuing solicitude for the child's welfare, for it illustrates the belief that to achieve eternal life any dead person must assume the identity of Osiris – the murdered and dismembered god, mystically revivified by Isis in order to father their son Horus.[9]

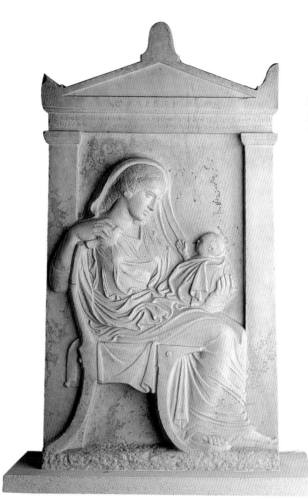

47 Attic gravestone of Ampharete, late 5th century BC, Athens, Keraimeikos Museum, P695

While texts and inscriptions in pharaonic Egypt may thus allude to parental grief, the funerary imagery of children, where it exists at all, is prospective – a means of attaining immortality in Osiris' divine realm, that symbolises both death and fertility.

Although their funerary beliefs and rites were different, Greek burial practices in many ways paralleled those of the Egyptians.[10] The bodies of dead infants were not cremated like those of adults, but placed in a variety of containers, from amphorae and pithoi to household terracotta tubs, clay water pipes, wooden coffins and stone sarcophagi. They were interred with adults or in special children's cemeteries, but also near or under the house. Gifts were buried with them: toys and terracotta animals, ceramic baby feeders, the miniature festival vases known as *choes*,[11] jewellery, and sometimes pet animals. Grave gifts for older children, such as weapons for boys and spindles for girls, signified the adult roles they would now never fulfil. But while children were pictured as participants in adults' funerary rites as early as the eighth century BC,[12] grave markers dedicated to them became frequent only from the fifth century onwards.[13] Even in Classical and Hellenistic art, however, monuments featuring dead infants may also commemorate adults: a mother dead in childbirth, or even a dead grandmother, as on this late fifth-century BC gravestone of a woman called Ampharete, gazing at an infant cradled on her knee and wrapped in her mantle (fig. 47).[14] In her right hand she holds a bird, or the terracotta figure of one, to amuse the baby who reaches out to her. The relief may appear to depict mother and child, but the inscription makes Ampharete say,

Mourning and Consolation 69

48 a, b. Attic white-ground lekythos, attributed to the Painter of Munich 2335, *c*.430 BC,
New York, The Metropolitan Museum of Art

> I hold this my daughter's dear child, whom I held on my lap, when we were alive and
> looked at the rays of the sun with our eyes, and now being dead, I hold it dead.

The theme of a woman tenderly holding an infant on her lap had became standard
from the sixth-century onwards; from its earliest days, however, the conventions of
Greek art, unlike those of Egyptian painting and sculpture, were directed at express-
ing emotion. Even the schematic little figures on eighth-century Geometric tomb
vases raise their hands to their heads in gestures of mourning. By depicting grief and
longing, funerary images and the poetic texts associated with them reinforced the
bonds between the living and the dead, and family relationships more generally. An
epigram inscribed on a third- or second-century BC stele from Kios, a Greek city in
Bithynia on the Black Sea, reads,

> Over Asklepiodotos who died before his time, Father Noetus piled up this well-enclosed
> mound, and before the grave of his poor son, he placed this finely smoothed stone and let
> be carved on it the picture of a five-year old child – an empty delight for the eyes; for he

had saved all joy and hope in the earth; at home, however, the suffering mother mourns and with her own laments overcomes the mournful nightingale.[15]

Embarking on his journey beyond the River Styx, his body already facing old Charon's ferryboat moored at the right, a dead toddler turns to wave farewell to his mother (fig. 48a).[16] She stands wrapped in her mantle, downcast, made silent and motionless by grief; it is no longer the living child she sees, pulling his roller toy about the house, but his dismal absence. The little boy is for the first time setting out alone, with only his toy for company, yet he still has no concept of eternal parting; the mother will live with her loss for ever. The rude ferryman waits patiently, merely extending his hand to show it is time to go (fig. 48b). Sketched on a fifth-century BC white-ground lekythos – a type of Athenian funerary vase filled with olive oil, placed by the bier while the body lay in state as relatives paid their last respects, and later put in or on top of the grave as a gift to the deceased – the scene must be one of the most delicately poignant ever painted. Like Egyptian funerary imagery, it depicts a mythical account of the soul's transit from life to death, but its real theme is individual identity and familial love.

Once it gained the ability to communicate such emotionally complex subjects, art was also able to offer consolation to grieving survivors. The poet Philitas of Samos (?c.330–270 BC) is known for two funerary epigrams; one is for a child: 'This tombstone heavy with grief announces/ "Death took little Theodota's tiny life",/And the little one says to her father, "Don't be unhappy,/Theodotos. Men are always having bad luck."'[17]

Something of the same spirit informs the beautiful fourth-century BC grave stele inscribed to 'Melisto, daughter of Ktesikrates from the deme [township] of Potamios' (fig. 49).[18] Melisto, some six to eight years old, plays with her pet Maltese dog, whom she gently teases with a bird in her right hand; in her left is a doll, or possibly a votive offering to ensure her health, but one that she holds like a toy. A smile on her face shows her happy absorption. Small holes in the background suggest that her head was once decorated with a metal marriage crown, presumably referring to the future she will never experience. But if the image appears serenely simple, its message is more complex: are we to understand the relief as retrospective – an idealised memory of the live Melisto, or prospective – a wishful vision of her afterlife?

Greek religion held contradictory and fluid beliefs about life after death; the mystery cults seem to have offered greater promises of posthumous survival and bliss.[19] When Homer's Odysseus descends into the underworld, he sees 'the ghosts of those that are dead, brides, and unwed youths . . . frisking girls with hearts still new to sorrow'; his mother's spirit eludes his embrace, flitting through his arms 'like a shadow or a dream'; the great Achilles would 'rather be a serf in the house of some landless man . . . than king of all these dead men that have done with life.' Other spirits recall the past, prophesise the future, or, like the hunter Orion, pursue their life's activities; still others, like Tantalus and Sisyphus, are being punished for unnamed crimes or vices. There is no mention of very small children.[20] It is only when the first-century BC Latin poet Virgil replays the episode, in Book VI of *The Aeneid*, that Aeneas and his guide, the Cumaean Sibyl, entering the underworld 'At once . . . heard voices and wailing sore – the souls of infants weeping, whom, on the very threshold of the sweet

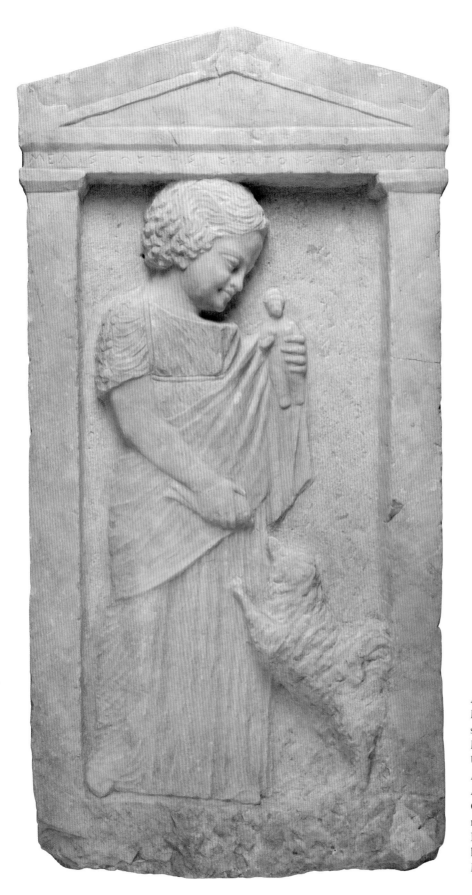

49 Gravestone of the Girl
Melisto, Attic marble grave
stele, *c.*340 BC, Cambridge,
Massachusetts, Harvard
University Art Museums,
Arthur M. Sackler Museum,
Alpheus Hyatt Purchasing and
Gifts for Special Uses Funds in
memory of Katherine
Brewster Taylor, as a tribute to
her many years at the Fogg
Museum

life they shared not, torn from the breast, the black day swept off and plunged in bitter death.'[21] Neither the earliest nor the last of the great bards of Antiquity paints the after-life in terms congruent with Philitas' epigram or the happy image on Melisto's funerary stele.

By referring to the beliefs of a mystery cult of which they were adepts, the Greek author Plutarch's letter of consolation to his wife on the death of their two-year-old daughter may most accurately represent the state of mind in which Melisto's gravestone was meant to be viewed, although it was written some four centuries after the monument had been carved. Plutarch had received the sad news while on a trip to Tanagra, and dispatched the letter home before rejoining his wife. Intimate and individualised, the text nonetheless relies at first on commonplaces of ancient 'consolation literature'. The bereaved father condoles with his wife on the loss of 'the longed-for daughter' born to her after four sons, whom he was able 'to call . . . by your name', Timoxena. 'Our affection for children so young,' he writes, 'has a poignancy all its own: the delight it gives is quite pure and free from all anger or reproach.' He praises the baby's mild, good-tempered and kind nature. But after various exhortations not to give way to incontinent grief, as lesser women do, he introduces a new note:

> That she has passed to a state where there is no pain need not be painful to us; for what sorrow can come to us through her, if nothing now can make her grieve? For even great deprivations lose their power to cause pain when they reach the point where the want is no longer felt; and your Timoxena has been deprived of little, for what she knew was little, and her pleasure was in little things; and as for those things of which she had acquired no perception, which she had never conceived, and to which she had never given thought, how could she be said to be deprived of them?[22]

Referring to their shared participation in 'the mystic formulas of the Dionysiac rites', Plutarch reminds his wife that the soul is imperishable; when it has lived in the body for only a short while, it is less attached to it and less cramped: 'set free by higher powers [the soul] proceeds to its natural state as though released from a bent position with flexibility and resilience unimpaired.'[23]

We cannot know whether the parents of little Melisto, Ktesikrates and his wife, were also initiates of a mystery cult teaching the immortality of the soul and that a child's spirit is less liable to be 'entangled in the passions and fortunes of this world' than an adult's. But the little girl's knowledge of only 'little things', and her pleasure in them, are underlined in the relief. Occupying virtually its entire surface, she is shown contentedly alone, concentrating on her doll, her bird and her dog, all of whom may have accompanied her in the grave. From her expression it is clear that 'nothing now can make her grieve', and even the marriage crown could not arouse her own sense of deprivation, for she can never have understood its full significance.

Melisto's stele, and others like it,[24] are neither quite idealised memories nor wishful visions of children in the afterlife. By showing the dead pleasurably absorbed in 'little things' – girls with dolls and birds, boys with toy rollers and knucklebones, both sometimes with pet dogs – they define the quintessential nature of childhood, and seek to convince bereaved parents that they need not feel sorrow for children who will never again have cause to grieve.

Von Eneas

Wie mancherlei zvischen ordenlichen in der hellen seind.

Sie da iung gestorben waren von müters brüsten hin gefaren

50 Hans Wechtlin(?), woodcut CCLXX, Sebastian Brant Strasburg *Virgil*, 1502.

51 Detail of fig. 50

The Vulnerable Child

There is a curious Northern Renaissance postscript to this. In 1502 the Strasburg poet and humanist, Sebastian Brant, published an edition of Virgil's *Aeneid* illustrated with 135 woodcuts. Attributed to the draughtsman and woodcut maker Hans Wechtlin, they proved to be perhaps the most influential book illustrations ever produced in Europe.[25] Brant/Wechtlin devoted nine woodcuts to Aeneas' descent into the underworld in Book VI, faithfully illustrating every place and inhabitant described by Virgil. But when it came to representing the 'souls of infants weeping . . . plunged in bitter death', the printmaker balked (fig. 50).[26] Like the sculptors of Greek children's gravestones, he chose to show the infants as happily unconscious of their fate – basing his interpretation, however, on Infancy's traditional image in contemporary popular prints of the different stages of human life, the so-called Ages of Man.[27] In his version of Hades, infants lie swaddled in the cradle, are cuddled and suckled by a smiling woman, pull each other's hair and hit their fellows with a wooden spoon, upset their potty to crawl on the ground trailing its contents, and learn to walk with the aid of a baby-walker. It is not in their nature to weep at being deprived of the 'sweet life they shared not', for they can have known nothing of it.

An illustration to Book VI of Virgil's *Aeneid* is an unexpected place to find consolation on the death of babies.

In the letter to his wife, Plutarch mentions 'ancestral and ancient usages and laws' that prohibit elaborate funerary rites for dead infants; the younger the child, the hastier its burial, and the shorter the duration of official mourning. Such usages also appear to have been in force in ancient Rome, although, with the rise of familial intimacy under the Empire – that is, from the first century AD – grief for a child's death was more freely expressed even by men, becoming a metaphor for the most profound of sorrows.[28]

A high proportion of sculptural funerary monuments dedicated to children is associated with first and second-century AD Rome.[29] Of these monuments the most telling are sarcophagi, stone coffins or tombs carved in bas-relief; although they continued to be produced for several more centuries, my discussion is limited to those with no overt Christian symbolism.

Numerous Roman children's sarcophagi naturally repeated, in reduced format, the decoration of adult tombs – mythological subjects, scenes of Bacchic revels, the Seasons, or simply garlands of fruit and flowers, sometimes framing a bust portrait of the deceased. Other motifs, however, seem to have been designed in the sculptors' workshops specifically for the small sarcophagi held in stock for children's burials, to be adapted rapidly, if at all, to individual requirements. They include children's games, especially those played with nuts by both boys and girls, and the games and chariot races of *putti* or cupids. (The *putti* of Hellenistic and Roman art are not necessarily the little sprites of Venus' entourage. They often appear simply as amusing and decorative motifs; they may personify emotions suppressed by adult figures in narrative imagery; in funerary contexts they are playful denizens of the afterlife, associated with Bacchus or other deities of death and resurrection: immortal child-substitutes. *Putti* are also the direct antecedents of medieval representations of the soul as a little child borne up to heaven after the adult body's death, and of the 'cherub' angels in Renaissance and later art.[30]) Equally child-specific are marine feasts, emblems of the soul's passage through the storms of life to safe harbour; biographical scenes of a child's

life-cycle, and scenes known as *conclamatio* (literally, 'bewailing together'), showing mourners gathered around the body of the dead child laid out on a couch. I illustrate three sarcophagi from the last two of these categories.

My first example is the earliest, dating from around AD 120; its poetic interpretation of a child's biography is exceptional (fig. 52).[31] I was attracted to this work many years ago, when I first began to collect images of baby-walkers, a motif in the imagery of childhood whose antiquity, persistence and mutable significance intrigued me, and to which I shall return in Chapter 5. But I could not interpret the relief until I was made aware that, contrary to other Roman narrative sarcophagi and to most European images, it reads from right to left. A newborn child begins his life's journey with his parents in a horse-drawn carriage; swaddled, he is held on his mother's lap. A faint smile seems to play about the parents' faces. The next vignette shows him as a chubby toddler, naked but for a belly band, vigorously pushing his baby-walker. Taller and more powerful, he then plays with, or feeds, a large bird, recalling *The Boy with a Goose*, a much-copied motif of Hellenistic art in which a baby grapples with a goose as large as himself. In the background, between these two scenes, stands a highly stylised tree with oval leaves and fruit, perhaps olives, whose branches spread over both versions of the child. The cycle of his life ends with the family speeding away in the horse-drawn carriage, a flying *putto* pointing ahead to an unknowable destination. The little boy is now seated on his father's knee; his father's arm is on his shoulder. The parents' faces may be creased with grief, but the coarse and worn carving makes it hard to tell. Two torches flank the relief and mark the corners of the sarcophagus, whose sides are undecorated. Torches figure regularly in Roman funerary art, sometimes held raised by cupids; they may have a particular significance here, since some children's funeral rites were held at night by torch- and candle-light, though even daylight funerals may have been lit by torches.[32]

This imagery is at once enigmatic and clear. The galloping horses evoke transience, the brevity of the child's passage through this world. But the speeding carriage is a metaphor for his parents' experience of his life, not his own. Like Melisto's, his private universe has been bounded by 'little things', perhaps by a garden where he took his first steps and played with pet animals, under the aegis of fruitful Nature. Is the second carriage symbolic of the parents' continuing bond with the dead child, of their own destinies, of all life as fleeting beyond recall, or of all these things together?

My second example is a somewhat later, more conventional child's life-cycle sarcophagus, possibly from Ostia, dedicated to Marcus Cornelius Statius (fig. 53).[33] Elegantly carved, the relief shows four key scenes from the life of a boy of good family, groomed for adult success. On the far left a well-dressed and coiffed Roman matron suckles her son as her husband watches meditatively. Next, the father carries the baby on his shoulder, an indirect prototype of seventeenth-century representations of Saint Joseph with the infant Jesus. He gazes intently at the child; the little boy (who may be holding a ball) looks about him curiously from the safety of his father's grasp. In the third scene the child, much grown, plays without the intervention of any adult, driving a miniature chariot pulled by a ram. Finally, as a schoolboy holding a scroll, he declaims in front of his father. The story of his life ends here; the sides of the sarcophagus are decorated with griffins and ram skulls.

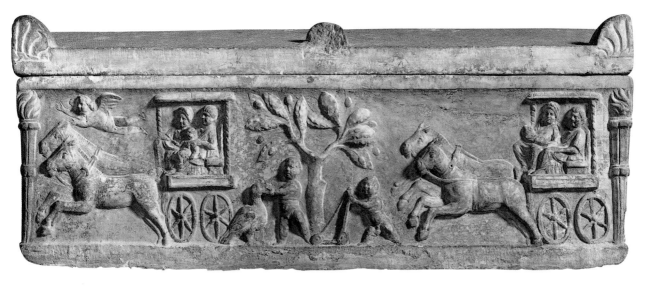

52 Roman sarcophagus, *c.*120 AD, Rome, Museo Nazionale Romano, inv. no. 65190

53 Roman sarcophagus of M. Cornelius Statius, 150–60 AD, Paris, Louvre

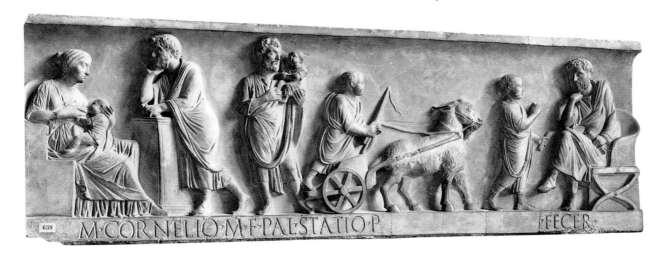

Similar scenes of nurture and education form part of the decoration of some adult men's sarcophagi, as preludes to distinguished public careers.[34] Even the playful scene of the chariot shows the boy learning an adult's skill; more importantly, by controlling the ram, he also learns to harness and direct his own 'animal' nature. The declamation, supervised by the father, who also holds a scroll, is a rehearsal for public oratory, the highest and most prized skill of a Roman citizen. But Marcus Cornelius Statius, of course, was to have no public career; this is the imagery of an unfinished life.

Such child's life-cycle Roman sarcophagi show a retrospective view of prospective hopes, simultaneously advertising very particular parental virtues. Writing only a few decades earlier, Plutarch – Roman imperial official as well as Greek philosopher – had reminded his wife that she had 'reared so many children in partnership with me, all of them brought up at home under our own care', and complimented her on her restrained show of grief at the earlier death of their son 'the fair Charon', despite having

> nursed him at your own breast and . . . submitted to surgery when your nipple was bruised. For such conduct was noble, and it showed true mother love.
>
> But we observe that most mothers, after others have cleansed and prettied up their children, receive them in their arms like pets; and then, at their death, give themselves up to an unwarranted and ungrateful grief, not out of good will toward them – for good will is rational and right – but because the combination with a little natural feeling of a great deal of vain opinion makes their mourning wild, frenzied and difficult to calm.[35]

Poor little Marcus Cornelius Statius' sarcophagus seems to illustrate the very ideal of family life praised by Plutarch. Father and mother are partners in the rearing of their child; the mother nurses the baby herself, the father himself attends to his education. No wet-nurse is employed; no slave women 'cleanse and pretty up' the child, no tutor drills him in his lessons. Scenes of death or mourning are not shown here; the par-

54 Roman sarcophagus, London, British Museum, GR 1805.7–3.144, Townley Collection

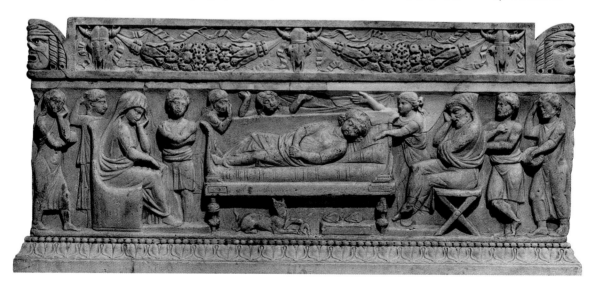

ents' grief is stoically restrained by reason and decorum. The relief demonstrates their 'good will . . . rational and right' for their son, sole focus of their attention, and the 'joy and hope' that they, like 'Father Noetus' before them, bury with him.[36]

By contrast, my third Roman child's sarcophagus depicts only the *conclamatio* around the body of a little girl laid out on the funerary couch (fig. 54).[37] This scene, explicitly recording the fact of death, is found, you will recall, almost exclusively on children's sarcophagi; it also occurs more often on those of girls than of boys. Girls as well as boys might be shown with scrolls, but while literary accomplishment was prized in women, a career of public oratory was not open to them. Their sphere was domestic, and it is within the home that the *conclamatio* takes place.

In this formulaic scene that must preserve many features of the actual rites, the high-backed couch is flanked by the father at the child's head, seated on a stool, and the mother at her feet, in a chair. Both are veiled in mourning, and support their heads on their hands in the conventional pose of grief. Behind the couch a professional woman mourner, hired for the occasion, raises her arms in ritual lamentation; another places one hand on the couch, and a third leans on it with hand to head. Other personages presumably represent members of the household.

These are conventional figures, but the dead child seems more individualised; her face may have been recarved into a portrait likeness. The feature that appears most personal and most touching – her pet dog (or cat?) and her little shoes under the couch, that look as if she had just stepped out of them to lie down in sleep – in fact recur, with variations, on most *conclamatio* reliefs.

The front of the sarcophagus lid is carved, like a Roman altar, with the funerary emblems of garlands and bucrania (ox-skulls) and tragic actors' masks at the corners.

Conclamatio scenes such as this one purport to give a last glimpse of the dead child as she was actually seen. Neither retrospective nor prospective, they represent an eternal present. Locked in dignified grief while hired mourners mimic frenzy, the parental figures appear to be enacting rites set down by law and custom, and limited in duration by these same binding rules. Yet just as 'donor' portraits in Christian altarpieces proclaim the sitters' everlasting devotion, these effigies present the parents' mourning for their daughter as perpetual. By erecting this tomb to their child, father and mother commemorate their own grief; it will outlast their earthly life and set an example to posterity, although, in Plutarch's view, a pernicious one,

> for each person takes grief in of his own accord. But once it has fixed itself with the passing of time and become his companion and household intimate, it will not quit him even at his earnest desire. We must, therefore, resist it at the door and must not let it in to be quartered on us by wearing mourning or cropping the hair or by any other manifestations of the kind that, confronting the mind daily and shaming it into submission, make it dispirited, cramped, shut in, deaf to all soothing influences, and a prey to vain terrors, in the feeling that it has no part in laughter or the light of day or the friendly board, since it has adopted such habiliments and engages in such practices because of its grief.[38]

We may suspect that outwardly the parents of this particular little girl and others like her returned to social life once the period of ritual mourning was over. Yet the evidence of the sarcophagus, visible whenever they visited her tomb, is that they had no 'earnest desire' ever to evict grief from their house.

55 Edwin Romanzo Elmer, *Mourning Picture*, c.1889,
Smith College Museum of Art, Northampton, Massachusetts

Graeco-Roman funerary monuments set the pattern for most later European images commemorating dead children. Whenever they appear subsequently, such images stress the continuing bond between the living and the dead. The lost children remain forever members of their family, and may appear in family portraits as little angels fluttering above their parents and surviving siblings, as in Jacob Jordaens's *Portrait of the Artist's Family*, c.1615–16;[39] dead infants are numbered among a family's offspring even on their parents' tombs.[40]

Perhaps the strangest, and bleakest, image ever to commemorate a child is a portrait by the American nineteenth-century naif painter Edwin Romanzo Elmer, that at first sight appears as a quasi-photographic record of family life in the family home on a sunny summer's day (fig. 55).[41] In his teens, the amateur artist had gone with his brother to Ohio to work in the spool-silk business; having made their fortune, they returned home to Massachusetts and decided to build a large new house for their parents, themselves and their prospective brides and offspring. This is the Victorian building in the background, patterned after the houses the brothers had admired in Cleveland, Ohio, and completed in 1876. Edwin married, and in 1880 his daughter Effie was born; her

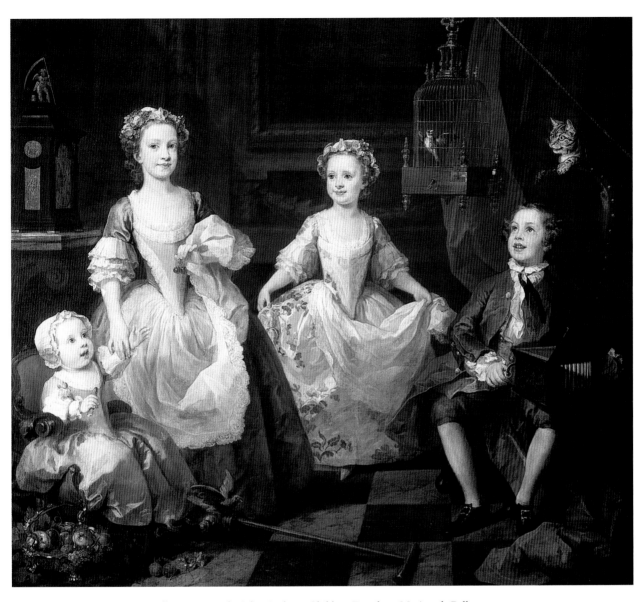

56 William Hogarth, *The Graham Children*, London, National Gallery

death occasioned this surreal picture. On the lawn in front of the house the child's parents sit on what appears to be indoor furniture; the artist depicts himself hatted and formally dressed, yet with legs crossed, looking up from reading a newspaper. Disproportionaly large, Effie stands sadly apart in the foreground, holding the bridle of a pet lamb. Alfred Frankenstein's suggestion that it represents the Lamb of God, 'to show that she was dead', is surely wrong; far more probably, it is both an actual lamb and a symbol of childlike innocence, while the stalking cat may depict both a real pet and an emblem of impending danger (as does most obviously the tabby threatening a caged bird in fig. 56). A toy baby carriage with doll stands as if abandoned at some distance from the little girl – clearly a reference to the children she will never now bear,

57 William Hogarth,
*Study of a Dead Child's
Head, c.*1742, Black and red
chalk on grey paper,
London, British Museum

a destiny prefigured in play, that will remain unfulfilled. Summer flowers dot the grass; trees are in full leaf, bearing fruit, the sun casts sharply outlined shadows. There are no obvious expressions of mourning, no tears or religious rites, no funerary emblems; time has simply come to a standstill. It is, in every sense, a haunting picture.

A dead child might also be included among his brothers and sisters as if death had never separated them, the procedure most famously followed in William Hogarth's *The Graham Children* (fig. 56).[42] In this triumphant life-size portrait, merry little Thomas Graham in a gilded go-cart, eagerly reaching for the cherries held by his eldest sister Henrietta Catherine, had in fact been buried some weeks before Hogarth painted him. Many of the details of the picture – such as the still life of fruit and the short-stalked carnation flowers at the child's feet, the figure of a cherub with scythe and hour glass on the clock above him – can be read as symbols of transience and mortality. The artist almost certainly based Thomas's likeness on a chalk study made while the baby, not yet two years old, was laid out on his deathbed (fig. 57).[43]

Numerous drawings of this kind survive;[44] many were worked up into unfeignedly post-mortem portraits. Sometimes, as in a picture attributed to Peter Paul Rubens (fig. 58),[45] consolatory motifs were added. Half-wrapped in his shroud, the dead child, his sightless eyes part-open, is lifted up to heaven by angelic descendants of Roman *putti*. The objects they carry are also inherited from Graeco-Roman sources: the palm branch and laurel crown, awarded in antiquity to victorious athletes and generals, have in Christian art become the attributes of victory over death. Here, they signify the child's assumption into heaven.

In about 1674, the pioneering English potter John Dwight, working at Fulham (where he patented a 'transparent earthenware'), made two remarkable stoneware figures of his little daughter Lydia. The first is a portrait bust showing her laid out on her deathbed (fig. 59); in the second, full-length, figure, she is resurrected from the tomb (fig. 60).[46]

58 Peter Paul Rubens, attrib., *Angels bearing a Dead Child to Heaven*, Oxford, Ashmolean Museum

59 John Dwight, *Lydia Dwight on her Deathbed*, stoneware, *c.*1764, London, Victoria & Albert Museum

60 John Dwight, *Lydia Dwight Resurrected*, stoneware, *c.*1764, London, Victoria & Albert Museum

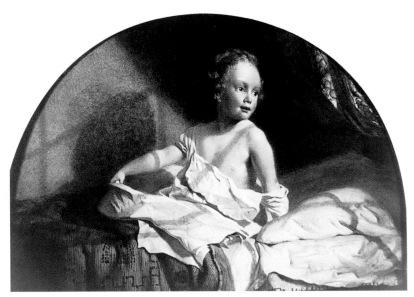

61 George Elgar Hicks, *'The Peep of Day', Freddy Hicks (1850–55)*, 1855,
Southampton Art Gallery

The posy of flowers she is shown clasping in Figure 59 has been interpreted as 'symbolising her state of purity',[47] but may represent actual deathbed practice that arose partly from traditional beliefs that posies, wreaths and aromatic herbs ward off evil spirits, and partly as a precaution against infection.[48] If they are to be read as symbols, however, flowers are less likely to signify purity than fragility, the sweet but quickly fading bloom of a young life. Apart from this possible symbolism, the bust of Lydia is bleakly objective; the father's tenderness is expressed in scrupulous attention to details – of embroidery, tassels, flowers; of the child's waxen face with its immobile, turned-down mouth. Everything that could be done for Lydia has been done; yet she is dead.

The second, full-length figure, patently based on the same study of the dead child as the bust, is very different. Lydia's eyes are open and looking upwards, her hands clasped in prayer. Shedding her shroud as she will shed her material body, stepping lightly over the fallen petals and ignoring the wreathed skull at her feet, she rises to heaven – her nakedness reminiscent of a *putto*'s, her unwinding shroud assuming the folds of drapery in Roman sculpture.

Both the Flemish artist and John Dwight appear to have subscribed to a widespread conviction that was never directly challenged by Christian churches at the time: that the souls of baptised infants were assumed into heaven directly after death.[49] Dwight's second figure of Lydia may be read as the little girl resurrected in the flesh at the end of time, but her transfigured *putto*-like body shedding its shroud is more likely an image of her soul in the presence of God.

That consoling Victorian icon of child mortality, George Elgar Hicks's *'Peep of Day', Freddy Hicks (1850–55)* (fig. 61),[50] reinterprets the objective death-bed portrait as an implicit affirmation of this reassuring belief. The artist's second son and third child, five-year-old Freddy Hicks, died at the end of June 1855; the painting was exhibited at the Royal Academy in May. Obviously the result of detailed studies at the child's bedside, and anticipating his actual death, it shows Freddy eagerly stripping off earthly clothes to rise towards the brilliant dawn light that floods in through the window,

casting shadows of the glazing bars across the painting: cross-shaped shadows, but also resembling the bars of a prison cell. Plutarch's consolatory words are here uttered in the idiom of a painter and 'strict churchman of the Evangelical School', whose eldest daughter married a clergyman, and both of whose surviving sons became vicars.[51]

Another son of Hicks's, Charles, died less than a month after his birth in 1865, unrecorded by his father's brush. Many years later however, in 1890, the artist returned to the theme, depicting parents standing in shadow mourning the death of their child, while in bright light above his soul is carried up to heaven by an angel. The picture was exhibited at the Royal Academy under the title *A Cloud with a Silver Lining*, and the copyrights for reproduction were eagerly snapped up.[52]

In both the seventeenth-century 'Rubens' painting and John Dwight's stoneware figures, the elements testifying to Christian belief in the afterlife, and the consoling folk belief of little children's immediate access to Paradise, are represented in the idealising

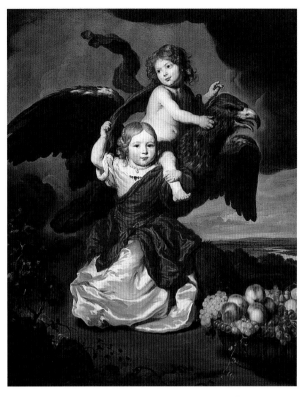

62 Nicolaes Maes, *Girl with her Younger Brother as Ganymede*, c.1672–73, New York, Otto Naumann (as of 2000)

idiom of Graeco-Roman Antiquity. This could be pumped up to engulf the entire image, as in Nicolas Maes's roughly contemporary portraits of little boys in the role of Ganymede.

In ancient myth, the beautiful young Trojan princeling Ganymede caught the roving eye of the king of the gods. Ovid recounts how Jupiter (the Greek Zeus) in the guise of his thunderbolt-bearing eagle, 'without delay . . . cleft the air on his lying wings and stole away the Trojan boy' to Olympus, where Ganymede became the gods' cup-bearer;[53] Jupiter made him immortal by placing him among the constellations as Aquarius, the Water-Bearer, the zodiacal sign of winter. Fifth-century Greek vase painters pictured the scene of abduction as an erotic encounter between the bearded god and a naked youth, his childlike innocence symbolised by the stick and hoop with which he has been playing.[54] The scabrous tale, already viewed as an allegory in classical times, was interpreted by Ovid's Christian commentators as meaning that the pure soul is so beloved of God that he often takes it prematurely. From having been portrayed as a youth in the talons of the divine eagle, Ganymede was transformed into an infant; the Dutch painter Nicolaes Maes, a pupil of Rembrandt, frequently employed the motif in consolatory portraits of dead children in families aspiring to high culture. The one reproduced here is especially luxuriant, showing a live little girl with her dead younger brother as Ganymede (fig. 62).[55] Their likenesses resemble *putti* more than real children, and it is clear that Maes did not assist at the boy's deathbed,

nor looked very searchingly at his surviving sister. Dressed in a stylish frock made timeless by *all'antica* armholes and swoops of drapery, the girl holds on to her brother as if to stop him being carried off by the gigantic bird. Neither her frontal pose nor her direct gaze at the viewer betray urgency or distress, however – and no wonder, for she can hardly be shown objecting to his going straight up to God. Far from resisting the raptor, the baby straddles his back like a pony's, turning his eyes heavenwards, beyond the dark clouds, in a saccharine expression of piety.

On the ledge or platform beneath the children a platter of fruit recalls the similar motif of a fruit-laden silver basket in Hogarth's *Graham Children*.

This is a death scene more triumph and apotheosis than grief and consolation. Yet we cannot aver that the sentiments of the patrons were as insincere as the picture now appears to be. Painted fruit does not perish; grief may be sublimated. To have one child happy in Paradise and one alive on earth, with hopes for her own fruitfulness, is more blessed than not to have had children at all. Plutarch might have disliked the ostentation, but he would have approved the message.

The greatest consolation for the death of a child would be its return to life; failing this, the dead child might be reborn. It is difficult to know whether parents ever literally believed that the soul of a dead child could be reincarnated in a later-born sibling,[56] but the widespread custom of naming a newborn after its dead brother or sister attests to the desire. Despite affirmations that 'Today, of course, no siblings are given the same name because a name is seen as intrinsic to the irreplaceable person'[57] the usage persists, at least in Italy.[58] Its most famous illustration, however, dates from 1479–85, in the Sassetti Chapel of Santa Trinità, Florence.[59]

One of the best preserved and most elegant monuments of the Early Renaissance, the funerary chapel bears, in fulfilment of a vow, a double dedication: to Francesco Sassetti's name saint, Francis of Assisi, and to the Nativity of Jesus. Stories from the life of Saint Francis decorate the upper two thirds of its three walls, while the altarpiece depicts the Nativity and Adoration of the Shepherds, with in the distance the approaching cortege of the Magi. Both frescoes and altarpiece are by Domenico Ghirlandaio, the leading painter in Florence. Sassetti, manager of the international Medici bank and custodian of the Medici family's financial affairs, was also an enthusiastic antiquarian and a promoter of humanistic studies; he had his chapel, and in particular the *pietra serena* niches and black porphyry tombs carved for himself and his wife Nera, embellished with many erudite Graeco-Roman motifs. Ghirlandaio's paintings, however, also contain portraits of contemporaries in contemporary settings; these anachronistic features have been interpreted, for once convincingly, as references to current political preoccupations. But it is a private aspect of the chapel's dedication and decoration that concerns us here.

In Ghirlandaio's altarpiece (fig. 63),[60] the Christ Child is shown lying on a corner of the Virgin's mantle as she kneels on the ground adoring him. His head and halo are propped against an ornate Roman sarcophagus; its inscription, devised by Sassetti's humanist friend, Bartolomeo Fonzio, informs us that it held the bones of a Roman

63 Domenico Ghirlandaio,
Nativity and Adoration of the Shepherds, altarpiece, 1485,
Saint Francis resuscitating the Notary's Son, fresco,
Sassetti Chapel, Santa Trinità, Florence

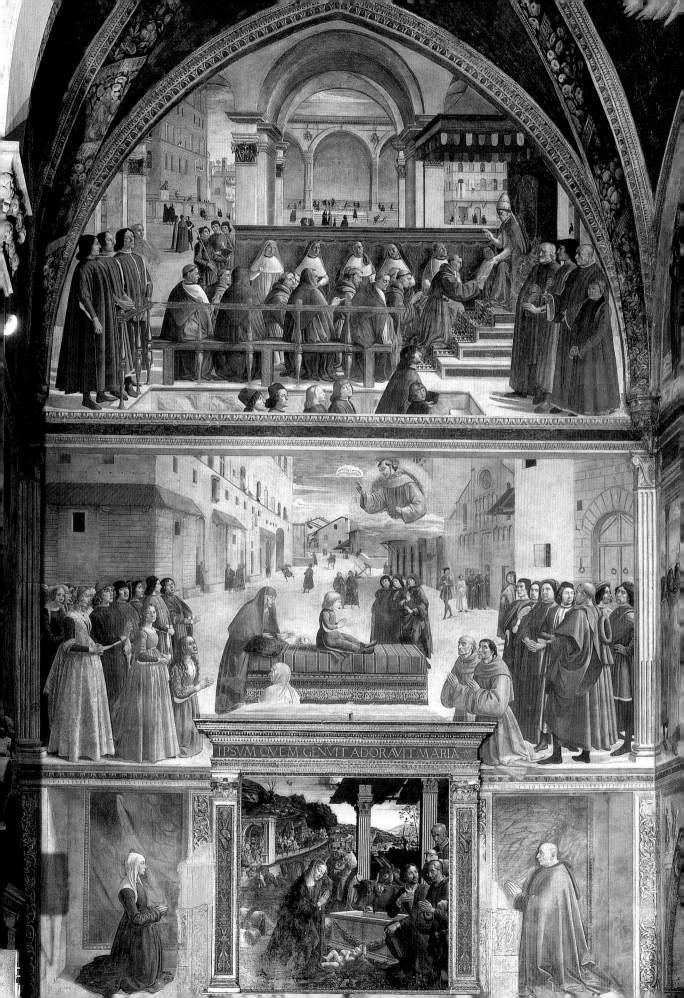

IPSVM QVEM GENVIT ADORAVIT MARIA

augur (or official soothsayer), who died during the Romans' siege of Jerusalem, predicting that his tomb would serve a new deity. Together with the broken classical pillars supporting a makeshift roof above it, and a Roman triumphal arch in the distance, the sarcophagus conveys the notion of Hebrew and pagan kingdoms giving way to Christianity. But since it is a manger for the ox and ass behind it, and will be the infant Christ's cradle, it is also a clear allusion to new life succeeding death.

Directly above the altarpiece, out of chronological sequence before, rather than after, the *Funeral of Saint Francis* on the right wall, Ghirlandaio painted the posthumous miracle of *Saint Francis resuscitating the Roman Notary's Son* (fig. 63).[61] Instead of the Piazza San Marco in Rome where the miracle was supposed to have taken place, the setting is in Florence, directly outside the church in the Piazza Santa Trinità. In the centre foreground, parallel to the picture plane, stands a draped catafalque; the boy who had been lying dead in state a moment ago, watched over by mourners on either side, is sitting up. From the clouds above, Saint Francis raises his hand in blessing; in the distant background, the little figure of the child can be seen falling out of a window. Except for its size and the many witnesses, this is the kind of votive scene we know from Simone Martini's triptych of Beato Agostino Novello.[62]

Death and resurrection are fitting themes for a funerary chapel. But the juxtaposition of Nativity and a dead child's resuscitation had a particular significance for the Sassetti. Between late 1478 or early 1479 their first-born son, Teodoro, died in Lyons at the age of nineteen. On 12 May 1479, another boy was born to the couple. It is his birth that must have seemed to the aging parents a miraculous response to their prayers, the fulfilment of their vow to dedicate their chapel to Saint Francis and the Nativity. They named him Teodoro, and Ghirlandaio's image of the six-year-old son of the Roman notary is almost certainly his portrait.

Rather than with Ghiralandaio's much-studied fresco, however, I should like to close this chapter with a little known ex-voto, dated 1790, from Trentino–Alto Adige, a German-speaking region that belonged to Austria until 1919, when it was ceded to Italy (fig. 64).[63] Unusually complex and enigmatic for an anonymous small votive painting, it can, I believe, be understood as a thanks-offering for the birth of a child 'replacing' an older, recently dead sibling.

Typically for the 'folk' art of the Tyrol, the Virgin and Child are shown limbless in conical-shaped robes, the apex of a triangular composition. Beneath them, but judging by the clouds still in heaven, kneels the Archangel Michael, commander of God's armies. In his left hand he holds the scales with which he weighs souls at the Last Judgment; he has set down his sword and shield, so that his right arm is free. He gestures warmly to welcome the little child standing on the earth below; his glance, however, is directed at the Guardian Angel recommending the toddler to him. The latter's black-edged cap, and the black rosary piously clutched in his or her hands, characterise children's funerary outfits in the Tyrol of the period; despite the apotropaic coral bracelet around its wrist this child has died. Trustingly fixing its eyes on Saint Michael, it now stands in expectation of a favourable judgment and a *laissez-passer* to heaven. In his right hand, the Guardian Angel holds the rocking-string of a cradle in which a swaddled infant lies placidly.

The key to the picture may be in the cave and the seven sleeping figures beneath Saint Michael. A later inscription in German on the back of the ex-voto identifies

64 Ex-voto, inv. no. 27047, Rome, Museo delle Arti e Tradizioni Popolari, Raccolto da Paolo Toschi, 1940, Bolzano

them as the Apostles, but this cannot be: Christ chose twelve, not seven, disciples to preach his gospel; only Peter, James and John slept during His night of Agony in the Garden. Yet the seven sleepers wear 'biblical' robes, and they seem to issue from a dark mountain cave in the background.

I believe them to be the heroes of a legend that, because it confirmed the resurrection of the dead, gained lasting popularity throughout Christendom.[64] According to the story, seven young Christian men of the city of Ephesus held high rank under the Roman Emperor Decius (*c.*AD 200–51), but disobeyed his orders to sacrifice to pagan idols on pain of death. Rather than abjure their faith, they gave their property to the Christian poor and withdrew to a cave in Mount Celion. There they fell into a miraculous sleep. Decius decided to have the cave in which they were hiding immured with stones, so that they would die of hunger; pious Christians wrote an account of the martyrdom and left it concealed among the stones. Three hundred and seventy-two years later, the Christian emperor Theodosius was grieved by the outbreak of a heresy that denied the resurrection of the dead; God inspired shepherds building a shelter to take away the stones from the mouth of the cave, and awaken the holy sleepers. After much puzzlement and marvelling, bishop, people, Emperor and

the sleepers themselves accepted that theirs was a miracle. The Emperor cried, 'Seeing you thus, it is as if I saw the Lord raising Lazarus from the dead!' Saint Maximianus, one of the seven, responded, 'Believe us, it is for your sake that God has raised us before the day of the great resurrection, so that you may believe without the shadow of a doubt in the resurrection of the [flesh]. We have truly risen and are alive, *and as an infant is in its mother's womb and lives feeling no pain,* so were we, living, lying here asleep, feeling nothing!' (italics mine).

No one has an ex-voto painted to thank God and the Virgin for the death of a child, though many such artefacts record gratitude for a birth. This little picture surely commemorates a dead toddler, and registers its parents' belief in the purity of its soul earning it a place in Paradise; but it was almost certainly commissioned to express their thankfulness for its 'resurrection' in its mother's womb 'before the day of the great resurrection'. Like the Seven Sleepers of Ephesus (whose hair has turned grey during the three centuries of their slumber in the cave) the baby in the cradle, watched over by the Guardian Angel, represents a miraculous return from the grave.

PART II

STAGES OF CHILDHOOD

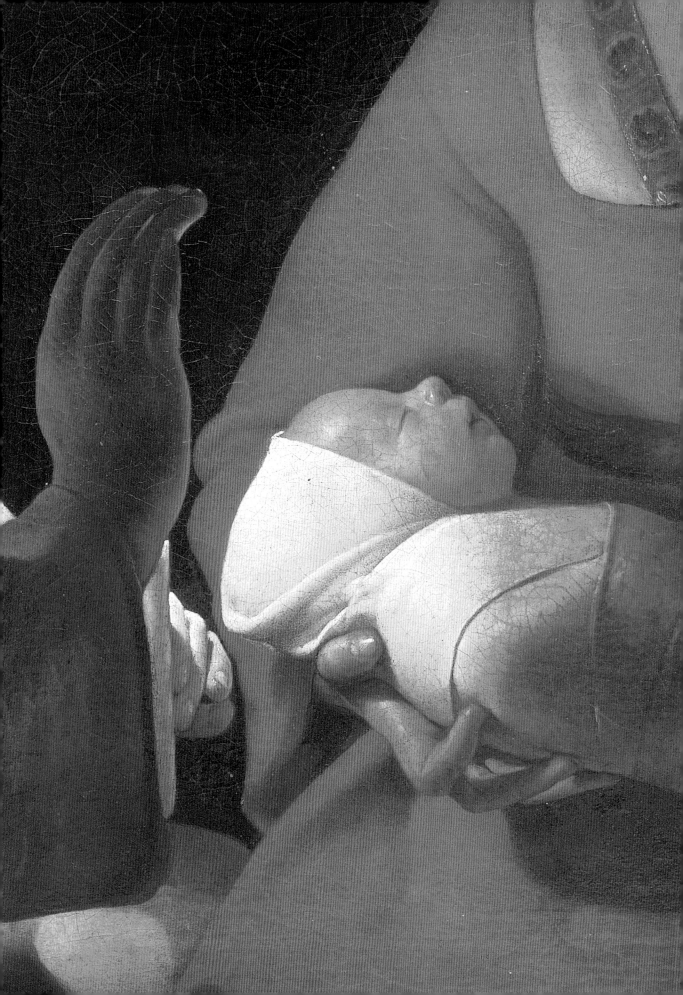

CHAPTER 4

'The vilest state of human nature': swaddled infancy

THE MAINLY APOTROPAIC, CAUTIONARY, COMMEMORATIVE or consolatory images we have so far considered presuppose certain notions of the nature of the child. Infants[1] and toddlers are shown as vulnerable, dependent; taking pleasure in little things; and, for good or ill, innocent; in some sense 'pure', educable or, by implication, corruptible (a point to which I shall return). Marked out for mortality, they may also personify the life-force and the future, aspects of immortality.

For a more systematic and detailed picture of how people have viewed childhood as a stage, or series of stages, in human life, we must turn to other types of images, only peripherally connected with illness, accident and death. Having discussed representations of Horus-the-Child or Harpocrates, the childlike aspect of the Egyptian god Horus, as protectors of children, I also touched upon the similar role played by images of the Christ Child.[2] Irrespective of this apotropaic function, however, images of the newborn Jesus were also generated by adult devotion, revealing attitudes to early infancy long before this had attracted the attention of secular disciplines. For this reason, the iconography of the Nativity is a good starting point for the second part of this study.

In obedience to the second of the Ten Commandments, the earliest representations of Christ were coded signs: a monogram and a cross formed from the interlaced first two letters of the Greek word *Christos*, XP, transliterated as Chi Rho in the Roman alphabet; a diagrammatic fish, *ichthys*, because the word is an anagram of the initials of the Greek for *Jesus/ Christ/ Son of God/ the Saviour*; the Eucharistic vine; the sacrificial or triumphal Lamb, and so on.[3] When, some time after AD 200, he first came to be depicted in human form, it was in the guise of a youthful, beardless Graeco-Roman miracle worker, teacher and philosopher. He would later appear as Christ, King and Judge, majestic and fully robed even on the cross; naked only in the scene of the Baptism, when the dove of the Holy Spirit was seen to descend on him and his divine nature was revealed. Although he was often represented on his Mother's knee, it was as a 'miniature adult', blessing or holding a scroll: the Word of God, the second person of the Holy Trinity, seated on the Throne of Wisdom. The focus was never on his childlike nature, nor on the nature of his childlikeness.

It was not until after the 'invention' of Christmas by Saint Francis of Assisi, in the sanctuary at Greccio in 1223, that the Nativity and the newborn Christ became objects of popular devotion, and frequently depicted in art.[4] Francis's theology, based on that of conventual mystics such as Bernard of Clairvaux (canonised in 1174), was primarily directed at the newly urbanised masses of laymen and women, the unlettered and the poor as well as artisans and the emerging mercantile classes. It focused on two key phases in the earthly life of Jesus: his birth and infancy, and the Passion culminating in his death. By freely assuming these universals of the human condition,[5] the incarnate Word had redeemed humanity from sin and death, granting us eternal life. In Francis's message, it is love that binds us, through Christ, to God: not the awe provoked by a miracle-worker, the deference due to a ruler, nor the fear felt before a judge, but the needy love of a child for its mother.

The crude fourteenth-century fresco in the chapel at Greccio that records Francis's Christmas celebration depicts the friar, a mere deacon, adoring the newborn Child before a Mass on one side, and the Virgin suckling her baby on the other (fig. 65).[6] She lifts the tightly swaddled infant out of a stone sarcophagus rather than a contem-

65 Anonymous, *Franciscan crib with the Madonna del Latte*, 14th century,
Greccio, Chapel of Franciscan sanctuary

porary wooden manger. While the Christ Child's proximity to a Roman sarcophagus
in Ghirlandaio's Sassetti Chapel altarpiece (fig. 63), signifies the new life of
Christianity arising from the remains of dead paganism, the Franciscan image conveys
a different message. Jesus's swaddling bands resemble and prefigure a shroud; his birth
portends his entombment. Christ's Incarnation and his Passion are in a sense equiva-
lent.

We are now more familiar with Renaissance paintings of the Nativity and
Adoration of the Shepherds,[7] such as Ghirlandaio's, in which the Christ Child stars as
a plump, naked baby. Yet in medieval Infancy scenes he was represented, as at Greccio,
swaddled, with only his head or face exposed. The statuettes of a naked infant Christ
disseminated throughout Europe by Franciscans after they had established a convent
in Bethlehem in 1375 – to be used as objects of public veneration, like the miracle-
working Bambin Gesú in the Roman church of Santa Maria Aracoeli, or cherished
by nuns in their cells[8] and private individuals at home,[9] and all to be feted in
Christmas cribs – were intended to be provided, like real babies, with actual swaddling
bands and clothes. Only later did artists interpret the Christ Child as a naked, playful
Graeco-Roman *putto*; nor did his nakedness originally symbolise mere 'innocence and
purity', the argument adduced against Counter-Reformation critics of nudity in
sacred images.[10]

As a modern commentator notes, 'In one of the most bizarre, yet very common
miracles of the Middle Ages, the bread of the Eucharist is transformed between the
very hands of the priest at Mass into a small living child.'[11] Originating at least as early
as the ninth century, the miraculous transformation is related in many variations from
the eleventh century onwards (fig. 66).[12] The horrific vision was often granted to
children, and some would run in terror from a familiar priest after seeing him devour
a little child at the altar, fearing a like fate for themselves. This mystical equation of
the Eucharist with the Infant Saviour's body meant that images of the Nativity and

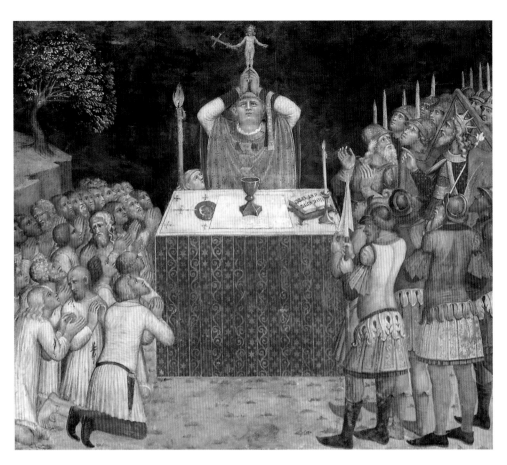

66 Ugolino di Prete Ilario, *Miracle of the Saracens*, fresco, 1357–64,
Orvieto, Cathedral, Chapel of the Corporal

Adoration of the Shepherds could be interpreted sacramentally as public displays of the Eucharist, analogous to those in the liturgical practice of elevating the consecrated Host in the Mass,[13] or at the feast of Corpus Christi,[14] both instituted in the thirteenth century. In such scenes his nudity identified the newborn infant as the sacrificial Victim of the Mass, whose body is the consecrated 'bread of angels', the very sight of which has the power to save souls.[15]

But the conflation of the Babe of Bethlehem with the Eucharist was a precondition, not the immediate cause, of the revolution in the depiction of the Nativity that took place from the 1370s,[16] when the hitherto predominant type – showing the Virgin lying in bed, with the swaddled Child lying beside her[17] – was replaced by another, in which the Virgin adores the naked Child on the ground before her, as she does in Ghirlandaio's Sassetti Chapel *Nativity and Adoration of the Shepherds* of 1485 (fig. 63), and in the Netherlandish painting that directly influenced it, the central panel of Hugo van der Goes's great triptych for Tommaso Portinari, the Medici bank's agent in Bruges (fig. 67).[18]

67　　Hugo van der Goes, *Portinari Altarpiece*, central panel,
Florence, Uffizi Galleries

This radical change of iconography was brought about by a text deeply imbued with monastic and Franciscan 'affective piety',[19] the *Revelations* of the Swedish mystic Saint Bridget, in which she described witnessing the very moment of Jesus's birth.[20] After being widowed in 1344, Birgitta Birgersdotter, related through her mother to the royal house of Sweden, entered a convent in Alvastra; in 1349 she left to travel to Rome for the Jubilee year 1350. She died there in 1373, having founded an order of nuns, and leaving eight volumes recording her visions; she was canonised in 1391.

Bridget's description stresses the miraculous nature of Christ's birth: the Virgin feels no pain; she kneels in prayer; suddenly and effortlessly the Child emerges from her womb. Light radiates from him as he lies naked and spotless on the ground; the Virgin venerates and welcomes him as 'my God, my Lord and my Son.'

This moment, that most closely accords with the sacramental interpretation described above, is the one represented in most Bridgetine images of the Nativity. But

Bridget's text neither begins nor ends here. It interweaves the miraculous and the quotidian, distinguishing sacred from secular, divine from temporal. The distinction resides specifically in the matter of swaddling bands.

When the Virgin had pulled off her shoes, drawn off her white mantle to let her 'beautiful golden hair' fall down her shoulders, like a queen at her coronation, she

> produced two small linen cloths [*panniculae*] and two woollen ones, of exquisite purity and fineness, that she had brought, in which to wrap up the child who was to be born; and two other small cloths with which to cover and bind his head, and these she put down beside her in order to use them in good time.

The Child having been born, worshipped and welcomed,

> As the child weeping and trembling from the cold and the hardness of the floor where he was lying, stretched out his limbs imploring her to raise him to the warmth and to her mother love, the mother then took him in her arms and pressed him to her breast, and with her cheek and her breast she warmed him with great joy and tender maternal compassion. She then sat down on the ground and laid the child in her lap tying up his small body, his legs and his arms with bands, first the linen garments and then in the woollen ones, that were sewn in the four upper parts of the woollen cloths. But then she enveloped the head of the child tying it up with the two linen garments prepared for this purpose.[21]

It is the radiant naked Child whom the Virgin addresses as 'My God', and who is identified with the consecrated Host, as he is more explicitly in Figure 66.[22] Since the fifteenth century, he has frequently been represented as literally luminous, the only source of light in nocturnal pictures of the Nativity or Adoration of the Shepherds.[23] But it is a mortal Child, weeping, trembling, imploring, whom Mary wraps in swaddling cloths. The *panniculae* provided by the Virgin and described so lovingly by Bridget are, to be sure, of superior quality, yet they are in essence the same cloths that have swaddled babies since time immemorial. The swaddled Infant remains the paramount signifier of the Incarnation, evoking compassion by sharing the condition and fate of all human infants.

Over two hundred years later, during the Catholic Reformation, the medieval devotion to the Christ Child was revived under the aegis of Franciscans and their spiritual heirs, notably the order of reformed or discalced Carmelite nuns founded in Spain in 1562 by Saint Teresa of Avila, and the congregations of the Oratory, founded in Rome in 1575 by Saint Philip Neri. Carmelites and Oratorians were both installed in France in the early 1600s by the French cardinal and mystic Pierre de Bérulle (1575–1629),[24] whose particularly austere teachings on the 'Mysteries of the Infancy' were rapidly translated into images of the swaddled Child.[25] Perhaps the most overtly 'Bérullian' of these identifies Jesus with the foundlings assisted (not coincidentally) by the cardinal's disciple, Saint Vincent de Paul (fig. 68).[26] The engraving was issued on behalf of the Confraternity of the Holy Infancy of Jesus Christ our Lord, attached to the chapel of the Hôpital des Enfants-Trouvés on the parvis Notre-Dame, successor of Vincent's Oeuvre des Enfants Trouvés, where each morning the sisters knelt before their little charges 'to offer to God all the services which they will render to the Infancy of Our Lord in the person of these little children'.[27] The inscription over the image claims the affiliated Confraternity was founded for the purpose of 'inciting the faithful to the Adoration and love of the Son of God who deigned to humble

himself so far as to make himself an Infant for us'; the image is further complemented with a long prayer addressed to the 'Divine Brother of the assisted Infants', pleading that we ourselves may become 'children after the spirit', acts and phrases, as we shall see, typical of Bérullian thought.

Bérulle himself, however, did not propagate the image that helped popularise his view of the Infancy. The motif of the swaddled Child may have been brought to the French Oratory and Carmel by Simon François (1606–71), a painter from Tours who studied in Italy with Guido Reni and returned to France in 1638, becoming a protégé of the queen, Anne of Austria (once the baby depicted in figure 19) herself a devotee of the Christ Child.[28] Or, having remained current in the Netherlands since the Middle Ages, the swaddled Babe may simply have entered the repertoire of 'realist' French painters influenced by Netherlandish naturalism. As inflected by Bérullian thought, however, the motif became a virtual hallmark of devotional art in seventeenth-century France.[29]

In essence a response to Protestantism, the Bérullian cult was said by its clerical proponents to originate in the early Church; in 1658, for example, one of the cardinal's followers wrote,

> 'Let us revere,' said the great Saint Augustine, 'Jesus-Christ in his crib . . . Let us revere the swaddling cloths of infancy.' . . . Is it in our own time that Saint Paula swore to Saint Jerome that, being in the stable in Bethlehem, she saw with the eyes of faith the swaddled Infant, the Lord who cried softly in his crib . . . ?[30]

68 Jean Langlois, *L'Enfant Jésus au maillot protégeant les enfants trouvés et emmaillotés, adoré par les anges*, image of the Confraternity of the chapel of the Paris hospital of the Enfants-Trouvés du Parvis Notre-Dame, 1676

Rather than Scripture or the Church Fathers, however, it was a harsh assessment of human infancy that conditioned Bérullian views of Christ's Incarnation. Bérulle was not unmindful of the gentle 'sweetness' and 'benignity' which God assumes in the form of the Babe in the Christmas crib;[31] early infancy nonetheless represented for him 'the vilest and the most abject state of human nature next to death', the state that is 'in nature most opposed to that of sapience'.[32]

69 Philippe de Champaigne,
Adoration of the Shepherds, 1644,
Rouen, Notre-Dame Cathedral

The writings of Bérulle and his followers stress the 'extreme misery' of early infancy, subject to Original Sin: its helplessness, its incapacity to communicate or be sociable with others, its obliviousness to reason or the workings of the Holy Spirit,[33] its 'four lowlinesses: smallness of body; indigence and dependence on others; subjection [to others]; uselessness.'[34] This lowliness, however, is in their view precisely why Christ chose to come into the world hidden in the guise of a newborn child, rather than to reveal himself already endowed with the force, the eloquence, the prestige of a man in his prime. The full sacrificial meaning of the Incarnation consists not only in Christ's Passion, but also in the enduring abasement that has no equal, the total humiliation, the annihilation of the will, that characterise his Infancy – the human infancy of everyone of us, a model to adults of Christian abasement before God.

One of the most pious francophone artists of the seventeenth century, Philippe de Champaigne, stresses this sacrificial aspect of the Incarnation in his altarpiece of the *Adoration of the Shepherds*, painted in 1644 for the Lady Chapel of Rouen cathedral (fig. 69).[35] As the Virgin unveils the newborn Saviour to the gazes of the humble,[36] the painter paraphrases Bérulle's definition of the Nativity as 'a mystery of offering and adoration', as 'the cross [is] a mystery of suffering and expiation'.[37] Light radiates from the Child, the Light of the World, yet, even as the white sheet is lifted, his body

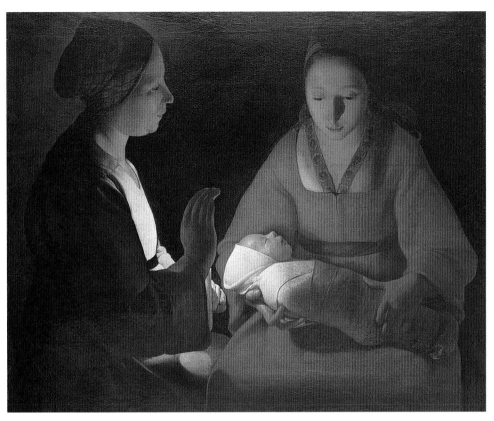

70 Georges de La Tour, *The New-born Child*, *c.*1648, Rennes, Musée des Beaux-Arts

remains concealed under swaddling cloths that imprison him as cruelly as the cords binding the trussed sacrificial lamb at his feet.

Perhaps the clearest and most moving response in art to the new devotion, however, is Georges de La Tour's nearly contemporary *The New-born Child* (fig. 70),[38] a work of private devotion not constrained by the traditional requirements of an altarpiece. De La Tour's native Duchy of Lorraine was undergoing a religious revival led by Franciscans, and the picture has been associated with this passage about swaddled infants, published a few years earlier by the Franciscan priest Sebastien de Senlis:

> If you look at these little chubby Babes in the arms of their Nurses, and who are wrapped in their little swaddling cloths, wouldn't you say upon seeing them that they are Prisoners who are garrotted in this manner for their very great crimes: they are however young Slaves, whom the sins of their Fathers cause to be tied in bonds which are no less painful for being invisible, and who need a Liberator.[39]

Disadorned, contemporary in dress, quotidian in gesture, intimate – only in its solemnity, and through viewers' sense of art-historical decorum, does the painting reveal its religious function. The 'garrotted' infant lies pale, still, silent, in a sleep that not only prefigures death, but is itself the nearest thing to it. The Liberator who will redeem

Vt Luna Infantia torpet

Will: Marshall.sculpsit.

71 Francis Quarles, *Hieroglyph IX*, from *Hieroglyphikes of the Life of Man*, 1638

humanity from its bonds appears in the guise of any woman's child, a God truly hidden within human nature. Made flesh, he becomes the English preacher's 'Word without a word, not able to speak a word';[40] the Light of the World merely the reflection of a candle held by a marvelling midwife, the Mother gazing at her Child with more awed apprehension than worshipful joy.

Admittedly, just as Bérulle himself recognised the 'sweetness' and 'benignity' of the Christ Child, so not all Counter-Reformatory art and literature followed his model of 'the vilest state of human life'. The Antwerp Jesuit Adriaen Poirters wrote 'little songs' for the 'newborn Babykin Jesus', extolling the bare, plump, white little feet, the coral-red lips, and the little curly-heads of 'Jesuskin and Saint Johnnikin playing with the lambkin'.[41] His verses could have illustrated, or been inspired by, many paintings of seventeenth-century Catholic artists, notably those, like Guido Reni and Rubens, who sought inspiration in classical Antiquity and its *putti*. Yet Bérulle's dismal view of the nature of the newborn child had adherents in unexpected places.

Perhaps the strangest expression of this view is an image, or rather a metaphor, of a swaddled baby, that does not, however, refer to the Incarnation of Christ but directly to the earliest stage of human life: the first in a set of 'hieroglyphs' of the Seven Ages of Man, by the devout Anglican poet Francis Quarles (fig. 71).[42]

A graduate of Christ's College, Cambridge, Quarles attended Lincoln's Inn, and in 1613 travelled on the Continent in the entourage of the Earl of Arundel, the famous art connoisseur and diplomat; like Arundel, he supported the Stuart court's efforts to open Protestant England to the philosophical and artistic influences of Catholic Europe. Quarles established in English a form of devotional literature pioneered by the Jesuits, to which I shall return at greater length below: the meditational 'emblem book' combining text and symbolic image to 'capture the senses and the mind, stir the imagination and move the affections'.[43]

The format itself was the invention of an Italian academic lawyer, Andrea Alciato, or Alciati, who, during the Saturnalia or winter holiday of 1522, composed for his erudite friends a playful 'little book of epigrams' which he called *Emblemata*.[44] In its printed and published versions, Alciati's book is organised as a series of different entries, each with an epigram, a short motto as caption to an enigmatic picture, sup-

posedly on the principle of ancient Egyptian hieroglyphs, illustrating the epigram. This tripartite scheme was adapted by the thousands of volumes on every conceivable topic, in every European language and often multilingual, spawned by Alciati's 'little book'. Emblem books became a favoured reading matter of generations of men, women and children of all classes, and, like almanacs,[45] also a favoured means of instruction and indoctrination.

Quarles's second emblem book was the *Hieroglyphikes of the Life of Man*, published in 1638, and the most important English rendering of the theme of the Ages of Man. Its fifteen entries consist of static images, with a burning candle as the central motif. The last seven hieroglyphs follow a traditional system of allotting human life 'threescore years and ten', divided into seven 'ages' each lasting a decade; they are symbolised by candles of decreasing length, surrounded by planetary, animal and other emblems.[46]

Figure 71 reproduces the image of Quarles's *Hieroglyph IX*, 'Infancy', with the motto, *Ut Luna Infantia torpet*, 'Infancy is as torpid as the moon'.[47] The taper stands in a candle-holder which could double as a funerary urn. In the background are grafted

EMBLEMATA
III.

Dit lijf, wat ift, als ftanck en mift?

Z iet hier, ô Courtiz aen, hier light de Af-goddinne,
Die ghy aen-bidt en fmeeckt met over-aerdfche minne.
Zy fy Gravin', Princes, en van het hooghfte bloed,
Van leden noyt zoo fchoon, van wezen noyt zoo zoet;
Zy is (met eer gezeyd) in duyfter fchaemt' gewonnen,
In vuyligheyd verwarmt, uyt on-reyn bloed geronnen:
En als fy nu al is, met fmerte, voort-ghebracht,
Zy drijft en fmelt daer heen vă vuyle mift en draght.

C Wt-

72 Adriaen van de Venne, '*Dit lijf, wat ist, als stanck en mist?*', emblem III in Johan de Brune, *Emblemata of Zinne-Werck*, Amsterdam, 1624

branches, a rose bush in bud; in the foreground, a baby's rattle and a cradle. These benign, or, at worst, neutral emblems are not, however, the only references to new life: parallel to the (waning) crescent moon in the sky is a chrysalis, the quiescent pupa of butterflies and moths, encased in its hard outer shell.

The accompanying text is headed by a citation from the Book of Job (14:2): 'He cometh forth like a Flower and is cut downe'; it consists of a lugubrious poem in eight triangular-shaped stanzas, whose italicised first lines further reinforce the entire book's principal message: 'Behold/Alas/Our daies/Wee spend/How vain/They bee/How soone/They end.' Early infancy is characterised in the third stanza: '*Our daies*/Begun, wee lend/To sleep . . . Wee rather breathe, then [*sic*] live'.

While most of the treatises on the Ages of Man, as we shall see, differentiate between early infancy and later phases of childhood; Quarles barely does so. To drive home his pessimistic reading of the whole of human life,[48] he interprets, through visual image more than through text,[49] its entire first decade as a state of physical and spiritual torpor: the comatose sleep of the infant encased in its swaddling bands, as unlike a fully human being as the chrysalis is unlike a butterfly. It is surely the striking visual resemblance of swaddled baby to pupa that suggested the metaphor,

although it is an underlying view of infancy as 'the vilest state of human nature' that sustains it.

One of swaddling's practical functions is to secure nappies and conceal the disagreeable smell of an infant's excrement – the background to a representation of a baby's toilette from the *Emblemata of Zinne-Werck* by the Dutch Calvinist humanist and moraliser Johan de Brune (fig. 72).[50] Published in 1624, de Brune's emblem book is more like a collection of penitential sermons than explications of 'hieroglyphs'. Like Quarles, however, the author generalises from infancy to the whole of human life; the motto above this image baldly translates as 'This life, what is it but stink and shit?'[51] The poem below recalls that even the most beautiful and idolised woman is born of sin and darkness; the lengthy text on the following pages contrasts human amorousness with the pure adoration of God. The general meaning of the emblem has been paraphrased as 'there may be no creature more glorious than man, but then again neither is there a more miserable one'.[52] Nothing in these texts explicitly refers to swaddling, and we can surely credit the sly visual interpretation of de Brune's motto to the painter and draughtsman Adriaen van de Venne, who, having already made his name illustrating the most popular of all Dutch emblem books, Jacob Cats's *Sinn' – en Minne-beelden*,[53] seems to have been given a free hand designing the illustrations for the *Emblemata*. For this more highbrow and literary work, he drew seemingly naturalistic scenes of contemporary Dutch life.

In this cozy domestic interior, a young woman, seated by the fire in a wicker nursing chair, holds her baby across her lap. She lifts up his little feet in her left hand to expose his bottom, which she has just washed in the basin of water warming by the hearth and is now drying with a cloth, preliminary to re-swaddling with the clouts in the basket at her side. Were this an independent image, we might be mildly disconcerted by its frankness, but won over by what appears to be its pragmatic good humour. As one of a series representing the Five Senses, the same motif might seem a witty way of illustrating Smell. It might have stolen into the repertory of art on the coat-tails of more decorous Early Netherlandish devotional pictures of the Virgin Mary bathing or nursing her Child,[54] illustrating the Virgin's humility and maternal attentiveness, the Child's fully male humanity, the tenderness of their mutual love: she both Mother and Bride, he Bridegroom as well as Son. De Brune's motto or caption, however, sheds a luridly negative light on the iconography of van de Venne's image, robbing it of either wit or tenderness. In conjunction with this text, the mother's practised gesture is seen to have revealed the 'shameful' parts of her son's body – of all human bodies – associated with the 'works of darkness': excretion and sex. The infant, who cannot control his bodily functions, remains passive and unperturbed. Neither he nor the woman is repelled by the stench that must be invading the room – the stench of corruption that accompanies us throughout our lives.

Different contexts make for different meanings. Swaddling, practised in much the same way throughout Europe, kept babies warm, and safely immobilised; it was believed essential to straightening the fragile, frogs'-leg-shaped limbs of newborn infants. When not reflecting what theologians and moralists professed but what mothers and nurses actually did, pictures of swaddling were not intended to convey shame or revulsion. On birth trays such as the one on Figure 17, or in portraits of real live infants, they denote the 'tender maternal compassion' displayed by the Virgin in Saint

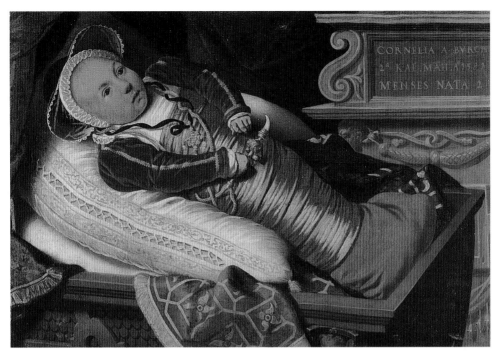

73 Dutch School, *Portrait of Cornelia Burch aged two months*, 1581, Hull, Ferens Art Gallery

Bridget's vision of the Nativity,[55] with no doubt an element of apotropaic anxiety for the life of the child celebrated or depicted. However tightly wrapped, babies in such pictures are shown alert and reactive, the very antithesis of de La Tour's chrysalis-like *New-born Child* (fig. 70).

From the end of the sixteenth century, portraits were being painted of princelings in ornate swaddling clothes,[56] but it is rare to find such a portrait of a live Dutch baby girl from an unknown family (fig. 73).[57] The inscription is dated May 1581, and identifies her as two-month-old Cornelia Burch; old enough now for her arms to be left free. Although her swaddling bands are plain, she wears elaborate detachable sleeves. A fashionable adult arched hood has been set on top of the frilled baby's cap on her head; a long gilt chain around her neck is attached to the combined rattle and amulet (a wolf's tooth?) that she holds in her right hand. Whatever the original purpose of having this solemn baby portrayed in oils, it was not to demonstrate the 'indigence' of Cornelia's infancy.

An eighteenth-century Italian allegory of *Winter* expresses the benign female view of swaddling almost as a deliberate rebuttal of the male theologians' position (fig. 74).[58] At a brazier in a poor interior, an old woman warms her hands, and a younger one, probably her daughter, has set down her spindle to wrap her baby in swaddling bands, having presumably washed it (although its bottom is visible, its sex is not) with warm water from the pot on the floor. Unperturbed by having its arms pinioned, the baby still kicks its plump legs; it is looking up with happy interest at its older sister, who kneels on the floor gently holding its head. In the shadows behind the women a man and two little boys stand in tattered outdoor clothes; the man, still holding his

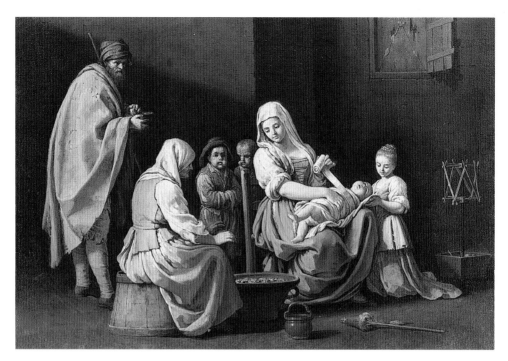

74 Giuseppe Gambarini, *Winter*, *c.*1721–7, Bologna, Pinacoteca Nazionale

staff, is dipping a piece of bread in a bowl of soup. Rather than members of the little family by the brazier, they appear to be vagabonds, charitably given food and shelter by the women.

The painting is constructed through contrasts between cold and warm. Warm primary colours and off-whites make up the women's clothes, as opposed to the beggars' ashen greys. The latter have been, in every sense, out in the cold, while the women and the baby bask in more than the purely physical warmth of embers and swaddling clothes: domesticity, shared affection, tenderness, compassion and good example transmitted from generation to generation. It is an image of the human condition that stresses swaddled infancy's potential for sociability and virtue rather than its isolation and helpless misery.

Ambivalence towards early infancy, enshrined in European art after the rise of Christianity, is eloquently expressed in a text of 1509:

> First of all, everyone knows that by far the happiest and universally enjoyable age of man is the first. What is there about babies which makes us hug and kiss and fondle them, so that even an enemy would give them help at that age? Surely it's the charm of folly, which thoughtful Nature has taken care to bestow on the newly-born so that they can offer some reward of pleasure to mitigate the hard work of bringing them up and win the liking of those who look after them.[59]

The writer of these words is Desiderius Erasmus of Rotterdam, one of the greatest, and certainly the most influential, of the Renaissance humanists. But their supposed speaker is Folly, that candid yet unreliable guide to human affairs.

CHAPTER 5

The first steps and the baby-walker

THE RIDDLE OF THE SPHINX – 'what is it that has only one vo s four-footed, two-footed and three-footed'? – suggests ancient Greeks did not share the fear of later Europeans that infants, if left to their own devices, would never learn to walk upright, human-fashion.[1] Crawling babies have been a popular motif in Greek art since the Late Minoan period in the second millennium BC; though less than two inches long, this bronze figurine is a realistic representation of a happily unfettered six-month-old baby (fig. 75).[2] Reputedly found in 1869 in the Dictaean cave on Crete where Rhea hid her infant son Zeus from the infanticidal appetite of his father, Kronos, it would have been an ex-voto for the birth of a boy, or his survival beyond earliest, torpid infancy. Crawling babies in exactly similar poses appear especially frequently in the Classical period, painted on the miniature wine jugs, called *choes*, given to children at the spring festival;[3] I shall return to these below. A baby is encouraged to crawl on the famous decoration of a fifth-century *pelike*, or storage jar, that unusually includes not only a mother or nurse beckoning to the child, but also a father or tutor looking on.[4] But crawling is a gradual process, that seems never to have quite acquired the portentous significance of a child's first upright steps.

The ancient Romans seem to have invoked a goddess, Abeona, to protect the first steps of children walking away (*abeuntes*) and another, Adeona, to guard those coming back (*adeuntes*). They are known, however, from early Christian polemics against paganism: 'To the Gentiles' by Tertullian,[5] and in a chapter of Saint Augustine's *City of God*, obviously influenced by Tertullian:

> Book IV, Chapter 21, 'That those who did not know the one God should at least have been content with Virtue and Felicity.'
>
> What need was there for women in labour to call upon Lucina when, with Felicity present, they would have not only an easy delivery but also good children? Why was it necessary to commend the newly born to the goddess Ops, or wailing infants to the god Vaticanus? Or those in their cradles to the goddess Cunina? Or sucklings to the goddess Rumina? Or those who could stand up to the god Statilinus? Or those who could walk towards someone (*adeuntes*) to the goddess Adeona? Or those who could walk away (*abeuntes*) to Abeona?[6]

It is difficult to know which of these obscure entities were actually venerated as deities, and which were merely virtual, spirits or simply names to invoke in specific

75 Figurine of a Crawling Baby, bronze from the Dictaean Cave, Crete, Late Minoan I, *c.*1550–1450 BC, Oxford, Ashmolean Museum, Gift of Sir Arthur J. Evans

circumstances of life, and listed for that purpose in the *Indigitamenta*, a pontifical collection of folk prayers, recipes or formulae.[7] Lucina ('she that brings to light') was an aspect of Juno or Diana; Ops, 'wife of Saturn, the earth', was a protectress of agriculture and fertility; the word Vaticanus is related to 'soothsayer'; similarly, the name Cunina is related to *cunis*, 'in the cradle'. Rumina, on the other hand, was venerated in a temple near the fig-tree under which the she-wolf was said to have suckled Romulus and Remus. Statilinus derives from the same root as 'static' and 'stationary', i.e. 'standing still', and the functions of Abeona and Adeona are also implicit in their etymology. Whether or not actual objects of cult, however, the 'divinities' enumerated by Tertullian in the second or third century AD, and by Augustine in the fifth, must have still seemed plausible to their readers. The focus on childbirth and infancy is significant, as is the minute anatomising of the developmental stages of earliest childhood. While crawling does not seem to rate its own supernatural protector, walking, a skill normally acquired with greater effort, marks the transition from a more dependent to a more autonomous (and thus in every sense more vulnerable) relationship of the child to mother or nurse. A toddler's first steps have always been viewed as a significant moment in human life[8] and a metaphor for beginnings and initiations, but since beginnings presuppose endings, the metaphor's optimistic purport is also tinged with melancholy.

Among the hundreds of modern ex-votos for the birth or the miraculous rescue of a child in the sanctuary of Divine Love in Rome, there hangs a pair of tiny gym shoes; the accompanying letter, signed only '*una mamma*', makes poignantly clear, however, that the child who wore them died: 'Forgive me, Jesus, for the times when I inveighed against you, but my suffering is so great; yet now I thank you for having allowed my great love to take his first steps.'[9] Even in predominantly secular countries such as Britain, a child's learning to walk may be commemorated by a pair of baby's shoes cast in bronze, signifying both the successful overcoming of obstacles and dangers, and the loss of pristine infancy. Yet however well understood in life, the 'First Shoes' synecdoche has never caught on in the visual arts, presumably because the iconography of the First Steps had evolved long before toddlers were shod, and well before the era when a van Gogh could make paintings of only workmen's worn-out boots.[10]

If the Dutch artist's *Boots* each resume a working man's entire life, his painting of the First Steps conforms to pictorial tradition (fig. 76).[11] Not only is it not an original invention or observation from life, but it quite openly relies on the printed reproduction of a black-and-white drawing by Jean-François Millet, the French proponent of 'peasant naturalism'.[12] Van Gogh conceived the notion of copying prints after Millet at the asylum of St-Rémy, writing to his brother in October 1889,

> Last night the canvas arrived and the Millet reproductions . . . You know it might be interesting to try to do Millet's drawings in painting, that would be quite a special collection of copies . . . How beautiful that Millet is, 'A Child's First Steps'!.

And in January 1890 he added,

> This week I am going to start on the snow-covered field and Millet's 'The First Steps', in the same size as the others. Then there will be six canvases in a series, and I can tell you, I have put much thought into the disposition of the colours while working on these last three of the 'Hours of the Day'.[13]

76 Vincent Van Gogh, *The First Steps*, 1890, New York, Metropolitan Museum

The Millet image that so attracted van Gogh shows a peasant who has been tilling the kitchen garden outside his cottage. Having dropped his spade, he kneels, opening his arms out to the toddler launched towards him by his wife. The child opens its arms in turn, partly with eagerness, partly to balance itself on wobbly legs, partly because compelled to by its mother's grasp.

Millet had first turned to the rural subjects that made him famous during the revolution of 1848, when a republican government was briefly reinstalled in France. He was thus responding partly to memories of his own peasant childhood, but more importantly to the agitation for a new art renouncing its traditional religious and epic themes to deal with the common man and contemporary issues, such as the depopulation of the French countryside. Although not a believer in political reform, Millet did not object to his paintings being co-opted in the socialist cause, and his elevation of the peasantry into the realm of high art was in itself a radical statement.

At the time he drew *The First Steps*, the artist had fathered two, possibly three, children: Emilie, born in 1856, Charles in 1857, and Jeanne in March 1859. Their birth may

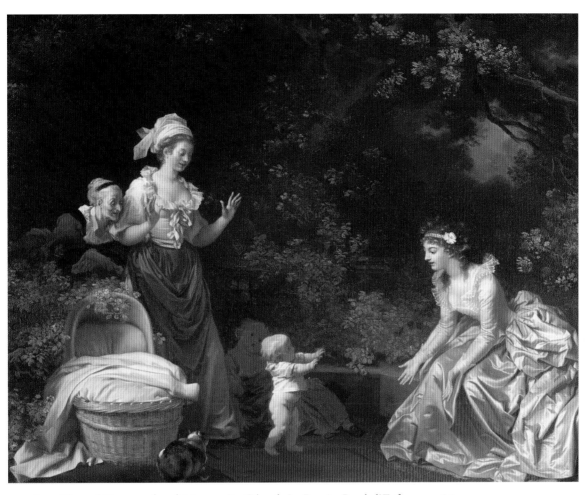

77 Jean-Honoré Fragonard and Marguerite Gérard, *Le Premier Pas de l'Enfance, c.*1786, Cambridge, Massachusetts, Harvard University, Fogg Art Museum

have inspired him to turn to subjects of the life of women and children, but this imagery also attracted the overseas buyers who were the artist's best clients – although Millet's paintings for this market never became as cloying as those by his younger, more academic and conservative contemporary, Bouguereau.[14]

Most of Millet's pictures in this domestic genre were inspired by seventeenth-century Dutch works;[15] the motif of the First Steps, however, is more likely to have been suggested to him by a late eighteenth-century French engraving, *Le Premier Pas de l'Enfance,* after a painting by Jean-Honoré Fragonard and his pupil Marguerite Gérard (fig. 77).[16] If this was indeed Millet's inspiration, however, he wilfully subverted that composition's aristocratic and feminine ambience: the park-like setting, the elegant silk-clad mother beckoning to the half-naked toddler, the only visibly male person in the painting, as his little sister, nurse, grandmother (and a large calico cat) look admiringly on.

But while Millet may have altered Fragonard's Rococo fantasy to reflect peasant reality, van Gogh in turn reinterprets, perhaps unconsciously, Millet's contemporary

scene in the light of a tradition rooted in antiquity. Through his use of colour, which enables him to show white blossoms on the apple tree and fresh green leaves sprouting in the furrows, he specifies that it is springtime. The white laundry drying on the picket fence is more prominent than in Millet's drawing, and together with the painting's generally cool radiance suggests a morning scene. Van Gogh makes explicit what Millet's drawing only implies: a parallel between the stages of human life, the seasons of the year and the hours of the day, still acknowledged in such expressions as 'salad days' or 'the evening of life'.

That man is a microcosm ('little world') epitomising the macrocosm ('great world', a larger and more complex structure, usually but not necessarily the universe), has been a commonplace in pagan, Jewish, Muslim and Christian thought from at least the fifth century BC. In the medieval West, the notion was communicated to a very wide, unlearned audience largely through the illustrated schemata of the stages of human life, traditionally called the Ages of Man,[17] relating the human life cycle to various aspects of the world and the heavens. Van Gogh's association of the toddler's First Steps with morning and springtime may seem to us – and no doubt seemed to the artist – natural and obvious, but it combines two of the oldest, simplest and most enduring models of the Ages of Man: the triadic one of the Sphinx's riddle, in which infancy, youth and old age correspond to morning, noon and evening respectively, and a tetradic one in which infancy, youth, maturity and old age reflect spring, summer, autumn and winter. It is typical of such schemata of the human life cycle that they agree on a developmental sequence rooted in observation, but distort chronology to fit preconceived schemes not based on demographic fact.

Quarles's *Hieroglyphikes of the Life of Man*, you will recall, postulated seven Ages corresponding to the seven 'planetary spheres', each age reflecting the influence of its tutelary planet, a scheme attributed to the second-century astronomer and geographer Ptolemy,[18] and echoed in Jaques's famous speech in Shakespeare's *As You Like It*.[19] The Christian encyclopaedist Isidore of Seville (*c.*560–636), on the other hand, defined a six-fold scheme based on Latin etymology and paralleled by six ages of human history.[20] In Isidore's model, *infantia*, (derived from *in fari*, 'unable to speak'), extends to the age of seven; *pueritia*, childhood, (according to Isidore rooted in the word for 'pure'),[21] is the period before puberty ending at fourteen; *adolescentia*, (from the verb 'to grow, mature'), is a time of maturation and concupiscence that ends at twenty-one; *iuventus*, (from *iuvare*, 'to help or assist'), ends at forty-nine and the *aetas senioris* or *gravitas* at seventy; *senectus* or the age of decay is the period before death – but these six can be extended to seven with the addition of *senium*, the very end of life.

While Isidore's definitions proved lastingly influential, his schema never superseded others. The great Arab physician-philosopher Ibn Sina (*c.*980–1037), better known in Europe as Avicenna, adapted a tetradic division corresponding to the four seasons, the cardinal points of the compass, and the four fluids, or humours – blood, phlegm, yellow bile and black bile – that according to the Greek 'father' of medicine, Hippocrates (d. 377 or 359 BC), govern human temperament and health. But since Avicenna also subdivided the first age (translated as *aetas adolescendi* and lasting until thirty) into infancy, childhood and adolescence, his system also added up to a total of six ages.

The Jewish tradition likened the seven ages to animals, different from those adopted by Quarles: three is a pig rolling in the mud, ten is a kid jumping about; twenty is a

lustful wild horse; the married man is a dull ass; the parent, a dog protecting its litter; old age is furrowed like an ape.[22] Permutations based on the Hebrew Bible divided the cycle of human life into ten Ages.[23] Whether transmitted through direct influence or arrived at independently, these notions too are echoed in Christian writings, and above all in imagery; although most of the animal equivalences have changed, the identification of ten-year-old boys with kids has proven lasting.[24]

Despite their endless complications, virtually all the systems of the Ages of Man have since the Middle Ages inspired visual interpretations: in the stained-glass windows of churches, in fresco or sculptural cycles, in manuscript illuminations and printed book illustrations, in popular imagery. The medieval versions often borrowed diagrammatic schemata from other symbolic systems, such as the Wheel of Fortune or the Tree of Wisdom. In the sixteenth century, as printmakers came increasingly to improvise on the theme independently of texts, new pictorial forms, such as the ascending and descending staircase, rapidly eclipsed the more complex earlier imagery.[25]

The First Steps appear, normally as the second stage of human life, in the majority of these pictorial sequences. Throughout the centuries, the theme's most frequent signifier (especially when no other figures are depicted but the toddling child) has been a baby-walker – the wheeled walking aid we noted on the second-century Roman child's sarcophagus (fig. 52), and in the woodcut illustration to the 1502 Strasburg *Virgil* (fig. 50). In use since time immemorial, the device was recommended to Roman parents by the famous early-second-century Greek physician, Soranus;[26] although no longer advocated on medical grounds, it survives in various forms today. Also referred to as 'scooter-like vehicle', 'go cart' and 'walking machine' in English,[27] *diphros hypotrochos* ('supporting chariot') in Greek, *sustentaculum* ('support') in Latin,[28] *rolwagentje* ('little wheeled wagon') or *looprek* ('walking machine') in Dutch,[29] *machayan* ('[walking] machine') in Arabic,[30] *chariot d'enfant, poussette, trotte-bébé* or *baby-trott*, and *parc à roulettes* in French,[31] *Laufstuhl* ('walking chair'), *Laufgestell* or *Laufgitter* ('walking frame') in German, *strumento per avviare i bambini, carretto* and – especially in the form of a circular walking frame – *girello* in Italian, the baby-walker seems never to have acquired a specific and generally agreed nomenclature in any language, which may explain why its starring role in the history of the imagery of childhood has until now barely been acknowledged.[32] Yet, like the well-studied imagery of perennial children's toys, discussed in the next chapter, representations of baby-walkers simultaneously reflect contemporary reality and constitute a well-worn *topos*, acquiring in over two millennia a wide range of symbolic connotations.[33] This ambiguity sometimes makes it difficult to interpret the motif's precise signifance in a given context: it is not possible to say, for example, whether the endearing second-century toddler with the baby-walker, depicted on a group of crudely moulded Graeco-Egyptian terracotta statuettes,[34] is Harpocrates with his characteristic lock of hair, or a child dedicated to the god; whether the little figurines were simply toys, or apotropaic or votive offerings, intended to avert the dangers attending a child's First Steps, or to express gratitude for the successful completion of this crucial stage in its life, like the baby's gym shoes in the sanctuary of Divine Love at Rome. But whatever its intended function, implicit in any representation of the baby-walker is the notion of the Ages of Man, the universal and ineluctable progression through distinct stages from the cradle to the grave.

78 William de Brailes, *Wheel of Life*, *c.*1240, Cambridge, Fitzwilliam Museum, ms. 330, no. 4

One of the earliest and most complex images of the Ages of Man that exploits the idea of 'man the microcosm' dates from around 1240 and adorns a manuscript psalter' extending by visual means the Psalmist's meditations on the nature of human life and its relation to God. The work of an English artist, William de Brailes, the illumination combines the Ages of Man with a Wheel of Fortune (fig. 78).[35] The attribute of a wheel, that raises the fallen and abases the proud, was first ascribed to that inconstant goddess Fortune, whom we now more often call Fate or Chance, by the Late Antique statesman and philosopher Boethius writing in prison while awaiting execution.[36] In de Brailes's miniature, crowned Fortune sits enthroned behind the hub of her wheel, turning its golden spokes. In the four medallions that protrude from the wheel's outermost rim are enclosed figures holding scrolls inscribed with verses, the medieval equivalent of modern 'speech bubbles'. The youthful ascending figure on Fortune's right exclaims, 'I am borne again to the stars'; a seated king at the rim's highest point announces, 'I exalt on high'; the figure tumbling headlong on Fortune's left cries, 'Reduced, I descend', while the dying figure beneath, hands clasped in prayer, dejectedly asserts, 'Lowest, I am ground by the wheel'. Similar sentiments are inscribed on other Wheels of Fortune.

The half-roundels just inside the outer rim contain twelve, twice six, figures personifying the Ages of Man. The sequence begins low on Fortune's right with a swaddled infant lying between a bareheaded woman, presumably its mother, and a coiffed one, perhaps the goddess herself, who holds a scroll inscribed, '[Here] begins the wheel of fortune'.

In the next medallion, a little boy in his childish short tunic propels a baby-walker. The third medallion contains a youth shooting arrows; in later sequences, less well-differentiated adults continue their ascent to maturity, only to descend towards senescence and death with the turning wheel.

These two universal accounts of human experience – the life cycle from birth to death, good and bad fortune – enframe the story of an individual, the priest Theophilus. De Brailes relates this legend of humility, envy, a pact with the Devil to attain worldly power, repentance and the miraculous intervention of the Virgin Mary, in the innermost eight medallions, starting at a point directly opposite the swaddled infant. Theophilus's enthronment as bishop appears at the wheel's nadir, opposite the throne of his secular counterpart the king; his saintly death, with two angels lifing up his soul to Heaven, is pictured at the zenith opposite the man ground down by Fortune. Worldly success is here equated with spiritual downfall, and spiritual triumph with repentance and bodily decay.

De Brailes's complex diagram gradually reveals itself as a philosophical disquisition on the nature of human life and time. Life lived within time conceived as an ever recurrent cycle – as it is in Nature and in pagan thought – is subject to mere chance, and lived in vain: the First Steps lead to nowhere but death. Theophilus's life, on the other hand, unfolds within a framework of Christian morality that implies a linear concept of time beginning at Creation and ending with the Second Coming. The random, morally neutral but ineluctable workings of Fortune are replaced by a struggle between good and evil; by exercising free will, and with the aid of divine Grace (here dispensed via the Virgin Mary), an individual can achieve redemption and eternal life.

Another scheme of the Ages of Man forms part of a particularly interesting variant of the Tree of Wisdom, illustrating a miscellany of moralising and medical texts in an early fifteenth-century south German manuscript (fig. 79).[37] The title, 'Tree of Wisdom', is given to a group of diagrams, the earliest dating from the twelfth century, that graft the seven Ages of Man (here on our left) and the Seven Liberal Arts (on our right) onto the visual representation of a verse from the biblical Book of Revelation: 'the Tree of Life, which bare twelve manner of fruits, and yielded her fruit every month' (Revelation 22:2). The Franciscan Saint Bonaventura (1221–74) described a vision in which the crucified Christ was identified with the Tree of Life, or *Lignum Vitae*, and this iconography, associated mainly with the Franciscan order,[38] may have affected later versions of the Tree of Wisdom.

The diagram reproduced in Figure 79 alludes to its connection with the Bible through its crowning image of God, Creator and Judge, enthroned on the celestial sphere; its leafy branches – sixteen rather than the textual twelve – end in roundels containing figures identified through inscriptions. Descriptive verses run between the branches, though the pictorial cycle does not strictly illustrate them. The lowest roundel on the right encloses Philosophy, 'mother' of the Seven Liberal Arts practised by the figures in the roundels above.[39] Nature, Philosophy's counterpart in the lowest left-hand roundel, demonstrates the artist's experience of illustrating medical material: it is pictured as a foetus in the womb. This unique image conflates the idea of Nature as Mother with the first, pre-natal stage of life, captioned *embrio*. The normal post-natal sequence of the Ages then begins with a swaddled *infans* in a cradle, and continues with the First Steps of *puer* propelling a baby walker; *adolescens* shoots with bow and arrow at birds in a tree. There is no correlation between the stages of human life and the various Liberal Arts – yet the diagram as a whole implies progression. The First Steps lead us heavenwards, but also towards learning: via the school curriculum, to that true wisdom that is attained only after death, when we may see God face to face.

Despite their references to Christian doctrine, the encyclopaedic medieval schemata of the Ages of Man are essentially secular, referring to humanity's earthly life. Their purely religious equivalent necessarily applies to the unique person of Jesus Christ, who, through his Incarnation, took upon himself all that is human – excluding old age, but including, as we have seen, helpless infancy, and, logically, also the First Steps. An anonymous thirteenth-century work, *Vita Beatae Virginis Mariae et Salvatoris rhythmica*, probably written in Germany, specifies that Jesus started to walk at the age of two with the aid of a *sustentaculum*.[40] Whether directly influenced by this widely translated and adapted text, or spontaneously, the First Steps of the Infant Jesus became a popular image in northern Europe and Spain in the fifteenth century, especially in nunneries – as the French iconographer of Christian art, Louis Réau, writes, with disdain for what he calls 'this puerile "nursery" theme'[41] – and seems to have reached Italy by the sixteenth. Most representations are fairly unambiguous, showing Jesus

79 *Tree of Wisdom*, London, Wellcome Institute
 for the History of Medicine, ms. 49, fol. 69v

80 Hieronymus Bosch, *The Christ Child (?) with a Baby Walker and a Whirligig*,
reverse of the left wing of *The Carrying of the Cross*, late 15th century,
Vienna, Kunsthistorisches Museum

with or without a baby-walker, normally with the aid of one or more angels, in the presence of the Virgin Mary or in the domestic context of the Holy Family. We may assume that by depicting his First Steps, such works simply underline the orthodox Catholic position on the Incarnation and the full humanity of Jesus.

One fifteenth-century image, however, has puzzled scholars and given rise to an extensive bibliography. On the reverse of the left wing of his early triptych of *Christ Carrying of the Cross*, the Early Netherlandish master Hieronymus Bosch painted a naked toddler propelling a baby-walker with one hand and holding a toy windmill with the other (fig. 80).[42] It has been postulated that the painting may have been influenced by a similar figure, lacking, however, the whirligig, carved on a keystone in the south porch of St John's Cathedral at 's-Hertogenbosch, Bosch's native city.[43] Yet the geographical location of the sculpture may be coincidental rather than causal, for not only is its date unknown, but other such images exist in the Netherlandish art of the period,[44] and the whirligig seems to be a significant component of Bosch's picture.

This detail has been interpreted in different ways, which have in turn influenced the reading of the painting as a whole: the whirligig as a symbol of frivolity, by those who assume the boy with the baby walker to be not Jesus but an emblem of foolish humanity that rejects its Saviour; as a solar symbol; as a lunar symbol; as an emblem of dependence on a beloved other person, or of sacrificial love.[45]

Without pre-empting the discussion of toy windmills in the next chapter, it seems, however, reasonable to assume with the art historian Walter S. Gibson that Bosch's *Boy with a Whirligig* represents the infant Jesus, that the whirligig is a childish adumbration of the cross, and that the image as a whole 'parallels Christ struggling with his cross on the obverse' – illustrating the notion that the Passion encompasses Christ's entire life on earth.[46]

In parallel with devotional imagery of the life of Christ, the iconography of the Ages of Man from cradle to grave continued to evolve. As print publishing increased in volume in the sixteenth century, particularly in Germany and the Low Countries, the theme was translated into edifying popular engravings, with inscriptions in vernacular languages replacing Latin text. Artists now invented original variations, mostly based on a decimal system, with death delayed until the ripe age of one hundred. In 1540 Jörg Breu the Younger of Augsburg designed the first known engraving of the Steps of Life, a staircase built over an arch through which we see the Last Judgment.[47] The youthful ages ascend to the top, where the fifty-year-old man sits in the prime of life, seemingly unaware of skeletal Death with bow and arrow behind him; clouds gather over the aging figures descending the steps to where a sealed coffin has been placed on a bier. Without abandoning the idea of upward and downward movement, the Steps of Life replace the cyclical scheme of the Wheel of Life by a linear, eschatological one. Niches below the ten figures of the Ages contain nine animals: since the first animal, the kid, is equated with the child of ten, the infant in the cradle has no animal companion.

Breu's invention of the *Lebenstreppe* proved lastingly influential.[48] I reproduce a seventeenth-century version of the theme by Abraham Bach, who depicts men and women as couples ascending and descending the steps of *Ten Ages of Human Life* (fig. 81)[49] like a sort of human gangplank to Noah's ark, boarded 'two by two'. The

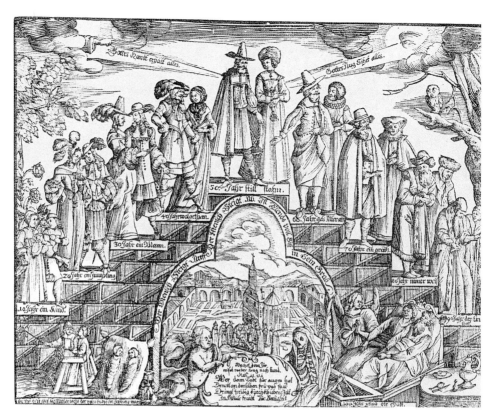

81 Abraham Bach, *Das Zehen Jährige Alter*, The Ten-Year Ages, *c.*1600,
Augsburg, Städtische Kunstsammlungen

complete sequence actually comprises twelve rather than ten Ages. It begins on the
left with two swaddled infants lying on an outsize pillow on the ground, smiling at
each other. Next to them, a boy and a girl companionably share a single walking
frame, the version of the baby walker that seems to have become current throughout
Europe in the late sixteenth century. Instead of offering support like the ancient and
medieval *sustentaculum*, the modern Zimmer frame or certain types of shopping trol-
ley, this square or rounded baby walker firmly encased the child, keeping it upright at
all times; most had wheels, although some, as here, were merely pushed along by the
toddler's own efforts. Obviously, the type of walking frame shown by Bach could not
in actuality have been used on stairs – indeed, one of its functions must have been to
keep small children from climbing up steps[50] – so the First Steps are undertaken on
the flat, and it is ten-year-olds who begin the staircase's ascent, shaded by outsize roses
and a leafy tree. In the skies the hand of God points at the fifty-year-old couple at the
apex, and the eye of God watches them. The descending stairs are framed by a dead
tree, and observed by that nocturnal bird, the owl. The end comes to the hundred-
year-old couple in bed, guarded by an angel. Rather than a Last Judgment, the lobed
arch frames a realistic scene of burial; the inscription in the cartouche held on either
side by a *putto* and Death urges viewers to bear the latter in mind 'early and late'
throughout life, in order to find joy and happiness in Heaven.

Ostensibly a *memento mori*, the print is actually deeply reassuring. Decorously dressed, couples walk together through life in perfect harmony, dying peacefully in bed of extreme old age and ensured a Christian burial. Neither illness nor violence interrupts this idyll; no one is poor, crippled, widowed and alone. Perhaps most soothing of all, nothing happens by chance, and no dramatic reversals of fortune are depicted. Having from their First Steps onwards been mindful of God and Death, these couples need never stumble, never repent the path they have chosen to walk.

Depictions of the baby-walker may represent the First Steps of human life in schemata of the Ages of Man, but they do not, as we have seen,[51] necessarily originate in systematic diagrams of the latter. In fact, the earliest known representation antedates even the second-century Roman child's sarcophagus of Figure 52 by some five hundred years. It appears on a *chous*, one of the miniature wine jugs given to little children at the Attic Dionysiac spring festival, the Anthesteria (from *anthos*, flower) (fig. 82).[52] This particular toy vessel was found in southern Italy, for some Greek colonies outside Greece must have also observed the festival.

We now associate Dionysos mainly with wine, forgetting that in Greek myth he is a god who partly submits to a mortal's fate: killed and dismembered as a child, he was resurrected thanks to Mother Earth. He was consequently also identified with the realm of the dead in the netherworld, and the yearly cycle of wintry decay and springtime's rebirth; on some Greek vases, Mother Earth is shown emerging from the ground holding out the child god in a cornucopia.[53] Having rescued the lovely

82 *Chous*, decorated with *The First Steps of Dionysos*, early 4th century BC, Paris, Louvre Museum

Ariadne abandoned by Theseus on Naxos (an episode more familiarly ascribed to his Roman manifestation, Bacchus[54]), Dionysos married her and became that exception in the Greek pantheon: an affectionate husband and father. For all these reasons, he is a child-friendly god, and the festival of Anthesteria links early childhood to the macrocosms of the social, natural and supernatural orders.

On the first day (*Pithoigia*), the large storage jars, or pithoi, containing the new wine were opened, and the wine tasted. Originally, the pithoi that were opened were the bottomless jars placed as monuments on graves, through which libations of wine were poured for the dead.[55] On the festival's second day (*Choes*), adults held a wine-drinking contest, with a large cake as prize. Crowned with flowers, three-year olds were initiated into the community by receiving their first taste of wine, in the miniature *choes* wreathed with ivy (the evergreen plant dedicated to Dionysos) given to children as presents. On the third and last day, sacred to Hermes, guide to the underworld, the spirits of the dead returned to earth, sent forth by Dionysos himself, and had to be appeased with offerings of wine and cakes. Partly as a ritual in expiation for a mythical murder and consequent suicide by hanging,[56] partly to imbue them with the life-force emanating from the earth with the sprouting springtime vegetation (and no doubt largely to please and amuse them!) children, most particularly girls, were pushed on swings. There were picnics featuring eggs, lots of cakes, raisins dried from the previous autumn's grapes, drunkenness and excitement. With its combination of spring-time flowers and red-coloured eggs, of envious ghosts, children's presents and revelry, the Anthesteria seems to have resembled Christian celebrations of Easter, Hallowe'en and Christmas rolled into one.

Much of this is self-referentially recorded on the miniature children's *choes*; over a thousand survive, many from the graves of babies who may have died too young to participate in the festival. In general, the size of the *chous* parallels the age of the child, which seems to have been reckoned by the number of *Choes* experienced.[57] I have earlier referred to the quantity of these little jugs, usually the smallest ones, decorated with babies crawling towards their *choes*, their festival cakes, birds or other pets. Others show toddlers with their favoured toy, a roller, on which they often give rides to their wine jugs; others still depict little boys in goat-drawn chariots, or astride wild fawns, the Dionysiac animal, or playing with their dogs. More rarely, girls are also shown with rollers and pets.[58] A few *choes* depict ghosts attacking children for the wine in their jugs, or lured by the food offered on an altar.[59]

Figure 82 has always been interpreted as depicting the First Steps of Dionysos: the well-muscled little boy striding behind a baby-walker is being beckoned by a woman dangling an outsize bunch of grapes, to which a fawn is also attracted. Too elegant to be a nurse and too bold to be a mortal's mother, the woman appears to be a maenad, one of the adult Dionysos' female followers – or, less probably, one of the nymphs who cared for the god during his childhood on Mount Nysa, where he would later invent wine.

The life story of a god who is born, dies and is reborn is of particular interest to those who fear for their own survival and that of loved ones. Dionysos' mythical life cycle, pictured in individual scenes on Greek vases, is unlikely to have directly inspired Christian imagery of the life of Jesus; it was, however, the stimulus for a group of Roman adult biographical sarcophagi,[60] predecessors of medieval schemata of the

Ages of Man – and, more significantly, the earliest monuments to endow the baby-walker with an allegorical sense that would later enable it to function as an emblem in diverse contexts.

The earliest and best-known of these sarcophagi dates from *c*.AD 100 and is designed in the semblance of a bed.[61] The entombed man is represented reclining on the lid, a female mourner seated by his head. A frieze carved between the legs of the bed, on the long side of the sarcophagus facing the spectator, depicts significant scenes from his earthly life.

At the foot of the bed, the dead man's mother, having just given birth to her son, is shown watching him receiving his first bath. The scene is followed by a representation of the First Steps – the child propelling his *sustentaculum* towards the old nurse who stretches her arms out to him. This is in turn succeeded by a school scene, then one showing the boy playing games with other boys. The last episode is a *declamatio*, or formal speech, delivered by the deceased as an adult – public oratory marking the acme of a Roman gentleman's social, intellectual and spiritual achievements. Scenes of country life, to be read as complementing a metropolitan career, are carved on the sarcophagus's less well-preserved short sides and back.

It has been argued that the imagery of such biographical sarcophagi reflects Stoic ideas about optimal human development; in this reading, the bath scene signifies sensory impulse, the First Steps learning by experience, and the school episode the acquisition of notions and opinions.[62] Named after the Ancient Greek philosophical school of Zeno (early third century BC), who used to lecture in the *Stoa Poikile*, or painted colonnade, in Athens, Stoicism taught that the highest good, virtue, is based on knowledge. Only the wise man can be truly virtuous, living in harmony with the divine Reason that governs Nature, and as indifferent to the vicissitudes of Fortune as to pleasure and pain. The doctrine became especially influential among the Roman governing classes – the very people likely to commission biographical sarcophagi. Transmitted in the West through the writings of the Roman philosopher Lucius Annaeus Seneca (*c*.5 BC–AD 65), it once again found adherents in the sixteeenth and seventeenth centuries, when elements of Stoical philosophy influenced both Protestant Reformers and Jesuit missionaries, and were diffused widely through manuals of manners as well as popular emblem books.

That the scene of the First Steps on Roman so-called biographical sarcophagi alludes to Stoical doctrines of learning by experience receives unexpected confirmation across the centuries, from numerous seventeenth-century sources summed up in a famous etching by Rembrandt (fig. 83).[63]

One of three prints of male nudes made *c*.1646, all recording the same model posing in Rembrandt's studio for the benefit of the artist and his pupils,[64] Figure 83 depicts in the background the seemingly unconnected scene of an elderly woman teaching a toddler to walk. Crouching, she beckons to the child who stretches its arms out to her from within its wheeled walking frame. Often interpreted as a random sketch from life, perhaps representing Rembrandt's son Titus with his nurse, the vignette recognisably conforms to the traditional imagery of the First Steps. The Dutch master could not have helped but be familiar with the motif's emblematic versions embodying Stoical doctrine, widely circulating throughout northern Europe. One of the best-known was the cheerful *putto* waving his rattle as he propels his

8z

Apprentif deuiendra Maistre.

Le chef d'œuure ne va auant l'apprentissage,
Il est donné à tous, d'aspirer au haut bout,
Mais ne faut perdre coeur, s'il ne vient tout à coup,
Car une heure ou un iour ne fait pas l'homme sage.

Wer Ein Kind ist/wird kein Mann.

Wer kan bald klug zur Weise man weise mir nur Einen/
Ausser Christum/keinen.
Diß bleibt gewiß/wer nie kein Kind ist/wird kein Mann
Alle zeigens an.

X 3 				Yc

walking frame, from a much reprinted polyglot book, the *Emblematum Ethico-Politicorum Centuria Iulii Guilielmi Zincgreffi, A Hundred Ethico-Political Emblems of Julius Wilhelm Zincgreff*, with etchings by Matthaeus Merian, first published in Heidelberg in 1619 (fig. 84).[65] Zincgreff's Emblem 82 is headed with the Latin motto, *Qui nunquam sic, nunquam melius*, 'Who never [does] thus, never [does] better'; the French verse below is entitled 'The apprentice will become Master' and may be translated,

> The masterpiece never precedes apprenticeship,
> Everyone can aspire to the heights,
> But don't lose heart, if you don't get there at one go,
> For one hour or a day does not make a man wise.[66]

The title of the German verse, in turn, paraphrases the well-worn notion of the child being father to the man. The Latin text on the previous page completes the emblem with suitable citations from Seneca, Plutarch, Ovid, Quintilian – all ancient authors taught in seventeenth-century schools and influential on educational theory.

The whip and top lying next to the walking frame in Rembrandt's etching – a toy with which the toddler is in reality too young to play – are also the subject of a

popular Dutch emblem in Roemer Visscher's *Sinnepoppen*, or *Dolls of the Spirit*, published in Amsterdam in 1614.[67] The image shows a hand coming out of the clouds to whip a spinning top; the motto is *'Soo langh de Roe wanckt'* ('So long as the whip beats'), and the text expands: 'The further the whip is from the backside, the lazier [men] grow in the service of God.'[68] The explanation given of the top by that most famous of Dutch emblematists, Jacob Cats, in a commentary on a print of children's games, makes Visscher's meaning even clearer:

> The top spins merrily on the floor, whipped by a biting cord and the harder one hits the better it spins. But let up a bit with the whip and it falls in the dust. From then on it won't do a turn, but lie forever like a block. One never watches it better than in times of sorrow and unhappiness. For if anyone lives without pain, he rusts from idleness. When man has too much leisure, you see, that's when the heart yearns for Lust.[69]

The context of Rembrandt's etching explains these emblematic motifs' relationship to the foreground's more formal and elaborate imagery of a young male model posing for a life class, once standing and a second time seated.

Rembrandt derived much of his income from teaching, and also a large part from the sale of his prints to collectors. The three etchings of male nudes, and certain

studies of heads, were probably planned for the instruction of pupils,[70] while a famous print of *The Artist drawing from the Model* alludes more generally to the role of study from life. All were however also designed to appeal to connoisseurs, and as advertisements for the nobility of art and Rembrandt's own prowess. While the female nude of the latter etching recalls the classical legend of Pygmalion, in which the artist's love brings his creation to life, the First Steps vignette of Figure 83 illustrates the motto, *Qui nunquam sic, nunquam melius*. The need for discipline and effort to attain mastery is stressed through the additional detail of the top and whip. The exhortation to constant practice also echoes a contemporary tag, *Nulla dies sine linea*, 'no day without a line', that serves as the motto of yet another popular emblem, depicting an artist's hand at work.[71]

Ostensibly advocating the primacy of drawing and constant study from the life, as practised by the Italian Renaissance masters who were at this time the touchstone of great art, and advertising the possibility of pursuing such studies in Rembrandt's Amsterdam studio, this group of prints actually offers a shortcut to aspiring artists: a compendium of useful poses. The background in Figure 83 appears as a swift, spontaneous notation of fleeting reality, the artist's touch that vivifies literary and visual *topoi*; conversely, it raises intimate domestic incident to the realm of high art. And although the youthful model's gawky individuality seems today one of the etching's most attractive features, the print as a whole was certainly intended to demonstrate Rembrandt's virtuosity in both his native Dutch *genre* and the Italianate academic manner privileging the idealised male nude.

Surprisingly, and unnoticed by Rembrandt scholars, one of the Dutchman's Italian Renaissance predecessors had similarly depicted a *putto* in a walking frame in the background of a sheet of academic studies of male nudes (fig. 85).[72] The motif appears in a book of drawings compiled by an unknown Umbro-Florentine artist around 1500, and now in the Accademia, Venice, where it was for a long time attributed to Raphael. The drawings record figures from art works of various types – paintings, prints, and sculptures – compiled as a sampler for an artist's use. The male nudes of Figure 85 are not drawn from life, but present three views of the same statuette, one of many fifteenth-century little bronzes, in turn derived from an ancient Graeco-Roman prototype, most probably a figure of the satyr Marsyas playing the flute.[73] Such statuettes *all'antica*, 'in the antique mode', were highly prized by Renaissance collectors, but also provided artists with easy access to nude models in complex 'classical' poses, adaptable to virtually any scene of action.

A late fifteenth-century Italian artist could not have been familiar with a seventeenth-century emblem, and it is improbable that he knew the Roman sarcophagus imagery of the First Steps and its Stoic significance. The meaning of this drawing is thus less certain than that of Rembrandt's etching. The *putto*, itself a classical motif, seems almost to mirror the youth's more exaggerated stance; does it portray the infant's desire for emulation? Or is the draughtsman merely referring to the Ages of Man tradition, or wittily demonstrating the contrast between 'dry', angular adult musculature and plump baby fat, one of the preoccupations of Florentine Renaissance art? Without further evidence, we cannot tell, just as we cannot tell whether the drawing might have influenced Rembrandt. We know that the Dutchman refused to visit Italy, insisting he could learn all he needed from Italian works passing through the auction

Ingeritur manfum, inceffum docet illa, loquelæ
Os homini hæc format naturæ vt fponte nihil quá ·

Pere fciat, fine doctrina, cùm cætera cuncta
Mox penna vtantur, curfu, liquidoque natatu.

Belleeflen lompen/ fe fuiffchen fy feunneg ex eegen
Ex feghefl connen folleghen olfuy izleere
Maer fe mensfrib en ray met den regten enfneegen
Dieuf eleylawefl garey leu ly bahnent langleere.

La befie court, le raffon nage vo volatté
Et laufeau fatt haut pie lpie apde veler.
Mais rien propre a l homin eft qui le ploure,
Car fant apprenlet d ai ma ige ou ne tratte.

II

houses of Amsterdam; he could not, therefore, have seen the original of Figure 85, which seems never to have crossed the Alps. No 'intermediate' artefact transmitting the composition seems to have survived, although the drawing might have been described orally to Rembrandt by one of the many Dutch artists who did venture south. Yet whether the juxtaposition of an 'academic' male nude and a toddler in a walking frame was suggested to Rembrandt by an Italian precedent, or whether the resemblance between drawing and etching is coincidental, does not materially alter the interpretation of the print outlined above. What the existence of the Renaissance drawing changes is our sense of Rembrandt's originality: we are left with the nagging suspicion that his tribute to academic study may be a reworking of an image at the very origins of the academic tradition.

Combining overt and covert messages at various levels, Rembrandt's etching itself becomes a kind of emblem, to which viewers must supply the texts, and whose final enigma may never be resolved.

The image of the baby-walker as an emblem of learning is not necessarily flattering to humankind. The second in a series of six emblematic engravings depicting *Human Nature*, with texts in Latin, Flemish and French, by the sixteenth-century Dutch-born Antwerp artist Philips Galle, shows two women and five children in a landscape with animals (fig. 86).[74] One of the women carries a baby whom she feeds with a spoon from a pot in her hand; the other is teaching a little boy to walk,

cajoling him on with a rattle; two other boys follow, crying and pulling their hair. All the children are naked bar the little girl in a walking frame holding her doll as she follows in the women's footsteps.

The French epigram below may be translated,

> The beast runs, the fish swims and floats,
> And the bird flies without any help:
> But nothing is man's own except tears,
> For without learning how, he neither eats nor trots.[75]

The author's knowledge of bird behaviour may have been flawed, but his meaning is plain: human nature is more infirm than that of animals, for we cannot master even the most basic skills without painful effort. The baby-walker as an emblem of learning comes to signify humanity's frailty, its need of support. The notion is summarised in the lapidary motto of the *sustentaculum* emblem of the Accademia degli Assicurati, the Academy of the Assured, an association of professors of law and letters founded in Pistoia in 1655: *Vestigia Firmat*, 'makes [its] footprints firm'.[76]

It is principally as a religious metaphor for human frailty that the baby-walker appears in the most frequently printed of all religious emblem books, *Pia Desideria*, 'Pious Yearnings', by Father Herman Hugo – Rector of the Brussels Jesuit College, military chaplain to Ambrogio Spinola, the general of the Spanish armies in the Southern Netherlands, expert in fortification, classical scholar and mystical poet.[77] Written in Latin and first published in Antwerp in 1624, with engravings by Boëtius a Bolswert, *Pia Desideria* grafted the Jesuits' methods of meditation, based on the *Spiritual Exercises* by their founder Saint Ignatius Loyola, onto the emblematic tradition, adapting a device pioneered by Rubens's teacher, the erudite Otto van Veen or Vaenius. The 'Little Loves', *amorini* or cupids who acted out a whole range of erotic sentiments in van Veen's secular *Amorum Emblemata* or 'Emblems of Loves', 1608, were transformed in its devotional successor of 1615, *Amoris Divini Emblemata*, 'Emblems of Divine Love', into barefoot but fully clothed childish figures: a winged and haloed little boy, *Amor divinus*, and a little girl with her hair in a psyche knot, *Anima*, the Human Soul. These became the protagonists of Hugo's *Pia Desideria*.

There had long existed a rich vein of mystical literature crackling with desire, inspired by the Psalms and the Song of Solomon (also called Song of Songs, or Canticle of Canticles), the collection of marriage poems in the Hebrew Bible interpreted by Christians as an allegory of the love of Christ for his Bride – variously understood as the Virgin Mary, the Church, or the Human Soul yearning for God. Now for the first time, in keeping with the didactic aims of emblem books and their intended audiences of 'Children and Childish Gazers',[78] the Canticles' Lover and Beloved were depicted as little children, enacting sometimes puerile, at times enigmatic or even sinister charades. It is difficult for us now to recapture the evident pleasure with which this bathetic and *avant la lettre* Disneyfied convention was once greeted by Hugo's avid readers, scholarly clerics and their flocks.

The work found innumerable imitators, not only among Jesuits and throughout Catholic Europe, but also in Protestant countries; its engravings were copied with only a very few alterations, though sometimes reversed and with increasing loss of quality, and even adapted for church windows and other decorations. Through the

Perfice greſſus meos in ſemitis tuis, vt non moueantur veſtigia mea. Pſal. 16.

18.

III.

Perfice greſſus meos in ſemitis tuis,
vt non moueantur veſtigia mea.
Pſal. 16.

Ergo caducâ gradum toties mihi tibia fallet,
 Sternet & in planâ pes vitioſus humo?
Aſpice, qui Cœlis hominum veſtigia ſpectas,
 Firmáq́, fac preſſo ſtet mea planta ſolo:
Inſtruit implumes pennata Ciconia pullos;
 Et docet aërias præpes inire vias.
Exemplo volucrem ſequitur modò filia Matrem,
 Tutáq́, iam peragit, quod metuebat, iter.
Prouocat expanſis ſobolem Iouis armiger alis,
 Et iubet inſuetas ſollicitare plagas.
Mox præit, & pleno ſe iactat in aëra lapſu,
 Remigio ſoboles ſubſequiturq́, patrem.
Dum primùm ignotas tentat puer inſcius vndas,
 Corporis indoctum ſubere fulcit onus:
Mox opis oblitus, flumen ſine cortice tranat,
 Flumen inexperto ſæpe ſed ore bibit:
Sapiùs at doctis vbi plauſerit æquora palmis,
 Ducit in immenſo brachia tuta ſalo.
Aſpice, qui in Cœlis hominum veſtigia ſpectat,
 Aſpice, quâ nobis arte leuetur iter:
Suſtineor fragili puerilia membra curuli,
 Quæq́, vehunt ſocias ipſa propello rota.
Nempe tripes baculi ſic ſtipite nititur ætas,
 Quíq́, ſenem vectat à ſene fertur equus.

L N

87 Boëtius a Bolswert, emblem III, Herman Hugo, *Pia Desideria*, Antwerp, 1624, pp. 160–1

many editions of the free adaptation by Francis Quarles, *Emblemes*,[79] the four editions of a more faithful though by no means literal English translation, *Pia Desideria or, Divine Addresses* by the post-Restoration Protestant Archdeacon of Armagh, Edmund Arwaker,[80] and their less well-known imitators, Hugo's emblem book continued to play a leading role in Anglo-American Protestant devotional literature and moral attitudes throughout the nineteenth century.

The baby walker appears twice in *Pia Desideria* and its derivations, most significantly as emblem three, with as motto verse 5 in Psalm 17,[81] 'Hold up my goings in thy paths, that my footsteps slip not', the religious equivalent of the Accademia degli Assicurati's *Vestigia Firmat*. I reproduce the original spread in Hugo (fig. 87),[82] closely followed in Arwaker. Quarles's *Emblemes* reverses the image, in a more vigorous but iconographically identical engraving by William Marshall. The English texts share Hugo's premise that the human soul needs God's help to find and love Him, but differ from each other in emphasis. Quarles cites his 'merchant soul's' eagerness to run and fly towards the 'Charmes of Profit'; to seek 'time-beguiling Pleasure'; to take pains in order to gain 'blazing Honour' – yet his reluctance to abandon the world 'when the home-bound vessel turnes her sails', his need of God's 'helpfull hand' to guide him: 'I am thy child, O teach thy Child to go'. The contrast between worldly and religious attitudes is summed up in the closing epigram:

I X.

Quis mihi det te fratrem meum fu-
gentem vbera matris meæ, vt
inveniam te foris, & deofculer
te , & iam nemo me defpiciat!
Cant.8.

Quis cumulet patrias tãto mihi ftẽmate ceras,
 Frater vt ad fratres annumerere meos!
Non tamen hoc facio pro ftirpis imagine votum,
 Nulla mihi augendi fanguinis ambitio eft.
Stirpe licet noftrâ fanguis tibi vilior effet,
 Optarem fratrem te tamen effe meum.
Non pubente quidem vernantem flore iuuenta,
 Prima cui rofcas veftiat vmbra genas:
Sed puerum, toto qui nondum vixerit anno,
 Lactis adhuc mater quem mea pafcat ope.
Quiq, ego quas fuxi, paruo trahat ore papillas,
 Infideatq, illos, quos ego fæpè.finus.
Hoc ego vel fimili cupiam te corpore fratrem,
 Si fueris maior, non ego te cupiam.
Quin igitur noftris, mea vita renafcere faclu,
 Vt videam cunas pufio parue, tuas?
Et nifi fallor, habent pueri quid amabile mores,
 Quoq, carent iuuenes, virq, fenexq, carent.
Vtq, fuam quæuis laudem fibi vendicet æt.u,
 Ille tamen pueros fcilicet ornat amor.

Av

Quis mihi det te fratrem meum, fugentem vbera
matris meæ, vt inueniam te foris et deofculer
te et iam me nemo defpiciat! *Cantic. 8.* 24.

88 Boëtius a Bolswert, emblem IX, Herman Hugo, *Pia Desideria*, Antwerp, 1624, pp. 218–19

 Fear not, my soule, to lose for want of cunning;
 Weep not; heav'n is not always got by running:
 Thy thoughts are swift, although thy legs be slow;
 True love will creepe, not having strength to go.[83]

Arwaker follows Hugo by focusing more generally on the process of learning by prac-
tice and from example. With a better understanding of bird life than Philips Galle's
collaborator (fig. 85), the text moves from storks and eagles teaching their young to
fly, through boys learning to swim, at first supported 'On spungy Cork's light weight'
until 'by use [they] perfection gain', to expand on the metaphor of learning to walk
in God's footsteps:

 Thy footsteps, Lord, o'ercome the roughest way;
 A Gyant's Feet move not so swift as they.
 Thou with a step dost East and West divide,
 And o'er the world, Like a Colossus, stride.

It is fear of death that is mainly responsible for the human soul's reluctance to follow:

 But like the Tortoise, my dull Foot's delay'd,
 Or rather, like the Crab, moves retrograde.
 How can I then hope to that Goal to run,

I make the bus'ness of my life to shun?
But do thou, Lord, my trembling feet sustain,
Then I the Race and the Reward shall gain.

Worldly distractions are mentioned only in the closing citation translated from Saint Ambrose:

Who among so many troubles of the body, among so many allurements of the World, can keep a safe and unerring course?[84]

The baby walker's second appearance in Emblem IX of *Pia Desideria* is more ambiguous; I once again reproduce the spread from Hugo's original (fig. 88).[85] The motto is derived from the Song of Solomon 8:1:

O that thou wert as my brother, that sucked the breasts of my mother! when I should find thee without, I would kiss thee; yea, I should not be despised.

The burden of Quarles's adaptation is the human soul's desperate yet vain desire to preserve the 'blessed Infant' from 'Herod's fury, or the High Priest's Harmes'; sinful but loving Anima assumes responsibility for Christ's Passion. The Passion is viewed as perpetual, not only because of Jesus's lifelong suffering, but also because our sins prolong his torments until the end of time. This is a coherent position of much Christian mysticism, though it takes only scant account of the erotic fervour of the verse from the Canticle cited and of the passage by the thirteenth-century Franciscan theologian, Saint Bonaventura, that ends the text[86] – and none of the baby walker in the illustration pirated from Boëtius. Arwaker struggles faithfully to translate his Jesuit author's effusions; the erotic transports of Anima and Divine Love – for *pace* Quarles, the winged infant is not identical with Jesus Christ – need the excuse of a nursery setting, and, surprisingly, the classical precedent of the childlike Cupid:

Children have pretty, pleasant, charming Arts,
Above the elder sort, to win our Hearts;
And though each Age wou'd its own merit prove,
Childhood is still most prevalent in Love:
Ev'n he who tames the world, tho' calm and mild
His Face appear – even Love himself's a Child.

If she were Divine Love's elder sister, Anima could, 'unblamed . . . clasp thee closely in my Arms' and she would be 'Nor blam'd, nor censur'd if my Love were known.' Singing the infant to sleep, stealing kisses, removing his mantle 'eager t'enjoy the object of my Love', she would also be able to instruct him - hence the baby-walker:

I'll teach thee safely how to praunce along,
And keep thy nimble Footseps firm and strong:
And if some naughty Stone offend thy Feet,
My ready Arms their stumbling Charge shall meet;
Pleas'd with a frequent Opportunity
Of thus receiving and embracing Thee:
Nor shall I any Recompense regard,
The pleasing Service is its own reward.[87]

Piling on adjectives and expressions of affection, Arwaker's English rhymes lighten and

89 Hieronymus Bosch, *The Temptation of St Antony*, triptych, *c.*1510–16, Lisbon, Museu Nacional de Arte Antiga; detail

sweeten Hugo's more laconic Latin, and the two anglophone texts I have quoted seem to signal an extraordinary shift in sensibility. Quarles's Metaphysical meditation on love and suffering, the Passion and human sin, is half-a-century later transformed by Archdeacon Arwaker into a cloying *sentiment de l'enfance* in which 'Children have pretty, pleasant, charming Arts . . . to win our Hearts', the Passion is reduced to 'some naughty Stone', and love, being childish, is innocent. But Arwaker, we recall, translated Hugo for 'the Religious Ladies of our Age'. Eighteenth-century and Victorian sentimentality is just around the corner, its path smoothed by seventeenth-century emblematics' exploitation of the imagery of childhood, though by 1880 the original illustrations to Quarles were condemned as 'almost throughout absurd, in that the chief 'figures' are (to say the least) childish even when adults are necessary to the 'moral' of the verse.'[88] The peripeteia of baby-walkers in art does not, however, end here. As an emblem signifying both learning by experience and human frailty, it accompanies us into old age.

The image of the old man in the walking frame seems to have originated in northern Europe at the end of the fifteenth, or the beginning of the sixteenth century, perhaps in the context of the Ages of Man.[89] Mildly satirical, it disparages old age by comparing its physical and mental infirmities with those of infancy. It is once again Hieronymus Bosch who introduces an enigmatic variant: the armless figure of an old man, perhaps a dwarf, his lower jaw bound, a whirligig stuck in his cap, an empty pitcher dangling from the bar of his walking frame, scurrying barefoot towards the outer edge of the inside right-hand shutter of the Lisbon triptych, *The Temptation of Saint Anthony*, c.1510–16 (fig. 89).[90] More puzzling by far than the *Christ Child (?) with the Baby Walker and the Whirligig* (fig. 80), this personage has given rise to innumerable interpretations, none entirely convincing. The Lisbon retable is dedicated to Saint Antony Abbot (AD 251?–356), hermit and patriarch of Early Christian monasticism; his contemporary popularity was due to his supposed founding of the Antonines, a religious order specialising in nursing lepers and and the victims of ergotism, the deadly disease of 'St Anthony's fire' caused by a fungus of rye and other cereals, and at that time endemic in Northern Europe. The sufferings of the Antonines' patients being compared to the torments endured by Saint Anthony at the claws of devils in his Egyptian desert solitude, as recorded in the *Lives of the Fathers* and the *Golden Legend*, his temptation by demons and erotic visions became a favoured subject of Antonine altarpieces, presenting the Saint's resistance to Satan as an example of Christian fortitude to the order's unfortunate charges. We do not, however, know who commissioned this particular retable from Bosch; it is first recorded in the ownership of a Portuguese noble in royal service in the Low Countries from 1523 to 1544.

The outside shutters of the triptych show the Arrest of Christ and the Carrying of the Cross. The inside is devoted to scenes of Saint Anthony's tribulations, in the fantastical manner we associate with Bosch: against vast landscapes of burning cities, ruins and towers, amongst grotesquely metamorphosing and compound beings – demons, vices, heresies, sorceries or hallucinations – the holy hermit firmly resists the onslaughts on his mind and body. The right-hand shutter is dominated by his seated figure, reading Scripture as he averts his eyes from the naked Devil-Queen; he appears as virtually an enlarged mirror image of Figure 89, the dwarfish, mute, armless whirligig man in the baby-walker. While the saint is fully adult, sound of mind and

90 Agostino Veneziano, *Anchora Inparo*, engraving, 1538, Bartsch XIV, 302, 400

91 Goya, *Aun aprendo*, black crayon drawing, 1824–8, Madrid, Prado Museum, Bordeaux Album I, p. 54, *c.*1825–8

92 Paige, *Nursery Slope*, cartoon illustrating 'Leapman in America', *The Times*, 16 January 1978

firm in his faith, the child-like old man, the old Adam of the senses, is driven to flight. We may never know what precisely were Bosch's intentions, what the meaning might be, for instance, of the empty pitcher – lack of doctrine, perhaps? – but the contrast between the dignified Christian hermit and the ridiculous mannikin must be central to any interpretation.

A less engimatic yet nonetheless ambiguous image is an engraving variously credited to the Florentine sculptor Bandinelli, to the engraver Marcantonio Raimondi, and even to Michelangelo himself; now, however, generally attributed to Marcantonio's pupil, Agostino dei Musi, called Agostino Veneziano (fig. 90).[91] This much copied image[92] is captioned with a banner headline in Italian – *Anchora Inparo* [sic], 'I am still learning' – and a Latin inscription beneath: TAM DIV DISCENDVM EST QVAM DIV VIVAS – BIS PUERI SENES. The first half of this is a partial quotation from Seneca's Epistle LXXVI to Lucilius: 'You should keep on learning as long as you live.' We recognise here the Stoical imperative to knowledge and self-knowledge as a way to virtue, the highest good. The second half of the inscription translates as 'The old are twice children', referring to what we still call the 'second childhood' of senility. The sentiment is probably as old as time, but the classical tag is by the Latin satirist and poet, Horace; like so much else by that most influential of writers, it was once again given currency by Erasmus.[93]

Within the image itself, an exotically dressed old man – ancient sage or magus? – moves forward with the aid of an equally fanciful walking frame decorated with rams' skulls like a pagan altar. On a shelf in front of him stands an emblem of the passing of time, the hour glass. Between his luxuriant beard and moustache, his lips are parted, seemingly with effort; his brow is furrowed and his eyes staring. There is nothing to suggest that he is senile, and the figure is not overtly comical.

Is this a parody/portrait of the ancient Stoic, Seneca, the noble emblem of some Renaissance University of the Third Age – Man pursuing knowledge and virtue to the very brink of the grave? Or does it depict the foolish gravitas of the twice-child-ish old, spuriously pretending to wisdom?

To Blake, who tactfully dropped the baby-walker but adopted the caption, *Ancora Imparo*, for his engraved portrait of the aged Michelangelo leaning on a cane in front of the Colosseum,[94] it is undoubtedly a heroic conceit.

A late drawing, however, made in exile in Bordeaux by Francisco Goya, recaptures something of the ambiguity of the sixteenth-century engraving that certainly inspired it (fig. 91),[95] though its influence on the Spanish painter has seldom been recognised. A page from one of the eight albums of drawings Goya made for his own pleasure, it shows an old man, long-gowned, long-haired and bewhiskered, painfully advancing

with the help of two canes. Above him is written the Spanish translation of the Italian caption: *Aun Aprendo*. Goya was about eighty years old when he made this drawing, and naturally – as many have thought – it must be in some sense autobiographical, although that in no way precludes it also being a variation on the Renaissance work. I have been looking at my reproduction of the drawing through a lens, and still cannot make up my mind about the eyes: sad and vacant, or sharp and focused?[96] The figure's frontal pose causes him to walk directly towards us, uncomfortably reminiscent of those medieval and Renaissance images of skeletons that proclaim 'I was once as you are now, and what I now am, you shall become.' The old man may be frail, foolish, ridiculously 'twice a child'; his last steps are as tottering, as needy of support, as were his first. But he is 'still learning' – perhaps, as the artist and critic Tom Lubbock suggests, only 'learning to dodder'.[97] Yet I think that is not Goya's message. He is more likely to be referring ironically to one of the various forms of lunacy recorded (or imagined) on many of this album's pages: an 'old man mad with drawing',[98] still learning his craft. *Nulla dies sine linea*, however shaky the old artist's hand.

To illustrate a humorous newspaper item about the difficulties of learning to ski, as an adult given to 'wobbling, jiggling, jerking and shaking', the cartoonist Paige wittily updates Agostino Veneziano's image (fig. 92).[99] Calling attention to the absurdity of the grown man on a NURSERY SLOPE, and pointing out the affinity between the modern Zimmer frame and the baby walker, Paige succeeds in conveying in a comic key the messages of the orginal: *Ancora imparo* and *Bis pueri senes*. But, perhaps unwittingly, the depiction of a 'downward slope' also implies a melancholy awareness of the ineluctable course of life towards the grave.

Other motifs in the imagery of childhood are as persistent as the baby-walker, but perhaps none is more protean. Representing a familiar object in use since Antiquity – with only one decisive change in structure, from the frontal *sustentaculum* to the body-enclosing walking frame – it signifies the moment when a child has learnt to walk upright, that is, has become truly human, differentiated, as the crawling infant is not, from quadruped animals (although maintaining an affinity with kids and goats, dogs and monkeys). By alluding to learning and practice more generally, the image of the baby-walker may stand for discipline, the way to acquire mastery over oneself and the mastery of an art; but it also signals the natural infirmity of the human race. The nature of the child is revealed as human nature *tout court*, for we are all children of God, and childhood's unsteady steps symbolise mankind's need of divine guidance and support. Finally, the walking aid that sustains our faltering First Steps may support our doddering last ones: *bis pueri senes*. Erasmus's Folly boasts of her power to 'recall people who are on the brink of the grave . . . to childhood once again', affirming that 'except for the old man's wrinkles and the number of birthdays he has counted' the aged and toddlers 'are exactly alike: white hair, toothless mouth, short stature, liking for milk, babbling, chattering, absurdity, forgetfulness, thoughtlessness, everything in fact.'[100] Yet the old person in the baby-walker, still learning, seeking a goal that is forever out of reach, may be a heroic figure as well as a foolish one.

CHAPTER 6

'Better to keep still': Playful childhood and adult laughter

Timareta, the daughter of Timaretus, before her wedding, hath dedicated to thee, Artemis of the Lake, her tambourine and her pretty ball, and the net that kept up her hair, and her dolls, too, and their dresses; a virgin's gift, as is fit, to virgin Diana.[1] But, daughter of Leto, hold thy hand over the girl, and purely keep her in her purity.

<div align="right">Anonymous</div>

To Hermes, Philocles here hangs up these toys of his boyhood: his noiseless ball, this lively boxwood rattle, his knucklebones he had such a mania for, and his spinning top.

<div align="right">Leonidas of Tarentum[2]</div>

As they came of age, boys and girls in ancient Greece dedicated their favoured childhood toys to *kourotrophic* deities such as the virgin Artemis, at whose shrines girls celebrated premarital rites, or Hermes, patron of the gymnasium and inventor of the spinning top.[3] Toys, as well as more ambiguous objects that could have been either playthings, protective amulets or votive figurines, have been found in Mediterranean sanctuaries and children's tombs dating from as long ago as 5000 BC.[4] Ancient Greeks even personified play itself, *Paidia*, as a playful young girl,[5] but the concept's kinship with 'child', *pais*, was already enshrined in the language.

Although in actuality countless children have worked for their living, European culture has consistently identified childhood or *pueritia* – the stage of life that follows infancy and the First Steps[6] – with toys and play. In this late fifteenth-century woodcut illustrating a seven-fold scheme of the Ages of Man (fig. 93),[7] for example, the

93 *The Ages of Man*, from Bartholomeus Anglicus, *Proprietaire des Choses*, Lyon, 1482

Zehen Jahr ein Kindt.
Exultat leüitate puer nullaq; moratur,
Sede diû, lusu deditus vtq; suo.

94 Nikolaus Solis, *Childhood*,
from David de Necker, *Ain
Newes . . . Stamme oder Gesellen
Büchlein*, Vienna, 1579

swaddled infant lies immobile in its cradle while the exuberant *puer*, mounted on a
hobby-horse and holding a whirligig like a lance, charges at the toddler in his baby
walker. Behind them, the soberly gowned schoolboy turns to hear the gallant youth,
and the mature man converses gravely with the old man counting his beads.

Ages of Man imagery, and the visual arts more generally, show little regard for the
actual duration of playful childhood: *pueri* may be assigned a precise though arbitrary
age, such as ten, but they are also often depicted as *putti* or 'miniature adults' of
indeterminate years. More than by actual age, artists define *pueritia* by its ceaseless
playfulness and mobility, and a concomitant emotional volatility – qualities wittily
summarised by the German printmaker Nikolaus Solis in this 1579 emblem (fig. 94).[8]
The '*Zehen Jahr ein Kindt*', 'Ten Years, a Child', capers in step with his companion ani-
mal the kid or billy goat; it is the latter who holds the whirligig, since the child's hands
are busied with his hobby-horse and a fluttering pet bird. Tops and a whip lie on the
ground. The extended Latin caption specifies:

> The *puer* rejoices in fickleness; he doesn't keep still for long anywhere, so much is he
> absorbed in his play.

Some sixteen years earlier, Guillaume de la Perrière, author of the first emblem book
written in French, had made fickleness – a whirligig that turns with every breeze –

Playful Childhood and Adult Laughter **139**

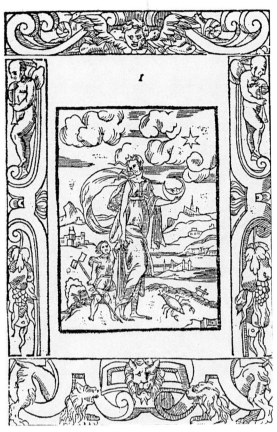

95 Emblem I, *L'Enfance*, G. de la Perrière, *La Morosophie*, Lyon, 1553

96 *Boy with Drawing*, attr. to Giovanni Francesco Caroto (1480–1555), Verona, Museo Civico

the main attribute of *Enfance* in his second, bilingual Latin and French collection of emblems, *La Morosophie* (fig. 95).[9] Like Quarles,[10] la Perrière conflated the first ten years of life in a scheme of seven 'planetary' Ages of Man, and placed them under the influence of the moon. This French moon, however, is not 'torpid' like that of the English writer; though humid, she is 'mobile' and 'wandering', and the 'inconstant age' of childhood follows her with tottering steps. The title, *La Morosophie* or 'Foolish Wisdom', was coined by la Perrière to stress the wit of his inventions, and with an eye to Erasmus's original title of his seminal text, *Praise of Folly*, *Encomium Moriae*, defended by its author on the grounds that

> truth finds a way into the minds of men more agreeably, and with less danger of giving offence, by favour of these pleasantries.[11]

Neither Erasmus nor la Perrière defined 'pleasantries' as images of children, yet laughter, in all its shades of meaning from delight to derision, seems to be the response most consistently evoked by depictions of playful *pueritia*; not least because, in those periods when art strove for maximum expressivity, it was noted that 'fickle' children laugh more freely than adults (fig. 96).[12] I shall return to this point in the next chapter.

While laughter has been a topic of scholarly interest since Antiquity, laughter in the visual arts has only recently begun to attract serious attention, for, to paraphrase one author, the subject is 'no laughing matter'.[13] To the core difficulty identified by the first-century Roman rhetoretician Quintilian –

> I do not think that anybody can give an adequate explanation, though many have attempted to do so, of the cause of laughter, which is excited not merely by words or deeds, but sometimes even by touch[14]

– must be added the natural ambiguity of images[15] and our propensity to find cause for laughter, even where none is intended, in unfamiliar artistic styles. Without straying into this ungrateful topic for its own sake, however, I shall in this chapter attempt to assess the causes and types of laughter elicited by some of the copious representations of playful children in Graeco-Roman, late medieval and Renaissance art,[16] how in the seventeenth century similar images were used as emblems to deride universal human folly (rather than mocking only a section of the population, such as the old in their 'second childhood'), and whether this emblematic mode can be read back into that notoriously enigmatic sixteenth-century work, Pieter Bruegel's *Children's Games*.

In his history of ancient painting, Pliny refers to comical pictures designed with lively wit; unfortunately for my argument, the subjects he cites do not include children,[17] but the reference confirms that in Antiquity visual images could be deliberately used to provoke laughter.

Although not systematically illustrating schemata of the Ages of Man, Greek art, notably on the miniature *choes* associated with the festival of the Anthesteria,[18] frequently depicted evolving stages of children's play, with emphasis on physical movement. In addition to crawling and toddling babies, the little jugs were decorated with pictures of slightly older boys, and sometimes girls, wheeling toy rollers or wagons; they dash about chasing birds (fig. 97)[19] or run carrying large cakes. Less realistically, but with reference to the presiding deity of the festival, Dionysos, boys may be pictured riding fawns or driving chariots drawn by galloping goats.[20]

The *choes* are said to have been made for children themselves; they would nevertheless have had to attract adult buyers, and a large part of their appeal must have been their painted decoration's 'cuteness' factor, the charm that elicits a smile or a laugh.

A crawling baby would probably have evoked greater tenderness, but the little girl who rushes through Figure 97 brandishing her toy roller at a very still large bird, would almost certainly have seemed even more comical originally than she does today. Her top knot, long chiton, and the *himation* or mantle draped over it, were the sober outdoor dress of

97 *Girl With Toy Roller chasing Bird*, Attic red-figure *chous*, c.420 BC, Worcester, Massachusetts, Worcester Art Museum

women, worn by little girls on festive occasions. But her actions simultaneously abandon any pretence at adult decorum and ungender her: she may aspire to womanhood, but she behaves like a child too young to be aware of her sexual identity. Laughter is evoked by the interaction of the giddy human child with the imperturbable bird, but in large part also by the contrast between the child and her implicit adult role model.

Usually less overtly comical, but always radiating the charm that raises indulgent smiles, other kinds of vase paintings and numerous statuettes depict girls and boys playing *ephedrismos*, a game combining blindman's buff and riding piggy back; tossing knucklebones; throwing balls, or spinning tops. Rolling hoops was a prerogative of pre-adolescent boys, and identifies Ganymede pursued by the amorous Zeus.[21] Cockfights occasion the show of both joy and tears in a single image, a realistic manner of depicting childhood's emotional 'fickleness'.[22] Roman sarcophagi continue the tradition, portraying boys riding goat-drawn chariots, as in Figure 53, and taking part in chariot races; *putti*, boys and girls bowl hoops and play throwing games with nuts and balls.[23]

Children in ancient art will be children; their natural playfulness amuses adult viewers, but it does not reflect ridicule on their adult role models; much less illustrate universal human folly.[24] If they live, then – like Timareta and Philocles – they will grow up and put away childish things. Although in literary texts a grown-up occasionally evokes mirth by playing like a child among children, ancient Greek and Roman art does not generally mock adults for being childish, but for departing from the idealising canons of society and aesthetics. From the fourth century BC, under the influence of a new, naturalistic form of theatre, ugly, old, fat, deformed, drunk, visibly foreign and/or slave adults appear as stock comic characters in Greek painting and sculpture.[25] Laughter at such representations of 'the other' may be sanctioned by Aristotle, but it reminds us of cruelties we wish we had outgrown.[26]

The situation changes as we fast-forward from Antiquity to the later Middle Ages and the Renaissance.

A Greek vase painting, reproduced in a work of reference in 1904, when it was said to be in a Berlin museum, represents a boy riding his hobby-horse (fig. 98),[27] a toy mentioned in ancient literary sources yet rarely pictured in Graeco-Roman art; according to a Roman historian, Socrates himself was surprised straddling a reed horse while playing with a group of children. By the fifteenth century, however, the hobby- or cockhorse, with or without whirligig lance, had become accepted throughout Europe as the signifier *par excellence* of *pueritia*.[28]

The frequency with which it was depicted in the arts surely reflects its actual popularity until the 1700s, when the democratic reed or stick horse, that cost nothing and could be ridden anywhere by any child, began to lose ground to the more elaborate indoor rocking horse.[29] It is easy to understand, as E.H. Gombrich once wrote, 'how the horse could become such a focus of desires and aspirations, for our language still carries the metaphors moulded by a feudal past when to be chival-rous was to be horsy.'[30]

By the mid-1400s, hobby-horses with carved heads gallop even above the altar: sometimes ridden by the child Jesus or his cousins,[31] but also by thoughtless boys in the crowd escorting Christ to Golgotha, as in a German altarpiece of 1445.[32] In the latter context, childish playfulness is no longer morally neutral, although – like the sadistic comedy of medieval Passion plays – it may evoke laughter. Its full significance

PSALTES contra Iudæos excandefcit, ac eos qui CHRISTVM Meffiam Deum in lege promiffum infideliter, & impié abnegant, infipientes uocat.

PSAL. LII.

Folz font ceux là (comme efcrit le Pfalmifte),
Qui en leurs cueurs dient que Iefus Chrift
N'eft Meßias, Dauid tant f'en contrifte,
Qu'en plufieurs lieux encontre iceux efcrit.

98 Reproduction of Greek vase painting, *Boy riding a Cane Horse*, from C. Daremberg, E. Saglio, E. Pottier, *Dictionnaire des antiquités grecques et romaines*, Paris, 1904

99 Hans Holbein the Younger, *The Godless Fool*, Psalm 53 (titled LII), *Historia veteris Testamenti Icones*, Lyon, 1538, no. 69

is revealed in a crude woodcut that first appeared as an illustration to Psalm 52 (53 in the Authorized Version) in an Italian-language Bible published in 1490.[33] Re-used by the publisher in 1511 in a (Latin) Vulgate Bible, the image inspired Hans Holbein's infinitely more accomplished version, one of the artist's set of emblematic 'icons' of the Old Testament, first printed in 1538 (fig. 99).[34] Psalm 52 opens with the phrase, 'The fool hath said in his heart, There is no God'; the prints depict the 'godless fool', in the semblance of what was then called the 'natural fool' – that is, a mentally ill or deficient person – in contrast to the professional fool or jester. 'Natural fools' had long been pictured as 'savages', barefoot (or, as here, with one shoe off and one shoe on), in short or ragged tunics with feathers in their hair; it is in this guise that Giotto personifies *Stultitia*, Folly, in the Arena Chapel in Padua, *c*.1304–13, despite the unwritten rule that Latin abstract nouns, being feminine, are depicted as women. The Psalmist's words and Holbein's print are glossed by texts in Latin and French, explaining that the fools are those who in their hearts deny Jesus Christ's Messianic divinity; these include the Jews.

 The prints' 'godless fools' are twice identified with playful *pueritia*. The fool rides a cockhorse and carries an exceptionally long whirligig; like the pitiful village idiot of not-so-long-ago, he is surrounded by jeering children. Holbein introduces an

100 Israhel van Meckenem, *Children at Play*

imaginative variant: his fool straddles the stick horse sideways, so that one of the chil-
dren stumbles over it: Folly trips up the 'firm steps' learned in toddlerhood.

By the late fifteenth century, though woodcut relief prints such as Figure 99 were
also used to adorn printed books, single-sheet woodcuts, and more especially costlier
metal intaglio engravings, had evolved into collectors' commodities. Paradoxically,
the hobby-horse made its first appearance in this medium largely because of ancient
Graeco-Roman art, which, though sparing in reed horses, swarmed with frolicking
putti. Rather than a novel *sentiment de l'enfance*, it must have been the new fashion for
antique motifs that *c.*1475 motivated Israhel van Meckenem, German goldsmith, pio-
neer engraver and print entrepreneur, to issue paired engravings of *The Children's Bath*
and *Children at Play* (fig. 100).[35] His nude *putti* at their 'modern' games cleverly strad-
dle *all'antica* artifice and mundane realism; at a time when religious subjects still dom-
inated the arts, the allusion to the traditional theme of the Ages of Man must have
made these innovative, light-hearted secular images more acceptable. In Figure 100 it
is the hobby-horse rider who catches the viewer's eye, for *pueritia*'s playfulness is
meant to be infectious.

Like many of Israhel's engravings, the prints have elaborate banderoles looping
above the figures, left blank for the eventual owner to inscribe; as a modern com-
mentator observes, these 'may serve as an invitation to interpret, to provide a witty

84 FLORENTII SCHOONHOVII

Semper pueri.

EMBLEMA XXVII.

Rixantur pueri, ſi quis lapideſve nuceſve
Auferat, & ſemper vilia quæque ſtupent;
Nos etiam pueri, qui, donec vita ſuperſtes,
Propter opes luteas digladiamur humi.

COMMENTARIVS.

VEriſſimè Seneca inquit, Non bis pueri ſumus, ut vu
dicitur, ſed ſemper, verū hoc intereſt quòd majora ɪ
ludimus.Majora? immò minus ferenda.Quis enim ɟ
juventam, graveſque annos, tantam animi cœcitatɕ
& dementiam,quantam circumferimus, in nobis toleret? Q
non naturæ monſtra, pueros cum rugis, & canis, nos appel
Puɕ

101 *Semper pueri*, Florentius Schoonhovius, *Emblemata, partim Moralia partim etiam Civilia*, Gouda, 1618, emblem XXVII

aphorism for the subject; in this sense, they represent an artist's ploy to engage the ingenuity of his client in playing at inventing a subject.'[36] Moral judgment is left to the prints' owner. While a hobby-horse on the road to Calvary, or ridden by the godless fool, directs viewers to meditate on their own heedless collusion in Christ's Passion, Israhel's secular prints draw adult viewers into a playful world parallel to that of the irresponsible children it portrays.

When in 1522 Andrea Alciati composed the first emblem book, assorting motto, image and text,[37] he was in effect making public his own version of the game first proposed by the likes of Israhel van Meckenem – and its resemblance to children's play did not escape him. His dedicatory emblem to the erudite Augsburg archivist Conrad Peutinger, student of Roman inscriptions, compares inventing emblems to children playing with nuts and other toys, in allusion to the proverb *Ad nuces redire*, 'to return to one's nuts, that is, childish games'.[38]

By the seventeenth century, Dutch emblem books, in the spirit of Erasmus's 'truth finds a way into the minds of men more agreeably . . . by favour of these pleasantries', regularly derided adult mores by equating them with realistically depicted contemporary children's games. In homage to Alciati, I first reproduce emblem 27 of Florentius Schoonhovius's *Emblems, partly Ethical and partly also Popular*, published in Gouda in 1618 (fig. 101).[39] The motto, *Semper pueri*, 'always children', is expanded in

Beter ſtil geſtaen.

102　*Beter stil gestaen*, Emblem xxi, Roemer Visscher,
Sinnepoppen, Amsterdam, 1614

the commentary: 'Truly Seneca said, we are not children twice, but always'. The poem informs us that 'boys fight if someone takes away their stones or nuts, and are dazzled by things of no value; we are also children, struggling fiercely throughout our lives on account of our filthy wealth.' In other words, children's toys are worthless when compared to the treasures prized by adults, but material possessions are in turn childish trifles when set against the salvation or damnation of our souls, and our materialism makes us as absurd as squabbling children.

The Amsterdam poet Roemer Visscher includes the image of a boy rolling a hoop in emblem 21 of his *Sinnepoppen* of 1614 (fig. 102).[40] (The title of the book, literally 'Dolls of the Spirit', itself draws a parallel between emblematics and children's play.) The motto reads, *Beter stil gestaen*, 'Better to keep still', and the text below cites Pliny: 'It is better to remain quiet than to act to no purpose.'[41] The children's game, that reflects the cycle of existence in the endlessly rolling hoop,[42] is an example of futility, to which adult preoccupations, such as a baronial estate, music or the hunt, are compared.

But images, as I have stressed, are ambiguous, and lend themselves to a wide range of verbal commentary. Long after Visscher's emblems had become familiar, the Amsterdam playwright, poet and town glazier Jan Vos (1611–67) wrote an epigram, 'When Maria Vos, my little daughter, together with other children, was playing with the hoop':

> My daughter hits the hoop, when struck it will rotate:
> She finds no end, but runs, till panting ends her cheering.
> A child will through a hoop eternity indicate.
> The eternal may be gained by sweat and persevering.[43]

The imaginary picture this glosses is entirely similar to that of Visscher's emblem, except that the child with the hoop is a girl. Both authors purport to view human behaviour *sub specie aeternitatis*, and both play on the ancient association of the closed circle with eternity (the 'eternal return'). Yet Vos, perhaps because of its personal association with little Maria, finds in the children's game a meaning contrary to Visscher's.

In place of futile exertion, he sees exemplary effort: only through 'sweat and perseverance' may we gain eternity.

Despite the labile significance of most other toys – witness the earnest emblematic readings of the top, discussed in the previous chapter[44] – *Pueritia*'s hobby-horse generally retained the association with folly it had originally acquired in religious imagery; secular emblem books throughout Europe were not slow in exploiting it.

Figure 103 reproduces emblem 81 in *A Choice of Emblemes* by Geffrey Whitney (d.1601); published in 1586, this was the first English emblem book on the Continental model, printed at the Plantin press in Leiden. Despite its author's promise of 'dooble delight', it never achieved the lasting popularity of Quarles's more misanthropic later publications.[45]

As Whitney himself admitted, his emblems had been 'for the moste parte gathered out of sundrie writers'; emblem 81 had originally appeared in Plantin's 1564 edition of *Emblemata* by the Hungarian physician and historian, Johannes Sambucus.

Under the motto *Fatuis levia committo*, 'entrust fools (only) with trifles', the image shows four personages in a palace interior: a crowned and sceptred king; a naked *puer* astride his cockhorse; a gentleman in a petitioner's pose, and a hooded fool in short tunic, holding a club. Whitney's English verse cautions 'fondlings', that is, foolish persons, against seeking unmerited preferment. It begins by comparing the 'idiot', a 'natural fool', with the *puer*:

103 *Fatuis levia comitito*, 'entrust trifles to fools', emblem 81, Geoffrey Whitney, *A Choice of Emblemes, and other devises*, Leyden, 1586

> The little childe, is pleas'de with cockhorse gaie,
> Althoughe he aske a courser of the beste:
> The ideot likes, with ba[u]bles for to plaie,
> And is disgrac'de, when he is bravelie dreste:
> A motley coat, a cockescombe, or a bell,
> Hee better likes, then jewelles that excel.
> So fondelings vaine, that doe for honor sue,
> And seeke for roomes, that worthie men deserve:
> The prudent Prince, dothe give hem ofte their due,
> Which is fair wordes, that right their humors serve:
> For infantes hand, the rasor is unfitte,
> And fooles unmeete, in wisedomes seat to sitte.

104 After Tobias Stimmer, *Ten-year-old girl, Twenty-year-old maiden*, from *Ten Ages of Woman*, Strasburg, probably 1570s, Andresen, III, p. 39

Whitney seems to be equating folly with unwarranted ambition, wisdom with 'knowing one's place' and not being taken in by fair words. A not dissimilar notion is later expressed by the most popular Dutch author of the seventeenth century, Jacob Cats (1577–1660), in his handbook of domestic life, *Houwelijk*, 'Marriage', first published in 1625. Verses of the proem, *Kinder-spel* or 'Child's play', denounce the folly of self-delusion: the child thinks he rides a brave horse, but he who considers well finds there is only a piece of wood and nothing else.[46]

A modern reader will have become acutely aware of a glaring absence in these visual images of 'playful childhood': though the poet Vos writes of his little daughter, the artists depict the playfully mobile child as a boy. This is especially obvious in Figure 93, which illustrates all seven Ages; the scheme is enlivened by being represented as an extended family in a domestic interior, but the device makes the absence of women and girls only more noticeable. We rapidly realise why the canonical image of *pueritia* is male when both sexes are pictured, as in Abraham Bach's 1660 print of the Ages of Man, Figure 81. Bach's male and female partners may be inseparable as they ascend and descend life's staircase, but while the ten-year-old boy holds the reins of a half-hidden hobby-horse, his girl companion clutches a doll.

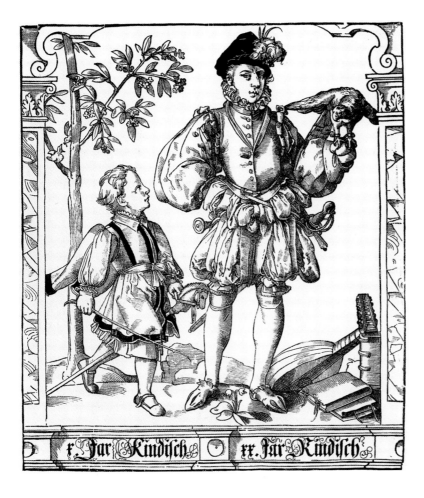

105 After Tobias Stimmer, *Ten-year-old boy*, *Twenty-year-old youth*, from *Ten Ages of Man*, Strasburg, probably 1570s, Andresen, III, p. 40

As we know, e.g. from Vos, girls were never actually disbarred from active games, but when visual images must perforce distinguish *puellae*, 'girls', from *pueri* – the collective noun meaning both 'children' and 'boys', and the root of the more abstract *pueritia*, 'childhood'[47] – their attributes are seen to diverge at this playful Age.

No one has shown this more poetically than Nikolaus Solis's contemporary, the inventive German print designer Tobias Stimmer, in two parallel but separate series of the ten Ages of Man and of Woman (figs. 104, 105).[48] For Stimmer as for Solis, to be a child is to be ten years old; life is lived in multiples of ten, and death comes at one hundred. Each series consists of five woodcuts; every print shows two Ages: the ten-year-old boy is paired with the twenty-year-old youth, the ten-year-old girl with the twenty-year-old maiden.

While the boy rides his hobby-horse, the girl sits pensively holding a basket of flowers and cradling her doll, play that rehearses European society's most highly gendered adult stereotypes: the fearless cavalier and the nurturing mother.[49]

The utility of play as a preparation for adult life has always been recognised – even Plato wrote that future builders 'should play at building toy houses', and recommended playful riding lessons for future soldiers[50] – but the asymmetry perceived

between 'child's play' and 'man's work' is one of the reasons why children at their games arouse adult laughter. At the same time, laughter can reflect from the child onto its adult role model, not only because adult activities appear, as in Dutch emblems, childishly foolish *sub specie aeternitatis*, but also when they seem to mirror children's play too closely, in restlessness or inconclusiveness. For this reason, and despite the misogyny of which European culture stands accused, stereotypically male occupations are more likely to arouse laughter than female ones.

Something of this kind seems to be at work in Stimmer's first and second Ages of Man. The boy looks up, literally and metaphorically, to the fashionable youth, apparelled with sword and dagger, hunting hawk, a lute to accompany love songs, and books. In the flowering tree behind the child, a gaping-mouthed chick awaits the worm brought by the adult bird. The ten-year-old's candid admiration throws into relief the swagger of the twenty-year old, and the child's sham horse casts doubt on the real value of the youth's many and varied attributes. Both are still playing; as the captions uncompromisingly state, 'X years childish', 'XX years childish'.

The Ages of Woman do not seem to evoke laughter in a similar way. Only flowers – in wreaths and basket, growing underfoot and in the thorny rose bush of the background – connect the 'X years, of the childish sort' to the 'XX years, a fine maiden'. Behind the fiddler, birds are courting or mating. Her back turned on her companion, the child with her doll and doll's-house furniture is facing the thirty-year-old 'lady in the house' of the next print, who carries a toddler on her arm, and a bunch of keys and purse on her belt. (The latter's partner, a forty-year-old 'punctilious matron', holds a lap-dog.) The five prints of the Ages of Woman range from the dreamy to the dramatic: in the last, the toothless ninety-year-old, 'a picture of martyrdom', bends down tenderly to her great-granddaughter, who is showing her her doll. The hundred-year-old rises from her pillow in her mortal agony; skeletal Death runs up behind her to thrust an hour-glass before her face, and set fire to the withered rose bush. In an extraordinary punning image, Death's skull is encased in a retort, the chemist's glass vessel, with round bulb and bent-down tapering neck, used in the process of distillation: the woman is literally, in the caption's words, 'precipitated into the grave'.

But perhaps it is not so much respect for motherhood as the absence of the cock-horse that deflects laughter from the Ages of Woman.

Images that actually juxtapose children or *putti* riding hobby-horses with adult cavaliers are among the most perplexing in art. They are almost certainly intended to arouse laughter, but of what kind, and directed at whom?

Perhaps the most unexpected of such images is number 46 of the 137 woodcuts that constitute the *Triumph of Maximilian I*, 'one of the world's richest and most unusual monuments of art' (fig. 106).[51] The German Emperor Maximilian I (1459–1519), reviled by some for the long wars that depleted his empire's treasury, is praised by posterity for his artistic patronage – and particularly for the use he made of woodcuts to disseminate the fame of his Habsburg dynasty, and his own renown as 'the last of the knights'. Of the many works in woodcut he commissioned from the greatest German artists, three illustrated books and two series of printed sheets stand out: an allegorical autobiography, the *Weisskunig* or 'White King'; the *Theuerdank* or 'Knight of Adventurous Thoughts', a long poem about Maximilian's youth and courtship of his

106 Hans Burgkmair, *The German 'Gestech'*, woocut 46 in *The Triumph of Maximilian I*, designed before 1519; 1st edn 1526

beloved first wife, Mary of Burgundy; the *Freydal*, an account of the tournaments and masquerades in which he participated during his happy days in Burgundy; the *Ehrenpforte* or Triumphal Arch (of which the great Albrecht Dürer was general artistic director), a paper edifice composed of 92 separate sheets that, mounted together, would have towered at over ten feet, and – grandest of all, though never completed in the Emperor's lifetime – the *Triumph*, to be executed in miniatures on vellum for Maximilian's own collection, and in woodcuts for publication.

Based on the Emperor's own descriptions of this imaginary event, and celebrating his own pleasures and achievements, Maximilian's *Triumph* translated into contemporary idiom a complex institution, that had originated in ancient Rome in the victory parades granted by the senate to successful generals. In the Middle Ages, ceremonial 'triumphal entries' of illustrious men functioned as secular complements to religious processions. The Italian fourteenth-century humanist Petrarch popularised an allegorical interpretation, in a poetic cycle in which Love, personified as Cupid standing on his triumphal car shooting arrows at followers and bystanders, is defeated by the triumph of Chastity, in turn vanquished by Death, Fame, Time and Eternity. Suitably altered to take account of modern preoccupations, the triumph remains with us today in the form of festive or celebratory parades of decorated floats.

Illustrations to Petrarch's *Trionfi* reintroduced the motif of the triumph *all'antica* into the visual arts; Mantegna's nine large tempera paintings of the *Triumph of Julius Caesar*, based on textual accounts and on the visual evidence of Roman sculptural remains, was its most lavish interpretation. Completed in 1492 for the princely Gonzaga court in Mantua (and now in the royal collections at Hampton Court) this cycle, almost certainly known to Maximilian and/or his artists, is the direct inspiration for the Emperor's small-scale but more extensive, and of course more personal, virtual version.

Maximilian's *Triumph* may have been imaginary, but there was nothing imaginary about the courtiers and servants – his real huntsmen, musicians, jesters and 'natural fools', knights and soldiers, baggage handlers and exotic subjects – who process through these prints, on floats, on foot or horseback, wearing real costumes and real armour, carrying real musical instruments or weapons, with real coats of arms and other heraldic devices. Maximilian dictated the text to his secretary in 1512; from these, an architect and designer, Jörg Kölderer, prepared rough sketches. The commissions for the woodcut designs were given to artists in Nuremberg and Augsburg.

The leading painter and draughtsman in Augsburg, and the most wholehearted in Maximilian's service, was Hans Burgkmair (1473–1531). He drew 66 of the 137 woodcuts of the *Triumph*, including number 46, the *German Gestech*: a type of jousting using lances with three hooks (coronals) at their tips. Its object was to unhorse one's opponent – in contrast to the *Italian Gestech* that precedes it in the *Triumph*, in which the combatants tilted at each other from opposite sides of a low barrier, each man's object being to splinter his lance on his opponent's shield.

Maximilian intended the four prints of knights in jousting armour, each *Gestech* shown 'five abreast in good order', to be preceded by a woodcut of 'Herr Wolfgang von Polhaim . . . [whose] verse shall read thus: How knightly sports are nowhere in the world performed in such variety as he has caused them to be at court by order of the Emperor.' The actual inscription on the print translates as:

> Always promising new advances
> In jousting with hooked or pointed lances,
> Thanks to His Highness, I unfurled
> Skills never seen in all the world.
> These jousts in novel styles and ways
> Have earned for me great fame and praise.

The Emperor's text concludes, 'The participants in the *Gestech* shall bear their lances over their heads and grasp the lances beneath the round guards. The participants in the *Gestech* shall all wear laurel wreaths on their helmets and each shall have a crest on his helmet.'

A winged *putto* riding a hobby-horse, charging with whirligig lance at an unseen opponent, decorates the caparisoned croup of the horse nearest the viewer of the *German Gestech* in Figure 106; its forequarters are ornamented with a banderole enlacing two crossed whirligigs. A fourth whirligig forms the crest on the knight's helmet.

What is the significance of these devices, in prints so close to the Emperor's heart, and so faithful to the words of his prescriptive text (note the lances grasped 'beneath the round guards')?

In the circumstances, it is unthinkable that Burgkmair, an artist favoured by Maximilian, added the *putto* with cockhorse and whirligig in order to deride the *Teutsch Gestech*. It is, conversely, entirely probable that he based his design on the actual jousting armour of one of the Emperor's knights.

Between 1516, when Burgkmair is presumed to have designed the prints, and 1519 when work on the *Triumph* was stopped by Maximilian's death, Holbein's woodcut of the 'godless fool' had not yet been published, much less acquired its subsequent fame and influence. Alciati did not write his emblem book until 1522. The association of *pueritia*'s hobby-horse and whirligig with adult folly is not likely to have spread far beyond its original context in religious imagery. In the very different world of heraldry, the decorative motif of playful *putti* at their childish game of 'knightly jousting' would have raised a laugh, but not one deriding the adults being mimicked.

Lacking contemporary textual evidence, we can only speculate on the precise character of that laugh. Jousts were games of skill and strength, they entailed real dangers, but were themselves, or had been until recently, only rehearsals for 'real' war. Probably what the German knight's heraldry intended was a gallant and light-hearted equation: 'jousting is to war as child's play is to jousting'.[52]

A miniature in a Flemish manuscript, now in the British Library, also juxtaposes adult jousters and playful children seemingly mimicking them (fig. 107).[53] The manuscript is one of several early sixteenth-century Books of Hours, breviaries and prayer-books produced, mainly for now unknown patrons, in the workshops of Simon Bening in Bruges and Gerard Horenbout in Ghent; their calendar pages illustrate adult occupations of the months, with a wide variety of children's games depicted in the margins. In this manuscript, the month of June is devoted to a tournament. Two types of combat appear to be taking place simultaneously in a specially apparelled town square, with spectators standing behind a barrier, or seated on bleachers, and the VIPs on a platform under an awning: two knights ride on either side of a low fence in what looks like an Italian *Gestech*; another two, kept in line by the lances of unarmed men on foot, hack at each other with swords. The ground beneath them is strewn with broken lances. A trumpet blows; other knights await their turn.

Stages of Childhood

As on the other calendar pages in this manuscript, the 'real' scene is viewed through an opening in fanciful part-Gothic, part-antique architecture; a strip at the foot of the picture shows the complementary children's game. Although presented as live little boys in contemporary dress, the playful *pueri* are painted in monochrome – sometimes in stony shades of grey or white, at other times, as here, in the metallic colour of the architectonic ornaments. They cast shadows on the supposed back wall of the illusionistic shallow niche that contains them.

Were this the only miniature of its kind, we might suspect that the marginal image of the children's game was indeed intended to parody and mock the knightly tourney. But that is almost certainly not the case. The adult occupations for the month of June vary; hay making or sheep shearing are depicted more frequently than jousting, yet whatever the adult activity in the principal scene, in four out of the five manuscripts in this group the children's game depicted in June's margin is the same. Cockhorse and whirligig jousts are the most frequently represented of the seven childhood pastimes, such as bird trapping, archery, marbles, associated with this month in other manuscripts.

As we might expect, children play with snowballs and sledges in the winter months; but it appears that all their games follow their own specialised calendar,[54] only rarely and coincidentally reflecting the adult activities in the main scenes. The adult tourney in this miniature may have been substituted for a more usual June occupation at the express wish of a patron. It is simply the children's hobby-horse joust, not the adult pastime, which, like all children's games, is meant to raise a smile.

The relationship between the text, the main illustrations, and the 'drolleries' in the margins of illuminated manuscripts has long been a matter of speculation and contention. The most recent research, however, suggests that the laughter-inducing little marginal scenes of peasant life, animal fables and children's games seldom correspond in any sense – amplificatory, subversive, oblique or otherwise – to either the text or its principal illustrations.[55] The most convincing view is that they offered pleasurable light relief from the main devotional or epic burden of the text – an occasional invitation to adult readers/viewers to refresh themselves with play without lifting their eyes from their book.

The floods of ink spilled over manuscript marginalia are but a trickle compared to the torrents washing over Pieter Bruegel's *Children's Games*, now in Vienna (fig. 108).[56] Painted in 1560, it was recorded in 1594 under the same title, *Kinderspill*, in the collection at Brussels of the Archduke Ernst of Austria, Governor of the Netherlands. In 1604 it was described as a picture 'with all manner of children's little games';[57] modern authors who also view it as a visual encyclopedia of '*kinderspelletjes*' have identified between fifty-eight and ninety-one different ones.[58]

There can thus be little doubt as to the overt subject of Bruegel's painting. Much as humanist scholars of the time listed and defined children's games, and educators recommended them as bodily restoratives,[59] so Breugel painted them, vividly capturing the gestures and attitudes appropriate to each, and the social interactions to which

107 *June*, miniature, 'Golf-book', Add. MS. 24098, British Library, f. 23v.

they give rise. Not all the games are strictly classifiable, and some are certainly paro-dic: facing the boy riding a hobby horse in the centre foreground, for example, two housewifely little girls bend over a neat round of excrement, one solemnly stirring it with a stick. This episode cannot be said, however, to provide a key to the painting as a whole, which noticeably lacks any visual or narrative focus, or even a resting point. Yet few scholars of Netherlandish art have refrained from interpreting *Children's Games* as a single, unified image. It has been said to represent *Infantia* (*Pueritia* would have been more accurate) in a never-completed scheme of the Ages of Man; Spring or Summer among the seasons of the year. Some have viewed it as an allegory of the first Age of the World, others as a depiction of adults in the guise of children, still others as an emblem of human folly, a catalogue of specific vices amounting to folly, or the folly of marriage, in the context of a Midsummer Eve's celebration.[60]

Yet, as the art historian W.S. Gibson has recently reminded us, there is one dimension that has been neglected by these learned, observant and inventive authors, but which was readily apparent to Bruegel's early critics. Karel Van Mander (1548–1606), writing a generation after the artist's death in 1569, observed that there are few of his works the spectator 'can contemplate seriously and without laughing, and however straight-faced and stately he may be, he has at least to twitch his mouth or smile'.[61]

Nicknamed 'Droll Piet', Bruegel nonetheless cannot be identified with the rollick-ing peasants depicted in his most famous paintings; he was in fact an exceptionally sophisticated artist, employed by the foremost print publisher, Hieronymus Cock, in the cosmopolitan city of Antwerp, accepted in intellectual circles, and enjoying the patronage of an international elite. He travelled through France and Italy, and either directly or through engravings was familiar with the work of the leading Northern European and Italian artists. He designed prints in the style of Hieronymus Bosch, and was in his own right a painter of panoramic views and encyclopaedic themes. Bruegel's earlier paintings of *Netherlandish Proverbs* and *The Battle between Carnival and Lent* are as teeming with figures as his *Children's Games*. He would go on to depict landscapes with the Occupations of the Months, scenes of peasant celebrations, reli-gious narratives, allegories and parables. Although when working on the painting in 1560 he could not have seen seventeenth-century emblem books, he would have been fully aware of all the artistic and literary contexts in which playful childhood had been depicted by previous generations, and according to which it could be interpreted; it is more than likely he would have expected the same from his patrons. Like the col-lectors of Israhel van Meckenem's engravings in the previous century, the original owners of Bruegel's *Children's Games* and their friends would almost certainly have been willing 'to interpret, to provide a witty aphorism' to the picture. Not having a banderole to inscribe, they could have changed their mind with every viewing of the painting; its 'proliferation of meaning', so much greater than that of a black and white print, could 'engage [spectators'] ingenuity' in perpetuity – as has indeed proven to be the case. Bruegel's contemporaries would have been more likely than modern critics to grasp that the only response to *Children's Games* intended by its author to remain constant, though not unchanging, is laughter.

The sixteenth century witnessed a revival of the ancients' interest in laughter as a biological, social and moral phenomenon.[62] On the one hand, hearty laughter was

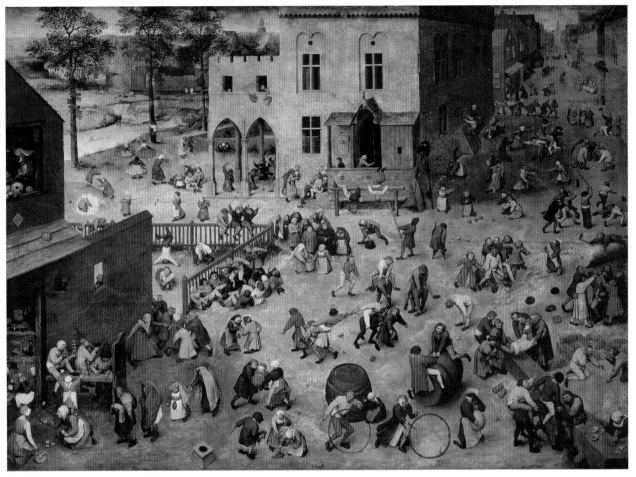

108　Pieter Bruegel the Elder, *Children's Games*, 1560, Vienna, Kunsthistorisches Museum

associated with the lack of self-control typical of peasants, fools and children; on the other, as an exclusively human faculty not given to other creatures, laughter was valued as restoring 'weary and melancholy spirits', an antidote and therapy for that widespread and much-feared disease we now call 'depression'. Along with the vernacular comic novel,[63] jestbooks – collections of facetious anecdotes – became a recognised literary genre. Often scatological, always politically incorrect, finding humour in sexual, social and national stereotypes, they were designed to evoke laughter by holding a mirror up to unregenerate nature. In Flanders, the *rederijkers* or rhetoreticians, literati who put on public performances of poetry readings and plays, included comic songs and farces in their repertories along with morality plays. It would indeed be surprising if paintings had not been created in the same ludic vein,[64] and whatever else it may suggest to the viewer, Bruegel's *Children's Games* is by definition such a painting.

With Bruegel, the 'drolleries' and 'pleasantries' that had earlier entertained viewers in prints and from the margins of illuminated manuscripts move onto the main stage of easel painting. As Gibson also stresses, this offered painters the opportunity to introduce into their medium not only novel, popular subjects and characters, but also a

wider and more realistic range of poses, gestures and expressions. It is precisely to this aspect of *genre* painting that we owe the difference between the comparatively narrow range of emotions studied by Renaissance art, limited largely to religious and mythological subjects,[65] and the more complex, subtler or ambiguous expressions prescribed, and pictured in all narrative and anecdotal genres, from the seventeenth century onwards.[66]

The fickle emotions and the unfettered expressivity of *pueri*, and the uses made of them in visual imagery, are the subject of the next chapter.

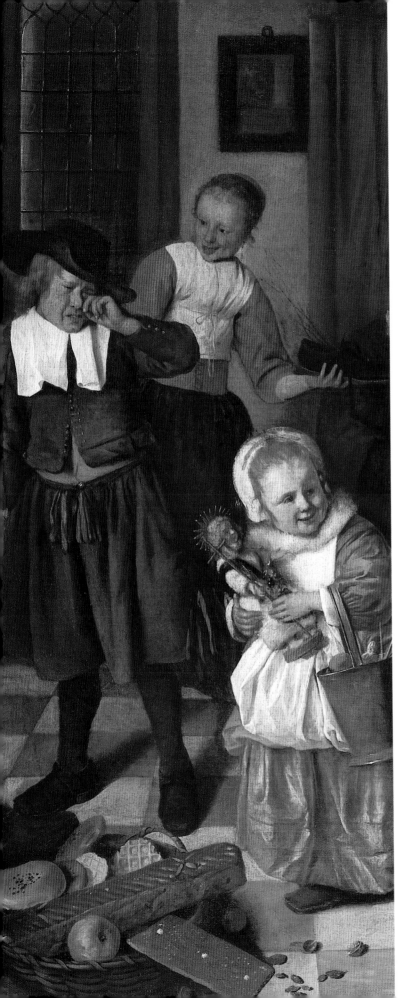

CHAPTER 7

'Jean qui pleure et Jean qui rit', and 'As the old have sung so pipe the young'

Jean qui pleure et Jean qui rit
C'est le beau temps et la pluie
L'un toujours vous réjouit
Rien qu'à voir l'autre on s'ennuie.
Oh! la la! hi! hi! hi!
Qu'il est laid, Jean qui pleure
Oh! oh! oh! hi! hi! hi!
Qu'il est beau, Jean qui rit.

Jean qui rit, soit indulgent
Avant d'éclater de rire
Demande à ce pauvre Jean
Pourquoi toujours il soupire.
Oh! la la! hi! hi! hi!
Ne nous hâtons pas de rire
Oh! oh! oh! hi! hi! hi!
Des misères d'ici bas! …

Rire comme Jean qui rit
Pleurer comme Jean qui pleure
Ce n'est point montrer d'esprit
A chaque chose à son heure
Oh! la la! hi! hi! hi!
Rions du bonheur des autres
Oh! oh! oh! hi! hi! hi!
Pleurons du chagrin d'autrui.[1]

IT IS SURPRISING THAT FACIAL EXPRESSIONS, so important in Bruegel's paintings of peasant revelry, hardly show in *Children's Games*. The uninhibited expressivity of childhood had been a *topos* in literature and the visual arts since antiquity – and images of playful children, used for comico-didactic effect in early-seventeenth-century Dutch emblematics, were soon enlisted by Dutch artists to broaden painting's expressive range. In the 1630s the famous Haarlem master Frans Hals leavened the solemn task of bourgeois portraiture with 'character heads' of laughing boys and girls;[2] his former pupils, his own brother Dirck, Jan Miense Molenaer and his wife Judith Leyster, pioneered pictures of children laughing at their games.

In Molenaer's *Children making Music* of 1629 (fig. 109),[3] village boys play the violin and a *rommelpot*, a jug covered with a pig's bladder pierced by a stick, while a girl beats time with spoons on an old-fashioned helmet that, like her oversized gorget, recalls the wars of the previous century. A *kolf* stick stands propped up against the wall; the empty birdcage on the left, from which the bird has flown, may have been intended to suggest the transience of this carefree, Carnival-like time of childhood.[4] All three children grin at the viewer. Dirck Hals's 1631 *Two Girls playing with a Cat* laugh at their sulky pretend 'baby'; in a paired picture, *A Boy and a Girl playing Cards* (fig. 110)[5] the little girl who has produced an ace flashes a triumphant gap-toothed smile at the viewer. Like her counterpart in the pendant, she has barely lost her milk teeth; but while the girl in the companion painting is rehearsing for motherhood, she will evidently grow up to be a triumphant femme fatale.

The boy she has beaten at cards looks with dismay at his own losing hand. The contrast is important, for even more challenging to artists than childhood's expressivity

109 Jan Molenaer, *Children making Music*, London, National Gallery

110 Dirck Hals, *A Boy and a Girl playing Cards*, 1631, Williamstown, Massachusetts, Sterling and Francine Clark Art Institute

was its notorious emotional fickleness. To solve the problem of showing in a single image how rapidly children alternate between laughter and tears, the second-century Greek modeller of terracotta figurines depicted an anecdote of cockfighting: the winning bird's owner rejoices while the defeated one's weeps (fig. III).[6] By the seventeenth century, when little boys no longer kept fighting cocks as pets, the Netherlandish printmaker Crispin van de Passe adapted the device in his engraving of *Pueritia* from a series of the Ages of Man: among the *pueri* – who 'with sure step leave their mark on the ground', play with their companions, are easily angered and just as rapidly placated – two in the foreground struggle, weeping and laughing, over a scratching cat (fig. II2).[7] It can be no coincidence that *kattekwaad*, 'cat's mischief', is a Dutch idiom for children's naughtiness.[8] The phrase, and images such as Van de Passe's, underline the kinship of *pueri* with animals: both cats and children are incompletely domesticated, emotionally unreliable and potentially dangerous.[9]

The contrast of tearful and joyful children proved so popular that seventeenth-century artists continued to vie with each other in devising for it ever richer, more plausible and more compelling contexts. Probably the most inventive was the Dutch painter Jan Steen, in such pictures as *The Schoolmaster*, *c*.1663–5,[10] where a malicious girl laughs at the weeping boy about to be beaten, or in the famous *Feast of Saint Nicholas*, *c*.1663–7.[11] The Spaniard Bartolomé Esteban Murillo, whose pictures of Seville ragamuffins were painted for export to a northern European public already eager for such images, proved even more influential in later centuries.

Murillo's *Invitation to a Game of Argolla* (fig. II3)[12] is one of a celebrated pair of paintings, dated *c*.1670 and almost certainly in Britain since 1690, that justify the appearance on the same canvas of one jubilant and one dejected child by constructing a moral argument. It has been convincingly interpreted as showing an obedient boy – poor, but fed and clothed, even if in torn garments and broken-down shoes –

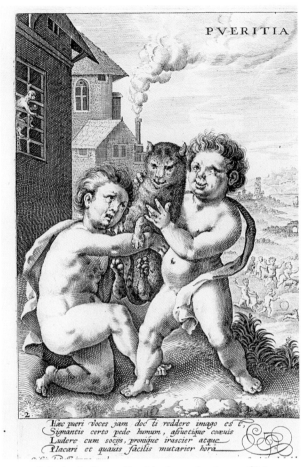

112 Crispin de Passe, *Pueritia*, from the Ages of Man, Hollstein, *Dutch and Flemish Etchings, Engravings and Woodcuts*, XV, no. 494

113 Bartolomé Esteban Murillo, *Invitation to the Game of Argolla*, c.1670, Dulwich Picture Gallery

employed on an errand, being tempted by an even poorer, barefoot but carefree street child into shirking his duty for a croquet-like ball game. An expectant dog awaits his decision.

Although only a tiny proportion of his vast output, Murillo's works in this vein earned the artist posthumous fame throughout Europe.[13] They became the direct inspiration for Gainsborough's and Reynolds's 'fancy pictures' of beggar or cottage children,[14] whose expressivity, however, was mainly reduced to soulful melancholy, and more generally contributed to the taste of late eighteenth-century collectors for images of childhood. Together with Dutch seventeenth-century works, they influenced the Scottish painter David Wilkie, who on visiting Seville in 1828 was disappointed to find that the Murillos he most admired were those, like fig. 113, he had seen at Dulwich. And just as the Spanish master's clamorous mass appeal was causing his reputation to wane among English connoisseurs, his expressive urchins still helped spawn curious narratives of contemporary childhood, such as those by David Wilkie's friend William Mulready.[15]

114 Detail from Willem van Haecht II, *Albert and Isabella visiting the Collection of Cornelis van der Geest*, 1628, Antwerp, Rubenshuis

115 '*Desperation/Pacification/Expectation/Acclamation/Realization – it's Fry's*, photographs by Messrs Pulton & Son, 1885; from 1902 livery of Fry's Five Boys chocolate

Abstracted from all anecdotal context and abbreviated into mere pendant busts *all'antica*, happy and crying *pueri* also became popular as domestic ornaments, at first in the grand interiors of wealthy art collectors, which is how they appear on the cupboard in the centre background of Willem van Haecht's 1628 *Picture Gallery of Cornelis van Geest* (fig. 114).[16] Some decades ago, the magazine *Country Life* published an enquiry about the origins of two similar busts in terracotta, manufactured about 1880 by the Torquay Terra-Cotta Clay Company and believed to have been copied from an earlier modelling by a German firm, probably after examples in marble.[17] The editor

referred the questioner to the Louvre, and the French sculptor Henri-Joseph Ruxthiel (1775–1837), who in 1812 was awarded by Napoleon the title of *Sculpteur des Enfants de France*. I confess to not knowing the outcome of this search, but the query demonstrates the motif's longevity and its penetration through the various hierarchies of art production and the art market.

The childhood imagery that has come down to us as '*Jean qui pleure et Jean qui rit*' disturbingly parallels the iconography – invented in the Renaissance on the basis of ancient literary texts, but most popular in the seventeenth century – of two ancient Greek philosophers, Heraclitus and Democritus, as personifications of contrasting responses to the human condition.[18] Born in Ephesus in 535 BC, Heraclitus was the first Greek philosopher to explore the nature of knowledge. Having withdrawn to the mountains to live a life of melancholy meditation, he became known as 'the weeping philosopher'. The fifth-century BC philosopher Democritus, on the other hand, having argued for the accidental origins of the world through the random groupings of atoms, gained a reputation as a mocking sceptic, and came to be described as 'the laughing philosopher'. The earliest surviving image of the weeping Heraclitus and the laughing Democritus is a late fifteenth-century fresco by Donato Bramante, said to echo a painting in the schoolroom of a Florentine humanist, itself inspired by a Late Antique description of the decoration of a *gymnasium*.[19] By the 1600s, when Crispin van de Passe engraved their likenesses, the circular map of the world held by Bramante's two philosophers had been transformed into a terrestrial globe; the print was entitled *Vanitas et Vanitates*, referring to the opening words of the Apocryphal Book of Ecclesiasticus: 'Vanity of vanities, all is vanity'. If in seventeenth-century art the terrestrial globe had become a symbol of the transience, the folly and futility of human life, so had the extreme emotional reactions of the two ancient sages, described as 'equally farcical and foolish',[20] although to the heirs of Erasmus laughter generally seemed preferable.[21]

No overt reference to fickle *Pueritia* is made in the imagery of Heraclitus and Democritus, and perhaps the resemblance is fortuitous. Yet I cannot help but feel that, perhaps without one directly influencing the other, the two iconographies are complementary: the show of feeling that is natural to the foolish child becomes unseemly folly in the adult.

Seventeenth-century artists also looked beyond laughter and tears to depict more ambiguous expressions, or transitions from one emotion to another. Not the most moving consequence – though to older readers possibly the most memorable – of these researches may be the photograph by Messrs Poulton & Son supposedly recording 'Desperation/ Pacification/ Expectation/ Acclamation/ Realization – It's Fry's' on the face of the photographer's son Lindsay (fig. 115).[22] First used as an advertisement in 1885, the photograph became the livery of *Fry's Five Boys* chocolate from 1902 until the product was withdrawn in 1976. As the manufacturers' website explains, 'a rag soaked in ammonia was used to achieve the boy's "desperation face"'. Although less drastic, the story is a worthy descendant of art-historical legends recounting how the ancient painter Parrhasius tortured a slave to death to serve as a model for a picture of Prometheus, how Michelangelo crucified a porter to paint Christ, or how Gianlorenzo Bernini burned his own leg against a hot stove to study in a mirror expressions suitable for a sculpture of Saint Lawrence, martyred by being roasted on a grill.[23]

Besides characterising *pueritia*, children's ready display of emotions has also long been exploited in other contexts. *Loci classici* are found in fourteenth-century Italian literature and visual art. In the *Divine Comedy*, his long metaphysical poem of the soul's ascent to Paradise (and many other things besides), Dante compares the human soul – beloved of God and yearning to return to her Creator – to a little girl, 'crying and laughing' as children do.[24] Passing through Padua *c*.1304–5, the great poet might have met his Florentine compatriot, Giotto, at work on *The Expulsion of the Merchants from the Temple*, one scene in the biblical fresco cycle decorating the Scrovegni Chapel (fig. 116).[25]

The episode is recounted in all four Gospels.[26] Like other artists, Giotto relies on John 2:14–16 for the 'scourge of small cords' with which Jesus drives out the merchants and their 'oxen, sheep and doves', sold for sacrifice in the Temple on Mount Moriah at Jerusalem, the place where Abraham was believed to have built an altar on which to sacrifice his son Isaac. But neither John nor any other evangelist describes the children included by Giotto in an unprecedented pictorial interpretation of the scene.[27] As Jesus wields his scourge, one of the apostles bends down to reassure a terrified small boy nestling in the folds of his mantle, and shield him with his sleeve from the sight of the Lord's anger. Giotto's description is so vivid that we can read the child's feelings perfectly from just a corner of his open mouth, the way he turns his back on Christ yet his head towards him, his hand clutching the sheltering drapery, and from the apostle's calming touch on his back. More remarkably still, during the course of this work Giotto changed his mind to reinforce the point. Cutting out a piece of *intonaco*, the final layer of plaster, from St Peter's yellow robe, he inserted there, in *buon fresco* on a new patch of damp plaster, the upper part of another child, subsequently completed in red and blue lines painted *a secco* over the yellow, and now largely lost.[28] This second child, clutching a dove presumably escaped from one of the overturned crates or open cages, also shrinks from Jesus, watching him in anxious fascination. The two children are the only human figures on Jesus' right to demonstrate fear of his anger. 'They act, in other words, at the common human rather than the religious or symbolic level', writes the art historian Millard Meiss,[29] the earliest commentator on the expressive role of children in early fourteenth-century art. That these two little boys act at 'the common human . . . level' is true, yet their appearance in the fresco can also sustain a religious gloss. Although in Giotto's own *Last Judgment* on the chapel's entrance wall Christ's pose is more static, *The Expulsion* calls to mind later depictions, in which the Saviour raises his right arm to show the wound in his side and consign the sinners on his left (the spectator's right) to damnation. In all versions of the *Last Judgment*, including Giotto's, the blessed appear on Christ's right (the spectator's left). Good and evil are similarly located in fig. 116, where the Apostles and the two children are shown on Christ's right, while the merchants he is expelling, and 'the scribes and chief priests' who plot to destroy him,[30] appear on his left. If Giotto's *Expulsion* deliberately prefigures the Last Judgment, then the little children are right to be afraid: 'The fear of the Lord is the beginning of knowledge.'[31] They act 'at the

116 Giotto, *The Expulsion of the Merchants from the Temple*, fresco, *c*.1305, Padua, Scrovegni Chapel

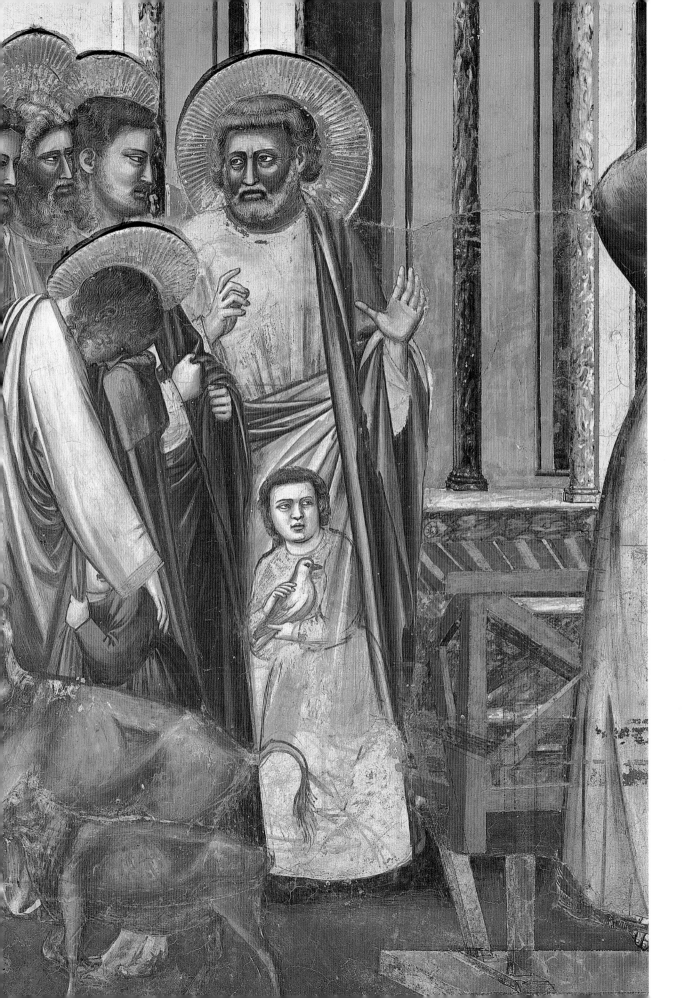

common human level' so that we – the common humanity of spectators – may follow their example: 'Whosoever shall not receive the kingdom of God as a little child, he shall not enter therein.'[32] And perhaps, more than the purely formal reason adduced by Meiss,[33] it was Saint Peter's role as the founding stone of the Church that motivated Giotto's afterthought – to insert a second child, who addresses us directly,[34] within the protective and all-enveloping outline of the apostle's mantle.

One of the great fascinations of Italian Trecento art is its poignant synthesis of the commonplace with transcendence and high drama. By the early sixteenth century, Italian art had sundered this pictorial unity of naturalism with tragedy or epic, its move towards greater idealisation masked by the invention of single-vanishing-point perspective and a more scientific approach to anatomy. Following the precepts of ancient literary theorists from Aristotle onwards, epic and tragic themes became once again the exclusive province of personages larger than life and shown as better than ourselves, while people like ourselves or lower were depicted warts-and-all in the pictorial equivalent of comedy and satire. Since northern European art never entirely abandoned its devotion to surface realism in favour of the classical ideal, it became internationally identified with the 'baser' modes. While Bruegel extended the boundaries of comedic Netherlandish tradition,[35] it was left to his seventeenth-century Flemish and Dutch successors fully to take advantage of art's potential for imparting truths through laughter, exploring that range of earthy expressions excluded from 'higher' Italianate genres.

Jacob Jordaens's reputation as a prolific portraitist and imitator of Rubens's religious and mythological subjects eclipses his originality as the inventor of comedic themes later more famously adapted by Jan Steen. Inspired by Bruegel's paintings of rowdy peasant feasts, such works by Jordaens caricatured his own comfortably urban social class.[36]

Born in Antwerp in 1593, some quarter of a century after Bruegel's death, Jordaens was in a sense his precise contrary. While his greatest influence was indeed the patrician and cosmopolitan Peter Paul Rubens, whom he succeeded as Antwerp's greatest painter, Jordaens hardly left his native city, content with the bourgeois milieu of his cloth-merchant father, neither travelling south nor hobnobbing with intellectuals and aristocrats. A cradle Catholic, he married the daughter of his Protestant master, the painter Adam van Noort, and by 1650 had converted to the Reformed Church, although continuing to reside in Catholic territory and to receive commissions from both Catholics and Calvinists in the Southern and Northern Netherlands.[37]

Jordaens' attachment to family – the family of his birth, his in-laws', and his own – may be gauged from the affectionate way he depicts them in group portraits, of which fig. 117[38] is an early example, perhaps celebrating the young Jordaens' matriculation in the Antwerp painter's guild of Saint Luke in the year 1615–16.

The twenty-two or twenty-three-year-old artist depicts himself playing a lute on our side of a table around which are ranged his parents and siblings; the youngest, Elizabeth II, born in 1613, is shown on her mother's lap, returning the embrace of one of her older twin brothers. A dog fawns at her feet, restrained by the other twin. The elder Jordaens holds a glass of wine; there is bread on the table. A maid brings in a dish of fruit. Three little cherubs flutter above the participants at this allegorical feast of fruitfulness, harmony and faith, pointing to heaven and extending blessings and pro-

117 Jacob Jordaens, *Portrait of the Artist's Family*, *c*.1615–16, Saint Petersburg, The Hermitage

tection over the assembled family; they have been convincingly identified as three little daughters baptised respectively in 1597, 1605 and 1610, but dead in infancy. Two of the painter's surviving sisters look tenderly up at them; the family remains united even in death, and, as was the custom, the memory of the first Anna and Elisabeth is kept fresh in the names of younger sisters.[39]

If the children's expressions are still sketchy in this youthfully awkward painting, the same cannot be said of Jordaens's later works. Like Giotto in the biblical scene of the *Expulsion of the Merchants from the Temple*, the artist introduced children into mythological subjects in defiance of the texts, in order to suggest additional implications through their uninhibited reactions; it is often these realistic, expressive little figures studied from the life that lend his compositions on classical themes a fresh and contemporary feel.

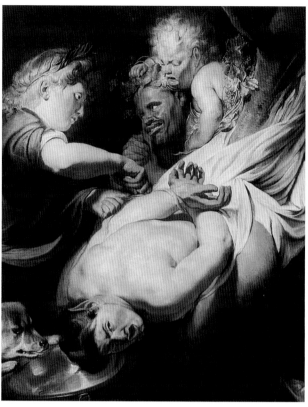

118 Jacob Jordaens, *Pan and Syrinx*, Brussels,
Musées Royaux des Beaux-Arts de Belgique

119 Jacob Jordaens, *Apollo flaying Marsyas*, c.1625,
private collection

In the *Pan and Syrinx* of c.1620, for example (fig. 118),[40] one of several versions of Ovid's story painted by Jordaens, the artist depicts two *putti*, modelled on the same blond child (perhaps his own little daughter Elizabeth, born in 1617) who shows three different expressions in a sketch from life now in Saint Petersburg.[41] Nowhere does the Latin poet specify the presence of infant sprites in his account of the beautiful nymph Syrinx, votary of virginal Diana, who fled from Pan until, halted by the waters of the River Ladon, she sought the aid of her sisters the naiads; when Pan thought he had at last caught hold of her, she was transformed into a reed. The lovesick goat-footed god, left sighing on the shore with only marsh reeds in his arms, heard the wind blowing through them. Enchanted by the plaintive music, he fastened reeds of unequal length together with wax, creating the pan-pipes, or *syrinx*, that forever keep him in contact with the nymph.

Jordaens follows pictorial tradition in showing Pan already holding both canes and pipes while still watching Syrinx eluding his grasp; the River Ladon, personified as a classical river deity, empties his water jar in the foreground. Unprecedentedly, however, one of the *putti* peers from behind the chagrined Pan, holding a torch downward in allusion to the frustration of his pursuit, and the inevitable cooling of his ardour. Both children's eyes are firmly aimed at the satyr's caprine erection, and their expres-

sions of amused wonder leave no doubt that the episode is to be read more as sex romp than high tragedy.

Apollo flaying Marsyas of *c*.1625, on the other hand (fig. 119),[42] becomes infinitely more tragic through the suggestion that the black satyr who implores the god to spare Marsyas might be carrying the latter's own faun-child, sobbing at his father's agony. A crescendo of emotion, progressing from the bestial *non curanza* of the dog lapping Marsyas' blood, through the divine impassivity of Apollo and Marsyas' own mask of pain, to the black African's more ambiguous and more lifelike expression of pity and impotent fear, culminates in the baby's naturalistic transports. The chasm perceived between the familiar causes of childish tantrums – colic, teething, a dropped toy – and the reason for the faun-child's despair, brings the horror fully home to the viewer. Karel Van Mander's 1604 commentary to *Metamorphoses* may recommend the scene for its moral warning against pride before God,[43] but Jordaens's treatment more obviously condemns the implacable cruelty of a pagan deity.

In these mythological pictures, children mediate between the 'low' comedic world shared by the artist with his viewers, and the 'elevated' realm of myth. Children are central, however, to the influential *genre* imagery Jordaens himself invented: mocking admonitions illustrating the proverb 'As the old have sung, so pipe the young', and depicting the transmission of folly from generation to generation. Ostensibly concerned with the formation of children's nature – with how human nature reproduces itself – Jordaens's treatment of the maxim implicitly reverses the conventional roles of 'foolish child' and 'responsible adult'.

The first to interpret it in paintings, Jordaens probably borrowed the proverb from Jacob Cats's 1632 collection, *Spiegel Van den Ouden ende Nieuwen Tijdt* (*Mirror of Old and New Times*), substituting humans in contemporary dress for Cats's examples from the animal world.[44] The Antwerp painter may also have recalled the variant of the proverb used as a caption to *The Family of Fools* in motley, an engraving issued in the previous century by Bruegel's print publisher, Hieronymus Cock.[45]

While Cock's print and Cats's commentary both refer to the transmission of innate character traits, Jordaens may also be alluding to a less deterministic but more moralistic interpretation of the proverb.[46] The warning,

> What you do, that your child will do,
> In evil children copy you . . .
> In children's presence take great heed,
> They'll copy you in word and deed . . .

first appeared in Sebastian Brant's *Ship of Fools* of 1494, illustrated with the woodcut of a motleyed fool handing a backgammon board to a child.[47] At about the same date, Hieronymus Bosch depicted the *Seven Deadly Sins* of the fathers being visited upon the children, more through nurture than nature: *Gluttony* includes a toddler, his breeches undone and his bottom soiled, rushing off his potty to reach for the tankard held by his greedily feasting father (fig. 120).[48] As his footwear demonstrates, the child is literally 'stepping into his father's shoes'.

Figure 121,[49] dated 1638, is the earliest of many versions of the subject by Jordaens and his studio. Three generations, suggesting a single extended family, are reunited around a well-furnished table. Having eaten together, they now make music; but while

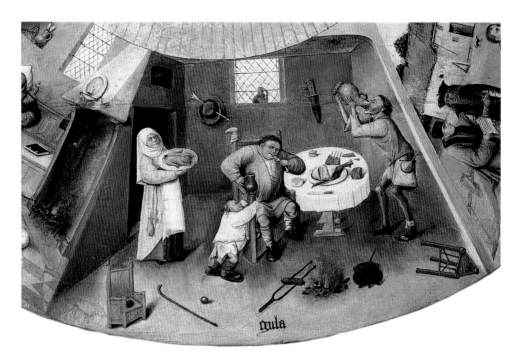

120 Hieronymus Bosch, *Gula (Gluttony)*, from the *Tabletop of the Seven Deadly Sins and the Four Last Things*, *c.*1490–1500, Madrid, Prado

similar ingredients denote harmony in Jordaens's genuine family group portraits, here they imply cacophony, a counterfeit togetherness. The old man beats time as he sings, seemingly directing the others, yet he barely shares his song book with the young man lustily playing the bagpipe at his side; nestling below, where he can see neither performers nor the music, a little boy 'pipes' on a descant recorder. Across the table, the old woman adjusts her glasses the better to follow her own song sheet. In the centre, under the proverb *Soo d'oude Songen, Soo Pepen de Ionge* inscribed in a cartouche, a florid young woman, the only personage to remain silent, presides smilingly over the table, while the baby on her lap contentedly blows the silver whistle and shakes the little bells on its teething toy.

Though not explicitly depicted as motleyed fools, the adult personages, who seem to have usurped *pueritia*'s playfulness and expressivity, are obviously behaving foolishly, and probably worse. The absurd grandparents lack the dignity of age, and are self-indulgently oblivious of others. The young man's bagpipe is a traditional emblem of lechery,[50] the young woman's dress and jewels imply worldliness, a love of luxury. Underlining both the suggestion of dissolute living and the verbal pun on 'piping', a *pijpkan* – the tankard with the long spout or pipe – stands on the table.

Are these people, and by implication the viewer, able to 'take great heed', reform their ways and set a good example to their children – a position characterised as more typically Catholic? Or are they demonstrating inherent characteristics about to be inherited by their offspring – a view of human nature more in keeping with Calvinist doctrine?[51]

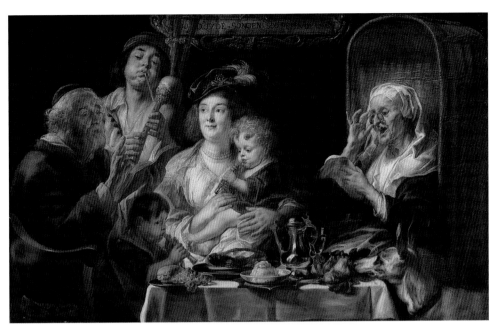

121 Jacob Jordaens, *As the Old have Sung, so Pipe the Young*, 1638,
Antwerp, Koninklijk Museum voor Schone Kunsten

Jordaens's own religious history and his patronage by both Catholics and Protestants probably make the question, as posed, irrelevant. The artist seems to have favoured one or other view in different versions of the subject. One version, for example, includes a bell-capped fool pointing at a bird 'piping' in a cage; an owl, probably referring to the Netherlandish proverb, 'What use are candle or glasses if the owl does not want to see?', and those well-worn emblems of futility, flowers and a smoking candle sitting on a pile of books.[52] This seems to point to an 'inborn nature' interpretation of the scene; other variants, however, feature a parrot, emblem of learning by imitation rather than nature.[53] Jordaens and his viewers probably did not split hairs over the proverb's logic; what mattered was that parents, both through biology and by example, transmit their mores to their offspring. This double causality is underlined by the Catholic Jan Steen in *The Cat Family*.[54] Under a pergola, boisterous adults encourage the misbehaviour of the young: a young woman even holds a *pijpkan* to an adolescent boy's lips. But girls around the table play with a mother cat and her kittens, illustrating one of the Calvinist Jacob Cats's fatalistic comments on the original proverb: 'He who is born of a cat catches mice'.[55]

The comedy of children playfully imitating adults, discussed in the last chapter, may be timeless. The theme popularised by Jordaens – the influence on children of parents and grandparents – was especially timely in contemporary Southern and Northern Netherlands, where Catholics and Protestants, sensitised by religious conflict to the nature of sin and of human nature, both agreed the latter was forged at home, at the family hearth. We ourselves tend to be exercised over the role of the state in the nature/nurture debate, through social engineering or genetic manipulation.

As a match to paintings of familial influence, Jordaens evolved an imagery of domestic celebrations of Twelfth Night. In his versions of *The King Drinks*, the king, elected to lead the festivities in memory of the Three Kings of Orient, is always the oldest man depicted. Based on portrait studies of Adam van Noort, he closely resembles the foolish patriarch of *As the Old have sung so pipe the Young*. Other figures, almost certainly based on members of the artist's family, appear repeatedly in paintings of both subjects. One pairing of the two subjects still survives;[56] the similarities between the pendant pictures are striking, down to the wide-eyed child in *The King Drinks* observing the riotous behaviour of the grown-ups. The more extravagant and foolish that behaviour, the more do the charming, lifelike children appear as morally neutral.

A striking exception is Jordaens's *The King Drinks* now in Brussels (fig. 122).[57] Less intimate than other versions, this Epiphany feast also includes friends and neighbours playing the other roles prescribed by tradition. The old king sits in the centre, under the ironic inscription *In Een Vry Gelag is Goed Gast Zijn*, 'It's good to be a guest where the drinks are free'. A piper plays; others sing. A belled fool at the upper left exhales smoke, brandishing his pipe to the music, left hand snaking as if of its own accord towards the cleavage of a woman sitting laughing in front of him. One of the guests, cast as the 'Doctor', upsets tableware and vomits out of the painting into the viewer's space. His counterpart across the canvas is the sobbing child slung across his mother's lap, having his bottom cleaned, (probably in time to the song). He twists to turn his tearful face to the viewer, and it seems that the fool's girl friend may be laughing at him – fickle emotions represented not by two *pueri* but by a sad infant and a foolishly jovial woman.

We have once before met a child having its bottom washed, under the caption 'This life, what is it but stink and shit' in Johan de Brune's *Emblemata* of 1624 (fig. 72). Is this what Jordaens intended us to recall? The motif – like that emblem of futility, smoking tobacco – was also often used to illustrate the sense of Smell. As an additional comment on the debased nature of this celebration of Christ's Epiphany, could the painting be alluding to the senses – Sight (the viewers'), Taste (food and wine), Hearing (singing, pipe music, the baby's howls, the clatter of falling vessels), Smell, and Touch, the fool's hand on the woman's breast, or the dog's scratching at his master's groin?[58]

More probably, the dog is eager to join the revels, and Jordaens is merely piling on scabrous examples from pictorial tradition, to make viewers laugh at this 'temporary reversal of the acceptable world'[59], much as we laugh at our own distorted reflections in fairground mirrors, so unflattering yet all too true. In another version of *The King Drinks*, the inscription reads, 'Nothing is more like the mad than the drunk'.[60]

Only a part-time interest of Jordaens's, Erasmian comico-cautionary *genre* is most consistently associated with his younger Dutch contemporary Jan Steen, who annexed the Flemish artist's inventions to his own repertory,[61] mainly inspired by proverbs, emblems, poems, theatrical farces and joke books, and ruled overall by the motto, inherited from Antiquity, 'All the world's a stage.' We must assume that Steen's own audience consisted mainly of an educated urban elite, tolerant regardless of religious allegiance, who delighted in his paintings' word play and multiple meanings as much as they laughed at their sexual or scatological associations.[62] But if changes in social mores, notions of morality, propriety and wit have made some of these incompre-

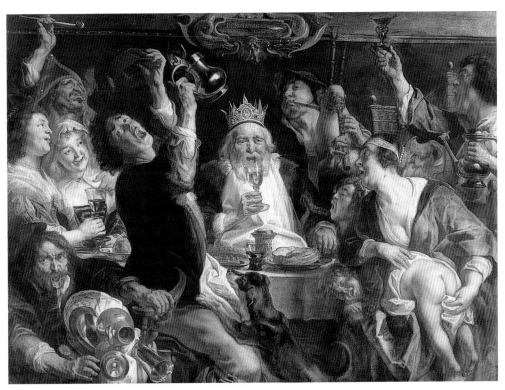

122 Jacob Jordaens, *The King Drinks*, c.1640, Brussels, Musées Royaux des Beaux-Arts de Belgique

123 Jan Steen, *The Effects of Intemperance*, c.1663–5, London, The National Gallery

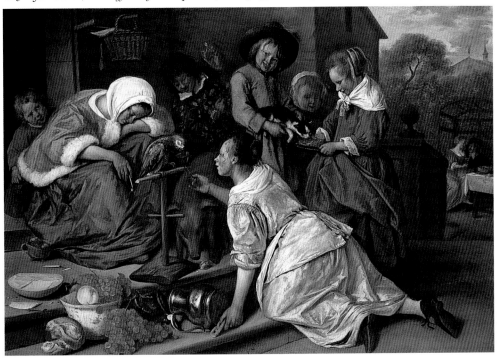

hensible, there is no mistaking the artist's and his clients' nearly obsessive concern with the upbringing of children – the first duty of a mother, as Jacob Cats stressed in verses that end, 'There is nothing that any man prizes more highly in a wife/Than her mature care in educating children.'[63]

Both the message and Steen's idiom are well exemplified in *The Effects of Intemperance*, *c.*1663–5 (fig. 123),[64] a more surreal and 'wordy' domestic scene than any by Jordaens. The title is modern; Steen himself called a similar scene *The Dissolute Household*, via the 'chalk inscription' on a tavern reckoning-slate in the painting;[65] a more ebullient variant has a slate inscribed 'Beware of luxury', with a reckoning below,[66] while a third bears the inscription 'To be a sleeping sot is to be forgotten by God', on a sheet of paper on the floor.[67] All versions would have evoked the widely cited biblical proverb, 'Wine is a mocker'.[68]

Accompanied by four children, a pig, a cat, a parrot, a wasteful youth (perhaps a domestic) and an overdressed maidservant, a Dutch housewife, derelict in her domestic duties, has fallen asleep on her stoop. A luscious still life is deployed at her feet, and a basket hangs over her head. At the side of the house, invisible stairs must lead down to a garden, where a man, probably the woman's husband, sits under an arbour wining and dining and canoodling with a younger girl, almost certainly a prostitute. The housewife-and-mother's pose descends from a long line of engravings, including Bruegel's, personifying Sloth, although the immediate cause of her slumber is more likely to be drink. A clay pipe slides from her hand, and the little brazier and paper spills she uses to light it are set perilously close to her skirt; twenty-first century viewers may be reminded of Marcel Duchamp's obscene caption to the *Mona Lisa*, L.H.O.O.Q.[69] Her youngest child is picking her purse; the youth 'throws roses before swine', as English speakers might 'throw pearls', while the woman's son and his two sisters are engaged in 'cat's mischief', feeding a good meat pie to their pet. The tipsy maid teaches the imitative parrot to drink wine; the pewter jug by her side is empty. A prominent pretzel in her hand recalls an emblem by Johan de Brune, inspired by a contemporary game, in which the knotted biscuit stands for the human soul caught up in a tug-of-war between Good and Evil.[70]

If the gluttonous foreground array of bread, cheese, and fruit in a costly Chinese porcelain bowl speaks of present luxury, the objects in the hanging basket foreshadow a disastrous future: a beggar's crutch and a *Lazarusklep*, the noisy clapper carried by infectious sick beggars – the proverbial reference here is to 'Young idlers, old beggars'[71] – and a birch for flogging wrongdoers.

Steen's best paintings, such as this one, enable us to have our cake and eat it too: their beautiful visual surface lures us into complicit sensual enjoyment, and this, like the 'laughing prompt' of the boy holding the cat and addressing the viewer, must be a deliberate part of the artist's strategy.[72] By mocking foolishness, laughter was supposed to cure us of folly; yet in the very act of urging viewers to mend their ways while there is still time, Steen unmasks the hypocrisy of this reasoning. Although 'the extent of the instruction and the degree of delight appear to have been left to the viewer's discretion',[73] he takes good care to make us respond more with pleasure than derision to interesting anecdotes, seductive motifs, colours and textures, and urges us to admire himself, the artist, who often takes a bow on his own stage by including his own likeness as 'laughing prompt' or mischief's chief offender. While, following

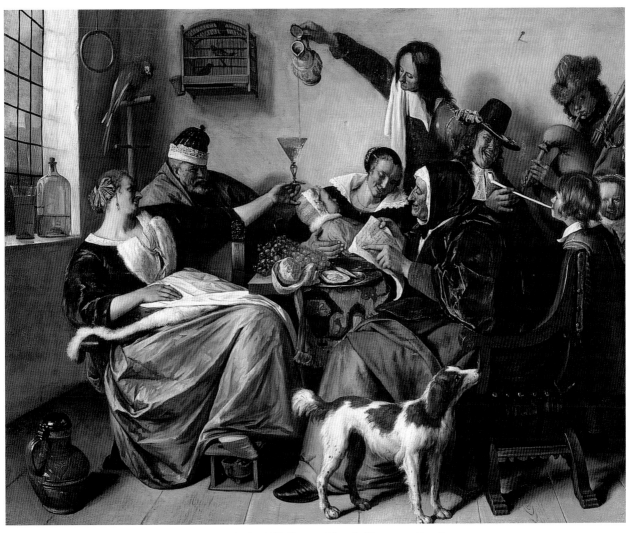

124 Jan Steen, *As the Old Sing, so Pipe the Young*, *c*.1663–65,
The Hague, Royal Cabinet of Paintings, Mauritshuis

Jordaens, Steen also models many of his other characters on members of his own fam-
ily, only he – whose features would have been known from 'straight' self portraits –
may have been meant to be widely recognised as a specific 'real' person.

In one of his most accomplished versions of *As the Old Sing, so Pipe the Young* (fig.
124),[74] his largest and most freely painted *genre* picture, Steen casts himself as the father
teaching his son to 'pipe', the pun underlined by the 'piping' birds in the cage against
the wall; the little smoker resembles the artist's son Cornelis. The musical piper behind
them was possibly drawn after his oldest son Thadeus, and his daughter Eva may have
sat for the laughing little girl who engages our gaze. The drunken woman 'linked in
bad exemplarity' to Steen through identical ribbons and 'the grand gesture of the ser-
vant'[75] pouring wine into her glass, has the features of his first wife, Margriet van
Goyen.[76] Jacket unlaced, she leans back, suggestively braced on a footwarmer. The ele-

gant way she holds her wine glass contrasts to comic effect with her otherwise disreputable behaviour.[77] An emblematic parrot perches above her head.

Beside this loose woman sits the family patriarch. The *kraamherenmuts*, the traditional new father's cap, falls forward on his head. In the centre of the composition, under the wine jug, a baby lies sleeping in its mother's arms. Facing them, a bespectacled old woman sings from a sheet inscribed 'Song/As it is sung, thus it is piped, that's been known a long time, as I sing, so all do the same from one to a hundred years old.'[78] At her side stands a dog; among the animal's many and contradictory symbolic significances, from fidelity to impurity, the most appropriate here is that of *leersucht*, eagerness and ability to learn. Since, however, this idea is generally expressed in Dutch seventeenth-century emblems and art by an image of a dog standing on its hind legs,[79] it may be that this particular dog should be viewed as just a dog.

The grouping of these figures is so pictorially convincing that viewers tend to ignore the ambiguities of their relationships: are 'Steen' and the temptress in the foreground really meant to represent man and wife, parents of the children clustered around their father? Might not the new baby's mother be identified as the wife, and the showy hussy impersonated by the real-life Vrouw Steen depict a maidservant turned 'salon lady' – one of those 'imps of hell' so feared by Dutch moralists, who ate and spoke with their employers on equal terms, encouraged their mistresses in extravagance, and tested the fidelity of husbands and the virtue of sons?[80] Is the old man wearing a *kraamherenmuts* merely to underscore 'the father's abdication of his paternal duties' as one scholar claims?[81]

Equally undermining the painting's supposed aim – to warn male viewers to choose their wives with care[82] – is its warm and indulgent air. Steen's figures act together on their little world's stage, colour echoing colour, profile turned to profile, harmoniously playing their parts in Nature's comic round: the child is a chip off the old block/ the child is father to the man/*semper pueri*.

Steen's most popular painting, the version of *The Feast of Saint Nicholas* now in Amsterdam (fig. 125),[83] depicts perhaps the richest context ever invented for the presence of laughing and crying *pueri* within a single image. The Catholic feast day on 6 December honouring Saint Nicholas, fourth-century bishop of Myra in Asia Minor,[84] was, and remains, the most characteristic Dutch family festival, celebrated with sweets and presents for children. In the seventeenth century, even some Calvinists viewed it as an innocent children's treat, despite the denunciations of Reformed preachers that it stoked youngsters' desires for vain material pleasures and fed them 'with lies, superstition and idolatry'.[85] Patron of children, sailors and nubile girls – groups especially in need of protection – Sint Niklaas migrated with the Dutch to North America. Here he became Santa Claus, and came down chimneys at Christmas instead of on his own Popish feast. Although he continued to put gifts in children's shoes or stockings, left on the hearth for this purpose, the original idea of 'just deserts' – toys for good children, a birch for naughty ones – was also lost in translation.

Artfully deployed with every semblance of naturalness, behind the discarded child's shoe and the spice cakes, nuts, fruit and sugary confections in the foreground, four adults and six children celebrate the holiday's comic rites. They are no doubt a Catholic family, to judge from two 'Popish abominations': a gingerbread Saint Nicholas in mitre and cope, clutched by the toddler on his brother's arm near the fire-

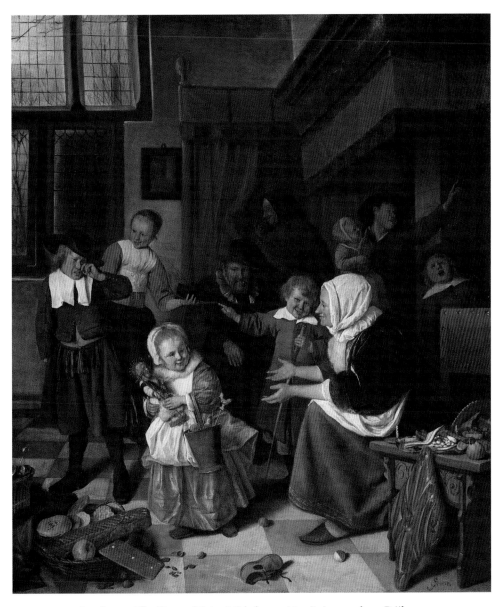

125 Jan Steen, *The Feast of Saint Nicholas*, *c*.1665–8, Amsterdam, Rijksmuseum

place where the children shout or sing their thanks to the kindly bishop, and a doll of Saint John the Baptist cradled by the spoilt little girl coquettishly witholding a kiss from her mother. One of her brothers has received a *kolf* stick; the ball lies on the floor, as he gleefully tries to attract the mother's – and the viewer's – attention to the tears of the gangling adolescent, who has just discovered that his shoe, held up by the maidservant, has been filled with the bare twigs of the birch. As yet unseen by the crying boy, the slyly smiling grandmother beckons to him; presumably a real present has been hidden in the four-poster bed.

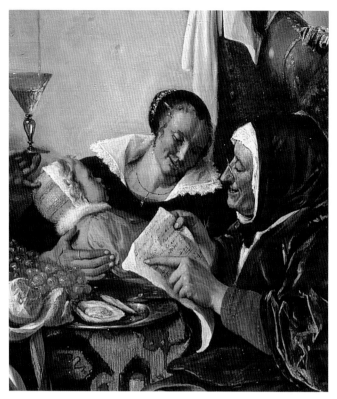

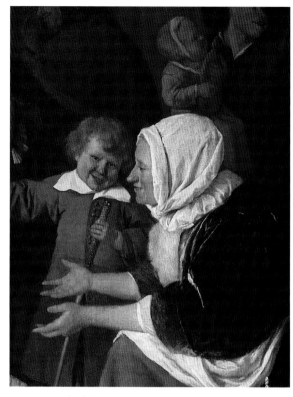

126 Detail of fig. 124

127 Detail of fig. 125

At the precise still centre of the canvas sits a watchful male figure, the only personage not actively participating in the festivities. He has been called 'the father' by some, 'the aged grandfather' by others.[86] What all agree on is that he wears a pleated collar about thirty years out of fashion. A source of iconographic unease, he calls attention to the ambiguity of even this apparently clearest of painted anecdotes.

The goddess Fortuna sits at the hub of William de Braile's *The Wheel of Life* as it rotates busily about her in Figure 78. Closer to the present painting, an allegorical figure, the traditional personification of Old Man Winter, sits among 'real' people in a seemingly naturalistic picture such as *A Scene on the Ice near a Town* by Steen's fellow Dutchman, Hendrick Avercamp.[87] There is not a very great mental leap between illustrating a maxim and personifying an abstract idea, and Steen, as we have seen, excelled at the former. I am not proposing that the patriarch in *The Feast of Saint Nicholas* is an actual embodiment of Father Time, merely that he may have been intended to remind us of time and its workings: the survival of the Catholic feast from 'olden days' and its yearly recurrence; the longevity of family and its perennial regeneration – for the mother in this painting is but a younger version of the old woman with the tell-tale song sheet in Figure 124 – and the ephemeral nature of childhood, as transient as a child's laughter or tears. The brooding figure may also vouchsafe us uncomfortable glimpses of the future: this pretty little child, the only girl in a brood of boys and her mother's pet, is surely a future *femme fatale* like Dirck Hals's card player in Figure 110. Other viewers have noted the incongruity of hiding an adolescent boy's treat in a cur-

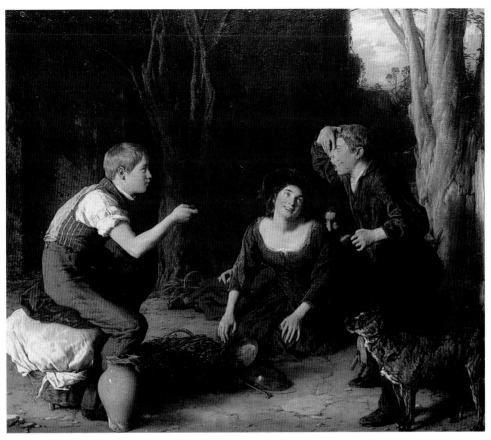

128 William Mulready, *The Butt: Shooting a Cherry*, 1847–8, Victoria and Albert Museum

tained bed, and the unsettling resemblance of the kindly grandmother to the old procuress of pictorial tradition, relating both to Sint Niklaas's comic reputation as a wishfulfilling matchmaker.[88]

Whatever the findings of developmental psychology, visual art assigns the process of human character formation to an age at which it can most readily be depicted: mobile, expressive, imitative and educable *pueritia*. The secular topic that so agitated Dutch seventeenth-century burghers also resonated with patrons in Victorian England.

Illustrator, painter of landscape and contemporary *genre*, inventive and influential interpreter of proverbial sayings and, above all, of childhood scenes,[89] the Irish-born William Mulready trained at the Royal Academy Schools still dominated by eighteenth-century tradition, and naturally turned to Old Master paintings for inspiration. Since he never travelled abroad, he relied on those he could see in reproduction and in private and public collections in London. At Dulwich Picture Gallery alone, he would have been able to study Dutch *genre* pictures and landscapes,[90] and, of course, the famous Murillos, *Two Boys and a Negro* Boy, and *Invitation to a Game of Argolla*.[91]

The Butt: Shooting a Cherry (fig. 128),[92] is one of the paintings whose debt to the Dulwich Murillos is suggested by the focus on unaccompanied children, the contrast

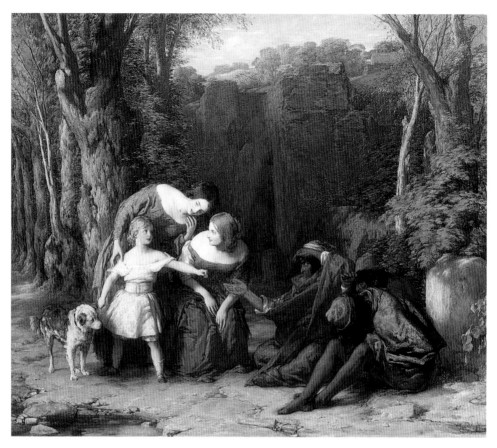

129 William Mulready, *Train Up a Child in the Way He Should Go and When He is Old He Will Not Depart from It*, New York, Forbes Magazine Collection

of seated and standing poses and the terracotta vessel in the foreground.[93] Mulready's anecdote of truant childhood is, after the Dutch fashion, more obviously comical than the *Invitation to a Game of Argolla*; its cottage-children protagonists are cleaner, better fed and better dressed, yet the subtler exploration of expression in this slick little picture conceals a far darker view of human potential. Whatever other thoughts they may arouse, the Spanish master's fickle *pueri* invite the viewer to meditate on free will: the moment's not too late, temptation may be resisted. The elaborate transactions of Mulready's characters are more opaque. The shyer of the girls has been picking lavender, and the bolder one cherries, for sale – copper scales and their weights lie beside the fruit. The girls have been stopped, in a kind of wasteland among walls and fences, by a laundry boy and a butcher's boy who interrupt their own errands to show off before them. The bigger, stronger, more aggressive of the lads has purloined cherries and is shooting them into the mouth of his sidekick; his misses are recorded in the cherry stains on the latter's cheek and on the fence behind him. Far from being 'passive observers',[94] the laughing girls goad the boys on, rewarding the bully and deriding 'the butt'; the grizzled butcher's dog, too old and wise for such games, observes in patent disapproval. The moment of decision is past, for the idle children

have already fallen into temptation: they are shirking their duties; the boys' friendship has soured through sexual rivalry; the foolish girl has wasted cherries she will no longer be able to sell.

The street children in Murillo's paintings, and their eighteenth-century descendants in English 'fancy pictures', are largely unaware of the eroticised nature of the viewer's gaze. In this picture Mulready displaces sexual guilt from viewer to viewed, stressing the cherry picker's pubescent allure, and depicting childhood play not as an omen of future vice, but a mask for already evolved depravity.

Ostensibly, however, *The Butt: Shooting the Cherry* shows the light-hearted world of childhood insulated from adult cares; the picture is meant to beguile and amuse. The work regarded by Mulready as his best, *Train Up a Child in the Way He Should Go and When He is Old He Will Not Depart from It* (fig. 129),[95] on the other hand, deals explicitly with a child's character as the foundation of national character: to train the former is to mould the latter. Unlike his seventeenth-century Flemish and Dutch predecessors, Mulready abandons Erasmian irony to deliver his admonition with seriousness, leavened only by subdued expressions serving to clarify the narrative, specify social class and elicit empathy from the viewer. The title, a quotation from Proverbs 22:6, was almost certainly chosen for the picture by the artist's patron, Thomas Baring, later MP for Huntingdon.

The little boy in the painting is too young to have been breeched.[96] The two young ladies, older sisters rather than a mother and an aunt, have given him a coin and urge him to overcome his fear and repugance by giving it as alms to three lascars – native seamen recruited in India for the voyage home of English ships, and abandoned without means in London docklands. Thomas Baring's grandfather Francis had been chairman of the East India Company, whose Lascar House in London offered accommodation to Indian sailors. It ceased operating effectively after the Company's commercial monopoly was broken in 1813, and the lascars' plight worsened after 1834, when the Company became a mere managing agency for British government in India. In 1838 the problem of destitute and vagrant lascars came to the attention of the national press; many – among them we may suppose Thomas Baring – looked back with sympathy to the period of the East India Company's exclusive charter.

The extent to which patron and artist collaborated on the subject is unknown. Mulready's contemporary biographer, the Pre-Raphaelite F.G. Stephens, writes that it 'was chosen by Mulready' as a testimony to the artist's own childhood training,[97] and Mulready himself decided to exhibit the picture in Paris at the Exposition Universelle of 1855. Modern critics have largely focused on the ideology of British imperialism that informs the painting, but even when it was first shown at the Royal Academy in 1841, while the lascars' fate was being hotly debated, the picture was misidentified – partly no doubt because its romanticised rural setting directed attention away from the London docks – as merely 'a child giving alms to a beggar'.[98] Very likely this was the aspect that particularly interested Mulready: of all his paintings of child education, this is the one that most clearly explores the link between the domestic, largely female, sphere of a boy's early moral education and the public arena of his adult life. It is not too fanciful to see in this plucky golden-curled child the projection of a future viceroy, a virtuous government minister or the responsible owner of a great landed estate.[99]

130 William Dyce,
*Titian's First Essay in
Colour*, Aberdeen, Art
Gallery

This prospective image of greatness is a precursor of the retrospective scenes, so popular in the nineteenth century, of formative incidents in the childhood of historic figures – such as William Dyce's *Titian Preparing to Make his First Essay in Colour* (fig. 130)[100] showing the great Renaissance painter as a schoolboy with a sketchbook, brooding over vividly coloured flowers before a white stone statue of the Virgin; John Everett Millais's *Boyhood of Raleigh*,[101] in which the future Elizabethan navigator has been sailing toy boats by the shore, and now sits enthralled by the reminiscences of an old sea dog, or even the same artist's *Christ in the Carpenter's Shop* (*Christ in the House of His Parents*),[102] a contentiously naturalistic depiction of the Christ Child wounded by a carpenter's nail.

Prospective or retrospective, such pictures share a certain solemnity. An episode in the childhood of a heroic adult must reach beyond *genre* to epic, for it depicts the origins of greatness rather than its comic mimicry. The idea is spelled out most clearly in the non-narrative predecessor of such scenes: dynastic imagery, in which the child, father to the man, is linked without irony to the man his father.

PART III

'MINIATURE ADULTS'

CHAPTER 8

Children's dynastic portraits

GOYA'S SAVAGE DRAWING OF *Childish Rage* (fig. 131)[1] demonstrates why dynastic portraits of children, some of the best-loved images of childhood in Western art, were specifically designed to deny the childishness of their sitters. Goya's creation, his torn clothes in disarray, his book thrown on the floor, one shoe kicked off, sits wailing and pulling his hair in a tantrum. He is as violently moved by his fickle passions as the whirligig beside him is by the wind: emblematically childish, perhaps a childish adult.[2] No one would wish to be the subject of such a person. When painted in their dynastic role, children of both sexes must be portrayed as exceptions to the laws of nature, embodiments of adult virtues in childish frames.

Portraits of (or in imitation of) royal children were painted to enable far-flung relations, often at foreign courts, to keep in touch,[3] played an important part in international alliances, and, like photographs of ruling families today, were frequently produced to be replicated. Many of the best artists of their day spent part or all of their working lives at a princely court, some running extensive workshops for the precise purpose of supplying portraits of the monarchs' familiars, 'down to the cats';[4] and many, acceding to the demands of their profession, gained the opprobrium of posterity for supposedly 'perceiving children as miniature adults'. Despite differences in details of etiquette and costume, and even in religious beliefs, courtly ideals have been

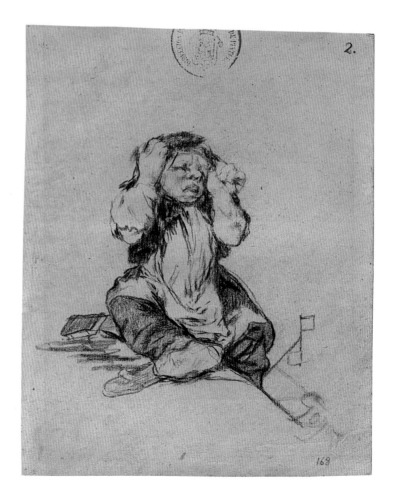

131 Francisco Goya,
*Childish Rage, c.*1825–8,
black crayon drawing,
Bordeaux Album II, 2,
Madrid, Prado Museum

strikingly homogeneous throughout Europe; differing local and individual artistic styles cannot disguise the similarity in pictorial strategies adopted by court painters, traces of which still surface in formal studio photographs.

By the sixteenth century, Western artists had regained and even surpassed classical Antiquity's ability to capture a likeness and depict childlike children, perhaps no one more so than the great Venetian master, Titian. Not a portrait specialist, yet the most illustrious portraitist of the age, this 'tractable and pleasant person'[5] who seemingly empathised with all his sitters from toddlers to the Holy Roman Emperor, was able to capture the elusive emotions of a small boy at a solemn family occasion that never actually took place (fig. 132),[6] or to convince us of the literal reality of a faun, trailing as his toy the head of a deer, dismembered by wild bacchantes (fig. 133).[7] Only part-human, this radiant *ur*-child, innocently cruel embodiment of the life-force, personifies a primitive stage in the evolution of mankind, as the similar figure of *Pueritia* in Nicolas Solis's print personifies a stage of individual human development (fig. 94).[8]

Despite his profound sympathy with children, even Titian, like all painters from the late 1400s until the emergence of the royal 'conversation piece' in the 1760s,[9] checked the movements of his 'dynastic' child sitters,[10] and wiped obvious emotions off their faces, immobility and impassivity being the most obvious means of confuting the stereotypes of *pueritia* without compromising physical resemblance. His celebrated portrait of the two-year-old heiress Clarissa Strozzi, daughter of an eminent

132 Titian, *The Vendramin Family venerating a Relic of the True Cross*, c.1540–5, London, National Gallery, detail of Federigo Vendramin with his dog and an elder brother

133 Titian, *Bacchus and Ariadne*, 1520–3, London, National Gallery, detail of faun-child with deer head

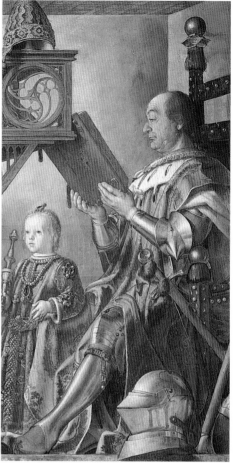

134　Titian, *Clarissa Strozzi*, 1542, Berlin, Staatliche Museen, Gemäldegalerie

135　Justus of Ghent and 'Petrus Hispanicus', *Federico da Montefeltro and his son Guidobaldo*, 1476–7, Urbino, Galleria Nazionale delle Marche

Florentine exile in Venice, beguilingly preserves the toddler's appearance while suppressing most clues to her age, except for her affinity with her dog (fig. 134).[11] While her own pose suggests only potential motion, Titian has wittily depicted 'real' movement in the fictive Antique stone relief of wildly struggling *putti* – timeless emblems of the kind of unbridled childishness that the living child, a future pawn in marriage negotiations, has seemingly renounced.

Although the daughters of hereditary rulers were routinely depicted,[12] it was the longed-for male heirs, often their fathers' only sons, who appeared in the most insistently prospective dynastic portraits, as if the idealised representations themselves could ensure the survival to adulthood, and form the character, of the child portrayed.[13]

One of the more poignant early dynastic images, the 1476–7 portrait of *Federico III da Montefeltro and his son Guidobaldo* by Justus of Ghent and 'Petrus Hispanicus' (fig. 135)[14] shows the four-year-old Guidobaldo, who had lost his mother at birth, in

a splendid gown that could have been worn by an elderly dignitary as well as by an unbreeched little boy. While his father displays his attributes as Duke of Urbino,[15] Captain General of the Church, recipient of the English chivalric Order of the Garter, and devotee of humanist learning, the child leans trustingly on the paternal knee – but expressionless, introspective, and still, '*sage comme une image*',[16] holding Federico's sceptre or baton of command. The relationship of father and son is represented as in a sense reversible: like the helmet at Federico's feet, Guidobaldo is an appurtenance of his father's, but everything that appertains to his father – sceptre, armour, books – will one day distinguish him. Baldassare Castiglione, attached to Guidobaldo's court from 1504 and writing some years after the young Duke's own death in 1508, unwittingly described the ideals, and the easily predictable future circumstances, so precisely encapsulated in this picture:

> Following then the course of nature and being already sixty-five years old, [Federico] died [in 1482] as gloriously as he had lived, leaving as his successor his only son, a child ten years of age and motherless, named Guidobaldo. This boy, even as he was heir to the state, seemed to be heir to all his father's virtues as well, and in his remarkable nature began at once to promise more than it seemed right to expect of a mortal; so that men judged none of the notable deeds of Duke Federico to be greater than his begetting such a son.[17]

Despite the attributes of power, the poses of father and son seem curiously informal and anecdotal for a state portrait; this is explained by the panel's original location in the Duke's *studiolo*, his preciously decorated private study, in the palace at Urbino. The fiction proposed is that the scene we are privileged to witness mirrors a real event happening in the same room. But the perspectival construction of the shallow niche in which Federico and Guidobaldo appear suggests the panel was made to hang high, among the Famous Men of the painted frieze above the intarsia of walls and cupboards. Even now, with the picture removed from its original location, the perspective ensures that we view the Duke and his small heir from below, and that they can look at us *de haut en bas*.

A generation later, across the Alps, the Elector of Saxony Johann the Steadfast, another widowed ruler, had his own likeness paired with that of his only son and heir, six-year-old Johann Friedrich, later known as 'the Magnanimous'. The court painter Lucas Cranach framed the two portraits – the father's bust-length, the son's half-length to emphasise his smaller size, although he fills more of the panel's surface – to form a hinged diptych that can be closed or opened like a book (fig. 136a, b).[18] In Northern Europe at this date the format was normally reserved for the likenesses of man and wife, but the little boy's mother, Sophia of Mecklenburg, had died giving birth to him in 1503; touchingly, on the back of his portrait are the coats of arms of Saxony and Mecklenburg. The chequer-board colour scheme of the two pictures – green background and black costume in the Elector's, black background and green costume in Johann Friedrich's – demonstrate that Cranach planned the pairing from the outset.

While the portrait of Johann the Steadfast may be derived from a pre-existing drawing kept in Cranach's workshop for use in different contexts,[19] the more spontaneous likeness of little Johann Friedrich appears to have been taken specifically for this painting – and may represent the boy's first formal engagement. He is posed full

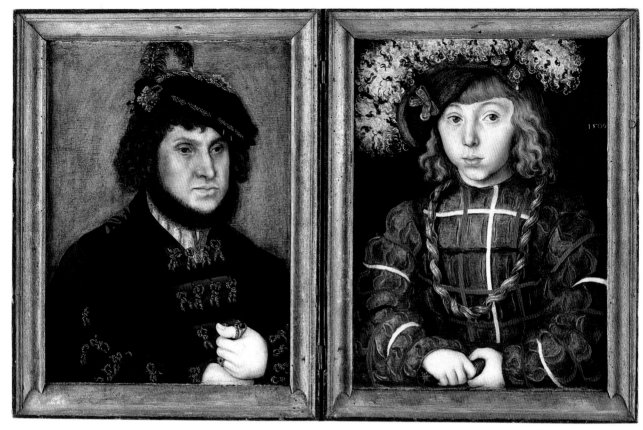

136a, b. Lucas Cranach the Elder, *Johann the Steadfast, Elector of Saxony, and his son Johann Friedrich the Magnanimous*, 1509, London, National Gallery

face, the slight forward tilt of his face and his sidelong glance suggesting childish curiosity restrained by the command to keep still. The fantastical ostrich plumes of his hat, his curls, the curving slashes of his doublet revealing its blood-red lining, the twisted gold links of his chain – all these vibrate as if with the child's pent-up energy, while he himself, like a coiled spring, sits immobile. Painting him clasping the hilt of a sword or poniard in the pose of a fearless knight, Cranach succeeds in suggesting the courage of a little boy striving to rise to the occasion, to do justice to his finery and his princely role. When the right-hand panel is seen alone, Johann Friedrich appears at the spectator's eye level; when both panels are viewed together, the higher placement of his face suggests he is looking down at us.

This device is particularly startling in portraits of small children, whom adults normally see from above. Hans Holbein makes perhaps the most deliberate use of it in his likeness of *Edward, Prince of Wales*, Henry VIII's only son (fig. 137)[20] – the earliest known portrait of the boy whose mother, Jane Seymour, also died when he was born, who was barely nine years and three months old when he succeeded his father on the English throne, and who died before his sixteenth birthday. The painting is generally identified with the New Year's gift Holbein is known to have presented to King Henry in 1539, when the child was about fourteen months. Whatever its precise date,

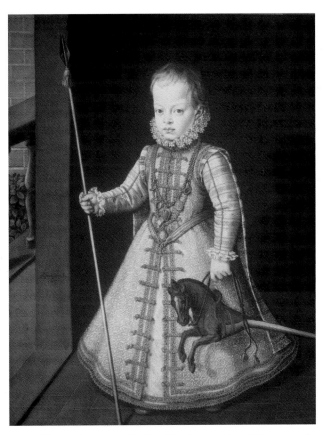

137 Hans Holbein the Younger, *Edward, Prince of Wales,* *c.*1538, Washington, National Gallery of Art, Andrew W. Mellon Collection

138 Alonso Sánchez Coello, *The Infante Don Diego, son of Philip II,* 1577, Private collection

the painting clearly shows Edward as still a toddler; he is nonetheless pictured in an adult pose, holding his gilt rattle like a sceptre, with his right hand raised in a gesture of regal salutation. We must not imagine that the baby could possibly have sat like this for Holbein; his face is based on a drawing from life still in the Royal Collection, but the haughty stance is an invention of the artist.

Holbein's subtlest means of idealisation, however, is to have shown Edward 'in close-up' just behind a velvet-covered barrier seemingly coinciding with the surface of the panel, his left arm as if protruding into our space. Although we are so near, minimal perspectival clues, mainly the visible underside of the plumed hat set over the baby's cap, locate our point of view below him, and his hooded, unfocused gaze planes indifferently over us, confirming us in our place.

Although Edward is portrayed alone, his father is present throughout. The Latin verses of the inscription, composed by Richard Morison, a protégé of Thomas Cromwell, Holbein's patron and the King's Secretary, translate as,

> Little one, emulate thy father and be the heir of his virtue; the world contains nothing greater. Heaven and earth could scarcely produce a son whose glory would surpass that of a father. Do thou but equal the deeds of thy parent and men can ask no more. Shouldst thou surpass him, thou has outstript all, nor shall any surpass thee in ages to come.

Children's Dynastic Portraits 193

There were, however, subtler ways of invoking a child's lineage. The stillness and gravity with which Alonso Sánchez Coello endows the two-year-old Infante Diego, son of Philip II of Spain (fig. 138),[21] invalidate the traditional significance of the hobby-horse as an emblem of playful *pueritia*, although there is no reason to doubt that this was the boy's real toy.[22] Accurately shown as an unbreeched toddler,[23] Don Diego nevertheless appears fully in adult control, of himself, his lance and his horse, which he holds by the reins like a live courser. The dynastic context, and the child's unnatural stance, transmute the painting into a prospective equestrian portrait, a genre introduced in Spain, and modern Europe, by Titian's *Charles V on Horseback*, painted in 1548.[24] This shows Don Diego's grandfather, the Emperor Charles V (d.1558), in the armour he wore on the occasion of his great, though ephemeral, victory against the German Protestant princes at Mühlberg in 1547, a victory that seemed to preserve the unity both of the Habsburg Empire and the Christian faith. Titian's portrait was less the celebration of a historic occasion than the allegorical embodiment of all of Charles's political ideals.[25] Its sources range from the antique equestrian statue of the Roman Emperor Marcus Aurelius, to the figure of the Christian Knight in Albrecht Dürer's celebrated 1513 engraving *Knight, Death and the Devil*. This allusion is strengthened by Charles being portrayed with a long lance rather than the short spear he normally carried in battle; the lance improbably held by little Don Diego in Figure 133 confirms the reference back to Titian. More than a child's aspirations, the painting conveys the certainty that the Infante already possesses the greatness of spirit of his own father's father, the Holy Roman Emperor Charles V, temporal head of Christendom and defender of the faith, and that only Diego's physical age confines him to skirts and a mere hobby-horse.[26]

In reality, Charles V had had to cede his German dominions and Imperial title to his younger brother Ferdinand, and neither his son Philip II nor the latter's descendants were ever able to restore Habsburg hegemony over Europe; Christian unity was sundered by the Reformation; little Don Diego died at the age of seven, and the Spanish throne was inherited by his younger brother Philip, the last and only surviving of their mother's five sons.

With Titian's equestrian portrait, Spanish court portraiture came to interpret mastery of the horse as emblematic of monarchic governance. The tradition was reaffirmed in 1634–5 in the reign of Philip IV, by the greatest of all court portraitists, Diego Rodriguez de Silva Velázquez, whose artistic development is heavily indebted to the great Titians in the Spanish Royal Collection.[27] Commissioned to decorate the *Salón de Reinos* – the grand Hall of Realms in the new Buen Retiro pleasure palace on the outskirts of Madrid, presented to the King by his chief minister, Velázquez's early patron the Count-Duke Olivares – the artist designed a scheme in which equestrian portraits of Philip, his Queen, Isabel of Bourbon, his parents, Philip III and Margarita of Austria, and his five-year-old only son, Baltasar Carlos, preside over paintings of Spanish victories and the Labours of Hercules, the King's mythical ancestor.

The longed-for male heir had been born on 17 October 1629,[28] while Velázquez was on leave in Italy; the King waited until his favoured court painter's return to have the precious child portrayed. The first likeness of Baltasar Carlos, and the first of Velázquez's portraits of Spanish royal children (fig. 139),[29] almost certainly commem-

orated the ceremony of *juramento*, the oath of allegiance to the heir to the throne, taken at the church of San Jerónimo on 7 March 1632, when the Prince was two years and four months old.[30]

Dwarves and 'natural fools', prized at most European courts though nowhere more than in Spain, were often included in their masters' portraits, to be leant on or petted in the same way as slaves or faithful dogs.[31] Their deformities and subservient status contrasted flatteringly with the royals' airs and graces, especially when the sitter was a child and the attendant an adult. Velázquez's treatment in the portrait of *Prince Baltasar Carlos, with an Attendant Dwarf* is less coarse and more moving than his predecessors'. The dwarf – himself an unbreeched child, though older than his companion – stands a step below the luminous little Prince, who is painted in the costume he actually wore at the *juramento*: a skirted captain-general's uniform with armoured collar plate and red sash. He holds a baton of command; his left hand rests on his sword. A 'black hat with pearly white feathers', recorded in the documents, sits on a cushion beside him. The toddler's stance and expression are as anachronistic as his accoutrements,[32] and the visual paradox is compounded by the figure's three-quarter turn, sash and skirts billowing behind, giving a sense of forward movement to an essentially static

Children's Dynastic Portraits 195

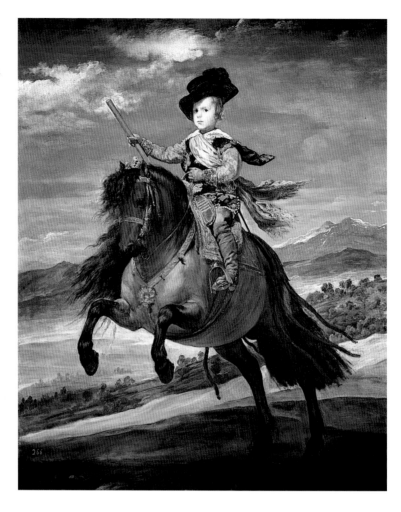

140 Velázquez, *Prince Baltasar Carlos on Horseback*, 1634–5, Madrid, Prado Museum

pose. By contrast, the dwarf, with his disproportionately large head and shadowed expression, turns back to look over his shoulder at his royal master and playmate. He wears a child's apron over his skirts, and carries a rattle and an apple, childish prefigurations of sceptre and orb, leaving the Prince's own hands free for his martial attributes. Baltasar Carlos represents the transcendent monarchic ideal to which, suspending our disbelief, we pledge allegiance; the dwarf is sublunar reality, a malformed and perennial child, subject to sulks and fretfulness, who will never grow up to be king.[33]

Only two to three years later Velázquez painted the Infante as an accomplished rider on a live pony, for an overdoor in the *Salón de los Reinos* (fig. 140).[34] Philip IV was an expert at dressage, and, unlike Charles V, had himself represented executing a movement of the *haute école*, the *levade*. *In situ* in the Hall of Realms, between the profile likenesses of his father on his rearing horse, and of his mother more sedately riding side saddle, Baltasar Carlos would have appeared to soar over viewers' heads, his rearing pony's exaggerated barrel designed to be seen from below. As Velázquez's eighteenth-century biographer, Antonio Palomino, court painter to Philip IV's successor Charles II, described it,

141 Velázquez, *Prince Baltasar Carlos in the Riding School*, *c.*1636, The Grosvenor Estate

Above the door is another picture of the Most Serene Prince Baltasar Carlos. Although very young he is armed and on horseback with a generalissimo's baton in his hand; the cob on which he is mounted, rushing with great impetus and speed, seems to be breathing fire, impatient with pride, as if anxious to seek a battle in which the victory of his master is assured.[35]

The painting's location allows the little cavalier, 'hope of Spain', to look us in the eye by looking down at us.

Even more clearly allusive to the equivalence between horsemanship and kingship is the half-narrative *Prince Baltasar Carlos in the Riding School*, painted the following year, probably for the Count-Duke Olivares, and showing the Prince's wing of the Buen Retiro palace (fig. 141).[36] On its balcony the King and Queen, with attendant courtiers, watch their five-year-old son demonstrating the *levade*; an adult dwarf is shown at the horse's tail. In the middleground, watched by the Master of the Hunt, the Prince's valet and Keeper of Arms[37] is handing a jousting lance to Olivares himself. Besides being the King's first minister, Olivares was also his Master of the Horse, and had once been an outstanding horseman. Baltasar Carlos is about to receive a les-

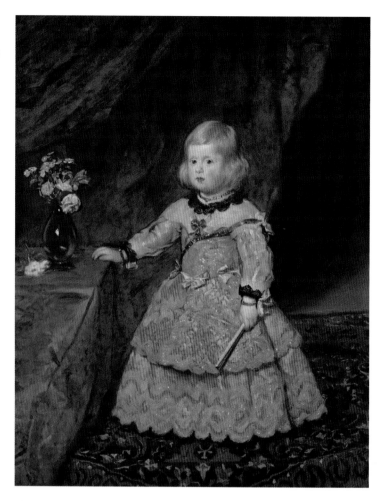

son from him in the knightly pastimes of tilting or jousting, practised by King and courtiers at the Buen Retiro.

Olivares, the not-so-grey eminence behind Philip IV's throne, claims to be teaching the King's heir, as he had earlier taught the King, how to govern.

It may seem that the bravura of these equestrian portraits violates the 'immobile, impassive' convention of royal children's dynastic imagery; Figure 141 has even been called the earliest 'conversation piece'.[38] On closer viewing, however, we see that while the horses gallop or rear, 'breathing fire', little Baltasar Carlos is not depicted as a child at play, an aspirant adult. He *is* an adult, albeit in the guise of a child: impossibly accomplished, frozen in grown-up poses and expressions. It is precisely the contrast between his adult demeanour and his carefully observed childlike physiognomy – and such details as his 'leading string' sleeves flying in the wind along with his general's sash in Figure 140 – that makes these works effective as dynastic portraits, their seeming realism almost disguising their tendentious aims.

Baltasar Carlos died in 1646 within a few days of his seventeenth birthday, two years after his mother. In 1649, the widowed forty-five year-old King, stricken with

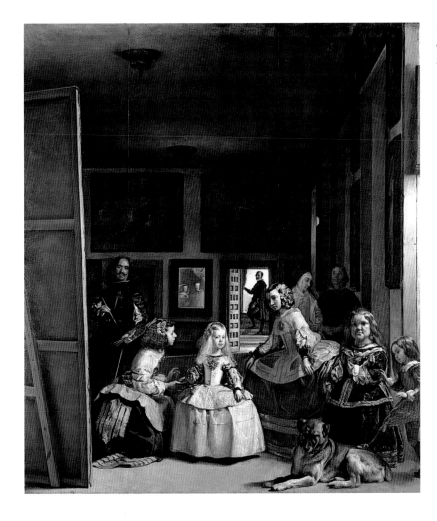

grief but also desperate to assure the succession within the Imperial branch of the Habsburgs, married his fifteen-year-old niece, Mariana of Austria, originally betrothed to his son. She was only four years older than her cousin, and now step-daughter, the Infanta Maria Teresa, Philip's only surviving child by Isabel of Bourbon.

Once again Velázquez was called upon to execute portraits of royal children. The Infanta Margarita was born 12 July 1651, shortly after the painter's return from his second trip to Italy. She is about two years old in the first of several portraits he painted of her (fig. 142).[39] Velázquez's technique was now freer than ever, the etiquette at the Spanish court more rigid. The Infanta is represented standing, resting her right hand on a low side table, in a traditional pose going back to Titian's 1550-1 portrait of the youthful Philip II, which was now reused by Velázquez also for portraits of the child's mother and step-sister. In place of their costly cambric handkerchiefs little Margarita holds a fan. Her hair is still lustrous and wispy, not yet the women's extravagant wig-like coiffure, and she wears petticoats, not a farthingale. These differences hardly account for why we immediately perceive her as a little girl and not a 'miniature adult',[40] and I am at a loss to explain by what means Velázquez has suffused

the picture with such tenderness, when his contemporary portraits of Queen Mariana, rendered with equally fluid brushwork and audacious colours, evoke such rigid formality. The child gazes impassively past us, yet it is not only the flower piece beside her that speaks of fragile and evanescent beauty.

Some three years and a few portraits later, in 1656, five-year-old Margarita became the protagonist of Velázquez's greatest painting, the masterpiece we now call *Las Meninas* or *The Maids of Honour*, that contemporaries entitled *La Familia* or 'The [Royal] Family', and inventories taken after Philip's death described as 'The Empress with her ladies and a dwarf', and 'A portrait of the Infanta of Spain with her ladies-in-waiting and servants by the Court Painter and Palace Chamberlain Diego Velázquez, who portrayed himself in the act of painting'.[41] Palomino refers to it as 'the large picture with the portrait of the Empress (then Infanta of Spain), Doña Margarita Maria of Austria, when she was very young' (fig. 143).[42] The huge canvas, over three by two and three-quarter metres, is so atmospheric, so natural-seeming, that in its presence we can but echo Palomino's 'for it is truth, not painting',[43] and the sentiment's witty reprise by the French nineteenth-century poet and critic, Téophile Gautier, 'But where is the painting?'[44]

There is little need to add to the vast flood of commentary spawned by this extraordinary work. Palomino tells us that it represents the room in the palace at Madrid formerly belonging to Baltasar Carlos, where Velázquez now had his studio and the picture itself was painted. He names all but one of the Infanta's retinue; explains that she is being served water from an earthenware jug, and remarks that the dog – 'ferocious in mien' but allowing itself 'tamely and gently' to be trod on by the dwarf Nicolasito Pertusato – remained motionless while it was being painted. He also calls attention to the 'ingenious device' by which Velázquez shows what he is painting on the large canvas resting on the easel: 'availing himself of the clear light of a mirror . . . at the back of the room and facing the picture, with its reflection showing our Catholic King Philip and Queen Mariana.' It is now generally thought, however, that the reflection in the mirror is meant to show the royal couple in person rather than a double portrait (otherwise nonexistent) of the King and Queen.[45]

As in Velázquez's *Prince Baltasar Carlos in the Riding School*, Figure 140, though on a grander scale and with more complex artifice, King Philip and his Queen (an older King, a different Queen) are shown sketchily in the background, admiring the accomplishments of their child, now heir to the throne of Spain[46], *faute de mieux* only a girl, but one who could ensure, through marriage to her Habsburg cousin-uncle Emperor Leopold I, the reunification of Spain with the Empire. As a girl she cannot be shown brandishing a general's baton, fingering a sword or mastering a horse. She can only exhibit, in Palomino's words, 'her great charm, liveliness and beauty' – albeit with an incipiently protruding Habsburg lower jaw – her white and silver frock with its grown-up farthingale, her elegant deportment as the centre of attention and ceremonious service. Of all the people in the room, the little Infanta is virtually alone in doing nothing but posing, for she has not yet picked up her little jug nor even eyed it. Her only counterpart is the German-born 'Maribárbola, a dwarf of formidable aspect', as Palomino calls her. When we strip away all the bustling incidentals, we find once more, as in the *juramento* portrait of little Baltasar Carlos, Figure 139, the traditional Spanish duo of prince and dwarf, the ideal and its malformed counterpart.

The 'ingenious device' of the mirror ensures that the Infanta's parents see her as we do, from the viewer's space in front of Velázquez's painting.

The story of this greatest of all series of dynastic children's portraits does not, however, end here, nor with the numerous portraits of Margarita, despatched at intervals to her promised bridegroom in Vienna. On 28 November 1657, a year or so after *Las Meninas*, a sickly little boy was born to King Philip and Queen Mariana, by virtue of his sex displacing Margarita as heir to the throne. In 1659 Velázquez painted two portraits, *The Infanta Margarita in Blue* and *Prince Philip Prosper* (fig. 144),[47] to send to the Emperor Leopold. The artist would never paint either of the children again. By this time elevated to the demanding posts of Gentleman of the Bedchamber and Chief Chamberlain of the Royal Palaces, he returned in 1660 from organising the celebrations of Maria Teresa's betrothal to her cousin Louis XIV of France, and died before he could unpack his bags. In 1661 little Philip Prosper breathed his last. Later that year Charles, Philip IV's last legitimate son, was born. The offspring of so much interbreeding, duly painted by Velázquez's successor Juan Carreño de Miranda, was mentally and physically unfit, but, partly under his mother's regency, reigned as the last Habsburg King of Spain from Philip IV's death in 1665 until his own in 1700.

Philip Prosper may have sat, or rather stood, to Velázquez in celebration of his second birthday on the feast-day of Saint Prosper. The military trappings of Baltasar Carlos at his *juramento* (fig. 139) have here given way to the snowy toddler's apron – 'befitting his tender years', says Palomino – with 'beside him a hat with a white plume'. Like his aunt Anne of Austria over fifty years earlier (fig. 19), the little boy is depicted wreathed in amulets – a fig hand of jet, a little bell to ward off sorcery and the evil eye – reflecting well-founded fears for his survival. Nor is Velázquez sparing in recording the child's thinner cheeks, and larger eyes; where little Margarita's plump hand does not quite reach the table she leans on (fig. 142), Philip Prosper's wrist rests limply on the back of his chair. In pitiful contrast to the frail, dutiful little boy is the bright-eyed smiling dog: 'a little bitch which seems to be alive and is a likeness of one for which Velázquez had much affection. It appears,' continues Palomino,

> that he followed the example of Publius, an excellent [ancient Roman] painter, who portrayed his beloved little bitch Issa in order to immortalise her, as [the Latin poet] Martial wittily relates: he could have said the same about Velázquez. That death should not rob him of her altogether, Publius portrays her in a picture, wherein you will see an Issa so like that not even the dog herself is so like herself. In fine, set Issa alongside her picture; you will think either that each is genuine or you will think that each is painted.

Palomino, the admiring court painter, finds a classical parallel for Velázquez's life-like representation of the little dog, but his words of praise for Philip Prosper's likeness reveal more about the austere demands of dynastic child portraiture:

> It is one of the finest portraits that Velázquez ever painted, despite the great difficulty in painting children, because they are exceedingly lively and restless.[48]

Next to Velázquez's, the best-known portraits of royal offspring must be those painted by his exact, though shorter-lived, contemporary, Anthony Van Dyck, at the court of Charles I, King of Great Britain and Ireland, and his Catholic wife Henrietta Maria (sister of Louis XIII of France, sister-in-law of Anne of Austria and of the latter's brother Philip IV of Spain). Under Rubens's influence, Van Dyck, like Velázquez, chose to emulate Titian; it is mainly the Venetian master who features in the sketchbook he compiled during his travels in Italy, 1621 to 1627.[49] And it was during this time, while portraying the families of Genoese grandees, that the precocious Fleming began to excel in portraits of children.[50]

The revolution in painting style effected by the artist's arrival in London is well documented. Holbein's originally robust yet sensitive realism had in his own later years and at the hands of his successors declined into two-dimensional 'playing-card' mannerism. Van Dyck's immediate predecessor at court, the Dutchman Daniel Mytens, had restored fidelity to three-dimensional appearances, but his work was too static and pedantic to inspire. Disrupting the rigid schemata of Elizabethan and Jacobean portraiture, Van Dyck endowed his sitters with his own refined version of Titian's vibrancy. When in 1635 he depicted the *Three Eldest Children of Charles I* (fig. 145),[51] he had already been the knighted 'Principal Painter in Ordinary to their Majesties' for some three years, and had in turn ennobled the images of an unprepossessing King and Queen. In 1632 he had portrayed them with their two eldest children – Charles, born in May 1630, Prince of Wales and the future Charles II, and his

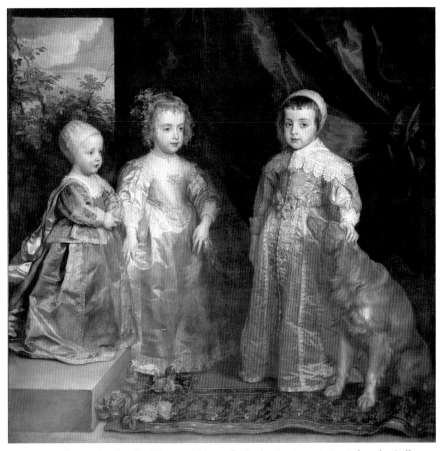

145 Anthony Van Dyck, *Three Children of Charles I*, 1635, Turin, Sabauda Gallery

sister Mary Henrietta, born in November 1631, Princess Royal, future wife of Prince William II of Orange – in the grand family portrait known as 'The Greate Peece', originally intended for the Privy Gallery at Whitehall. Now, however, he was representing Charles, Mary and their little brother James, born in October 1633, on their own; the picture was commissioned by the Queen to be sent to her sister Christina, Duchess of Savoy, in exchange for portraits of Christina's children.

Hierarchy is observed even in this family portrait: five-year-old Charles is isolated from his siblings, hand on large adoring spaniel. His dark and lustrous eyes, level with the viewer's, hold the latter's gaze. The other children solemnly stare into space.

The curious thing about this beautiful and seemingly irreproachable court portrait is the King's reputed reaction; he was said to be 'angry with' Van Dyck. The report, in a letter to his master from the Ambassador of Savoy in London, is somewhat garbled. Benoît Cize writes that the Queen had shown him '*Les Portraits des messieurs les Princes les enfans*', saying that the King was '*faché contre*' Van Dyck '*por ne* [sic] *leur avoir mis leur Tablié* [sic] *comme on accoustume aux petit* [sic] *enfans*'.[52] Despite literally meaning that the King was angry with the painter for *not* having shown the children in infants' 'coats', this has been interpreted as reporting Charles's anger that his heir *had* been depicted unbreeched like any small child[53] – despite the fact that the prince's cuffs

and collar are bordered more extravagantly than the others' with large points in precious lace, a fashion at the Stuart court so often depicted by the artist that it is now known as 'vandyke'. This reading of the King's displeasure is almost certainly correct, for a few months later Van Dyck was commissioned to paint another group of the three children, now in Windsor Castle (fig. 146).[54]

In this second picture, Prince Charles wears silk doublet and breeches. In the nonchalant pose of Van Dyck's young noblemen, he leans on his elbow against the base of a column, legs crossed, gaze absent, relaxed right hand showing off long and tapering fingers. In the painter's beautiful invention, his left hand is open to the trusting clasp of his little brother James, who hangs on Charles's arm but looks with faint anxiety towards his sister, mediating between the two older children. It is Princess Mary, hands demurely poised on her gauzy *tablier*, who catches the viewer's gaze. The group is book-ended by two spaniels; an implicit X runs from the head of Charles on our left to the spaniel on our right, and from Mary's head on our right to the left-hand spaniel, crossing at the joined hands of 'the heir and the spare' in almost the exact centre of the canvas.

Van Dyck deploys impassivity hierarchically, in descending order from the Prince of Wales down to his youngest sibling, who is shown behaving almost like a real child. The device animates the group portrait and disguises its artificiality, while at the same time reinforcing its dynastic message: the relationship between the Prince of Wales and the Duke of York is depicted as a vignette of sibling affection, dependence on and deference to the heir to the throne.

In 1637 Charles I commissioned from Van Dyck his most famous and influential portrait of the royal children, numbering five since the birth of the Princesses Elizabeth in December 1635 and Anne in March 1637 (the latter was to die in 1640) (fig. 147).[55] The heads of the youngest two are the subject of a rapid oil sketch, now in a private collection, establishing 'the touching relationship between them which Van Dyck developed on the final canvas'.[56] Although the baby appears to turn towards her, Princess Elizabeth is not actually looking down at Anne, and the 'touching relationship between them' in the painting was probably the artist's invention, as was almost certainly the Italianate state of unswaddled nakedness in which Anne is shown, incongruously still wearing the infant's cap that appears in the sketch from life. A more probable interpretation of the little Princesses' behaviour is that proposed by Christopher Brown: the baby reaches for her eldest brother and is stopped from falling out of her chair by her sister.[57]

Above the toddler and the infant Van Dyck painted a lavish still life of a silver ewer and basin with fruit – a common pictorial allusion to human fruitfulness, here framed in a precious setting. Below, a small spaniel attentively watches the lively baby's kicking feet.

In total contrast to this pseudo-informal passage, in which an infant wiggles and gurgles and her older sister affectionately plays 'mother', the three eldest children in the centre and to the left of the canvas composedly enact their dynastic roles in ascending order of dignity. The six-year-old Princess Mary Henrietta, although still in a child's leading strings and apron, poses like one of Van Dyck's aristocratic ladies, a hand across her stomach and the other in the folds of her skirt, coolly acknowledging our admiration. The four-year-old James stands almost to attention in his infant's

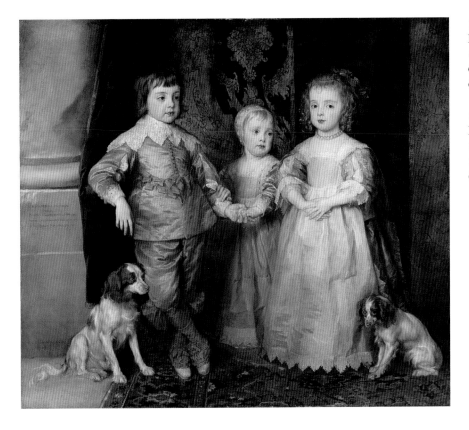

146 Anthony Van Dyck, *Three Children of Charles I*, 1635, Windsor Castle, Coll. H.M. the Queen

147 Anthony Van Dyck, *The Five Eldest Children of Charles I*, 1637, Windsor Castle, Coll. H.M. the Queen

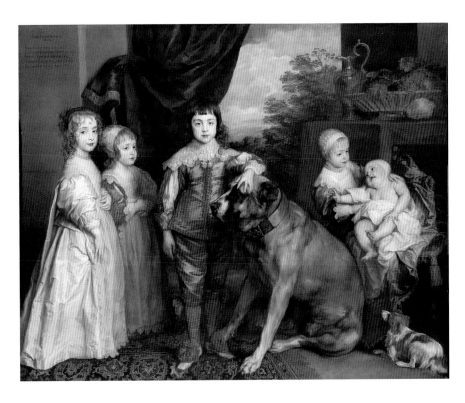

coats, hands folded across his middle (a sketch from life, now at Christ Church, Oxford, shows him with hands at his sides). Almost absurdly regal for a seven-year-old, Charles, a slight cast in his eyes as he focuses on the viewer, appears in the centre with his left hand on the massive head of the huge, deferential mastiff.

Probably based on the same sitting is a portrait, painted for the Earl of Newcastle but now at Windsor Castle, of the Prince of Wales alone, in armour, a pistol in his right hand and his left resting on an extravagantly plumed helmet.[58]

In May 1641 Mary Henrietta Stuart was married in the Chapel Royal to William, Prince of Orange, son of Frederick Henry, Stadtholder of the United Provinces of the Netherlands. The marriage marked the dynastic triumph of Frederick Henry's foreign policy: a minor princeling, head of government of a federation of oligarchic republics, he had succeeded in marrying his son to the eldest daughter of the King of England. The occasion was marked with a double, full-length formal wedding portrait from Van Dyck's studio, commissioned by the bridegroom's parents and executed in the last months of the artist's life.[59] It shows the fifteen-year-old Prince of Orange holding in his right hand the ten-year-old Princess Royal's left hand, on which a wedding ring has just been placed. No longer merely 'prospective', the image accurately mirrors the adult pressures on royal children's real lives. The following year the bride crossed over to Holland. In 1647, when she was sixteen, her husband succeeded his father as Stadtholder; when she was nineteen, in November 1650, he died, and eight days later she gave birth to his son, William III, Prince of Orange, who in 1688 would become co-ruler of England with his wife, another Mary Stuart, eldest daughter of his uncle James.

Van Dyck's 1630s paintings of the Stuart children facilitate viewers' suspension of disbelief in the myths of court life and dynastic succession. Unlike Velázquez, the artist succeeds in dispelling any sign of constraint, of disjuncture between the conventions of dynastic representation and the actual nature, desires or behaviour of the royal children. From now on, the young heirs of English kings shall be seen as worthy of their role because they appear naturally at ease and happy in it.

Van Dyck's lasting impact is most obvious in portraits by those leading eighteenth- and early nineteenth-century English painters who fell under his spell, notably Thomas Gainsborough and Thomas Lawrence. But his specific contribution to the portraiture of royal children can better be gauged from works by a very different and less brilliant artist, Johan Zoffany, born Johannes Josephus Zauffaly near Frankfurt-am-Main, Germany, in 1733 – the next foreign-born painter at the British court to effect a major revolution in the genre.

Not long after his arrival in Hanoverian England in late 1760, Zoffany was commissioned by the actor-manager David Garrick to paint him in various of his celebrated roles. The artist, trained in an eclectic German tradition that suited style to pictorial genre and function,[60] quickly showed his mettle in the theatrical conversation piece invented c.1728 by Hogarth, and shortly after in the conversation piece *tout court*: a full-length, small-scale informal group portrait in which friends, or the mem-

148 Johan Zoffany, *George, Prince of Wales, and Frederick, later Duke of York*, 1764, Coll. H.M. the Queen

bers of a single family, are shown in lively and plausible interaction, with hierarchy apparently ignored and all the figures given nearly equal prominence.

Having made his reputation in London with the paintings for Garrick, Zoffany found an even more influential patron in John, 3rd Earl of Bute, Prime Minister, friend and mentor to King George III and his German-born Queen, Charlotte Sophia of Mecklenburg-Strelitz. For the Earl, Zoffany painted, c.1763–4, a single portrait of his eldest son, *John, Lord Mountstuart, in masquerade dress*, a shimmering costume in the style of Van Dyck's young Cavaliers, and two better-known conversation pieces of the Earl's three younger sons and his three daughters, playing outdoors in compositions carefully contrived to seem spontaneous.[61]

Probably recommended to the Queen by Lord Bute, Zoffany inaugurated the genre of the royal conversation piece in 1764 with pictures of her two eldest sons at play in actual rooms at Buckingham House, the palace built earlier in the century for the Dukes of Buckingham, then bought and redecorated by the King for his wife when they married in 1761. The novelty may be as much to the patron's credit as the artist's. Like Queen Charlotte, Zoffany was brought up at a small German court and spoke better German than English; he must have gained her confidence and sympathy, and she may have purposely commissioned from him a type of painting in which he had already distinguished himself. Conversely, the artist may himself have suggested the domestic format, popular in Germany but thought of in England as typically English, to exceptionally family-loving monarchs eager to figure as enlightened patrons of learning and art.

The portrait of *George, Prince of Wales, and Frederick, later Duke of York* (fig. 149)[62] shows the little boys in the second Drawing-Room or Warm Room of Buckingham House.[63] Loose covers left on the chairs and sofa indicate that the room is not in use by adults, and emphasise the informal nature of the painting. George, some two years old – he was born in August 1762 – is standing hat in hand next to his little brother, born a year later, seated on a chair drawn into the centre of the room nearer the fire. Frederick is recorded to have taken his first steps 'quite alone' on 11 September 1764, and the picture may have been painted before he could walk steadily; since both children are depicted in infants' coats, it was certainly executed before Prince George was breeched on 31 March 1765. The boys are playing with a cheerful little spaniel, who has rucked up Frederick's skirts to reveal the child's chubby leg.

To the actual furnishings of the room, that included pictures by Van Dyck – we recognise the second group of the *Three Children of Charles I* with the Prince of Wales in breeches (fig. 145) – Zoffany added portraits of his own invention of the King and Queen, and imported from another part of the palace an Italian picture of *The Infant Christ Watched over by Angels*. With the lightest possible touch, invisible to those not in the know, the artist alludes to George's and Frederick's dynastic roles, and even suggests unbroken continuity between the Stuart and Hanoverian dynasties.[64] Watched over by their parents, the little boys are also under the special protection of the infant Christ, child-god of children.

Queen Charlotte with her Two Eldest Sons shows George and Frederick with their mother in her dressing-room in Buckingham House (fig. 150).[65] The boys' real fancy-dress costumes were ordered on 6 September 1764 and delivered two days later, when the princes put them on;[66] they are 'a Telemachus Dress for the Prince of Wales and

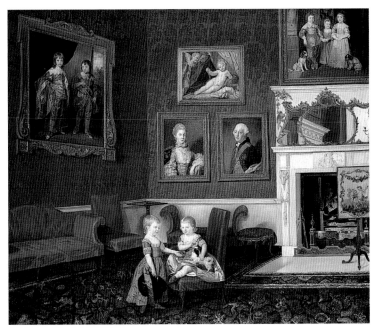

149 Johan Zoffany,
*George, Prince of Wales, and
Frederick, later Duke of
York,* 1764, Coll. H.M. the
Queen

150 Johan Zoffany,
*Queen Charlotte with her
Two Eldest Sons,* 1764,
Coll. H.M. the Queen

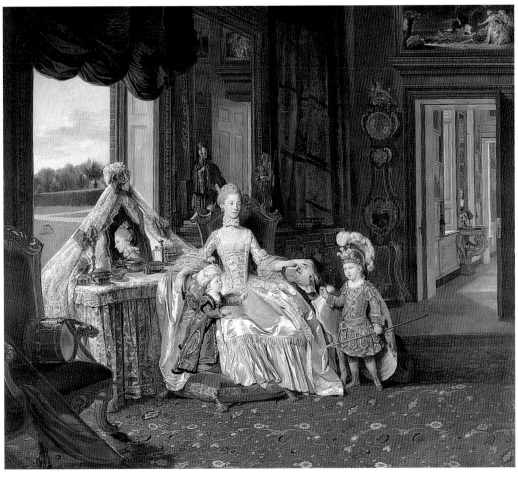

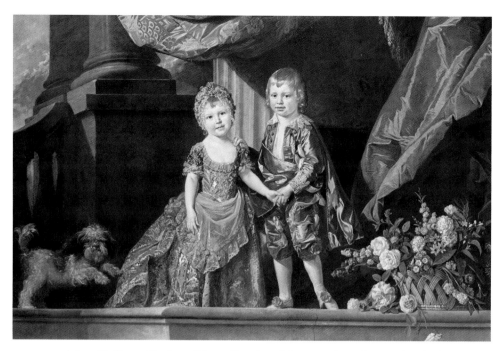

151 Johan Zoffany, *Charlotte, Princess Royal, and Prince William, later Duke of Clarence
and William IV*, *c.*1770, Collection H.M. the Queen

a Turk's for Prince Frederick'. The court's own sense of decorum makes it unneces-
sary for the artist to introduce extraneous or invented symbolism. Although George's
costume copies contemporary theatrical designs for Roman military dress,
Telemachus is a hero of Greek mythology. Son of Ulysses and Penelope, he is
described in the *Odyssey* as searching for his long-absent father; on his return, he finds
Ulysses at home and helps him kill the suitors who had gathered around Penelope.
Even in play, the heir to the throne is directed towards love for and loyalty to his
father, pressures which this Prince of Wales later notoriously resisted.

These pictures are vastly different from Van Dyck's portraits of the children of
Charles I, but they might never have been painted had Van Dyck not indelibly marked
the iconography of English royalty by stressing the 'natural' affections of his sitters. In
1770 Zoffany was commissioned to paint a formal portrait of the Royal Family
inspired by 'The Greate Peece', in which *George III, Queen Charlotte and their six Eldest
Children* are actually wearing 'Van Dyck' costume; the painting was publicly exhibited
and reproduced as a print.[67] Probably that same year, he also depicted *Charlotte,
Princess Royal, and Prince William, later Duke of Clarence and William IV* (fig. 151),[68] the
King's eldest daughter and his third son, in a decorative pastiche of Van Dyck that may
have been intended to hang above eye level.

Dressed in 'Van Dyck' costume, four-year-old Charlotte and five-year-old William
pose parallel to the picture plane, their left hands joined in a curve that delicately
echoes the swathe of Baroque drapery behind them. Charlotte is winsome, William
gently assertive. An optical paradox points up the contrasts of grandeur and intimacy:
the massive background colonnade springs high above the viewer's head, but the smil-
ing children, whose eye level is at that same height and who would in reality be look-

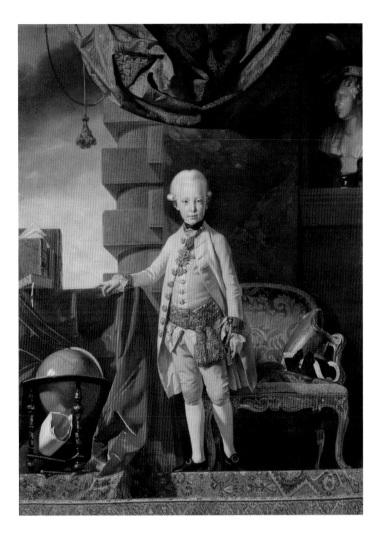

ing down at us, address us eye-to-eye. A comical dog bounds in towards Charlotte. Set on the ledge alongside William, the large basket overflowing with blossoms alludes to the fleeting joys of childhood, but, more importantly, creates an optical illusion that accentuates the sitters' miniature stature. If we first focus on the flower-piece, the ledge appears as a tabletop or mantelpiece, on which Charlotte and William stand as living ornaments, like the fashionable figurines of shepherd and shepherdess in Meissen porcelain.

It is the picture itself that is playful, while the children remain sedate. That the playfulness was intentional, and not an accidental side effect, is substantiated by a portrait using a similar perspectival construction, painted by Zoffany in 1775, in Florence, for Pietro Leopoldo of Habsburg-Lorraine, second son of the Empress Maria Theresa, Grand Duke of Tuscany, later Emperor Leopold II (fig. 152).[69] It represents the Grand Duke's eldest son and heir, seven-year-old Archduke Francis, standing on a ledge, in a pose familiar to us from Spanish royal portraits. He is surrounded by attributes of his education and prowess: books, a globe, maps, an Antique bust – thought at the time to represent the enlightened Roman Emperor Marcus Aurelius – and on the throne-

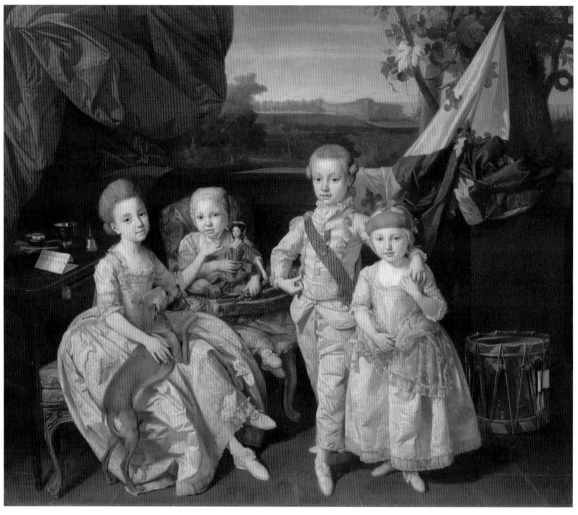

153 Johan Zoffany, *Four Grandchildren of Maria Theresa*, 1778,
Vienna, Kunsthistorisches Museum

like chair behind him, a breastplate and a cockaded hat. The child's hair is powdered;
he is dressed in uniform with elaborate sash and sword, most likely court dress as worn
at the Grand-Ducal court.[70] At his neck is the Order of the Golden Fleece, bestowed
on him at the age of one month and signifying his right to the Austrian crown. As he
tilts his head slightly forward, so as to avoid the distortion of foreshortening, his unfo-
cused gaze planes benevolently over us. The picture has charm, but it is patently
entirely serious, and although painted for the child's grandmother, represents little
Francis as an ideal Enlightenment monarch and a veritable miniature adult.[71]

Zoffany left Florence in the spring of 1778 for the court of Pietro Leopoldo's sis-
ter, the Habsburg Archduchess Maria Amalia, and her husband, Duke Ferdinand of
Bourbon Parma. At Parma he portrayed – also on behalf of their imperial grand-
mother, to whom the folded letter on the table is addressed – the ruling couple's four
eldest children (fig. 153).[72]

154 Laurits Tuxen, *The Family of Queen Victoria in 1887*, 1887,
Collection H.M. the Queen

The paradox here consists in the contrast between the children's mature gaze and poses, and the attributes suitable to their ages, such as baby Charlotte Maria's coral rattle, doll and high chair, and her sister's padded crash-helmet or 'pudding'. It is most apparent in Zoffany's treatment of Louis, the Duke's five-year-old son and heir, shown wearing the Order of the Golden Fleece. The blue and white flag of Bourbon Parma draped on the wall, and the drum beneath, can be read both as toys he has just set aside, and as militaristic emblems of his estate; the ducal palace appears realistically in the landscape beyond the terrace, but is located on the picture plane directly above the child's head. The painting also demonstrates Zoffany's studied but unslavish borrowings from Van Dyck. Louis stands with one arm elegantly akimbo, the other protectively about his four-year-old sister Antonia's shoulder. Like the little Duke of York in the *Three Children of Charles I* at Windsor Castle (fig. 145), the younger child trustingly grasps her brother's hand – or, rather, one of his fingers. The eldest daughter,

eight-year-old Carolina Maria Theresa, sits with her legs crossed. She touches her baby sister's chin, as if steadying it for a photograph, simultaneously keeping firm hold of the whippet attracted to the wriggling child, like the little spaniel in Van Dyck's *Five Children of Charles I* (fig. 146).

The charm of Zoffany's portraits of royal children has in these works been 'tempered by a typically Habsburg insistence on hierarchy and ceremony',[73] but the debt to his great seventeenth-century predecessor at the English court is well in evidence.

The influence of his own royal conversation pieces on British court art has never waned. It is as apparent in commissions by the House of Windsor[74] as in those of the last Hanoverian monarch, Queen Victoria.

In 1887, to celebrate the Golden Jubilee of her reign, the Queen commissioned a painting of 'myself, with my children, children-in-law, & grandchildren'[75] from the Danish artist Laurits Tuxen, on the strength of his 1883 painting of the royal family of Denmark. The resulting picture includes fifty-five portraits, each studied from life in preliminary drawings and oil sketches; in addition, a bronze bust of the Prince Consort, Albert of Saxe-Coburg-Gotha, who had died in 1861, is shown on the mantelpiece (fig. 154).[76] The composition was worked out well in advance of the family's gathering in May, and the work was completed in December; it has been called 'perhaps the most significant [dynastic image] of the queen's long reign'.

No such assembly would have been possible before the age of steam and rapid communications; earlier group portraits of ruling families, however numerous, appear slight in comparison with this dense plum pudding of princes, princesses, grand-dukes, grand-duchesses, dukes and a marquess, gathered together in the Green Drawing Room at Windsor Castle. At its heart is Victoria, Queen and Empress, flanked by children and holding her grandmotherly arms out to the little Princess Alice of Albany about to present her with a posy. The mother of nine who loathed childbirth, the 'shadow-side of marriage', is presented by Tuxen as an embodiment of the 'Victorian values' that idealised motherhood and the family. The painting is a conversation piece writ large; as the Queen put it in a letter to her son Arthur on 6 May 1887, 'It is not to be stiff and according to *Etiquette*, but prettily grouped.' One of the criteria of 'pretty grouping' is that the children of this imperial family appear as well-behaved yet plausibly childlike little beings, shy, or inattentive, looking through a picture book, in their mother's arms or with a hand affectionately clasped by an uncle. In the upper reaches of society – as opposed to the picturesque dregs of chimney sweeps and crossing sweepers – childhood had at last been domesticated.

We have come a long way from the dynastic portraits of earlier centuries. Instead of presenting them as aspirant or miniature adults, Tuxen, following Zoffany's lead, depicts Victoria's youngest descendants as models of appealing childhood. But this restitution of their age of life to the children has perhaps unexpected consequences: it subtly implies the infantilisation of Victoria's subjects. Elizabeth I distanced herself from the motherly aspects of the female condition to reign as the 'Virgin Queen'; in the nineteenth century, it is the matriarch of European monarchs who rules over an empire on which the sun never sets.

CONCLUSION

Bubbles

I'm forever blowing bubbles
Pretty bubbles in the air
They fly so high,
Nearly reach the sky
Then like my dreams, they fade and die
Fortune's always hiding,
I've looked everywhere . . .[1]

A LITTLE BOY, DREAMILY EYEING THE 'pretty bubbles in the air' conjured up with a clay pipe and a bowlful of soapy water – Sir John Everett Millais's '*Bubbles*' exemplifies much that is peculiar to the imagery of childhood and touched upon in this book (fig. 155).[2] Painted in 1886, in appearance now the acme of Victorian kitsch, it in fact draws upon a pictorial tradition originating in the Renaissance, but illustrating an antique Latin maxim, *homo bulla*, 'man the bubble', revived by Erasmus in his *Adages* of 1500, and further commented on in the 1508 edition.[3] Soap bubbles, much less a child blowing them are not specified either by the ancient authors or Erasmus; the ancients did not have soap as we know it, and seem to have had in mind bubbles made

155 John Everett Millais, '*Bubbles*', 1886, A & F Pears Ltd

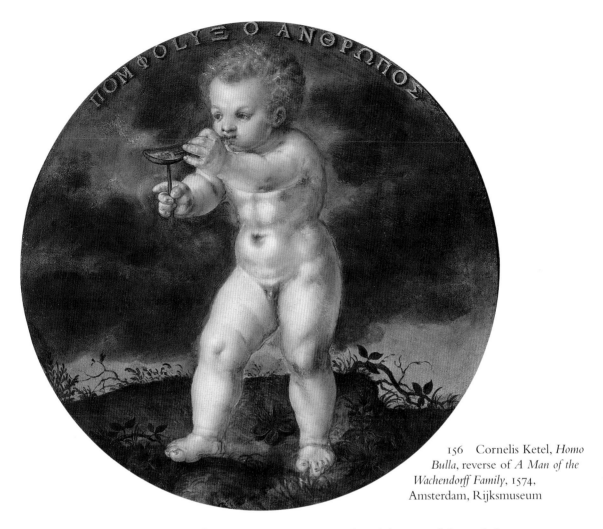

156 Cornelis Ketel, *Homo Bulla*, reverse of *A Man of the Wachendorff Family*, 1574, Amsterdam, Rijksmuseum

by sea water. The pictorial motif is thus an ingenious visual enrichment of the verbal metaphor. By the sixteenth century, blowing soap bubbles with a pipe, or, more frequently, with a reed or straw[4] must have become a familiar children's pastime; like any children's game, it evoked notions of foolishness and ephemerality that echo and extend the image of the fragile bubble itself. Even the straw, dry husk of a short-lived grass, might have recalled a venerable metaphor for the brevity of human life: 'As for man, his days are as grass' (Psalm 103:15), and 'All flesh is grass' (Isaiah 40:6; 1 Peter 1:24).

The man credited with creating the earliest known ancestor of '*Bubbles*' – an emblematic image of a *putto all'antica* blowing soap bubbles – is Cornelis Ketel, a cosmopolitan Dutch painter especially prized (though not by English patrons) for his inventive allegorical paintings. His first clients during his stay in London, 1573 to 1581, were German merchants; in 1574 he executed a double-sided circular portrait of *A Man of the Wachendorff Family*, perhaps Adam Wachendorff, Secretary of the Steelyard, the London trading centre of the merchants of the Hanseatic League (fig. 156).[5] The date and the sitter's age, 35 years, are inscribed on the front; the Latin inscription on the frame translates as 'The Word of God is eternal, all else is perishable'.[6] A watch on

157 Hendrick Goltzius, *Quis Evadet?*, engraving, 1594

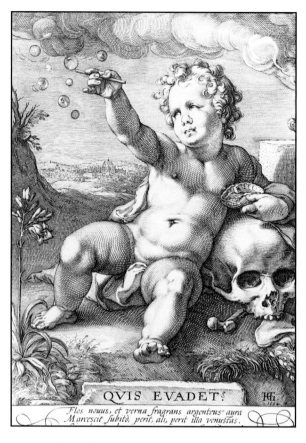

QVIS EVADET?

Flos nouus, et verna fragrans argenteus aura
Marcescit subito, perit, ah, perit illa venustas.

the table is a realistic reminder of the passage of time, the transience of life. The message is reinforced, as on a medal or coin, by the emblem on the reverse side of the round panel: standing on a wasteland against a stormy sky, a naked *putto* prepares to blow a bubble out of a mussel shell balanced on a stick. Above him is inscribed the Greek equivalent of *homo bulla*: 'Man's life is like a bubble'.[7]

Ketel's bubble-blowing *putto* soon joined the '*putto* with a skull', a popular *memento mori* introduced into European art in 1458, on the reverse of a medal by the Venetian medallist, Giovanni Boldù.[8] In 1594 Boldù's and Ketel's images were synthesised by the Dutch virtuoso Hendrick Goltzius, in a much-copied and enduringly influential engraving (fig. 157).[9]

This seemingly idyllic scene shows the *putto* reclining on a human skull and bones; he holds a shell of soapy water in his left hand, and with his right is shaking his latest-blown bubble off its straw. Smoke pours from an urn or incense burner at his side, alluding to the Psalmist's lament, 'For my days are consumed like smoke . . .' (Psalm 102:3). A lily, still in bud, grows at his feet. The Latin inscription 'carved' on a stone in the foreground asks, 'Who will escape?', and the verses below further clarify the image's lugubrious intent:

> The new and silvery flower, fragrant with the breath of spring,
> Withers instantly, its beauty perishes;
> So the life of man, already ebbing in the newly born, alas,
> Vanishes like a bubble or like fleeting smoke.[10]

More readily available than Ketel's private image, achieving symbolic resonance through a compilation of realistic details, Goltzius's poetic engraving and its variations alerted painters of later generations to the soap bubble as a *topos* of transience and futility. Seventeenth-century Dutch artists transformed the naked *putto* into a playful contemporary child, adapting the theme for more or less covertly moralising *genre* pictures. It is through the work of these '*petits maîtres*', so attractive to collectors, that soap bubbles floated into the art of eighteenth-century France and its great poet of reticent domestic genre, Jean-Siméon Chardin. The mid-nineteenth century redis-covery of both Chardin[11] and his sources occasioned the modern revival of the theme – and the retrospective structure of this concluding essay.

Unlike the more multivalent hobby-horse, the bubble always points to the single notion of transience; like all visual images, however, it is ambiguous in the absence of verbal explication. Where the words *homo bulla* or their Greek equivalent denote the fragility of human life, pictures of children blowing bubbles can suggest anything that is attractive but evanescent: not only human life and childhood itself, but also dreams, hopes, pleasure, love, honour, Shakespeare's 'the bubble, reputation',[12] the material world; they convey meaning less precisely than words, but in a more striking and memorable way.[13] Like other traditional themes of the imagery of childhood dis-cussed in this book, they can be represented as overt allegory or as a reflection of everyday life – and, for viewers aware of the pictorial tradition, simultaneously in both registers.

Millais's '*Bubbles*' remains famous in Britain because it was widely reproduced in an advertisement for Pears Soap. The picture was not, however, commissioned by Pears, but painted as a portrait of the artist's favourite grandson at the age of four, and was first exhibited under the title of *A Child's World*.[14] Millais – having earlier achieved great popularity with colour reproductions of his paintings of little girls, such as *Cherry Ripe* of 1879[15] – sold the picture to Sir William Ingram for chromolithographic reproduction as a supplement to the Christmas number of the *Illustrated London News*, 1887. In April 1886, Ingram in turn sold the work and its copyright to Thomas Barratt, chairman of A. & F. Pears, Ltd., who had a bar of soap added to the advertisement. In a biography of his father published in 1899, three years after the artist's death, Millais's son claimed that, although Millais had given permission for the advertising campaign and had admired the reproduction, he had been 'furious' at the soapy bowdlerisation of his picture. The ensuing controversy touched on contemporary debates – about the autonomy or otherwise of art, whether industry and commerce could replace the for-mer role of the Church as patron of the arts, whether advertisements debased art or elevated popular taste, the commodification and multiple reproduction of art works – whose echoes still resound today.

This thoroughly modern story centres on a painting of complex intentions. Privately recording the touching likeness of a beloved child, Millais nonetheless aimed at popular and commercial success, simultaneously striving – by referring to a *topos* of Old Master painting, and by meeting the challenge of representing convincingly the iridescent bubbles[16] – to secure the picture's status within an elitist artistic tradition. Technically, the painting resembles child portraits by Sir Joshua Reynolds; the resem-blance is underlined by the boy's artfully anachronistic costume, vaguely reminiscent of the 'skeleton' suits in vogue in the late eighteenth and early nineteenth centuries.[17]

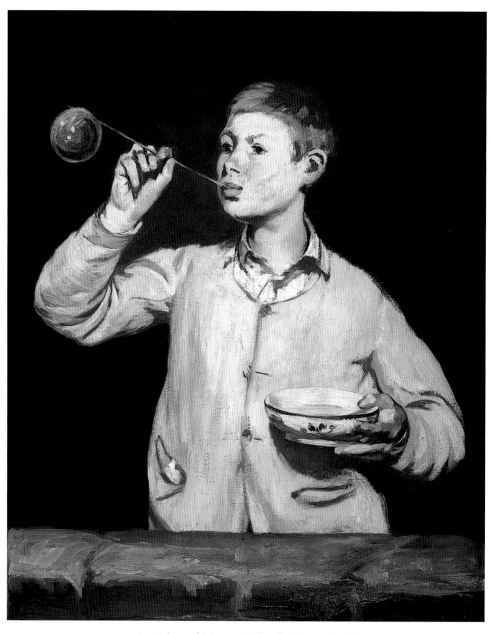

158 Edouard Manet, *Bulles de Savon*, 1867/8,
Lisbon, Calouste Gulbenkian Foundation

In choosing to portray his own grandson Willie James blowing bubbles, it may be
that Millais did not intend to return to the original significance of *homo bulla*. Despite
introducing other emblems of transience in the potted plant and the broken flower
pot beside the child, he is unlikely to be insisting on the precariousness of the boy's
life. More probably, as his title, *A Child's World*, suggests, he wished to represent the
evanescent charm of childhood, with its sense of wonder at 'little things' and its
capacity for living through the imagination and in day dreams.[18] This mood is not

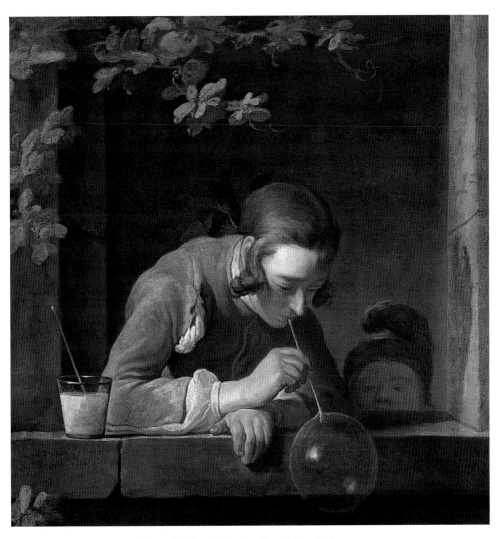

159 Jean-Siméon Chardin, *Les Bulles de Savon*, 1739,
Washington, National Gallery of Art

vastly different from that in a painting of 1859 by the French artist Thomas Couture,
showing a delicate, fanciful boy, his school books unopened before him, longingly
contemplating the soap bubbles floating above his desk.[19]

A more robust version of the theme was painted in 1867 by Couture's former pupil,
Edouard Manet. It may seem art-historical sacrilege to mention on the same page this
heroic pioneer of modern art and the Victorian author of 'Bubbles', yet it is a readily
forgotten truth that they were contemporaries. Manet, younger by three years, died
some thirteen years before Millais, and – if we except Millais's historical costume dra-
mas – both sought, in their different ways, to interpret modern life in the light of the
'art of the museums'. For his own version of *Soap Bubbles*, Manet eschewed his
teacher's dreamy mode, and posed his fifteen-year-old stepson (in all likelihood his
own son) Léon Leenhoff, behind a stone parapet, vigorously silhouetted against a dark
background (fig. 158).[20]

It has been thought for some time that the painterly treatment of the subject was suggested to Manet by Chardin's painting of *c.*1734, now in Washington, of an adolescent at a window blowing soap bubbles, watched by a toddler barely able to look over the sill (fig. 159).[21] In the spring of 1867 this picture, the only surviving vertical version of a composition which Chardin executed no fewer than four times, had featured in a highly publicised Paris art sale, where it would have attracted Manet's attention.

It is unlikely that Chardin himself intended his *genre* paintings to teach overt moral lessons, beyond tacit approval of industriousness, order, and natural affections. He derived the subjects for his pictures of children at play from seventeenth-century Netherlandish emblems and paintings related to them, however, and when his works were engraved, they were in turn published with edifying verse captions. These were often composed by the engravers themselves, several of whom were the artist's friends. Far from disowning their interpretations, Chardin must have welcomed their appeal to a broader audience, beyond connoisseurs to those who merely hung 'improving' images on their walls; sales of the prints became a major addition to his income.[22] A now lost vertical version of *Les Bulles de Savon*, exhibited at the Salon of 1739, was engraved by Pierre Filloeul with a rhymed caption that roughly translates as,

> Young boy, contemplate attentively
> These little globes of soap,
> Their changeable movements
> And their short-lived splendour
> Will rightly cause you to say
> That in these ways many an Iris resembles them.[23]

Comparing the variable motion and short-lived splendour of the soap bubbles to 'many an Iris' – punningly named after the goddess of the rainbow in Graeco-Roman myth, from whom the bubbles derive their 'iridescence' – the verses warn against love affairs with fickle young women. In view of the age of the youth in Chardin's picture, the warning might be thought apt, though nothing in the painting itself betrays an erotic subtext.[24] But the sense that Chardin's impassive originals are intentionally enigmatic, lending themselves to any number of different interpretations, is supported by the fact that another painted version of *Soap Bubbles*, now in Los Angeles, was in the eighteenth century paired with a version of *The Young Schoolmistress*, now in Dublin,[25] showing a toddler being taught to read by an older girl. In this context, the composition loses any association with fickle love and is understood as contrasting the boy's idleness with the girl's industriousness, bad with good example.

While Chardin's *Soap Bubbles* is open to various readings or none, it remains, inescapably, pictorially eloquent. Like the toddler from behind the sill, we watch with bated breath the bubble straining at the end of its straw, at that precise, wobbly instant before it either bursts or breaks free and floats away. Chardin's brush has arrested on the canvas a moment of maximum instability and tension, evoking from viewers the wordless absorption of the painted figures. This purely painterly act reaffirms, wittingly or not – and with a twist flattering to the artist's craft – the ancient idea of *homo bulla: Ars longa, vita brevis*,[26] 'art is long, life is brief'.

Manet chose to depict a similar moment, perhaps making explicit what Chardin

160 Jean-Baptiste-Siméon Chardin, *La Blanchisseuse*, 1733,
Stockholm, Nationalmuseum

leaves implicit. Rather than representing Léon Leenhoff striving to coax the largest possible bubble from his straw, he shows him about to nudge a bubble free, to rise in the air beyond the picture frame. The art historian Meyer Schapiro suggested that the boy's pose recalls a painter's standing at the easel, with a brush in his right hand and a palette in his left.[27] I tend to think that the sophisticated Manet knew Goltzius's engraving, Figure 151, and that Léon's gestures refer back to the sixteenth-century *putto*'s. But neither view is exclusive, and both support a similar reading of the picture: Léon's quietly triumphant air hints at Manet's frequent celebration of his art's enduring victory over the transience of life, whether in pictures of cherries falling out of a child's basket or of a peony shedding its petals.[28]

Millais's *A Child's World*, however, is less likely to have been inspired by Chardin's 'adolescent' versions of *Soap Bubbles*, influential in the 1860s, than by one of the French painter's earliest 'intimist' masterpieces, *The Washerwoman* of 1733 (fig. 160).[29] This composition had been popularised through Charles-Nicolas Cochin's etching of 1739, which became the first of many nineteenth-century reproductions of Chardin's work, being reprinted on wood from 1850 onwards for the review *Magasin Pittoresque*. Millais's interest in reproductive prints of French paintings is attested to by a framed

162 *Cuncta complecti velle,
stultum;* emblem 55b, Geoffrey
Whitney, *A Choice of Emblemes,
and other devises,* Leyden, 1586

161 Caspar Netscher, *Two
Boys blowing Bubbles,* c.1670,
London, National Gallery

engraving of Jacques-Louis David's 1801 *Napoleon crossing the Great St Bernard,* featured
in the background of *The Black Brunswicker* exhibited by Millais at the Royal Academy
in 1860. I have no external evidence that he looked at a print of Chardin's
Washerwoman; the moment depicted, Millais's technique and emotional key, are very
different from the French master's;[30] yet Willie James's unusual, low-seated pose, and
details such as the visible sole of a shoe, suggest an affinity between 'Bubbles' and the
Washerwoman, especially when we recall that Cochin's etching reverses Chardin's com-
position in the direction of Millais's painting.

Chardin's *Washerwoman,* originally paired with a picture of a *Woman drawing Water
at the Cistern,*[31] focuses on the repetitive tasks of working women. The boy blowing
bubbles in the foreground provides a welcome glimpse of red – the rest is open to
viewers' own readings. Yet however we choose to interpret the picture, fundamental
to it is the child's absorption, his detachment from the adult world in which the
washerwoman – her eyes turning to something or someone outside the painting –

must earn her living. Her trade's soapy water is his occasion for play, the natural occupation of childhood.[32] Different though the compositions are, Chardin's also depicts *A Child's World*, more poignant than Millais's.

Soap bubbles, on the other hand, were in the air. Millais's theme, like Chardin's, may have been suggested to him directly by one or more newly available seventeenth-century examples. In 1871, for example, London's National Gallery acquired one of several versions of *homo bulla* by Caspar Netscher, a Dutch painter of refined portraits and *genre* in a fashionable French-influenced style (fig. 161).[33] Painted around 1670, the composition – two half-figures behind a stone parapet, enframed by a niche – recalls that of Chardin's *Soap Bubbles*, Figure 153, but was derived by both Netscher and Chardin from works by the Leiden painter Gerrit Dou (1613–75), whose paintings of daily life, internationally prized in his lifetime, were as eagerly collected in eighteenth-century France.

In Netscher's picture it is the smaller child in the background who blows the soap bubbles; the older boy is trying to catch one on his feathered beret. On the ledge in front of the children are two exotic sea shells and a small silver dish, decorated with the figures of a man and a woman embracing; it reproduces exactly the design of the bowl of an actual dish by the famed Utrecht silversmith Adam van Vianen, signed and dated 1618.[34]

Shells and silver dishes were both luxuries prized by seventeenth-century Dutch collectors, and modern scholars have consequently interpreted the image as symbolising the futility of worldly possessions. Contemporaries would have seen rather more, such as 'worldly love' in the silver dish. The older boy's action echoes one of the *Emblemata* of the physician Hadrian Junius, much read throughout Europe in the seventeenth century.[35] Elegantly illustrated with woodcuts or engravings of apparently Italian origin, many of Junius's emblems, like those of Johannes Sambucus, were reused in Geoffrey Whitney's *Choice of Emblemes* of 1586.[36] Junius's emblem 16, reproduced as Whitney's 55 b., shows seven *putti* running out of a wood, chasing after the bubbles blown by an eighth seated under the trees (fig. 162).[37] The Latin motto above translates as 'It is foolish to wish to compass all things', and the vignette is inscribed in Italian, EMBRACING ALL I GRASP NOTHING.[38] Verses below enlarge on the motto and inscription; in Whitney's translation of Junius, they read:

> The little boys, that strive with all their mighte,
> To catch the belles, or bubbles, as they fall:
> In vain they seeke, for why, they vanishe righte,
> Yet still they strive, and are deluded all:
> So, they that like all artes, that can be thoughte,
> Do comprehend not anie, as they oughte.

In the light of emblematics, Netscher's image preaches the futility, *sub specie aeternitatis*, not only of worldly possessions and erotic love, but also of the 'artes': intellectual pursuits and professional accomplishments. This is a heavy weight of moralism for such a light picture to bear, and I cannot but feel that Netscher's tongue is slightly in cheek, the artist complicit with his viewers. Concentrating on his own single 'arte', he has, after all, managed to grasp a soap bubble with his brush, endow us with precious shells and silver we could never otherwise afford, and capture the charm of carefree

childhood: yet another Dutch painter of the world's vanities delighting us with what he urges us to deplore.

Absolute seriousness, conversely, characterises one of the rarer Italian paintings on the *homo bulla* theme: Salvator Rosa's *L'Umana Fragilità* of *c.*1657/8, known in English as *Human Frailty*, more accurately translated as *The Fragility of Human Life* (fig. 163).[39]

Born in Naples, Rosa trained there as a painter of decorative battle scenes, landscapes and coastal views. Ambitious, intelligent, intransigent, chafing at the traditional systems of art production and patronage, he reinvented himself in Florence and later in Rome as a poet, actor, musician, satirist, letter-writer, Stoic philosopher as well as painter and etcher, and attracted clients by devising new and dramatic subjects, or embellishing old ones with erudite and sometimes bizarre flourishes, inspired by literary texts, iconographic handbooks, fashionable Northern and Italian prints. From picturesque views with small figures he turned to monumental paintings with figures on the scale of life: brooding hermits and philosophers, and allegorised portraits, several of himself and his much-loved mistress, Lucrezia. The allegory of *L'Umana Fragilità* is closely related to an earlier picture, now in Copenhagen, of *Democritus in Meditation* before a portentous landscape and macabre *vanitas* still life, the 'laughing philosopher' paradoxically shown in the despairing posture of Heraclitus, the 'weeping philosopher'.[40] Rosa later inscribed an etching on the same theme, 'Democritus, mocker of all things is transfixed by the end of all things'[41] – the fragility of human life and the futility of worldly achievements.

The artist's brother, and Lucrezia and Rosa's son Rosalvo, had died of the plague in 1656; the painting may originally have been conceived as a kind of epitaph for them, though it found its way into the collection of a papal nephew, and contains an unusual reference, as we shall see, to the ceremony of crowning a new pope. The couple's last child, Augusto, was born in 1657; mother and, possibly, son modelled for the main figures in this painting.

Crowned with blown pink roses – the poets' favoured emblem of transience, but also an allusion to the artist's family name[42] – a woman is seated 'on a globe of glass'.[43] In the sixteenth-century a winged Fortune standing on a rolling globe had replaced the medieval goddess enthroned behind her Wheel;[44] a glass orb had also come to be associated with personifications of the World. Conflating globe, orb and bubble, the iconographer Cesare Ripa described *Miseria Mondana*, 'Worldly Misery', as a woman with her head inside a glass sphere.[45] Rosa's figure suggests all these significances, without clearly distinguishing among them.

The baby on this allegorical figure's lap writes on a parchment; neither mother nor child seems aware of the winged skeleton, Death itself, guiding the infant's pen to form the phrases *Conceptio Culpa, Nasci Pena, Labor Vita, Necesse Mori*, 'Conception is Sin, Birth Pain, Life Toil, Death a Necessity'. This 'conceit' had been expressed by Rosa's friend, the scholarly Giovanni Battista Ricciardi, in a *Canzone morale* dedicated to the artist; Ricciardi, however, had adapted his Italian verses from a Latin poem by the twelfth-century poet-monk Adam of St Victor, often reproduced in manuscripts and printed books, and it is this medieval original that is quoted by Rosa.

163 Salvator Rosa, *L'Umana Fragilità*, *c.*1657,
Cambridge, Fitizwilliam Museum

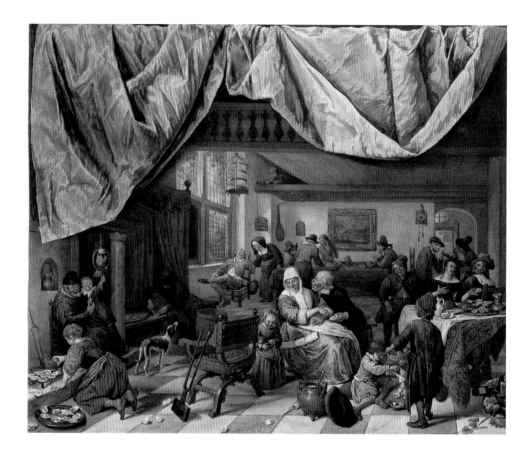

Two *putti* stand at the woman's feet, one blowing bubbles, the other leaning out of a cradle that could double as a sarcophagus,[46] setting fire to a bunch of tow wound about a distaff. This is the unusual rite repeated three times during a papal investiture, when the distaff is replaced by a silver staff and the tow is ignited to the chant of *Pater sancte, sic transit gloria mundi*, 'Holy Father, thus passes the glory of the world', recalling the words of Isaiah 43:17, 'they are extinct, they are quenched as tow'.

Butterflies, emblems of short-lived beauty and ancient symbols of the soul, flutter about the crib. Motifs are reused from Rosa's gloomy *Democritus*: a cypress-crowned herm of Terminus, Roman god of boundaries and endings, looks over Lucrezia's shoulder; an owl, bird of night and bad augury, peers out at the viewer, and an obelisk on the picture's right, carved with animal forms and the heads of a baby and an old man, signifies 'the condition of human life', according to Pierio Valeriano's *Hieroglyphica*, another compendium of symbols favoured by Rosa.[47] The thistle in the foreground also derives from Valeriano and stands for *Imbecillitas Humana*, 'human feebleness', for as soon as it blossoms its flower dries, and the slightest puff of wind can blow it away.

A spent rocket has fallen to the ground next to the thistle, and a knife, obviously modelled on a real, elegant eating implement, is signed on the blade with Rosa's monogram.

164 Jan Steen, *The World as a Stage*, also known as *The Life of Man*, *c*.1665–7, The Hague, Mauritshuis

165 Detail of fig. 164

A farrago in lesser hands, the painting manages to be beautiful and horripilating in equal measure. But what is most relevant here is the redundant child imagery. Rosa depicts the child as a human baby on its mother's lap, in the age-old group of infant and *kourotrophos*; as an allegory of Humankind in the lap of Fortune (or Worldly Misery); as the first of the Ages of Man; as *homo bulla*, in which the child as much as the bubble is a metaphor of fragility and transience, and as tow-burning reminder of the passing of worldly glory. Death's hand on its wrist, the child is both agent and acted upon, Life Force and harbinger of Death, 'the entrance to human misery'.[48] Drawing on the traditional repertory of the imagery of childhood, Rosa characterises the whole of human life: fragile, futile, short-lived – yet, like the rose and the butterfly, resisting with tender-coloured beauty the encroaching gloom of night and the malign fury of Death.

Some ten years after Rosa, Jan Steen, a painter with very different artistic ambitions and from a very different milieu, also represented earthly human life under the sign of *homo bulla* (fig. 165).[49]

In a large room that is neither domestic space nor tavern, men, women, boys and girls act out the worldly pleasures familiar from Steen's and other Dutch artists' *genre* paintings. Backgammon is being played, and a pipe smoked, in the background; an old woman offers a tall glass of beer to a man; there is music making and feasting; an old man offers an oyster, notoriously aphrodisiac, to a young woman no better than she ought to be; more oysters are being opened and seasoned. In the foreground, a little girl and a parrot are indulged; another little girl practises her coquetry on a pet dog, while a little boy 'teaches' a cat to dance.

A clock ticks on the back wall, and from a curious cranny high up in the rafters, a child, strangely accompanied by a skull, blows bubbles that drift down, disregarded, over the merrymakers.

Across the upper edge of the picture, Steen has 'draped' a curtain, like the ones hung in Dutch homes to protect paintings from dust – and like those pulled across the stage when the play is done.

Inscribed above the architrave of the Amsterdam Playhouse was a couplet written in 1637 by the Dutch poet and dramatist Joost van den Vondel: 'The world's a stage. Each plays his part and is allotted his portion.'[50] But already in 1599, Shakespeare's Jaques had declaimed,

> All the world's a stage,
> And all the men and women merely players:
> They have their exits and their entrances;
> And one man in his time plays many parts,
> His acts being seven ages. At first the infant,
> Mewling and puking in the nurse's arms.
> And then the whining schoolboy, with his satchel,
> And shining morning face, creeping like snail
> Unwilling to school. And then the lover,
> Sighing like furnace, with a woful ballad
> Made to his mistress's eyebrow. Then a soldier,
> Full of strange oaths, and bearded like the pard,
> Jealous in honour, sudden and quick in quarrel,
> Seeking the bubble reputation
> Even in the cannon's mouth . . .
> . . . Last scene of all,
> That ends this strange eventful history,
> Is second childishness, and mere oblivion,
> Sans teeth, sans eyes, sans taste, sans everything.[51]

More than we sometimes like to admit, the Swan of Avon is heir to a pan-European culture; behind Jaques, there peeps out Erasmus's Folly, wearing classical and medieval motley. The discovery of childhood, first and second of Shakespeare's Seven Ages of Man, characterises no single age: not the Age of Sensibility nor that of the Enlightenment; neither the nineteenth century nor the twentieth. And just as written texts have acknowledged the special nature of the child – mewling and puking, vile and adorable, weeping and laughing, fickle, playful and earnest, a promise and an elegy – so has visual imagery, from the earliest *kourotrophos* and Horus-the-Child to *Bubbles* and beyond. At the same time, images have always made plain that we are all childlike: children of God, or merely 'the child within'. Concealing or distorting many realities of the actual conditions in which children have lived and died through the ages, they have nonetheless reflected, and reflected upon, real ideals and universals of the human condition.

Notes

INTRODUCTION: MAINLY ABOUT PARENTS

1 Montaigne, *Essais*, Book 3, chapter 12: 'It could be said of me that I have amassed here only the flowers of others, having furnished of mine own merely the string with which to tie them together.'

2 E.W. Bredt, *Chodowiecki, Zwischen Rokoko und Romantik*, Munich, n.d.

3 Daniel Nikolaus Chodowiecki (1726–1801), Plates 7, *Affectation*, and 8, *Nature, Der Spatzier Gang, La Promenade*, from *Göttinger Taschenkalender*, 1779.

4 E.H. Gombrich, *The Story of Art*, 16th edn, London, 1995, p. 15: 'There really is no such thing as Art. There are only artists . . . they did and do many . . . things . . . Art with a capital A has no existence.'

5 Cited by R. Focke, *Chodowiecki et Lichtenberg: les tailles-douces des mois de Daniel Chodowiecki dans l' 'Almanac de Goettingue' avec les explications de Georg Christoph Lichtenberg, 1778–1783*, Leipzig, 1901, pp. XIV, XIX.

6 *Natürliche und affektierte Handlungen des Lebens.*

7 Lichtenberg, *1779, Nature et Affectation. Première Série. Quelque chose touchant l'enluminure des tailles-douces de cet Almanac*, reprinted in Focke, p. 10.

8 J.H. Bauer, *Daniel Chodowiecki*, Hannover, 1982, p. 94, pl. 553–64.

9 *Quand il n'y auroit au jeune homme de la planche 7me, qui paroit un peu pris de la boisson et harassé de la chasse, d'autre enseigne pour le reconnoitre, que celle d'avoir presque l'air d'un étranger, on verroit qu'il est Allemand. La Production allemande qui est à sa droite, et qu'on lui a associé par le mariage, ne paroit pas lui agréer autant que la créature d'origine anglaise à sa gauche, qu'il s'est choisie lui-même.*

Le couple de la huitième planche mène ses enfans auprès de soi, et celui de la septième au contraire, ce qui lui paroit être aussi cher, ses Chiens. En effet qu'y seroient les enfans? Du moins ils n'y aprendroient pas à cultiver les sentimens de tendresse. C'est dequoi, tandis que pere et mere se promènent, ils s'instruiront mieux et plus promtement dans les promenades bien plus tendres où en attendant ils accompagnent l'homme de chambre et la menagère, ou le précepteur, et la Demoiselle françoise. Focke, pp. 11–12.

10 'Life of Pericles', Chapter 1, in *The Rise and Fall of Athens, Nine Greek Lives by Plutarch*, tr. I. Scott-Kilvert, Harmondsworth, Middlesex, 1960, p. 165.

11 'Life of Solon', Chapter 7, in *ibid*., pp. 47–9.

12 Like all interpretations, this one is valid only in the appropriate context – see E.H. Gombrich, 'Aims and Limits of Iconology', *Symbolic Images, Studies in the Art of the Renaissance*, London, New York, 1972, pp. 1–22. Thomas Gainsborough (1727–88), *'The Morning Walk'*, 1785/6, London, The National Gallery, NG 6209, portrays a young English couple promenading through parkland with their jaunty Pomeranian. Since Mr and Mrs William Hallett sat to Gainsborough shortly before their marriage on 30 July 1785, the dog, an emblem of fidelity, can also be seen as a forerunner of children rather than a child-substitute; it demonstrates the couple's natural capacity for love and nurture. Gainsborough's composition was adapted by George Romney (1734–1802) for his portrait of Sir Christopher and Lady Sykes with a dog, 1786, later known as *'The Evening Walk'*; E. Waterhouse, *Painting in Britain, 1570 to 1790*, 4th ed., London, 1978, pl. 243.

13 Albrecht Dürer (1471–1528), *Young Couple threatened by Death ('La Promenade')*, c.1495–98; A. Bartsch, *Le Peintre Graveur*, vol. II, Vienna, 1808, No. 94.

14 In 1609–10, as a record of their marriage, Rubens had represented himself and Isabella seated in a honeysuckle bower, clasping hands: Munich, Alte Pinakothek.

15 Peter Paul Rubens (1577–1640), *Peter Paul Rubens, Hélène Fourment and Nicholas Rubens, ('The Walk in the Garden')*, c.1630, Munich, Alte Pinakothek, no. 313. Hans Vlieghe, *Rubens Portraits of Identified Sitters painted in Antwerp* (Corpus Rubenianum Ludwig Burchard, part 19, v. 2), New York and London, 1987, pp. 165–67, cat. no. 139, plausibly suggests that Albert, the only other surviving child of Rubens's first marriage, was not included in the painting because, aged 16, he had in June 1630 been appointed secretary of the Privy Counsel in Brussels, and was therefore no longer living at home.

16 Ovid, *Metamorphoses*, xiv:623–97 and 765–71.

17 Peter Paul Rubens, *Peter Paul Rubens, Hélène Fourment and Clara-Johanna Rubens*, New York, Metropolitan Museum of Art, Inv. No.1981–238. For a discussion of the toddler's identity and the probable date, see Vlieghe, *Rubens Portraits*, cat. no. 141, pp. 170–3.

18 James Mc Ardell (1728/9–65), *Rubens with his Wife and Child, From the Original in the Collection of His Grace the Duke of Marlborough at Blenheim*, mezzotint; C.G. Voorhelm Schneevoogt, *Catalogue des Estampes Gravées d'après P.P. Rubens*, Haarlem, 1873, p. 163, no. 84.

19 Since prints, like mirror images, reverse the direction of the composition etched or engraved on the plate, Chodowiecki probably drew the figures as they appear in McArdell's mezzotint (which does not reverse Rubens's painting), i.e. walking from right

to left. Allowing for this change of direction, compare the male fig-ures' outstretched hands, and heads turned towards their female companions, whose hands they clasp; both women hold a fan in the other hand. With the exception of the fan, Rubens's figures, in turn, echo the poses of the couple in Dürer's engraving.

20 Biedermeier painting in Berlin continued to draw on his vein of acute observation, and his etchings of contemporary scenes were a major source for the *Frederick the Great* series of paintings executed in the 1850s by Adolph Menzel (1815–1905); *Spirit of an Age, Nineteenth-Century Paintings from the Nationalgalerie, Berlin*, exh. cat., National Gallery, London, 2001, with previous bibliography.

21 Philipp Otto Runge (1777–1810), *The Artist's Parents*, 1806, Hamburg, Kunsthalle, Inv. Nr. 1001; J. Traeger, *Philipp Otto Runge und sein Werk, Monographie und kritischer Katalog*, Munich, 1975, pp. 86–7; cat. nos. 350–5, pp. 402–5.

22 E.g. Gainsborough's *'Morning Walk'*, see note 12.

23 Runge studied prints in the print collection of the Hamburg merchants M. Speckter and G.J. Schmidt, and had access to others through his friend the publisher and bookseller F. Perthes. Daniel Runge stated that one of his brother's *genre* drawings 'very much recalls Chodowiecki'; cited in Traeger, cat. no. 143, p. 292.

24 Drawings 1802–3; engraved 1805; Kunsthalle, Hamburg, Inv. Nrs. 34174, 34170, 34177, 34181. Of the paintings, there remain only a small version of *Morning*, Inv. Nr. 1016, nine fragments of the large version, Inv. Nr. 1022, both Kunsthalle; *Moonrise*, Oskar Reinhart Foundation, Winterthur, is closely related.

25 Cited in translation in *Caspar David Friedrich to Ferdinand Hodler: A Romantic Tradition, Nineteenth-Century Paintings and Drawings from the Oskar Reinhart Foundation, Winterthur*, exh. cat., Los Angeles, New York, London, 1993, p. 75.

26 R.M. Bisanz, *German Romanticism and Philipp Otto Runge, A Study in Nineteenth-Century Art Theory and Iconography*, Illinois, 1970.

27 *Lilium bulbiferum* var. *croceum*.

28 'At the root of Runge's new symbolic-pictorial language stands his invention of the child figure, the flower, and the child-figure-flower composite symbols', Bisanz, *German Romanticism and Philipp Otto Runge*, p. 99.

29 R. Rosenblum, *The Romantic Child: from Runge to Sendak*, London, 1988 (20th Walter Neurath Memorial Lecture) p. 50; this author also cites Runge's letter of 1808 to his brother Daniel, describing the painter's little daughter, Maria Dorotea, as 'a totally charming child, so smooth and pudgy that it's a pleasure to see her, and so densely packed that bullets could bounce off her.' See also K.F. Degner, ed., *Philipp Otto Runge; Briefe in der Urfassung*, Berlin, 1940, pp. 346–8.

30 Paris, 1960; translated into English as *Centuries of Childhood*, London, 1962.

31 An outstanding exception is J.B. Bedaux and R. Ekkart, eds., *Pride and Joy: Children's Portraits in the Netherlands 1500–1700*; exh. cat., Haarlem and Antwerp, 2000–2001. Bedaux's 'Introduction', pp. 11–31, for example, crisply disposes of the common fallacy equating the *sentiment de l'enfance* only with naturalistic (or 'supra-normal') representations of children.

32 D.I. Kertzer and Mario Barbagli, eds., *Family Life in the Long Nineteenth Century 1789–1913* (*The History of the European Family: Vol. 2*), New Haven and London, 2002.

33 William Bouguereau (1825–1905), *La Famille indigente*, 1865, Birmingham Museums and Art Gallery, no. 11.97.

34 Kertzer and Barbagli, *Family Life*, caption to plate 10.

35 Cited in *William Bouguereau 1825–1905*, exh. cat., Paris, Montreal, Hartford, Connecticut 1984–5; p. 168, cat. no. 37.

36 The catalogue entry above records that Father Lacordaire, who died in 1861, had actually preached such a sermon in Paris in 1844, albeit at the church of Saint-Jacques-du-Haut-Pas and not the Madeleine; Bouguereau, however, might have heard the Dominican preach in Bordeaux in the winter of 1841–2.

37 R. Freyhan, 'The Evolution of the *Caritas* Figure in the 13th and 14th centuries', *Journal of the Warburg and Courtauld Institutes*, XI, 1948, pp. 68–86. The first artist known to have represented Charity in this way was the Sienese sculptor Tino di Camaino (*c.*1285–1337). Tino's 'invention' is fully justified by the patristic lit-erature, but its appearance tempts one to wonder whether he could have seen an Antique sculpture of a *kourotrophic*, i.e. child-nursing, deity, see below pp. 22–8.

38 E.g. Edmund Spenser, *The Faerie Queene*, 1590, 1596, Book I, Canto X, 30–31: *Charissa*: 'She was a woman in her freshest age,/Of wondrous beauty, and of bountie rare . . . Her neck and breasts were ever open bare/That ay thereof her babes might sucke their fill . . . A multitude of babes about her hong,/Playing their sports, that ioyd her to behold,/Whom still she fed, whiles they were weake and young . . .'

39 The National Gallery, London, alone houses three such paintings: the earliest is German: NG 2925, 1537–50, by Lucas Cranach the Elder (1472–1553), depicting mother and all three children naked, as befits an allegorical image *all'antica*, but giving the girl child a doll fully dressed in sixteenth-century women's clothes. A slightly later, more classicising version comes from Florence: NG 652, *c.*1570, by Michele Tosini (1503–77); and the third is by Antony Van Dyck (1599–1641), a Flemish painter recently returned from Italy, later to become court artist to Charles I of England: NG 6494, *c.*1627–8. The Gallery also owns *Lady Cockburn and her Three Eldest Sons*, 1773, NG 2077, by Sir Joshua Reynolds (1723–92) in which the English artist adapts Van Dyck's allegorical composition, known to him through an engraving, to enrich the significance of a portrait, much as Rubens had done with his own allegorical imagery of the *Garden of Love*, pp. 6–7; see J. Egerton, *National Gallery Catalogues: The British School*, London, 1998, pp. 210–17. For another example of the imagery of Charity see the discussion of the Thomas Coram Foundling Hospital dec-orations below, pp. 56–7.

40 *Bouguereau*, pp. 204–7, cat. no. 74.

41 Danguin, engraving after Andrea del Sarto, *Charité*, (*Société Française de Gravure*, 1re série, pl. 19, fig. 125; cited in *Bouguereau*, pp. 204–7, cat. no. 74.

42 *Bouguereau*, p. 207, cat. nos. 75, 76, 77.

43 The pyramid formed by Andrea's figures has been lowered and broadened by Bouguereau, so that the latter's figures appear to sit below, rather than above, the viewer's eye line. The positions of the nursling and the second child – the girl in the painting – have been reversed from the engraving, and the mother's breast modestly covered. The child at her feet is still on the viewer's left, but Bouguereau has reversed the direction of his legs, so as to conform to Andrea's painting rather than to the engraving. Bouguereau has also removed the mother's left hand from around her child and thrust it towards the viewer in a begging gesture.

44 '*En peinture, je suis un idéaliste. Je ne vois que le beau dans l'art, et pour moi, l'art c'est le beau. Pourquoi reproduire ce qui est laid dans la nature? Je n'en vois pas du tout la nécessité.*' '*Un art nouveau! Mais pourquoi faire? . . . L'art est éternel, il n'y en a qu'un!*' '*Il faut chercher le Beau et le Vrai . . .*' cited in *Bouguereau*, p. 54.

45 Bouguereau, letter of 25 May 1863 to Count Nieuwerkerke urging the government to buy his painting, *Le remors de Oreste*, exhibited in the Paris Salon of that year; cited in *Bouguereau*, pp. 99–100.

46 For Bouguereau's use of working-class Italian women and their children as models, see *Bouguereau*, pp. 73–4.

47 Richard Banks Harradan, *Charity sympathising with Distress*, 1801, mezzotint, after Thomas Gainsborough, *Charity Relieving*

Distress, 1784, reworked 1787, private collection. See M. Rosenthal and M. Myrone, *Gainsborough*, exh. cat., London, 2003, p. 232, cat. no. 129.

48 The iconography of the Holy Spirit originates in two biblical descriptions of Jesus's Baptism: 'the heavens were opened unto him, and he saw the Spirit of God descending like a dove, and lighting upon him' (Matthew 3:16); 'I saw the Spirit descending from heaven like a dove, and it abode upon him' (John 1:32).

49 E.g. R. Rosenblum, *The Romantic Child*, still unquestioningly accepts Ariès's thesis.

50 The pitfalls involved in relying on such material when analysing paintings are cogently exposed by Wayne Franits in a review of M.F. Durantini, *The Child in Seventeenth-Century Dutch Painting* (*Studies in the Fine Arts: Iconography*, VII), Ann Arbor, 1983, in *The Art Bulletin*, December 1985, vol. LXII, no. 4, pp. 695–700.

51 A particularly tempting recent example is in *Aztecs*, exh. cat., London, 2002–03, pp. 46–7, fig. 36, 'The instruction of Aztec children aged between three and six', Folio 58r of the Codex Mendoza, *c.*1541, Bodleian Library, University of Oxford.

CHAPTER 1: PROTECTION

1 Sue Halpern, citing P.N. Stearns, *Anxious Parents: A History of Modern Childrearing in America*, New York, 2003, in 'Evangelists for Kids', *The New York Review of Books*, vol. I, no. 9, May 29, 2003, p. 20.

2 Simone Martini (recorded from 1315 to 1344), *Blessed Agostino Novello and Four of his Posthumous Miracles*, *c.*1324, on deposit in the Pinacoteca Nazionale, Siena. A. Bagnoli, M. Seidel, *Simone Martini e 'chompagni'*, exh. cat., Siena, 1985; pp. 56–72, cat. no. 7, with extensive bibliography. I am particularly indebted to Max Seidel's account of the history and iconography of the painting.

3 Seidel relates these picturesque details to the Pseudo-Augustinian text of *Sermones ad fratres in eremo*, an early fourteenth-century forgery 'intensely read' by the Eremitani; A. Bagnoli, M. Seidel, *Simone Martini*, pp. 70–71.

4 See below, pp. 47–9.

5 The hermit on the viewer's left appears by his T-shaped crutch to be Saint Antony Abbot, one of the fourth-century Egyptian 'Desert Fathers', venerated as the founder of monasticism.

6 '*Maximus advocatus pro dicto Comuni et civitate Senarum et statu eius pacifici in celesti curia*', cited by Seidel, *Simone Martini*, p. 72.

7 From among the vast literature on votive images, see F.C. Crispolti, E. Ranaldi, L. Valente, with Introduction by F. Zeri, *Le tavolette votive della Collezione San Lorenzo*, Assisi, 1994, with essential bibliography, lists of churches, sanctuaries and museums with the largest holdings of mainly Italian votive tablets. The Munich Museum of Folk Art has a collection of over 400 ex-votos from most European countries.

8 The fourth concerns the misadventure of a knight riding through the countryside, the *contado*, of Siena.

9 It is more often described as a wolf, though I emphatically agree with Seidel who calls it 'a black dog', *Simone Martini*, p. 68.

10 Balcony balustrades that give way, and children fallen from balconies, are among the most frequent subjects of ex-votos; see, e.g. a votive image from the Veneto, dated 1886, in *Le tavolette votive della Collezione San Lorenzo*, p. 31.

11 Seidel, *Simone Martini*, p. 56.

12 Simone Martini, *Blessed Agostino Novello* altarpiece, detail, '*The Paganelli Miracle*'.

13 E.H. Gombrich, 'The Visual Image: its Place in Communication', *Scientific American*, 227, 1972, pp. 82–96, reprinted in *The Image and the Eye, Further Studies in the Psychology of Pictorial Representation*, Oxford, 1982, pp. 137–61.

14 K. Krüger, *Der frühe Bildkult des Franziskus in Italien: Gestalt und Funktionswandel des Tafelbildes im 13. und 14. Jahrhundert*, Berlin, 1992.

15 British Museum, EA11641, turquoise-blue glazed composition, 7.4 cm high; between 1069 and 747 BC. C. Andrews, *Amulets of Ancient Egypt*, London; Austin, Texas, 1994, p. 16, fig. 10b.

16 The German term *Horuslocke* was formerly used for what is now usually called in English the 'sidelock of youth'. This archetypal symbol features in the hieroglyph for 'child', and appears in Egyptian portraits of royal and commoner children, and on children's mummy cases, although variants, such as multiple tufts or sidelocks also occur; for an extended discussion of the evidence, see R.M. and J.J. Janssen, *Growing up in Ancient Egypt*, London, 1990, pp. 38–41, where it is surmised that the lock was shaved off at puberty. Actual examples of sidelocks were found in graves at Mostagedda dating from the sixth dynasty, 2345–2181 BC, see I. Shaw and P. Nicholson, *The British Museum Dictionary of Ancient Egypt*, London, 1995 p. 270. I have been unable to find any rationale for this hairstyle – although in Morocco in 1942, the Muslim mother of a toddler with a similar plait on the top of his otherwise shaven head explained to me that if he died it would enable the Angel Gabriel to pull him straight up to heaven.

17 This was later reinterpreted as enjoining silence, and Harpocrates identified as the god, or the hieroglyph, of Silence. See, e.g. *Iconologia del Cavaliere Cesare Ripa, Perugino, Notabilmente accresciuta d'Immagini, di Annotazioni, e di Fatti, dell'Abate Cesare Orlandi*, Perugia, 1767, vol. V, p. 163, 3rd definition of *Silenzio*; or J. Baudouin, transl., *C. Ripa, Iconologie*, Paris, 1644, p. 180. For original edition(s) of Ripa's *Iconologia*, see below, Ch. 2, n. 7.

18 Of the many texts consulted, the most illuminating has been D. Meeks and C.F. Meeks, transl., G.M. Goshgarian, *Daily Life of the Egyptian Gods*, London, 1997.

19 Ibid., p. 78.

20 Ibid., see especially pp. 73, 74, 75 97 with references to original texts, and bibliography.

21 Cited in G. Robins, *Women in Ancient Egypt*, London 1993, p. 86, with references to original texts, and bibliography.

22 C. Andrews, *Amulets of Ancient Egypt*, p. 49.

23 Roman copy after Kephisodotos (or Cephisodotus) the Elder, fl. *c.*400 BC, *Eirene with Ploutos*, Munich, Staatliche Antikensammlungen. Rubens's allegory of War and Peace at the National Gallery, London, *Minerva protects Pax from Mars,* NG46, wittily reprises the notion of Peace as the mother of Wealth and the protector of actual children.

24 T. Hadzisteliou Price, *Kourotrophos, Cults and Representations of the Greek Nursing Deities* (Studies of the Dutch Archaeological and Historical Society, VIII), Leiden, 1978.

25 A famous, though much damaged, series of clay relief plaques from Persephone's sanctuary at Locri, Calabria, shows children of both sexes being presented in a basket to the enthroned goddess; see P. Orsi, 'Locri Epizefiri – resoconto sulla terza campagna di scavi locresi (aprile – giugno 1908)', part 2, *Bollettino d'Arte*, III, 1909, 463–82, fig. 39, p. 468; C. Sourvinou-Inwood, 'Persephone and Aphrodite at Locri: A Model for Personality Definition in Greek Religion', *Journal of Hellenistic Studies*, XCVIII, 1978, 101–21; H. Prückner, *Die lokrischen Tonreliefs*, Mainz am Rhein, 1969; Hadzisteliou Price, pp. 172ff.

26 Anonymous fifteenth-century Florentine painter, Florence, church of Santo Spirito. The 1593 altarpiece by Jacopo da Empoli (1551–1640) for the chapel of the Bargagli-Petrucci family in Santa Maria Soprarno, now in Florence, Galleria Palatina, Inv. 1890 n. 9383, repeats the same iconography, with the exception of God the

Father and attendant angels at the top of the painting placing a crown on the Virgin's head, and may have been directly influenced by the earlier painting. See M. Chiarini and S. Padovani, *La Galleria Palatina e gli Appartamenti Reali di Palazzo Pitti, Catalogo dei Dipinti*, Vol. II, Florence, 2003, p. 166. P. Perdrizet, *La Vierge de Miséricorde*, Paris, 1908, pp. 214–19, traces the iconography of the Madonna del Soccorso to that of the Madonna della Misericordia, and cites other examples, mainly in Umbria and the Marches.

27 British Museum, EA60958, wood, 39 cm high; dated to after 600 BC. Could artefacts such as this be the source for the myth of the baby demi-god Herakles, son of Zeus' adulterous union with a mortal woman, strangling the deadly snakes sent to destroy him by Zeus' jealous wife, Hera? The story is recorded in an ode by Pindar (*Nemean Odes* I, 35–72), and illustrated from the early fifth century BC. A seated infant Herakles strangling the snakes was a popular device on Greek coins. The motif later became a favourite of Hellenistic art. See J. Neils and J.H. Oakley, *Coming of Age in Ancient Greece, Images of Childhood from the Classical Past*, New Haven & London; Hanover, New Hampshire, 2003, pp. 211–13, cat. nos. 10, 11, 12.

28 S. Kelly Heyob, *The Cult of Isis among Women in the Graeco-Roman World*, (*Études préliminaires aux religions orientales dans l'empire romain; 51*), Leiden, 1975.

29 Roman portrait bust of unidentified boy with 'sidelock of youth' showing dedication to Isis; Petworth House, W. Sussex; see M. Wyndham, *Catalogue of the Collection of Greek and Roman Antiquities in the Possession of Lord Leconfield*, 1915, 78, no. 49; V. von Gonzenbach, *Untersuchungen zu den Knabenweihen im Isiskult der Römischen Kaiserzeit*, Bonn, 1957, Cat. 8, Pl. 9, where the bust is dated to the last quarter of the second century.

30 C. Bonner, *Studies in Magical Amulets, Chiefly Graeco-Egyptian*, Ann Arbor, Michigan, 1950, pp. 140–6; S. Michel, *Die Magischen Gemmen im Britischen Museum*, London, 2001, pp. 68–89.

31 J. Neils and J.H. Oakley, *Coming of Age in Ancient Greece*, pp. 143–4 and cat. nos. 75, 96–9.

32 See, e.g. Viterbo, Museo Civico, Room 1, case 9, number 19, votive sculpture from an as yet unlocated sanctuary near Bomarzo in the province of Viterbo, Northern Lazio, dated to between 100 BC and AD 300.

33 The use of coral as an apotropaic charm and for relieving the pain of dentition dates back to early Egyptian times. See S. X. Radbill, 'Teething in Fact and Fancy', *Bulletin of the History of Medicine*, vol. XXXIX, 1965, pp. 339–45.

34 Tommaso di Ser Giovanni Guidi, better known as Masaccio (1401–1428), *Confinement-room Scene*, front of childbirth tray, c.1427, Gemäldegalerie, Staatliche Museen zu Berlin, Preussischer Kulturbesitz; see J.M. Musacchio, *The Art and Ritual of Childbirth in Renaissance Italy*, New Haven & London, 1999, figs. 25, 127, and pp. 35, 131–2, also figs. 2, 11, 129 for other illustrations of coral charms depicted on childbirth trays.

35 See, e.g. Carlo Crivelli's *Madonna della Rondine*, c.1490, London, National Gallery, NG 724.

36 G. Dominici, *Regola del governo di cura familiare, parte quarta: On the Education of Children*, transl. and ed. A.B. Coté, Washington, 1927, Chapter I; cited in C.E. Gilbert, *Italian Art 1400–1500, Sources and Documents in the History of Art Series*, Englewood Cliffs, New Jersey, 1980, pp. 145–6, see also D. Freedberg, *The Power of Images, Studies in the History and Theory of Response*, Chicago and London, 1989, pp. 4–5, 11–12. Following the final session of the Council of Trent, 1563, Catholic Reformers revived and elaborated Dominici's recommendations for using images in the education of children; see, e.g. Andrea da Volterra, *Discorso sopra la cura e diligenza che debbono havere i Padri e le Madri verso i loro Figlioli sia nella civiltà come nella pietà Christiana*, Bologna, 1572, and Gabriele Paleotti, *Discorso*

intorno alle immagini sacre e profane, Bologna, 1582. For a discussion of the didactic use of religious imagery in Counter-Reformation Bolognese schools, see Caroline P. Murphy, *Lavinia Fontana, A Painter and her Patrons in Sixteenth-century Bologna*, New Haven and London, 2003, pp. 184 ff.

37 Marina Warner, *Alone of all her Sex, The Myth and the Cult of the Virgin Mary*, London, 1976.

38 The sculptors Donatello (c.1386–1466), Luca della Robbia (1399/1400–1482), Desiderio da Settignano (c.1430–64), Mino da Fiesole (1429–84) and the painter Botticelli (1444/5–1510) are especially associated with images of Jesus and John the Baptist as children or adolescents.

39 Normally a saint of the same name, although such Spanish and Italian names as Consuelo, Dolores, Assunta, Annunziata, Carmine and Carmelo all refer to aspects of the cult of the Virgin Mary.

40 Cristofano Allori (1577–1621), *Francesco (1594–1614) e Caterina (1593–1629) de' Medici*, Florence; Inv. [Poggio] Imperiale, esp. 505; exh. cat., *I principi bambini, Abbigliamento e infanzia nel Seicento*, Florence, 1985, cat. no. 24.

41 Cited in *I principi bambini*: 'un abito di saia biga fratesca col tonacha (?) . . . scapucino, che la saia la data la granduchessa'.

42 W. Deonna, *De Télesphore au 'moine bourru'. Dieux, génies et démons encapuchonnés, (Collection Latomus, XXI)*, Brussels, 1955. See n. 1, p. 28 for quotes from St Jerome and the monk Cassianus testifying that monks' habits are like the garments of 'innocent children'. But the *cucullus* has a cluster of significances: associated also with adults' nocturnal escapades, it becomes a 'cloak of invisibility' of spirits associated with the underworld. The best-known *cucullatus* divinity of Hellenistic antiquity was Telesphorus, a hooded, cloaked but barefoot child god, venerated either alone or as a companion of Asklepios, the healer god who visits patients in the night. Diffused especially through the eastern part of the Roman empire, Telesphorus came to signify the end of illness, i.e. either death or healing, and as a child god and protector of children is sometimes associated with Harpocrates. Ancient statues and statuettes of sleeping little hooded boys with a lantern, often called sleeping slave children waiting to light their master home, may have originally represented Telesphorus; see Deonna, *De Télesphore*, pp. 130 ff; p. 132, note 1, for references to all such works.

43 Juan Pantoja de la Cruz (1553–1608), *Infanta Anne of Austria, daughter of King Philip III of Spain*, 1602, Real Patronato de las Descalzas; Sociedad Española de Amigos del Arte, exh. cat., *Exposición de Retratos de Niño en España*, Madrid, 1925, cat. no. 21.

CHAPTER 2: INNOCENT VICTIMS

1 The bibliography on exposure and infanticide in Antiquity is vast; see, e.g. C. Daremberg, E. Saglio, E. Pottier, *Dictionnaire des Antiquités grecques et romaines*, entry on 'Infanticide', Vol. V, pp. 488–93, Paris, 1900; for the enslavement of foundling infants, see W.V. Harris, 'Towards a Study of the Roman Slave Trade', *Memoirs of the American Academy in Rome*, vol. XXXVI, Rome, 1980, pp. 117–40, especially pp. 123–4. The birth of malformed infants was in ancient Greece and Rome not a matter for individual families alone, but an omen of divine displeasure threatening general calamity in the form of sterility of crops, flocks and humans. The Greeks exposed infants above ground, the Romans on water; see M. Delcourt, *Stérilités mystérieuses et naissances maléfiques dans l'antiquité classique*, Bibliothèque de la Faculté de Philosophie et Lettres de l'Université de Liège; Fascicule LXXXIII, Liège and Paris, 1938.

2 The significance of this evidence has been queried; see S. Moscati, 'Sacrificio punico dei fanciulli: Realtà o Invenzione?'

234 *Notes to pages 24–34*

Accademia Nazionale dei Lincei, CCCLXXXIV, 1987, pp. 3–15; S. Moscati, S. Ribichini, 'Il sacrificio dei bambini: un Aggiornamento', Accademia Nazionale dei Lincei, CCCLXXXVIII, 1991, pp. 3–44, with a resumé of the literature on this disputed subject. Unpublished at the time of writing, newly found deposits of bones seem to demonstrate, however, that some healthy children were killed; oral communication, Neil MacGregor, Director, The British Museum.

3 Horrifically reprised by the Spanish painter Francisco Goya (1746–1828) in one of the 'black' paintings decorating his own house, the 'Quinta del Sordo': *Saturn devouring one of his Children*, c.1820–3, Madrid, Prado Museum.

4 Neils and Oakley, *Coming of Age in Ancient Greece*, pp. 178–9; 204–5, 217–18, cat. nos. 4, 13, 17; pp. 211–13, cat. nos. 10, 11, 12. See also above, Chapter 1, note 27, for the attempted murder of the infant Herakles by means of poisonous snakes.

5 Euripides' tragedy, *Medea*, was first performed in 431 BC. Having betrayed her own father, the King of Colchis, to help her lover Jason steal the Golden Fleece, Medea leads an exemplary married life in Corinth, until Jason casts her off for the King of Corinth's daughter. She murders the latter and her own sons so that Jason may grow old and die without either a wife or progeny: a ruthless revenge commensurate with the terrible injury done to her. Euripides presents her as a tragic emblem of the consequences of women's oppression by men.

6 M. Meiss, *Painting in Florence and Siena after the Black Death*, 2nd edn, New York, 1964, p. 51, where the resemblance to Ripa's later description of Cruelty is pointed out, see note 7.

7 Originally published unillustrated in 1593, Ripa's *Iconologia* was in 1603 republished in Rome, expanded to 400 entries and embellished with woodcuts. This edition includes but does not illustrate the entry on Cruelty. Charity's true contrary, Avarice, is characterised by Ripa as a woman with breasts full of milk who denies milk to a hungry child; this entry also appears without illustration, and the concept, difficult to represent visually, has never to my knowledge been depicted.

8 William Hogarth (1697–1764), *Gin Lane*, engraving, 1750/51.

9 Lichtenberg, Chodowiecki's employer, began writing about Hogarth's satirical prints in 1784, but it is probable that both he and the illustrator were well aware of them much earlier.

10 Francisco Goya y Lucientes (1746–1848), *Si quebró el cantaro* (*If he has broken the jug*), *Los Caprichos*, no. 25, c.1797–8. For a summary of the extensive bibliography on the *Caprichos*, see J. Wilson-Bareau, *Goya, drawings from his private albums*, exh. cat., London, 2001, p. 14.

11 *El sueño de la rason produce monstruos.*

12 *Mucho hay que chupar*, literally, 'It has much for sucking'; *Obsequio á el Maestro*, 'An offering for the Master'. The gruesome fate of infants at the hands of witches (or the Fates) is also of concern in prints nos. 44, 69. The subject had earlier been depicted by the Italian painter and etcher Salvator Rosa (1615–73), inspired by the *Malleus maleficarum*, *The Witches' Hammer*, c.1486, an encyclopaedia on witchcraft used in the persecution of witches, compiled by the Dominican inquisitors Johann Sprenger and Heinrich Kraemer, which had gone into 28 editions by 1600 – and by Goya himself in witchcraft paintings for the Osuna family. See also J. Wilson-Bareau, *Goya, drawings from his private albums*, cat. no. 89, p. 194, drawing 15 from *Witches and Old Women Album*, c.1819–23, *Sueño de buena echizera*, 'Dream of a good witch', showing an old woman carrying 'captured' babies on her back.

13 Eugène Delacroix (1798–1863), *Medea*, 1838, Lille, Musée des Beaux-Arts. A version of 1856–9, formerly Berlin, Nationalgalerie, is lost.

14 L. Whiteley, *Tradition & Revolution in French Art 1700–1880*,

exh. cat., National Gallery, London, 1993, cats. nos. 39–41, pp. 116–17.

15 Antoine Wiertz (1806–65), *Hunger, Madness, Crime*, (*Faim, Folie, Crime*), 1853, Brussels, Musée Wiertz.

16 This assumption accounts for accusations of infanticide not only against witches, see above note 12, but also accusations of ritual murder of children sporadically levied against Jews since 1144, when the mutilated body of twelve-year-old William of Norwich was found in a wood; 'Little St Hugh' of Lincoln, d.1255, and 'St Simon' of Trent, in northern Italy, d. 1475, were said to have been crucified by Jews; there are depictions especially of the latter. The classic account is C. Roth, *The Ritual Murder Libel and the Jews*, Oxford, 1935.

17 Attributed to Alessandro Allori (1535–1607), *Beatus qui allidit/parvulos suos/ad petram (Salmo CXXXVI)*, c.1590; L. Berti, *Opere d'arte della cassa di Risparmio di Firenze*, Florence, 1990, pp. 68–9, on which my text is based. I owe this reference to Elizabeth McGrath.

18 The inscription substitutes '*suos*' for the biblical '*tuos*' addressed to 'the daughter of Babylon'.

19 Käthe Kollwitz (1867–1945), *Seed Corn Must not be Ground* (*Saatfrüchte sollen nicht vermahlen werden*), 1942. A. Klipstein, *Käthe Kollwitz; Verzeichnis des graphischen Werkes*, Bern, 1955, K267.

20 Print no. 3 in Francisco Goya's *Caprichos* presents an interesting misogynist variation on the theme of protective mothers and abusive fathers. It shows a young woman shielding her two terrified little children from a hooded figure looming over them. The caption, *Que viene el Coco*, 'Here comes the Bogey-man', elicited Goya's further comment: 'Fatal abuse! To make a child fear the Bogey-man *more than his own father*, and to tremble at something which does not exist.' (Italics mine.) Juliet Wilson-Bareau interprets this print as the mother receiving her lover disguised as a bogey-man so that her children will not recognise him; *Goya, drawings from his private albums*, cat. no. 39, p. 179.

21 Elizabeth McGrath has reminded me of the learned artist Peter Paul Rubens's comments on his allegorical painting, *The Effects* (or *Horrors*) *of War*, c.1637, Florence, Palazzo Pitti: 'The principal figure is Mars, who, leaving the temple of Janus open (which in time of peace, according to Roman custom, stayed closed) goes with shield and bloodstained sword threatening some great disaster to the people . . . There are monsters nearby, which signify Plague and Famine, the inseparable companions of War . . . There is also a mother with a child in her arms, showing that fruitfulness, procreation and charity are wrecked by War, which corrupts and destroys everything'. Letter to Justus Sustermans, 12 March 1638; R.S. Magurn, *The Letters of Peter Paul Rubens*, Cambridge, Mass., 1955, pp. 408–9. In Rubens's earlier painting on a related theme, *Minerva protects Pax From Mars*, (see Chapter 1, note 23) Minerva only succeeds in saving Pax and baby Ploutos from Mars because she is not a mortal woman but a goddess, here fuctioning as the personification of Wisdom.

22 'Mykonos Pithos', metopes 14, 17, seventh century BC, Mykonos Museum, Cyclades. M. Ervin, 'A Relief Pithos from Mykonos', *Deltion*, 18 (1963), plates 26–7.

23 E. Vermeule, *Aspects of Death in Early Greek Art and Poetry*, Berkeley and Los Angeles, 1979, pp. 112–15. An echo of this significance is preserved in Thomas Gray's *Ode on a Distant Prospect of Eton College*, 1747: 'Alas, regardless of their doom,/ The little victims play!/No sense have they of ills to come,/ Nor care beyond today.'I, 51.

24 Vermeule, *Aspects of Death*, p. 114.

25 This sentence must now be qualified: shortly after it was written, the Turner Prize exhibition at Tate Britain, November 2003–January 2004, included a ceramic pot by Grayson Perry 'in lovely golds, whites and browns, called *We've Found the Body of Your*

Child and [depicting] scenes of death and grieving, along with slogans "All men are bastards" '. The potter subsequently won the Turner Prize. Perry's ceramics are not, of course, for domestic use; the artist is quoted as saying 'I have used imagery that some people find disturbing. I use such materials not to deliberately shock but because sex, war and gender are subjects that are part of me and fascinate me, and I feel I have something to say about them.' Stuart Jeffries, *The Guardian* newspaper, G2, 21 November 2003, p. 5.

26 See note 4 above, and Neils and Oakley, *Coming of Age in Ancient Greece*, p. 82, nn. 27, 28.

27 'Distant heirs' via battle scenes such as those on Roman triumphal reliefs and on sarcophagi, depicting the subjugation of foreign peoples.

28 P. Saintyves, '*Le Massacre des Innocents ou la persécution de l'enfant prédestiné*', J.A. Loisy, *Congrès d'Histoire du Christianisme*, I, Paris, 1928, pp. 229–72; cited in H.S. Silberger, *The Iconology of the Massacre of the Innocents in Late Quattrocento Sienese Art*, Ph.D. thesis, Case Western Reserve University, 1999, UMI Dissertation Service, Ann Arbor, Michigan, 2000. I am grateful to the author for making her text, from which much of the following information is drawn, available to me.

29 St Cyprian of Carthage, '*Epistula LVIII*', cited in Silberger, *Iconology of the Massacre of the Innocents*, p. 34.

30 See also Chapter 1, note 42, re: the adoption by medieval religious orders of the ancient child's and slave's garment, the *cucullus*.

31 As the infanticidal woman is the antithesis of the *kourotrophos* or of Charity, see pp. 22–8 above. See also pp. 85-8 below for the imagery of Ghirlandaio's high altarpiece of the Holy Innocents for Florence's Foundling Hospital of the Innocenti.

32 See p. 28.

33 For a copious, though by no means exhaustive, listing, see L. Réau, *L'iconographie de l'art chrétien*, Paris, 1955, vol. II, pp. 271–2.

34 Marcantonio Raimondi (*c*.1480–1534), engraving after Raphael (1483–1520), *Massacre of the Innocents*, second version, without fir tree, *c*.1518, Bartsch, *Le Peintre Graveur*, XIV.21.20, London, British Museum Print Room.

35 D. Landau and P. Parshall, *The Renaissance Print, 1470–1550*; New Haven and London, 1994, p. 134.

36 Antonio Pollaiuolo (*c*.1431–98), *Battle of the Nudes*, A. M. Hind, *Early Italian Engraving*, London, 1938–48, I.191.D.I.1; Andrea Mantegna (1431–1506), *Battle of the Sea Gods*, Hind, V.15.5.

37 Workshop of Pieter Bruegel the Elder (*c*.1525/30–69), *Massacre of the Innocents*, *c*.1565–7, Vienna, Kunsthistorisches Museum; F. Grossman, *Bruegel, Complete Edition of the Paintings*, London, 3rd edition, London, 1973, p. 198, cat. no. 112; Bruegel's badly damaged original, Hampton Court, Coll. H.M. the Queen. The composition exists in many versions, of which four have been claimed to be originals by Bruegel, L. Campbell, *The Early Flemish Pictures in the Collection of Her Majesty the Queen*, Cambridge, 1985, cat. no. 9, see esp. pp. 15–16.

38 The exact dating of the picture has a bearing on this. The Duke of Alva's murderous expeditionary force invaded the Netherlands in August 1567. Before that, however, the forces of order employed by the Netherlandish authorities were savage in enforcing sentences for 'heresy' or tax evasion. For a full summary of the debate about the iconography and its relevance to contemporary events, see Campbell, *Early Flemish Pictures*, p. 18.

39 Pablo Picasso (1881–1973), *Guernica*, 1937, Madrid, Centro de Arte Reina Sofia.

40 A. Blunt, *Picasso's Guernica* (*The Whidden Lectures for 1966*), pp. 44–6 'it would not be an exaggeration to describe *Guernica* as a *Massacre of the Innocents* – the *Massacre of the Innocents* of the Spanish Civil War. It was probably with a consciousness of the long series

of paintings illustrating the theme that Picasso chose, as an essential vehicle for conveying the tragedy of the scene, the group of mother carrying her dead baby . . .'

41 Picasso, in a statement written in May 1937, while he was painting *Guernica*, and made available to the press two months later at the time of an exhibition of Spanish Republican posters in New York. Cited by Alfred H. Barr, in J. Larrea, A. H. Barr, *Guernica, Pablo Picasso*, New York, 1947, p. 12.

42 Most have been interpreted in contradictory ways; for example, J. Larrea in *Guernica*, pp. 34 ff sees the horse as an embodiment of Franco's 'bestiality', and the bull as a metaphor for the Spanish people defending 'Mother Spain'; others cite Picasso's statement that 'the horse represents the people, and the bull brutality and darkness', Blunt, *Picasso's Guernica*, p. 14.

43 Its principal facade is shown in the background of Sandro Botticelli's fresco in the Sistine Chapel, sometimes entitled *The Cleansing of the Leper*, 1481–2. Sixtus, who is now best remembered for the building of the Sistine Chapel, pursued a vigorous and costly policy of embellishing Rome with new and restored buildings and bridges; as a Franciscan, he may additionally have been prompted to restructure Innocent's hospital because it was this pope who had approved Francis of Assisi's new preaching order of mendicant friars.

44 The frescoes are attributed to a team of Roman, Viterbese and Umbrian artists, but it is now useless to try to distinguish individual contributions. For the history of Santo Spirito in Saxia, reproductions of the frescoes and the various versions of the inscriptions, see P. de Angelis, *L'Ospedale di Santo Spirito in Saxia, vol. II, dal 1301 al 1500*, Rome, 1962, especially pp. 369 ff.

45 *Feminae clandestino stupro corruptae ne flagitij indicia extent prolem varijs modis clam interimunt. Anxius hoc placulo Innocentius III Pontif. Max. solemni supplicatione consiliuq. remedium mali A Deo exposcit.*

46 This conclusion seems to be in line with the opinion of those social historians who see foundling hospitals originating in Mediterranean Europe as a response to an 'obsession with female honour' that made mothers more likely to kill their illegitimate offspring; Britain and some northern European countries were more likely to seek legal means of identifying the fathers of such children and making them pay for their support. See summary with full bibliography in C. Heywood, *A History of Childhood, Children and Childhood in the West from Medieval to Modern Times*, Cambridge, 2001. Silberger, *Iconology of the Massacre of the Innocents*, plausibly adduces worries about depopulation, brought about by war and pestilence, as a motive for renewed efforts by medieval and Renaissance Italian cities to rescue endangered infants and children.

47 See pp. 18–21.

48 The last but one fresco of the cycle, by Domenico di Bartolo, represents the idealised life cycle of a girl child abandoned in the *pila*, a font-like stone basin. The swaddled baby is lifted out by the hospital's rector, entrusted to the female supervisor of the wet-nurses, lovingly suckled and unswaddled. As she grows, she is fed delicacies, and taught to read by a schoolmaster. When she reaches womanhood, the rector officiates at her marriage to a handsome youth.

49 Lorenzo di Pietro, 'il Vecchietta' (1410–80), *Dream of Beato Sorore's Mother*, 1440–4, Siena, Santa Maria della Scala, *Pellegrinaio*.

50 This is also how Vecchietta represents him on the *Arliquiera*, the front of a cupboard once containing Siena's hoard of precious relics, painted in 1445 for the sacristy of the church of Santa Maria della Scala; now Siena, Pinacoteca Nazionale.

51 A. Orlandini, *Gettatelli e Pellegrini, gli affreschi nella sala del Pellegrinaio dell'Ospedale di Santa Maria della Scala di Siena*, 2nd edn,

Siena, 2002, p. 44; a fuller discussion with bibliography in Silberger, *Iconology of the Massacre of the Innocents*, p. 229 and n. 426. Silberger also notes that a disputed relic, the foot of one of the Innocents, was recorded in the Sienese church of Sant'Agostino in 1393 and may have been acquired much earlier, perhaps by a Sienese participant in the Fourth Crusade, 1202–4.

52 The Hospital of San Gallo, administered by Augustinian friars, is documented from 1193 as both a general and a foundling hospital; the Hospital of Santa Maria della Scala, dependent on the Sienese hospital of that name, was established in 1313 to care for cast-out children as well as the adult poor. The property of these institutions was transferred in 1463 and 1464 respectively to the administration of the Spedale degli Innocenti.

53 The six of Matthew 35: feeding the hungry, giving drink to the thirsty, taking in strangers, clothing the naked, ministering to the sick, visiting those in prison, and the seventh inspired by the deuterocanonical Book of Tobit: burying the dead – the speciality of the Florentine Misericordia, who claimed Tobit as their patron and had distinguished themselves burying the dead during the plague of 1348. Their other favoured charities were the transport of the sick and the care of orphans. The hooded volunteers of the Misericordia still run the ambulance service in Florence. For the iconography of the Madonna della Misericordia, see note 56 below.

54 The building at No. 1, Piazza San Giovanni in Florence, is named 'Bigallo' for a confraternity which since 1245 had been staffing the general hospital at Fonteviva, known after its heraldic device as 'Bigallo' or 'twice a cockerel'. In 1425, this brotherhood, in financial difficulties, was by order of the Signoria fused with the Compagnia della Misericordia under the name of Santa Maria del Bigallo, moving to the Misericordia's headquarters in Piazza San Giovanni. The Misericordia's task of recovering abandoned children was reorganised so that foundlings were cared for 'in-house'. Since the interests of the Compagnia del Bigallo, specialised in the running of hospitals, prevailed over those of the more generalist Misericordia, growing tensions caused the combined confraternities to dissolve their union in 1525; the Misericordia moved its headquarters elsewhere. After many more vicissitudes the Compagnia del Bigallo was finally suppressed in 1776; the restored Bigallo building has since been turned into a museum. H. Saalman, *The Bigallo*, New York, 1969.

55 Detached in 1777 and now exhibited indoors in the Bigallo Museum, where there are also shown copies of the fresco made before and at the time of its removal.

56 The iconography of the Madonna of Misericord originates in a vision reported by the Cistercian Caesarius von Heisterbach, in his *Dialogus miraculorum*, written 1220–30. At first typical of conventual mysticism, the cult image came to be associated with lay confraternities and institutions – particularly those specialising in charity, such as the Compagnia della Misericordia in Florence. Although I know of no other such image specifically identified with the Holy Innocents, a fresco of the Madonna of Misericord, now detached and in Parma, Galleria Nazionale, had been painted by Antonio Barnabei (1567–1630) above the entrance of a girls' orphanage in Parma; a picture by François-Marius Granet (1775–1849), now Musée des Beaux-Arts, Aix-en-Provence, shows the interior of an orphanage with on the wall a Madonna of Misericord sheltering the institution's regents; see P. Perdrizet, *La Vierge de la Miséricorde*, Paris, 1908, p. 71.

57 Unknown Florentine follower of Francesco Granacci (1469–1543) *Madonna degli Innocenti*, first half of sixteenth century. Biblioteca dello Studiolo, *Spedale e Museo degli Innocenti*, Florence, 1977, cat. nos. 86, 84.

58 The earliest insignia of the Innocenti, as shown in the lead reliquary of the chapel's high altar, was the *pila* (see note 48) with inside it a swaddled infant with an aureole; this was later changed to a vertically posed swaddled baby. Andrea della Robbia's famous polychrome ceramic figures of babies, in loosened swaddling bands and holding out their arms to the viewer, placed in the roundels of the hospital's facade in 1487, allude both to the institution's heraldic emblem and to the martyred Holy Innocents.

59 On 20 October, 1421, the city's Council of the People voted to erect a new hospital '*sub titulo Sanctae Mariae degli Innocenti*', exclusively destined to receive the children '*qui vulgo dicuntur gittatelli . . . quorum patres et matres contra naturae iura, sunt desertores.*' *Spedale e Museo degli Innocenti*, p. 5. The terminology for abandoned children and the institutions sheltering them is interesting. The Italian words *proietti* and *gettatelli*, 'thrown out' or 'thrown away', put the emphasis on the parents' desertion, as do the Spanish *abandonados,* 'abandoned', and *desamparados,* 'deserted' or 'hapless'; on the other hand, *trovatelli,* the German *Findelkinder,* the French *enfants trouvés,* are equivalent to 'found children', 'foundlings', stressing the act of rescue. The Late Latin and literary modern Italian for 'foundling hospital', *brefotrofio,* is a compound of the Greek words for 'newborn' and 'to raise'. In some Italian foundling hospitals, the *conservati,* or 'preserved' children, were taught music, these institutions becoming the first secular schools of music – hence the word *conservatorio,* 'conservatory'. The conservatory in Naples is associated with boys, that in Venice with girls.

60 Domenico Ghirlandaio (c.1448–94), *Adoration of the Magi*, 1488; Florence, Museo dell'Ospedale degli Innocenti.

61 See note 58.

62 Bernardino Poccetti (1542–1612), *Massacre of the Innocents and Visit of Grand Duke Cosimo II de'Medici to the Innocenti*, 1610–12, Florence, Ospedale degli Innocenti, former women's refectory.

63 In conventional representations of the Massacre of the Innocents, this figure represents Elizabeth, the mother of John the Baptist; their escape to the hills is told in the apocryphal Book of James. The seated woman lamenting over her child's body traditionally alludes to Rachel weeping for her children in Jeremiah 31: 15; see p. 41.

64 Priors of the Innocenti were elected by a secret vote of all the members of the Arte della Seta, who were also taxed on behalf of the hospital; *Spedale e Museo degli Innocenti*, p. 8.

65 The fictive stairs are based on those designed by Michelangelo for the vestibule of the Biblioteca Medicea Laurenziana, Florence; Giorgio Vasari first used the motif as dadoes for the frescoes in the Sala dei Cento Giorni, Palazzo della Cancelleria, Rome, in 1546.

66 When grown, male foundlings were generally apprenticed to artisans; the young women worked for the Arte della Seta; many remained in the hospital, although dowries were given to those wishing to marry or to become nuns; *Spedale e Museo degli Innocenti*, p. 9.

67 See above, note 46; for additional discussion and bibliography on this specific topic, see also D. Kertzer and M. Barbagli, eds., *Family Life in Early Modern Times 1500–1789*, volume I in *The History of the European Family*, New Haven and London, 2001, pp. 147–50 and notes. For paintings commissioned for or donated to foundling hospitals in late sixteenth-century Bologna, see Caroline P. Murphy, *Lavinia Fontana, A Painter and her Patrons in Sixteenth-Century Bologna*, pp. 190–1.

68 Anonymous, *Hilleke de Roy and Four of her Orphans*, 1586, Gorinchem, Stichting Huize Matthis-Marijke; my account is based on J.B. Bedaux and R. Ekkart, *Pride and Joy, Children's Portraits in the Netherlands 1500–1700*, cat. no. 9, pp. 104–6. A similar portrait of a matron with her charges was painted in Gouda in 1568; Gouda, Stedelijk Museum Het Catarina Gasthuis. In 1663 Jan de Bray was commissioned to paint *Feeding and Clothing the Orphan Children* by

the Haarlem orphanage, the Heilige Geesthuis; Haarlem, Frans Hals Museum, *Catalogue*, Haarlem, 1969, cat. no. 35, plate 85. There are other group portraits of regents receiving children, such as that by Jürgen Ovens for the Amsterdam orphanage, H. Schmidt, *Jürgen Ovens, sein Leben und seine Werke*, Kiel, 1922, cat. no. 265, p. 192, pl. 24.

69 D. Pietersz. Pers, in the description of 'Duty, Obligation' in his 1644 Dutch adaptation of Ripa's *Iconologia*: 'orphans are identified in this way in the Netherlands so that, on seeing their clothing, one is aware that they must live by the kindness of others.' Cited in Bedaux and Ekkart, *Pride and Joy*, cat. no. 9, p. 104.

70 Samuel Wale (1721–86), *A Perspective View of the Foundling Hospital with Emblematic Figures 1749*, London, Thomas Coram Foundation for Children.

71 An anachronistic and absurdly sentimental painting of 1863 by Edward Matthew Ward (1816–79), depicts *Hogarth's Studio, 1739 – Holiday Visit of Foundlings to View the Portrait of Captain Coram*, York Art Gallery.

72 R. Paulson, *Hogarth, Volume 2, High Art and Low, 1732–1750*, Cambridge, 1992, ch. 13; B. Nicolson, *The Treasures of the Foundling Hospital, with a catalogue raisonné based on a draft catalogue by John Kerslake*, Oxford, 1972.

73 Michael Rysbrack (1694–1779), marble relief of *Charity*, 1746, London, The Foundling Museum; Nicolson, *Treasures of the Foundling Hospital*, pp. 17–18, 25, cat. no. 103, p. 88; pl. 49; M.I. Webb, *Michael Rysbrack, Sculptor*, London, 1954, pp. 131–5, fig. 63.

74 Cited by Webb, *Michael Rysbrack*, p. 135.

75 See Introduction, pp. 10–14.

76 Francis Hayman (*c.*1708–76) *The Finding of Moses*, 1746–7, London, The Foundling Museum; Nicolson, *Treasures of the Foundling Hospital*, pp. 25–6, cat. no. 34.

77 All the works discussed remain in the collection of the Thomas Coram Foundation for Children, London, The Foundling Museum.

78 P. Crown, 'Portraits and Fancy pictures by Gainsborough and Reynolds: Contrasting images of childhood', *British Journal for Eighteenth-Century Studies*, vol. VII, no. 2, 1984, pp. 159–65, argues that eighteenth-century so-called Fancy pictures of destitute children, modelled on the seventeenth-century Spanish painter Murillo's *genre* works, and presenting the children as picturesque motifs within a 'natural' order, implicitly evoke the pathos of their real models' actual situation. Such emotionally appealing works were, however, not considered for the decoration of the Foundling Hospital.

79 C. Wood, *Victorian Panorama, Paintings of Victorian Life*, London, 1976, pp. 69–72; the earliest paintings are reproduced as figs. 70, 68, 69 respectively; for the fourth, see Nicolson, *The Treasures of the Foundling Hospital*, cat. no. 55. All are still in the collection of the Thomas Coram Foundation for Children, London, The Foundling Museum.

80 Emma Brownlow King (1832–1905), *The Christening*, 1863, London, The Foundling Museum.

81 Also recorded at the time as *Young* [or *Little*] *Children brought to Christ, Christ shewing the little Child*; Nicolson, pp. 42–4, cat. no. 81; pp. 42–3, cat. no. 24 for Casali's *Adoration of the Magi*. West's painting is presently located on the staircase of the Foundling Museum.

82 The Adoration of the Magi is especially associated with the decoration of Paris foundling hospitals: an altarpiece on this subject hung in the chapel of Hôpital des Enfants-trouvés in the Faubourg Saint-Antoine, Paris. The entire chapel of the Hôpital des Enfants-trouvés on the parvis Nôtre-Dame, razed over a century ago, was designed as a *trompe-l'oeil* ruined Roman basilica in

Bethlehem, the site of Christ's birth, with the Adoration of the Magi painted above the altar, the shepherds departing to spread the joyful news along the east wall, and the Kings' retinue advancing along the west wall. Anachronistically, the foundlings and the nuns caring for them were painted in two bays of the upper west wall, leaning over wooden railings to gaze at the Child. The elaborate decoration was carried out in 1750–1 by Charles Natoire, who painted the figure compositions, and the Italian specialists, Gaetano and Paolo-Antonio Brunetti, for the feigned architecture. See C. Riopelle, 'Notes on the Chapel of the Hôpital des Enfants-trouvés in Paris', *Marsyas*, vol. XXI, 1981–2, pp. 29–35. For a brief summary of the history of foundling care in France, see below, pp. 62–5.

83 See, e.g., the *c.*80 pairs of staged *Before and After* photographs taken anonymously from *c.*1875 for Dr Barnardo's Homes for destitute children; Barnardo Photographic Archive, Ilford. Sotheby's loan exh. cat., *Childhood*, London, 1988, cat. no. 291, reproduces a pair depicting boys taken in at the East London Home for Destitute Boys in the 1880s, entitled *The Raw Material* and *The Manufactured Article* – the latter showing a group in sailors' uniforms. See also notes 84, 85, below. Destitute street children were viewed ambiguously as pitiful, but also as nuisances and potentially criminal; see M. Bills, 'William Powell Frith's *The Crossing Sweeper*: an archetypal image of mid-nineteenth-century London', *The Burlington Magazine*, vol. CXLVI, no. 1214, May 2004, pp. 300–7.

84 William MacDuff (fl. 1844–76), *Shaftesbury, or Lost and Found*, 1862, London, Museum of London. Wood, *Victorian Panorama*, pp. 69–70, pl. 67; Graham Reynolds, exh. cat., Arts Council, *Victorian Paintings*, London, 1962, no. 42; Bills, 'Frith's *The Crossing Sweeper*', fig. 9, p. 305.

85 The founding of the Shoe Black Brigade can be traced to the initiative of a Ragged School teacher (see n. 87 below), who employed vagrant boys to clean the shoes of visitors to the 1851 Great Exhibition.

86 Painted in 1855, the picture made Thomas Faed (1826–1900) one of the most popular British painters; it is now in Melbourne, National Gallery of Victoria. Faed exhibited it with the last two verses from 'The Mitherless Bairn' by the Scottish poet William Thom, published in a collection in 1844. Mezzotint reproductions of it by Samuel Cousins and Richard Josey were published by Henry Graves & Co. in 1860 and 1880 respectively.

87 The first 'ragged school' was started by John Pounds (1776–1839) a Portsmouth cobbler who had been crippled as a child. The Ragged School Union was formed in 1844; by 1848, over ten thousand children were in the care of Ragged Schools. See Sotheby's, *Childhood*, cat. no. 276, p. 140, for a sculpted group of Pounds seated flanked by a boy and girl, 19 inches, inscribed, mid-nineteenth century, The Shaftesbury Society.

88 Jules Bastien-Lepage (1848–84), *Le Petit Cireur de bottes à Londres (The London Bootblack)*, 1882, Paris, Musée des Arts Décoratifs; G.P. Weisberg, exh. cat., *The Realist Tradition, French Painting and Drawing 1830–1900*, Cleveland, Ohio, 1981, no. 170.

89 *Happy Tim*, from *Children's Delight* (Boston, 1889), Winterthur, Delaware, Winterthur Library, Printed Books and Periodicals. A. Schorsch, *Images of Childhood*, fig. 88; for other 'cheeky' working children, see also figs. 83, 88, 94, 106, pl. XVIII and extended captions.

90 See Chapter 4, pp. 98–100.

91 Anonymous, *Saint Vincent de Paul presiding over a Meeting of the Ladies of Charity who give him their Jewels for the Founding of the Oeuvre des Enfants-Trouvés*, after 1729(?), Paris, Musée de l'Assistance Publique. J. Simard, *Une iconographie du clergé français au XVIIe siècle* (*Travaux du laboratoire d'histoire religieuse de l'université Laval 2*), Quebec, 1976; pp. 56–7, pl. 27.

92 For the identification of foundlings with the swaddled Christ Child, see also p. 98 and fig. 68 below.

93 See Introduction, p. 28 and note 36.

94 Isidore Pils (1813–75), *La Mort d'une Soeur de Charité*, 1850, Paris, Musée d'Orsay; Weisberg, *The Realist Tradition*, pp. 108–9, cat. nos. 79, 79A–B; for *La Prière à l'hospice*, p. 112, cat. no. 81.

95 pp. 10–12.

96 See below, pp. 162–3 and fig. 111. Among the many paintings by Murillo that Pils could have seen in the Louvre or King Louis-Philippe's Galerie Espagnole were Murillo's *Street Urchin (Boy killing a Flea)*, 1645–50, and *Saint Thomas of Villanova distributing Charity*, c. 1665, now Los Angeles, Norton Simon Foundation.

97 Anonymous, *Saint Vincent de Paul et les soeurs de la charité*, nineteenth century, Paris, Musée de l'Assistance Publique.

98 Note the metal chandelier, the carpet, and the inexplicable drapery on the chair, copied from similar motifs in Dutch seventeenth-century paintings.

99 Joaquin Pallarés (1858–1933), *Abandonados*, 1881, Prado Museum, no. 6738, on deposit in Zaragoza, Institute Goya; exh. cat. *El niño en el Museo del Prado*, Madrid, 1983–4, cat. no. 64. Pallarés was twenty-three when he painted this picture in Rome; it was presumably the first of his works to be purchased by the state.

CHAPTER 3: MOURNING AND CONSOLATION

1 M. Lichtheim, *Ancient Egyptian Literature 2*, Berkeley, 1976, p. 138, cited *inter alia* by G. Robins, *Women in Ancient Egypt*, p. 85.

2 *Ibid*.

3 R.M. and J.J. Janssen, *Growing up in Ancient Egypt*, pp. 45, 21–2, citing W.M.F. Petrie, *Kahun, Gurob and Hawara*, London, 1890, and W.M.F. Petrie and J.E. Quibbell, *Naqada and Ballas*, London, 1896; G. Robins, *Women in Ancient Egypt*, p. 96, referring to the excavations at Deir el-Medina by B. Bruyère and E. Schiaparelli; I. Shaw and P. Nicholson, *Dictionary of Ancient Egypt*, with bibliographies relating to all five of the sites named here.

4 G. Pinch, 'Private life in Ancient Egypt', J.M. Sasson, ed.-in-chief, *Civilizations of the Ancient Near East*, vol. 1, New York, 1995, p. 376. I have not found evidence for this notion in the literature on Ancient Egypt, though it is certainly supported by later European art.

5 For the sidelock of youth, see p. 26; fig. 16. One of these side-lock-wearing mummies is that of a boy approximately eleven years old, found in the tomb of Amenhotep II, 1427–1400 BC, another, a boy about five, may have been a son of Rameses III, 1184–1153 BC; R.M. and J.J. Janssen, *Growing up in Ancient Egypt*, pp. 38, 95.

6 As, e.g., the infant's mummy case EA29588 in London, British Museum. The Osirid attribute of a false beard attached by cords was also worn by pharaohs to express their status as living gods; it is shown in images of Hatshepsut, 1473–1458 BC, a pharaoh's daughter who had herself crowned king. The seated statue of her chief steward, Senenmut, in his role as 'father-nurse', i.e. tutor, to Hatshepsut's daughter Neferura, shows the little girl on his lap with both the sidelock of youth and the 'divine' false beard; British Museum EA174.

7 See figs. 10, 18.

8 ' "The dog did nothing in the night-time." "That was the curious incident," remarked Sherlock Holmes.' A. Conan Doyle, *Silver Blaze* (1894).

9 See above, pp. 21–2.

10 What follows is mainly indebted to J.H. Oakley, 'Death and the Child', in J. Neils and J.H. Oakley, *Coming of Age in Ancient Greece*, pp. 163–94, with full bibliography. S. Houby-Nielsen is particularly credited for her work on child burial in Athens.

11 See below, pp. 121–2, fig. 82.

12 One of the best known of such early representations is on the Attic Late Geometric grave marker in the form of a wine bowl or *krater*, c.740–730 BC, New York, Metropolitan Museum of Art, Rogers Fund, 14.130.14.

13 The greater concern for child mortality in Athens in this period has been attributed to the catastrophic losses from plague and battle during the Peloponnesian War, 431–404 BC. Many writers refer to this, but see especially L.A. Beaumont, 'The Changing Face of Childhood', in Neils and Oakley, *Coming of Age in Ancient Greece*, p. 75.

14 Attic gravestone of Ampharete, late fifth century BC, Athens, Kerameikos Museum, P695.

15 W. Peek, *Griechische Vers-Inscriften I. Grab-Epigramme*, Berlin, 1955, no. 661; cited by Oakley, 'Death and the Child', p. 180.

16 Attr. to the Painter of Munich 2335, Attic white-ground lekythos, c.430 BC, New York, The Metropolitan Museum of Art Rogers Fund, 1909, 09.221.44.

17 P. Jay, ed. *The Greek Anthology, and other ancient epigrams, A selection in modern verse translation*, Harmondsworth, Middlesex, 1973, p. 65, no. 80, transl. by P. Jay from *The Palatine Anthology*, Book 7, no. 481. *The Palatine Anthology* is a collection of epigrams, or short poems, some by Greek authors, others by Romans writing in Greek; its name derives from the manuscript having been discovered in 1606 in the Count Palatine's library at Heidelberg. It is one of two anthologies of epigrams that make up what has come to be known as *The Greek Anthology*.

18 Gravestone of the Girl Melisto, Attic marble grave stele, c.340 BC, Cambridge Mass., Harvard University Art Museums, Arthur M. Sackler Museum, Alpheus Hyatt Purchasing and Gifts for Special Uses Funds in memory of Katherine Brewster Taylor, as a tribute to her many years at the Fogg Museum, 1961.86.

19 For a comprehensive discussion of Greek beliefs in the after-life, see W. Burkert, *Greek Religion, Archaic and Classical*, J. Raffan, transl., Oxford, 1985.

20 Homer, *The Odyssey*, XI, 37ff., A.T. Murray, transl., revised G.E. Dimock, Loeb Classical Library, Cambridge, Mass., 2nd ed., 1995.

21 Virgil, *The Aeneid*, VI, 426–429; H.R. Fairclough, transl., Loeb Classical Library, London and Cambridge, Mass., 2nd ed., 1935.

22 Plutarch, 'Consolation to his Wife', *Moralia*, VII, 611 C, D, P.H. De Lacy, B. Einarson, transl., Loeb Classical Library, Cambridge, Mass., 1959. The 'deprivation' of which Plutarch writes is the baby's 'departing unmarried and childless'.

23 *Ibid*. 611 F.

24 See Neils and Oakley, *Coming of Age in Ancient Greece*, cat. nos. 122–6.

25 For the importance of the Strasburg *Virgil Aeneid* illustrations, see L. Freund, 'Aeneas, Aeneis', *Reallexicon z. deutschen Kunstgeschichte*, vol. I, Stuttgart, 1937, p. 687.

26 Hans Wechtlin (c.1480/5–after 1526), woodcut p. CCLXX, Virgil, *The Aeneid*, S. Brant ed., Strasburg 1502.

27 See below, pp. 112–13.

28 Plutarch, 'Consolation to his Wife', 612; see also Plutarch, *Life of Numa*, Bernadotte Perrin, transl., Loeb Classical Library, London and Cambridge, Massachusetts, 1914, XII. Numa Pompilius was the legendary second king, lawgiver and first *pontifex maximus*, or high priest, of Rome (?715–?673 BC); he is said by Plutarch to have regulated periods of mourning according to the age of the dead child; J.-P. Néraudau, 'La Loi, la coutume et le chagrin, Réflexions sur la mort des enfants', in F. Hinard, ed., *La mort, les morts et l'au-delà dans le monde romain, Actes du Colloque de Caen, 20–22 November 1985*, Caen, 1987, pp. 195–208; B. Rawson, *Children and Childhood in Roman Italy*, Oxford, 2003, pp. 346–63.

29 What follows is heavily indebted to J. Huskinson, *Roman Children's Sarcophagi: Their Decoration and Social Significance*, Oxford, 1996.

30 See R. Stuveras, *Le Putto dans l'art romain*, Collection Latomus, XCIX, Brussels, 1969.

31 Rome, Museo Nazionale Romano, 65199. A. Giuliano, *Museo Nazionale Romano*, I, ii, pp. 73ff, no. 55; J. Huskinson, *Roman Children's Sarcophagi*, cat. no. I.29.

32 Huskinson, *Roman Children's Sarcophagi*, p. 117; for an extended discussion of nocturnal funerals and torch-light, see Néraudau, *La mort, les morts et l'au-delà dans le monde romain*, pp. 199–205.

33 Paris, Louvre, Ma 659, AD 150–60; Huskinson, *Roman Children's Sarcophagi*, cat. no. I.23.

34 See also Chapter 5, pp. 122–3.

35 Plutarch, 'Consolation to his Wife', 609 E, F.

36 See the epigram on pp. 70–1.

37 London, British Museum GR 1805.7-3.144, Townley Coll., AD 150–80, from Rome, Palazzo Capranica. S. Walker, *Catalogue of Roman Sarcophagi in the British Museum*, London, 1990, pp. 17–18. J. Huskinson, *Roman Children's Sarcophagi*, cat. no. I.11.

38 Plutarch, 'Letter of consolation to his Wife', 609 F–610.

39 See below pp. 168–9 and fig. 117; for other examples, J.B. Bedaux and R. Ekkart, *Pride and Joy, Children's Portraits in the Netherlands 1500–1700*, cat. nos. 28, 56, 58, 61, 79, 82.

40 As on the funerary monument erected to Edmund Fox, d. 11 April 1617, by his widow Anne Aberford in St Mary's Church, Much Cowarne, Herefordshire, where three babies – almost certainly dead in childbirth or infancy – are shown in a cradle on the short side of the tomb, beneath the feet of their parents lying in state. The long, front side is carved with the kneeling figures of Edmund and Anne's surviving three sons and seven daughters, the last much younger than the others. I owe the reference to Nigel Lewellyn, who has made a special study of English funerary art.

41 Edwin Romanzo Elmer (1850–1923), *Mourning Picture*, c.1889, Smith College Museum of Art, Northampton, Massachusetts; M.V. Elmer, 'Edwin Romanzo Elmer as I Knew Him,' *The Massachusetts Review*, Autumn-Winter 1964–65; A. Frankenstein, 'Edwin Romanzo Elmer', *Magazine of Art*, October 1952, p. 270.

42 William Hogarth (1697–1764), *The Graham Children*, 1742, London, National Gallery, NG 4756; J. Egerton, *The British School*, pp. 134–145.

43 William Hogarth, *Study of a Dead Child*, c.1742, London, British Museum.

44 E.g. Samuel Cooper (1609–72), *Dead: child*, 1670–2, drawing of the first-born child of John Hoskins the Younger, a miniature painter and Cooper's first cousin; see the Sotheby's loan exhibition catalogue, *Childhood*, London, 1988, cat. no. 20, p. 30 (location not specified).

45 Attributed to Peter Paul Rubens (1577–1640), *Angels bearing a Dead Child to Heaven*, University of Oxford, Ashmolean Museum, Department of Western Art, A 167. For a similar example of this comparatively rare iconography, see the Flemish School *Allegory of a Cherub crowning a Young Child and presenting Him with a Palm*, 1668 (according to the inscription, the child was born on 1 June, and died on 3 July); Collection Fundacion Yannick y Ben Jakober, Inv. No. 443; Nins, *Portraits of Children in the Fundacion Yannick y Ben Jakober*, exh. cat. Museu de Arte Brasileiro, São Paolo, 2000, cat. no. 10.

46 John Dwight (c.1635–1703), *Lydia Dwight on her Deathbed*, and *Lydia Dwight Resurrected*, c.1674, London, Victoria and Albert Museum; N. Lewellyn, *The Art of Death, Visual Culture in the English Death Ritual, c.1500–c.1800*, London, 1991, pp. 28–9, figs. 29, 30.

47 Lewellyn, *The Art of Death*, p. 28.

48 Bedaux and Ekkart, *Pride and Joy, Children's Portraits in the Netherlands, 1500–1700*, cat. nos. 19, 46, 78; pl 46b illustrates Ferdinand Bol's 1659 portrait of a dead little boy holding a bouquet of flowers. According to the authors, 'wreaths and bouquets remained part of funerary ritual in the seventeenth century [in the Netherlands], although the Protestant Church was fiercely opposed to them.' pp. 277–8. The custom may have been equally common in England.

49 A similar belief is already apparent in the pagan Plutarch's reflections on the immortal souls of little children, 'set free by higher powers', proceeding to their 'natural state', see p. 73. That human souls could return to heaven as angels, having originally been angels who remained neutral when Lucifer rebelled against God, was a heretical doctrine condemned in the fifteenth century – see M. Davies, *The Earlier Italian Schools*, National Gallery Catalogues, London, 1951, re: *The Assumption of the Virgin*, ascribed to Francesco Botticini – yet I am not aware of any clerical condemnation of dead infants being pictured as angels in family portraits. In seventeenth-century Netherlands, contrary to twentieth-century art historians' assumptions, Protestants were more likely than Catholics to employ this iconography. The theological justification is to be found in the five articles of the Synod of Dordrecht, refuting the charge that the Calvinists' God was a cruel deity who condemned newborn infants torn from their mothers' breasts to eternal damnation, affirming that 'God-fearing parents ought not . . . to doubt the election and salvation of their children, whom God has taken from this life in their infancy.' Cited in Bedaux and Ekkart, *Pride and Joy: Children's Portraits in the Netherlands*, pp. 24, 278.

50 George Elgar Hicks (1824–1914), 'The Peep of Day', *Freddy Hicks (1850–55)*, 1855, Southampton Art Gallery. R. Allwood, *George Elgar Hicks, Painter of Victorian Life*, exh. cat., London, 1983, p. 19, cat. no. 14.

51 Unidentified obituary cutting. Hicks also wrote an unpublished book of family prayers; Allwood, *George Elgar Hicks*, p. 42, under cat. no. 40, *A Cloud with a Silver Lining*.

52 See also C. Wood, *Victorian Panorama*, p. 108, where the picture is titled *Death of a Child*.

53 Ovid, *Metamorphoses*, x, 158–61; F.J. Miller, transl., Loeb Classical Library, London and Cambridge, Massachusetts, 1916.

54 Neils and Oakley, *Coming of Age in Ancient Greece*, p. 215, cat. no. 15.

55 Nicolaes Maes (1634–1693), *Girl with her Younger Brother as Ganymede*, c.1672–3, New York, Otto Naumann; Bedaux and Ekkart, *Pride and Joy*, p. 17. In 1635, Rembrandt had depicted *The Rape of Ganymede* with the eagle carrying off an infant, bawling and urinating with fear, with reference to Aquarius, Water-Bearer, bestowing life-giving water on the world; M. Russell, 'The iconography of Rembrandt's *Rape of Ganymede*', *Simiolus*, 9 (1977), pp. 5–18; J. Bruyn, B. Haak, S.H. Levie, P.J.J. van Thiel and E. van de Wetering, *A Corpus of Rembrandt Painting* (Stichting Foundation Rembrandt Research Project), vol. III, The Hague, Boston and London, 1989, p. 166.

56 For the suggestion that this belief was current in ancient Egypt, see above, p. 68.

57 J.E. Illick, 'Anglo-American Child-Rearing', in L. de Mause, ed., *The History of Childhood*, 1974, first British edn London, 1976, p. 325.

58 Oral communication, the anthropologist Dott.sa Carmen Peluso.

59 The following is indebted to E. Borsook and J. Offerhaus, *Francesco Sassetti and Ghirlandaio at Santa Trinita, Florence; History and Legend in a Renaissance Chapel*, Doornspijk, 1981.

60 Domenico Ghirlandaio (c.1448–94) *Nativity and Adoration of the Shepherds*, 1485, Florence, Santa Trinità, Sassetti Chapel.

61 Domenico Ghirlandaio, *Saint Francis resuscitating the Roman Notary's Son*, fresco, by 1485, Florence, Santa Trinità, Sassetti Chapel.

62 See pp. 18–21.

63 Anonymous votive painting, 1790, Inv. no. 27047, Rome, Museo delle Arti e Tradizioni Popolari; collected in Bolzano, Trentino-Alto Adige, by Paolo Toschi, 1940. I am indebted to Carmen Peluso for this image.

64 It can be found in Jacopus de Voragine's influential compilation of *Readings on the saints (Legenda sanctorum)*, commonly called *Legenda Aurea*, the *Golden Legend*, *c*.1260. Some one thousand manuscripts have survived, and, with the advent of printing in the 1450s, editions in Latin and in every Western European language multiplied into the hundreds. W.G. Ryan, transl., Princeton, N.J., 1993; no. 101, vol. II, pp. 15–18. My quote is from p. 18.

CHAPTER 4: 'THE VILEST STATE OF HUMAN NATURE':
SWADDLED INFANCY

1 The literal meaning, 'dumb, speechless', of the Latin word *infans* foreshadows the discussion that follows.

2 See p. 28.

3 For a rapid survey of this development, see G. Finaldi, ed., *The Image of Christ*, exh. cat., London, 2000; more generally, A. Grabar, *Christian Iconography, A Study of its Origins*, (The A.W. Mellon Lectures in the Fine Arts, 1961), London and Henley, 1969.

4 For a vivid description of Francis's staging of the Nativity with live ox and ass, and a doll standing in for the Baby, miraculously perceived by a witness as the Christ Child himself, see Tommaso da Celano, *First Life of St Francis*, I, 30. Tommaso, Francis's earliest officially recognised biographer, submitted this *First Life* to Pope Gregory IX in 1229, the year after Francis was canonised. A readily available English translation of the passage in O. Karrer, ed., *The Little Flowers, Legends and Lauds*, London, 2nd edn 1979, pp. 54–6.

5 An anecdote of – to me – unknown origins recounts that an Emperor of China entrusted a committee of sages to discover what it is that all humans have in common. After years of enquiring all around the world, they reported, 'All men are born, all men suffer, all men die.'

6 Unknown artist, *Franciscan crib with the Madonna del Latte*, fourteenth century, Greccio, Franciscan sanctuary.

7 The two events follow each other in Luke 2:7–8, and are often conflated in art.

8 For miniature cradles and dolls of the Infant Jesus, and their use in convents, see A. Sturgis, in G. Finaldi, ed., *The Image of Christ*, exh. cat., London, 2000, pp. 54–5, cat. no. 24, with previous bibliography.

9 C. van Hulst, O.F.M., 'La Storia della divozione a Gesù Bambino nelle immagine plastiche isolate', *Antonianum*, XIX, 1944, pp. 35–54, with many fascinating citations from primary sources. Among these, p. 40, is the account of the holy couple, Saint Elzear of Sabran (1285–1323) and his wife the Blessed Delphina, who lived in perfect chastity, maintained with the aid of a wooden statuette of the Infant Jesus kept between them in their matrimonial bed at night. The same statuette was, perhaps still is, venerated in the Cathedral of Apt, Southern France. The 'virtual' Child thus substituted for a flesh-and-blood child which the couple's vows prevented them from conceiving. In a letter Saint Catherine of Siena dictated in the summer of 1375 to a Lucchese couple, Giovanni Perotti and his wife, thanking them for having clothed a destitute child, the Dominican tertiary assures them that, 'as you have, out of charity and love dressed the child in cloth, so may he, Eternal Truth, dress you similarly in himself, new man, Christ crucified.' (E

siccome per carità e per amor vestiste il bambino di drappo; così vesta egli (l'eterna Verità) voi di se medesimo, uomo nuovo, Cristo crocifisso.' P. Misciatelli, *Le lettere di S.Caterina di Siena*, III, 3rd edn, Siena, 1912, pp. 36–7.

10 E.g. the criticism of Philip of Spain's censor in the Netherlands, Johannes Molanus, *De Picturis et imaginibus sacris*, Louvain, 1570, ch. 42, cited in D. Freedberg, 'Johannes Molanus on Provocative Paintings', *Journal of the Warburg and Courtauld Institutes*, XXXIV, 1971, pp. 229–45, p. 239: 'For what sort of edification can there be in this nakedness? All one can hope is that children are not endangered by this or little ones brought to harm . . . Certainly if these painters should look at the work of past time, they would soon observe that the boy Jesus was decently and modestly portrayed then, and realise how far they have degenerated from the simplicity of their ancestors.' Francisco Pacheco, teacher and father-in-law of the great Spanish painter Velázquez, prescribed that the Infant Jesus in scenes of the Adoration of the Magi should appear 'very beautiful and smiling in his Mother's arms; and, contrary to common practice, wrapped in his swaddling-clothes and shawls, as St Bernard [of Clairvaux] has said and Fray Luis de Granada [d. 1588] muses: "Oh I marvel at the Child whose swaddling clothes are watched over by angels, attended by the stars and are bowed down to by the followers of wisdom!" '; *Arte de la Pintura*, Seville, 1638, B. Bassegoda i Hugas ed., Madrid, 1990, p. 616. This is precisely the iconography adopted by Diego Rodriguez de Silva Velázquez (1599–1660) in his *Adoration of the Magi*, 1619, Madrid, Prado Museum, almost certainly painted for the Jesuit Novitiate of San Luis, Seville.

11 L. Sinaglou, 'The Christ Child as Sacrifice: A Medieval Tradition and the Corpus Christi Plays', *Speculum*, XLVIII, 1973, 491–509; p. 491. For St John Chrysostom (*c*.347–407) on the identification of Christ Child and Eucharist, and for fourteenth- and fifteenth-century Byzantine imagery of the naked Christ Child replacing the Host on a paten, see M. Vloberg, *L'Eucharistie dans l'art*, Grenoble, Paris, 1946, p. 51.

12 Ugolino di Prete Ilario (recorded mid-fourteenth century), *Miracle of the Saracens*, 1357–64, Orvieto, Cathedral, Chapel of the Corporal; B.G. Lane, '*Ecce Panis Angelorum*; the Manger as Altar in Hugo's Berlin *Nativity*', *The Art Bulletin*, LVII, December 1975, pp. 476–86; fig. 6.

13 This change in liturgical practice occurred in 1215 as a result of the Lateran Council's decree that Christ was physically present in the Eucharist.

14 The feast of Corpus Christi or Corpus Domini honours the Real Presence of Christ in the Eucharist, and is principally observed by processions in which the Eucharist is publicly displayed. It was first celebrated in his diocese by the Bishop of Liège in 1246, under the influence of a vision experienced by the Blessed Juliana, a prioress in the nearby convent of Mont Cornillon, extended to the entire Catholic Church by Pope Urban IV in 1264, and confirmed by Pope Clement V at the Council of Vienne, 1311–12.

15 Lane, '*Ecce Panis Angelorum*', see also P. Parshall, *The Art Bulletin*, LVII, December 1975, pp. 639–41.

16 As is demonstrated by the fact that *c*.1305, in his frescoes for the Scrovegni Chapel in Padua, Giotto had already paired the *Nativity and Adoration of the Shepherds* with the *Last Supper* or *Institution of the Eucharist*, although following tradition in his depiction of the *Nativity* by showing the Virgin lying in bed, with the swaddled Christ Child in a manger by her side; M. Alpateff, 'The Parallelism of Giotto's Paduan Frescoes', *The Art Bulletin*, XXIX, 1947, 149–54, reprinted in J.H. Stubblebine, ed. *Giotto, The Arena Chapel Frescoes*, London, 1969, pp. 156–69. The poses of Virgin and Child in this *Nativity*, however, are virtually the same as those of

the Virgin and the dead Christ in the scene of the *Lamentation* later in the cycle, thus also making the same point as the anonymous painter at Greccio, that Christ's birth prefigures his death.

17 See E. Mâle, *Etude sur les origines de l'iconographie du moyen âge*, 2nd edn, Paris, 1924, ch. iii; E. Mâle, *L'art religieux du XIIIe siècle en France, Etude sur l'iconographie du Moyen Age et sur ses sources d'inspiration*, 6th edn, Paris, 1925, pp. 188–9, for the imagery of the Nativity in French art, in which the newborn swaddled Christ is laid on an altar behind and above the Virgin – an iconography that owes more to the direct influence of Saint Bernard than to Saint Francis.

18 Hugo van der Goes (active 1467–82), *Portinari Altarpiece*, 1483, Florence, Uffizi Galleries. Commissioned for Santa Maria Nova, Florence, the triptych, whose wings portray Tommaso Portinari, his wife and children under the protection of the couple's name saints, was painted on the monumental scale of an Italian altarpiece, while preserving all the realism of Early Netherlandish art. It was above all the 'social realism' of the adoring shepherds in the central panel that so rapidly influenced Ghirlandaio to produce his version of the work; Hugo's triptych reached Florence in May 1483, not, as previously thought, in the 1470s. B. Hatfield Stearns, 'L'arrivo del trittico Portinari a Firenze', *Commentari*, XIX, 1968, pp. 314–9.

19 J.V. Fleming, *An Introduction to the Franciscan Literature of the Middle Ages*, Chicago, 1977, p. 192, describes Bernard of Clairvaux as 'a great master of affective piety . . . a friar *avant la lettre*.'

20 Saint Bridget of Sweden, *Revelations*, VII, chaps. 21–22; see H. Cornell, *The Iconography of the Nativity of Christ*, Uppsala, 1924.

21 Saint Bridget, *Revelations*, chapter XXI, English translation from the contemporary translation into Latin of the original Swedish, cited in Cornell, *The Iconography of the Nativity of Christ*.

22 Many medieval theologians believed the adoring Virgin to have played a role analogous to that of a priest offering the Eucharist; for scenes of the Bridgetine Adoration depicting the motif of *Maria Sacerdos*, Mary as priest, see O. Pujmanova, 'Notes on the Iconography of the Adoration of the Child in Sixteenth-Century Italian Paintings in Czech Collections', *Bulletin of the National Gallery in Prague*, vol. X, 2000, pp. 18–26.

23 Hugo van der Goes is credited with originating this imagery in a much copied, now lost painting; the most famous and influential Italian example is the altarpiece by Antonio Allegri, called Correggio (c.1494–1534), *La Notte*, c.1527–30, Dresden, Gallery.

24 J. Simard, *Une iconographie du clergé français au XVIIe siècle* (Travaux du laboratoire d'histoire religieuse de l'université Laval 2), Quebec, 1976. Bérulle installed seven Spanish Carmelites in a convent of the Faubourg St Jacques in 1604; like the convent in Avila, it was dedicated to the Incarnation. By 1629 there were forty-four Carmelite convents in France. Bérulle founded sixty houses of the Oratory in 1611; pp. 12–14.

25 Although for purposes of this chapter I am focusing on the imagery of the swaddled Child and the Bérullian devotion it illustrates, Franciscan and Carmelite circles in Rome and Prague, and even the Oratorians in France, also fostered devotion to more regal images of the Christ Child: the Bambin Gesú in Rome crowned and dressed in cloth-of-gold (see above, p. 95); the Infant of Prague, a sixteenth-century Spanish statue kept since 1628 in the church of the Discalced Carmelites in Prague, crowned in 1655. For the French Little King of Grace, see note 28 below.

26 Jean Langlois, *The Swaddled Infant Jesus Protecting Swaddled Foundlings, Adored by Angels*, engraved image of the Confraternity of the Chapel of the Hôpital des Enfants-Trouvés du parvis Notre-Dame, 1676, Bibliothèque Nationale; Simard, *Iconographie du clergé français*, pp. 54–6, fig. 26. Simard transcribes the inscriptions from which I have translated extracts '*Le dessein de la Confrérie . . . est pour exciter les fidèles à l'Adoration et amour envers le Fils de Dieu qui a bien voulu s'humilier jusqu'à se faire Enfant pour nous; Divin Frère des*

Enfants assistés . . . faites-nous s'il vous plaît la grâce qu'en honorant par un culte continuel tous les mystères de votre sainte Enfance, nous devenions enfants selon l'esprit . . .'

27 '*Pour offrir à Dieu tous les services qu'elles vont rendre à l'Enfance de Notre Seigneur en la personne de ces petits enfants*'; cited in Riopelle, 'Notes on the Chapel of the Hôpital des Enfants-Trouvés in Paris', p. 30. It will be recalled that the entire chapel was decorated with a representation of the Adoration of the Magi.

28 Childless for twenty-two years of her married life, Anne of Austria gave birth to the future Louis XIV in 1638, supposedly through the intervention of the Christ Child seen in visions by Sister Marguerite du Saint-Sacrement of the Carmelite convent in Beaune (already in 1636/7 this nun had averted a Spanish invasion, commenting that 'A straw from the crib, a single strip of his swaddling bands suffice to put all enemies to flight. Do not fear, the Child who has power over everything has promised me to preserve the town and the province.') The Queen rewarded the convent with a statuette of her son, the '*Petit Louis XIV*', '*l'oeuvre du Saint Enfant Jésus*'. From Christmas 1638 the devotion to the Infant Jesus preached by the Oratorians at Beaune was radically transformed into a glorification of Jesus the Child-King, identified with the monarchy. A new image resembling the royal statuette was devised by Sister Marguerite, and the cult of '*le Petit Roi de Grâce*', associated with the divine right of kings, was vigorously propagated throughout France. The lavish temple of the Val-de-Grâce erected by the Queen in Paris is an ex-voto dedicated to him. H. Brémond, *Histoire littéraire du sentiment religieux en France depuis la fin des guerres de religion jusqu'à nos jours*, vol. III, Paris, 1921. See also note 56 below.

29 Simard, *Iconographie du clergé français*, pp. 45ff.

30 Père Amelote, *Discours sur l'Enfance du Fils de Dieu*, heading the *Petit Office du saint Enfant Jésus*, Paris, 1658, pp. cv, cvi. Cited in Brémond, *Histoire littéraire du sentiment religieux en France*, p. 515.

31 '*Dieu, épouvantable en l'éclat de sa grandeur, se fait sentir en sa douceur, en sa bénignité et en son humanité*'; P. de Bérulle, *Discours de l'état et des grandeurs de Jésus*, Discours IV, *Oeuvres*, Paris, 1644, p. 180, cited in *Le Dieu caché, Les peintres du Grand Siècle et la vision de Dieu*, exh. cat., Académie de France à Rome, Rome, 2000–2001, p. 101.

32 '*L'état le plus vil et le plus abject de la nature humaine, après celui de la mort*', '*dans la nature le plus opposé à celui de la sapience*', P. de Bérulle, *Oeuvres*, Paris, 1644, p. 1007, p. 1009, cited in Brémond, *Histoire littéraire du sentiment religieux en France*, p. 517.

33 '*L'extrême misère de l'enfance . . . où le Saint-Esprit est en silence, et le péché operant.*' Bérulle, *Lettres*, pp. 39–40; '*Il y a vie naturelle, mais incapable de plusieurs effets de vie et végétante et sensitive . . . Il y a humanité, mais incapable de societé et communication avec les homes . . . Il y a principe de vie, de mouvement et du repos; mais il n'y a ni mouvement vers Dieu, ni repos en Dieu.*' Bérulle, *Oeuvres*, p. 1013; cited in Brémond, *Histoire littéraire du sentiment religieux en France*, pp. 517–18.

34 '. . . *quatre bassesses: petitesse de corps; indigence et dépendance d'autrui; assujettissement; inutilité*'; C. de Condren, *Considérations*, p. 55, cited in Brémond, *Histoire littéraire du sentiment religieux en France*, p. 520, and E. Mâle, *L'Art religieux après le concile de Trente*, Paris, 1932, p. 327.

35 Philippe de Champaigne (1602–74), *Adoration of the Shepherds*, 1644, Rouen, Cathédrale Notre-Dame.

36 The preparatory studies for the composition do not include the angels near the apex of the altarpiece.

37 '*Comme sa croix est proprement un mystère de souffrance et expiation, aussi sa naissance est proprement un mystère d'offrande et d'adoration.*' P. de Bérulle, *Oeuvres*, p. 415, cited in *Le Dieu caché, Les peintres du Grand Siècle et la vision de Dieu*, exh. cat. Académie de France à Rome, Rome, 2000–2001, p. 102; see also cat. no. 11 for one of the preparatory studies.

38 Georges de La Tour (1593–1652), *Le Nouveau-né, c.*1648, Rennes, Musée des Beaux-Arts.

39 '*Si vous regardez ces petits Poupons dans les bras de leurs Nourrices et qui sont envellopez dans leurs petits langes, ne diriez-vous pas à les voir que ce sont des Prisonniers qui sont ainsi garrottez pour de bien grands crimes: ce sont néanmoins de jeunes Esclaves, que les pêchez de leurs Pères tiennent arretez avec certains Liens qui ne sont pas moins fâscheux pour estre invisibles et qui ont besoin d'un Libérateur.*' S. de Senlis, *Le Flambeau du Juste pour la conduite des esprits sublimes,* Paris, 1640, 2nd ed. 1643, Part I, ch. 29, *Misères de la vie humaine,* pp. 272–3. Cited in F.-G. Pariset, *Georges de La Tour,* Paris, 1948, p. 175.

40 L. Andrewes, *Of the Nativity,* 1618, Sermon 12. One of the most learned Anglo-Catholic theologians of his time, Lancelot Andrewes (1555–1626) is here thinking specifically of Jesus as a swaddled infant, and incidentally tells us something of how mothers and nurses might handle such an infant. The quote continues, 'He, that . . . taketh the vast body of the main Sea, turns it to and fro, as a little child, and rolls it about with the swaddling bands of darkness; He, to come thus into clouts, himself!'

41 Songs appended to Poirters's *Ydelheyd des werelds, Vanity of the world,* including *Liedeken Tot het nieuw gheboren Kindeken Jesus* and *Liedeken Van Jesusken end S.Janneken, die spelen met het Lammeken;* cited in Bedaux and Ekkart, *Pride and Joy,* p. 34.

42 *Hieroglyph IX,* from F. Quarles, *Hieroglyphikes of the Life of Man,* (1638), engraved by William Marshall, reprinted in *Emblematisches Cabinet,* with an introduction by K.J. Höltgen and J. Horden, Hildesheim, Zürich, New York, 1993.

43 K.J. Höltgen, 'Emblem and Meditation, Some English Emblem Books and their Jesuit Models', *Explorations in Renaissance Culture,* vol. 18 (1992), Lafayette, University of Southwestern Louisiana, 55–91; p. 57.

44 Also referred to as *imprese.* John Manning, *The Emblem,* London, 2002, p. 38. This is the most searching general study of emblematics, to which my own discussion is heavily indebted.

45 See pp. 2–3.

46 According to Höltgen and Horden, two Flemish series of prints by Gerard de Jode, published at Antwerp, may have served as iconographical models for the system of planets, occupations and symbolic animals: *Septem Planetae Septem Hominibus aetatibus respondentes,* 1581, and *Speculum vitae humanae,* undated. Further details were probably derived from three emblematic plates for the Healthy, Sick and Dying Man in *Aeternitatis Prodromus,* Munich, 1628, by the Jesuit writer Hieremias Drexelius. See Quarles, *Hieroglyphikes,* 'Introduction', p. 22.

47 The tradition of dividing human life into seven distinct stages, and associating infancy with the moon, goes back to the second-century astrological text, the *Tetrabiblos,* attributed to the Alexandrian astronomer and geographer Ptolemy (AD 90–168): 'In the matter of age-divisions of mankind in general there is one and the same approach, which for likeness and comparison depends upon the order of the seven planets; it begins with the first age of man and with the first sphere from us, that is, the moon's . . . For up to about the fourth year . . . the moon takes over the age of infancy and produces the suppleness and lack of fixity in its body, its quick growth and the moist nature, as a rule, of its food, the changeability of its condition, and the imperfection and inarticulate state of its soul, suitably to her own active qualities.' Bk. IV, chap. 10, transl. F.E. Robbins, Cambridge, Mass., and London, 1940, cited in J.A. Burrow, *The Ages of Man, A Study in Medieval Writing and Thought,* Oxford, 1986, pp. 197–8.

48 The final epigram of Quarles's *Hieroglyphikes* is addressed 'To the Infant'. Referring to the old man who lives life's final moments with 'eyes . . . dimme, ears deaf . . . hands fumbling, feet failing', it reads, 'He's helpless, so art thou; what difference then? He's an old *Infant;* thou, a young *old Man.*'

49 The text of the accompanying poem also includes traditional descriptions of post-infancy childhood, busied with 'antick plays and Toyes'; 'Our childish dreams are fil'd with painted joys/Which please our sense a while, & waking, prove but Toies.'

50 Adriaen van de Venne (1589–1662), Emblem III, p. 17 of J. de Brune, *Emblemata of Zinne-Werck,* original edition Amsterdam, 1624; facsimile, with introduction by P.J. Maartens, transl. G. Schwartz, Soest, 1970. The full title of this work translates as *Emblemata or emblems; presented in pictures, poems and longer explanations, for the characterisation and cure of certain evils of our age.*

51 *Dit lijf, wat ist, als stanck en mist?* The Dutch word *mist* is now used to mean 'mist', 'fog'; in the seventeenth-century, however, it was a variant spelling of *mest,* 'dung', 'manure', 'slurry'.

52 P.J. Maartens, Introduction to de Brune *Emblemata,* 1970, p. 5. The attitude expressed by the Calvinist de Brune has been traced back to an influential treatise written in 1195 by the future Pope Innocent III (founder of the hospital of Santo Spirito in Saxia, see pp. 88), *On the Misery of the Human Condition,* where human beings are said to be conceived in sin, formed from filthy sperm and fed on unclean menstrual blood, living in labour and sorrow until the time they die and their bodies become the food of worms. E. Sears, *The Ages of Man, Medieval Interpretations of the Life Cycle,* Princeton, New Jersey, 1986, p. 98, note 5.

53 Literally, 'Images of the Spirit and of Love', Amsterdam, 1618.

54 See, e.g. *The Virgin and Child in an Interior, c.*1435, National Gallery, London, NG 6514, formerly attributed to the workshop of Robert Campin, now tentatively to Jacques Daret; L. Campbell, *The Fifteenth Century Netherlandish Schools,* London, 1998, pp. 83–91, with references to similar paintings.

55 See p. 97–8.

56 E.g. exh. cat. *I principi bambini, Abbigliamento e infanzia nel Seicento,* Florence, Palazzo Pitti, 1985, cat. no. 1, Alessandro Vitali, *Federico Ubaldo della Rovere at birth,* 1605, Galleria Palatina, Florence, Inv. no. 55, formerly attributed to Federico Barocci; and fig. 3, Cristofano Allori, *Maria Maddalena of Austria with her Sons Ferdinand and Gian Carlo de'Medici,* 1611, Gallerie fiorentine inv. 1890 n.3802. The outermost of Federico Ubaldo's swaddling bands are in some ornate material such as brocade; Gian Carlo's swaddling bands are garnished with lace in hemp or linen. Madrid School, *Portrait of a Royal Baby,* mid-seventeenth century, Glasgow, Pollok House, Stirling Maxwell Collection, shows an infant entirely encased in lace on his swaddling bands and cap. A *Portrait of* [the future] *Louis XIV and his Wet-nurse Dame Longuet de la Giraudière,* Versailles, inv. no. 5272, attributed to Simon François by Simard, *Une iconographie du clergé français,* p. 48, shows the royal infant in lace-bordered swaddling clothes, with the order of the Saint-Esprit hanging from the ribbon around his neck. Simard suggests the swaddled portrait is related to the devotion of the infant's mother, Anne of Austria, to the Christ Child. A putative original of the version at Versailles, signed by the cousins Charles and Henri Beaubrun (1604–92) and (1603–77), and dated 1638, was sold at Christie's in 1980; R. Cohen, 'Saleroom Note: Charles and Henri Beaubrun', *The Burlington Magazine,* vol. CXXII, no. 938, December 1980, pp. 872–3, fig. 37.

57 Dutch School, *Portrait of Cornelia Burch aged two months,* 1581, Hull, Ferens Art Gallery; R.K. Marshall, exh. cat. *Childhood in Seventeeth Century Scotland,* Edinburgh, 1976, cat. no. 17.

58 Giuseppe Gambarini (1680–1725) *Winter, c.*1721–5, Bologna, Pinacoteca Nazionale.

59 Desiderius Erasmus, *Praise of Folly* (1509), 13; transl. B. Radice, Harmondsworth, 1971, p. 78.

CHAPTER 5: THE FIRST STEPS AND THE BABY-WALKER

1 As Oedipus deduced, the answer to the riddle is man, the biped who crawls on all fours in infancy and walks with the aid of a staff in old age. Yet the foundation myth of Nemea in the Peloponnese suggests a certain diffidence about infantile crawling: it records an oracle predicting death if King Lycurgus' newborn son, Opheltes, made contact with the ground before learning to walk; set down by his nurse, the child was killed by a serpent. Cited in Neils and Oakley, *Coming of Age in Ancient Greece*, pp. 141–2.

2 Ex-voto bronze *Figurine of a Crawling Baby*, *c.*1550–1450 BC, reputedly from the Dictaean Cave, sanctuary of the infant Zeus above Psychro in Crete, Oxford, Ashmolean Museum, 1938.1162; Neils and Oakley, *Coming of Age in Ancient Greece*, pp. 37, 237, cat. no. 38.

3 G. van Hoorn, *Choes and Anthesteria*, Leiden, 1951.

4 Attic red-figure *pelike* decorated with *Baby Learning to Crawl or Walk*, attributed to the Manner of the Washing Painter, *c.*430–420 BC, London, the British Museum, E 396; Neils and Oakley, pp. 71–2, 237, cat. no. 37.

5 Quintus Septimius Florens Tertullianus (*c.*AD 160–220), *Ad Nationes*, Bk. II, ch. 11.

6 Augustine, *De Civitate Dei*, AD 413–26, Bk. ¾ff, ch. 21; *The City of God against the Pagans*, ed. and transl. R.W. Dyson, Cambridge, 1998, pp. 167–8. Elsewhere, Bk. VII, ch. 3, p. 271, Augustine refers to 'the most obscure goddesses Adeona and Abeona'.

7 See C. Daremberg, E. Saglio, E. Pottier, *Dictionnaire des antiquités grecques et romaines*, vol. III, part 1, Paris, 1900, under *Indigitamenta*. The largest number of invocations seems to have been directed at mainly feminine entities listed as *Dii praesides puerilitatis* (or *puerilis aetatis*) or *dii pueriles*, 'divinities presiding over childhood'.

8 We have no problems empathising with Isabella d'Este's letter to her husband Francesco Gonzaga, then Marquess of Mantua, on 7 August 1501: 'Today our little boy [Federico, born 17 May 1500] began to walk, and took four steps wihout any help; although, of course, he was carefully watched, much to our delight and his own. His steps were a little uncertain, and he looked rather like a tipsy man! When I asked him afterwards if he had any message to send his father, he said, '*Ti Pà!*' so I must commend him to you as well as myself.' Cited [and transl.?] by J. Cartwright, *Isabella d'Este*, vol. I, 3rd edn, London, 1904, p. 186. I gratefully acknowledge owing this reference to Jennifer Fletcher.

9 '*Ti chiedo scusa Gesù per le volte che ho inveito contro di te ma il mio dolore è tanto, ma ora ti ringrazio per aver fatto muovere i suoi primi passi al mio grande amore. Una mamma.*' Cited by C. Bonvicini, *La Repubblica*, 29 January 2003, p. vii.

10 J.-B. de la Faille, *Vincent van Gogh*, London, Toronto, 1939, cat. nos. 255, 331, 332, 333, pp. 196–7, all dating from van Gogh's Paris period, 1886–8.

11 Vincent van Gogh (1853–90), *The First Steps*, 1890, New York, Metropolitan Museum of Art.

12 Jean-François Millet (1814–75); the pastel drawing, *Les premiers pas*, 1859, now in a German private collection, was reproduced in A. Sensier, *J.F. Millet*, Paris 1881, p. 345. Millet made some dozen sketches of the theme and at least four finished drawings, one of them for children; see exh. cat. *Jean-François Millet*, Paris, 1975, cat. no. 97, p. 139, a version now in Cleveland, Museum of Art. The phrase here in quotes is adapted from R.L. Herbert's essay '*Le naturalisme paysan de Millet hier et aujourd'hui*', pp. 13–19 of this catalogue, to which what follows is largely indebted.

13 J.B. de la Faille, *The Works of Vincent van Gogh*, Amsterdam, 1970, letters 611, 623.

14 pp. 97–8.

15 E.g. Millet's *Le Sommeil de l'enfant*, 1854–6, Norfolk, Virginia, Chrysler Museum; *La précaution maternelle*; 1855–7, Paris, Louvre; *La leçon de tricot*, 1858–60, Williamstown, Mass., Sterling and Francine Clark Art Institute; *La leçon de tricot*, 1869, retouched 1872–73, St Louis, Art Museum.

16 Jean-Honoré Fragonard (1732–1806) and his sister-in-law, pupil and probable mistress Marguerite Gérard (1761–1837), *Le Premier Pas de l'enfance*, *c.*1786, Cambridge, Mass., Harvard University Fogg Art Museum; engraved by Géraud Vidal and Nicolas-François Regnault in 1786 or possibly 1792, with a notation dedicating it to 'good mothers' (*Dédié aux bonnes mères*). P. Rosenberg, exh. cat. *Fragonard*, New York, 1988, cat. no. 303 pp. 573–5. The engraving, which reverses the painting, shows the child walking from right to left as in Millet's (and therefore van Gogh's) composition.

17 E. Sears, *The Ages of Man, Medieval Interpretations of the Life Cycle*, Princeton, New Jersey, 1986. I have for many years owed a debt of gratitude to Elizabeth Sears, who whilst she was writing this book shared with me her then-unpublished information and photographs of medieval baby-walkers.

18 See p. 243, note 47.

19 Act II, Scene vii. Shakespeare omits the First Steps to go directly from 'At first the infant, /Mewling and puking in the nurse's arms' to 'Then the whining schoolboy, with his satchel/And shining morning face, creeping like snail/Unwillingly to school.' See also below, p. 230.

20 Isidore of Seville, *Etymologiae* or *Origines* XI.2, ed. W.M. Lindsay, Oxford, 1911; M.E. Goodich, *From Birth to Old Age, the Human Life Cycle in Medieval Thought, 1250–1350*, London, 1989, on which much of the following material on Avicenna and the Jewish tradition is also based.

21 But in fact derived from the Greek stem meaning child, childhood, playful etc.

22 *Ecclesiastes Rabbah* I.2, *c.*640–900, cited in Goodich, *From Birth to Old Age*, p. 62.

23 *Pirqe Avoth*, 5.25, 5.24 in some editions; Goodich, *From Birth to Old Age*, p. 62.

24 According to Sears, *The Ages of Man*, in Germany the human life cycle was divided into ten stages as early as the thirteenth century; it became common from the fifteenth century to correlate each of the ten ages with an animal – 10 years, a child, being almost invariably identified with a kid. Bedaux and Ekkart, *Pride and Joy, Children's Portraits in the Netherlands 1500–1700*, p. 218, cat. no. 57, interpret a series of Netherlandish portraits of little boys with bridled goats, 'an animal traditionally associated with sensuality and lust' as a reference to Plutarch's warning in *De liberis educandis* to 'bridle the vicious lusts . . . all sorts of carnal desires' of children, with boys needing stronger discipline than girls 'with their almost innate sense of shame.'

25 E. Sears, *The Ages of Man*; for the Stairs of Life, exh. cat. *Die Lebenstreppe, Bilder der menschlichen Lebensalter*, Cologne, 1983–4. See below, pp. 119–21, fig. 81.

26 Author of a famous treatise on gynaecology, that continued in use through translations and abbreviated editions into the sixteenth century, Soranus was born in Ephesus, probably in the second half of the first century AD. He studied in Alexandria and practised medicine in Rome early in the second century under the Emperors Trajan and Hadrian. He refers to the baby-walker several times in Books I and II of his *Gynecology*, transl. O. Temkin, Baltimore, 1956, pp. 38, 116–17, ascribing the need for the device to the weakness of the baby's spine and legs, liable to become distorted if not supported.

27 R.K. Marshall, exh. cat. *Childhood in Seventeenth-Century Scotland*, Edinburgh, 1976, p. 18, cites the consignment in 1666 to a Leith merchant of 'go carts' from London, and, in 1707, a letter from Lord George Hay describing his nephew, little Lord Erskine, running 'up and down the room in an excellent machine made of willows'. See also cat. nos. 27, 28.

28 See note 32 below.

29 The popular Dutch title of Rembrandt's etching reproduced in fig. 83 is '*Het Rolwagentje*', 'the little wheeled wagon'. For '*Looprek*', see exh. cat. *Kinderen van alle tijden, Kindercultuur in de Nederlanden vanaf de middeleeuwen tot heden*, Noordbrabants Museum, 's-Hertogenbosch, 1997; e.g. cat. no. 21; I owe this reference to Professor Tatsushi Takahashi.

30 P. Perdrizet, *Les Terres-cuites grecques d'Egypte de la collection Fouquet*, Nancy, Paris, Strasburg, 1921, vol. I, p. 16, cat. no. 57; the author defines the device in French as an '*appareil élémentaire*' before citing the Arabic word, *machayan*, and its literal translation.

31 For '*chariot d'enfant*' and '*poussette*', L. Réau, *Iconographie de l'art chrétien*, vol. II, Paris, 1957, p. 284, entry for '*Les premiers pas de l'Enfant Jésus*'. For '*baby-trott*', and '*parc à roulettes*', J. Chailley, *Jérôme Bosch et ses symboles, Essai de décryptage*, Académie Royale de Belgique, Mémoires de la Classe des Beaux-Arts, 2nde série, vol. xv, no. 1, Brussels, 1978 p. 241.

32 Except by W. Dobrowolski, 'Jesus with a *Sustentaculum*', *Ars Auro Prior, Studia Ioanni Bialostocki Sexagenario dicata*, Warsaw, 1981, pp. 201–6. I gratefully acknowledge owing this reference to the late Sir Ernst Gombrich.

33 Perhaps the most grandiose claim for the baby-walker was made by the Russian thinker Nikolai Fedorov (1828–1903), who believed that 'the need for baby-walkers proves that the vertical posture is not innate in man . . . Indeed, man attains verticality by dint of effort and of work . . . the vertical posture is man's endeavour to raise himself above the destructiveness which prevails in Nature . . . protest against such struggles is an undeniable feature of man's humanity.' Cited in S. Lukashevich, *N.F. Fedorov (1828–1903)*, Newark and London, 1977, p. 47. I am grateful to Norbert Lynton for this reference.

34 Several examples are known; e.g. E. Breccia, 'Terracotte figurate greche e greco-egizie del Museo di Alessandria', in *Monuments de l'Egypte gréco-romaine*, vol. II, fasc.2, 1934, p. 42, no. 227, pl. LXXII, figs. 369, 371; Perdrizet, *Les terres-cuites d'Egypte . . .*; British Museum GR 1996.7.12.2.

35 William de Brailes (active *c.*1230–1260), *The Wheel of Life*, Cambridge, Fitzwilliam Museum, Ms 330, no. 4, *c.*1240. My discussion is based on Sears, *Ages of Man*, pp. 145–6.

36 Anicius Manlius Severinus Boethius (*c.*475–*c.*524), *De Consolatione Philosophiae*, *The Consolation of Philosophy*; Boethius was executed for supposed treason to the Gothic King Theodoric, ruler of Italy, whom he had served as Chancellor.

37 *Tree of Wisdom*, London, Wellcome Institute for the History of Medicine, ms. 49, fol. 69v. Sears, *Ages of Man*, pp. 143–4.

38 Most famously in Taddeo Gaddi (recorded 1332–66), fresco of *The Last Supper*, 1330–40, in the former refectory of the convent of Santa Croce, Florence.

39 The Seven Liberal Arts of secular learning in late Antiquity and the Middle Ages consisted of the *trivium* of Grammar, Logic (or Dialectics) and Rhetoric, and the *quadrivium* of Geometry, Arithmetic, Astronomy and Music. In the visual arts, they are either personified as women, each with her appropriate attribute, or, as here, exemplified through their most outstanding ancient pagan or biblical practitioners, normally male. See M. Evans, 'Allegorical women and Practical Men: the Iconography of the *Artes* reconsidered', in D. Baker, ed., *Medieval Women, Studies in Church History, Subsidia I*, Oxford, 1978, pp. 305–29.

40 Dobrowolski, 'Jesus with a *Sustentaculum*', p. 202, with previous bibliography.

41 L. Réau, *Iconographie de l'art chrétien*, vol. II, p. 284; see also E.J. Sánchez-Cantón, *Biblioteca de Autores Cristianos, los Grandes Temas del Arte Cristiano en España*, vol. I, *Nacimiento e Infancia de Cristo*, Madrid, 1948, pls. 275, 276 for an anonymous Catalan painter's version, *c.*1410, in the chapter room of Barcelona Cathedral, said to have been influenced by a Spanish adaptation of Pseudo-Bonaventura's *Meditations on the Life of Christ*, the seminal Franciscan text that traces the life of Christ in vivid and homely terms.

42 Hieronymus Bosch (recorded 1474–1516), *The Christ Child (?) with a baby walker and a toy windmill*, from the reverse of *Christ Carrying the Cross*, late fifteenth century, Vienna, Kunsthistorisches Museum.

43 See especially J.B. Knipping and M. Gerrits, *Het Kind in Nederlands Beeldende Kunst*, vol. I, Wageningen, n.d., pl. 21, p. 49.

44 A similar image of a naked toddler with baby-walker but no whirligig adorns, for example, a list of saints' names in the fifteenth century Book of Hours of Mary of Burgundy, illuminated in Bruges; Vienna, Österreichische Nationalbibliothek, Codex Vind. 1857, fol. 141 r. Exh. cat. *Kinderen van alle tijden, Kindercultuur in de Nederlanden vanaf de middeleeuwen tot heden*, cat. no. 21.

45 These readings summarised in Dobrowolski, 'Jesus with a *Sustentaculum*'.

46 W.S. Gibson, 'Bosch's *Boy with a Whirligig*: some iconographical speculations,' *Simiolus*, vol. 8, 1975–6, pp. 9–15; Gibson, *Hieronymus Bosch*, London, 1973, p. 28.

47 C. Harbison, *The Last Judgment in Sixteenth-century Northern Europe*, New York, London, 1976, fig. 93; exh. cat. *Die Lebenstreppe, Bilder der menschlichen Lebensalter*, Cologne, 1983–4, fig. 1.

48 Exh. cat. *Die Lebenstreppe*. For a Dutch version with couples by Jan Houwens, *Leventrap met paren*, before 1658, Rotterdam, Atlas Van Stolk, see exh. cat. *Kinderen van alle tijden*, Noordbrabants Museum, 'S-Hertogenbosch, 1997; also cat. no. 112 for a single sex version, and cat. no. 115 for a 1905 photograph pastiche, probably a birth announcement.

49 Abraham Bach (second half seventeenth century) *Das Zehen Jährige Alter*, *c.* 1660, Augsburg, Städtische Kunstsammlungen, exh. cat. *Die Lebenstreppe*, cat. no. 21.; fig. 9, p. 22.

50 An ex-voto of *c.*1950, from the Santuario della Madonna del Rosario in Fontanellato, Province of Parma, shows a small girl in a square baby-walker falling down twenty-two steps; miraculously saved, according to the image she never even let go her doll.

51 Fig. 52, p. 77.

52 *Chous* decorated with *The First Steps of Dionysos* (*Dionysos with baby-walker*), early fourth century BC, from Sta Maria di Capua, southern Italy; Paris, Louvre; Van Hoorn, *Choes and Anthesteria*, cat. no. 855, p. 173. For the festival of the Anthesteria, see also E. Simon, *Festivals of Attica*, Madison, Wisconsin, 1983; Neils and Oakley, *Coming of Age in Ancient Greece*, pp. 145–9, 284–7, with further bibliography.

53 L. Berczelly, 'A sepulchral monument from Via Portuense and the origin of the Roman biographical cycle', *Institutum Romanum Norvegiae, Acta ad Archaelogiam et Artium Historiam pertinentia*, vol. VIII, 1978, pp. 49–74.

54 As, e.g., in Ovid's *Ars Amatoria* I, lines 525–66.

55 Van Hoorn, *Choes and Anthesteria*, pp. 19–20.

56 Having received the vine from Dionysos, Ikarios the Athenian was the first mortal to make wine. He offered a sample from his first jar to a party of shepherds, who, not having mixed the wine with water, grew so drunk they believed they had been bewitched or poisoned. They killed Ikarios; in despair, his daughter Erigone hanged herself, praying that the daughters of Athens

should suffer the same fate as long as Ikarios remained unavenged. The guilty shepherds were found and executed thanks to the intervention of the Delphic oracle, and the curse was lifted. Neils and Oakley, *Coming of Age in Ancient Greece*, pp. 149, 288.

57 In the play *Thesmophoriazusae* by Aristophanes (*c*.448–*c*.388 BC), a character asks a mother the age of her child by saying, 'Three *Choes*? Or four?' cited in Neils and Oakley, *Coming of Age in Ancient Greece*, p. 146.

58 See below, p. 148, fig. 104.

59 Van Hoorn, *Choes and Anthesteria*, p. 21.

60 P. Barrera, 'Sarcophagi romani con scene della vita privata e militare', *Studi romani*, vol. 2, 1914, p. 93 ff.

61 Biographical sarcophagus, Rome, Museo Nazionale delle Terme, no. 125605; Berczelly, 'A sepulchral monument from Via Portuense'; Amedick, Anne, *Vita Privata auf Sarkophagen (Die Antiken Sarkophagreliefs, Erster Band: Die Sarkophage mit Darstellungen aus dem Menschenleben)*, vol. IV, *Vita Privata*, Berlin, 1991, cat. no. ★178, pp. 150–1, with previous bibliography.

62 Berczelly, 'A sepulchral monument', p. 67.

63 Rembrandt Harmensz. van Rijn (1606–69), *Two male Nudes and a Mother and Child ('Het Rolwagentje')*, etching, 2nd state of 3, *c*.1646, B. 194; H. Bevers, P. Schatborn and B. Welzel, exh. cat. *Rembrandt: the Master and his Workshop, Drawings and Etchings*, New Haven and London, 1991, p. 224, cat. no. 21, with previous bibliography. The interpretation outlined below is mainly due to J.A. Emmens, *Rembrandt en de regels van de kunst*, Utrecht, 1964 (PhD diss.) and 1968, pp. 155–8.

64 Four drawings by Rembrandt's pupils record the same model as the etchings; three, each from a slightly different point of view, show the boy standing in the same pose as in fig. 83, demonstrating that at least three pupils and Rembrandt himself drew from the model at the same time. The reversal occasioned by printing shows that Rembrandt drew directly on the prepared copper plate during the studio sitting; *Rembrandt: the Master and his Workshop*, p. 224.

65 Matthaeus Merian the Elder (1593–1650), Emblem LXXXII, J.W. Zincgreff, *Emblematum Ethico-Politicorum Centuria Iulii Guilielmi Zincgreffi*, Heidelberg, 1619, 1664 . . . last edition 1681, facsimile Heidelberg 1986.

66 *Le chef d'oeuvre ne va avant l'apprentissage,/Il est donné à tous, d'aspirer au haut bout,/Mais ne faut perdre coeur, s'il ne vient tout à coup,/Car une heure ou un jour ne fait pas l'homme sage.*

67 R. Visscher, *Sinnepoppen*, Amsterdam, 1614, III–XLIII, p. 165; facsmile, L. Brummer, *Sinnepoppen van Roemer Visscher*, 's Gravenhage, 1949. Visscher was directly influenced by a similar emblem with the motto *Non nisi percussus*, 'not unless beaten' in a Spanish book of emblems by King Philip III's chaplain: *Emblemas morales de don Sebastián de Covarrubias Orozco*, Madrid, 1610, centuria II, emblem 76. The text states that those who refuse to work unless beaten are of 'the condition of a low and vile serf'.

68 The full text reads, '*Veel menschen zijn deughdelijck, soo langh zy onder het kruys en verdruckinghe leven: maer als de Roede van den eers is, soo worden zy luy in den dienste Goods. Ghelijck een Drijf-tol, die niet meer gheslaghen of ghegispt en wort, die valt haest in onmacht ende blijft ligghen.*'

69 Cited in C. Brown, exh. cat. *The National Gallery lends Dutch Genre Painting*, London, 1978, p. 30; *Scenes of Everyday Life, Dutch Genre Painting of the Seventeenth Century*, London, Boston, 1984, p. 50. Demonstrating, however, the crucial role of context in, and the labile nature of, emblematic imagery, is a similar emblem, showing boys whipping a top, in a manuscript composed in 1660 by the pupils of the Jesuit College in Brussels: *Mors-Vita* 20318, fol. 119 v. The motto, taken from Virgil's *Aeneid*, VII, 383, reads '*Dant animos plagae*', 'The blows give it life', and the emblem is now applied to

heroic martyrdom: 'It stands firm amid the blows' (in fact the contrary of Virgil's meaning). Cited in J. Manning, *The Emblem*, London, 2002, p. 161.

70 The French art critic d'Argenville reported in 1745 that Rembrandt had assembled a drawing instruction booklet of ten to twelve pages; J.A. Emmens, 'Ay Rembrandt, maal Cornelis stem', *Nederlands Kunsthistorisch Jaarboek* 7 (1956), p. 157, cited in *Rembrandt: the Master and his Workshop*, p. 225.

71 Number 24 in *Gabrielis Rollenhagii selectorum Emblematum centuria secunda*, (*The Second Hundred selected Emblems of Gabriel Rollenhage*), Arnhem, 1613. The motto 'No day without a line' is first credited to the most renowned painter of Graeco-Roman Antiquity, Apelles, by the Latin author Pliny the Elder, *Naturalis Historiae*, XXXV, XXXVI, 84; H. Rackham, transl., Pliny, *Natural History*, (The Loeb Classical Library), vol. IX, London, Cambridge, Mass., 1961, p. 322.

72 Unknown Umbro-Florentine artist, drawing from *Libro di schizzi di Raffaello*, *c*.1500, Venice, Accademia; U. Middeldorf, 'Su alcuni bronzetti all'antica del quattrocento', *Il mondo antico nel rinascimento, Atti del V convegno internazionale di studi sul rinascimento, Firenze 2–6 settembre, 1956*, Florence, 1958, p. 172 and plate VII–2.

73 Middeldorf, 'Su alcuni bronzetti', pp. 170–2.

74 Philips Galle (1537–64), Plate II of the series *Human Nature*, 1563; El Escorial, Library, Monastery of San Lorenzo; *Anales y Boletín de los Museos de Arte de Barcelona*, vols. XVI–XVII, 1963–66, *Catálogo de la colección de grabados de la biblioteca de El Escorial*, cat. no. 406, plate 36.

75 *La beste court, le poisson nage & flotte,/ Et l'oyseau sans quelque ayde vole:/Mais rien propre à l'homme que le pleure,/Car sans l'apprendre il ne mange ou ne trotte.*

76 M. Maylender, *Storia delle Accademie d'Italia*, vol. I, Bologna, 1926, reprint 1988, p. 369.

77 The following discussion of Hugo, Arwaker and Quarles is mostly dependent on K.J. Höltgen, J. Horden, introduction to reprint of F. Quarles, *Emblemes (1635)* and *Hieroglyphikes of the Life of Man (1638)*; K.J. Höltgen, 'Emblem and Meditation, Some English Emblem Books and their Jesuit Models', *Explorations in Renaissance Culture*, Lafayette, University of Southwestern Louisiana, vol. 18, 1992, pp. 55–91; 'Catholic Pictures versus Protestant Words? The Adaptation of the Jesuit Sources in Quarles's *Emblemes*', *Emblematica, An Interdisciplinary Journal for Emblem Studies*, vol. 9, no. 1, Summer 1995, pp. 221–38. I have also long been indebted to Professor Höltgen for his monograph, *Francis Quarles (1592–1644), Meditativer Dichter, Emblematiker, Royalist*, Tübingen, 1978.

78 Manning, *The Emblem*, 'Children and Childish Gazers', Chapter Four, pp. 141–65.

79 See also pp. 102–3.

80 E. Arwaker, *Pia Desideria: or, Divine Addresses in Three Books, Illustrated with XLVII Copper Plates*, London, 1686. Arwaker justifies his own translation of Hugo by not wishing to see 'such an excellent piece of Devotion be lost to those who wou'd prize it most, the Religious Ladies of our Age . . .'; 2nd edn, London, 1690, unnumbered first page.

81 Psalm 16 in the Vulgate Bible, the numbering used by Hugo.

82 Boëtius a Bolswert (*c*.1580–1633) emblem III, Herman Hugo, *Pia Desideria*, Antwerp, 1624, p. 161.

83 F. Quarles, *Emblemes (1635)*, pp. 193–5.

84 Arwaker, *Pia Desideria*, 2nd edn, 1690, pp. 92–3.

85 Boëtius a Bolswert, emblem IX, Hugo, *Pia Desideria*, Antwerp, 1624, p. 218.

86 Bonaventura, *Soliloquy*, chapter 1. Quarles's version is longer: 'O sweet Iesu, I know not that thy kisses were so sweet, nor thy society so delectable, nor thy Attraction so vertuous: For when I love thee, I am cleane; when I touch thee, I am chaste; when I

receive thee, I am a virgin: O most sweet Iesu, thy embraces defile not, but cleanse; thy attraction pollutes not, but sanctifies: O Iesu, the fountain of universal sweetness, pardon me, that I believed so late, that so much sweetnesse is in thy embraces.' Arwaker cites only: 'I was ignorant, O sweet Jesu, that thy Embraces were so pleasant, thy Touch so delightful, thy Conversation so diverting; for when I touch Thee, I am clean; when I receive Thee, I am a Virgin.'

87 All these quotes, Arwaker, *Pia Desideria*, 2nd ed., 1690, pp. 117–18; 119–20, 121.

88 A.B. Grosart, ed., *Quarles' Works*, 3 vols., Edinburgh, 1880–81, vol. I, p. lxxiv. I owe this reference to Prof. Höltgen, who kindly listed for me the references of later authors and editors to the childish figures in Quarles's *Emblemes*.

89 E.g. in a fragment of tapestry at the convent of St Johann bei Zabern, showing an old man pushing a baby-walker towards two fashionably dressed women and a youth, with the inscription '*sehent ir jungen wer ir sint ich bin worden gar ein toreht kin(t)*', 'behold them, they're youngsters, while I have indeed become a foolish child'; see B. Kurth, *Die deutschen Bildteppiche des Mittelalters*, Vienna, 1926, pp. 126f, 234, plate 122 b, c.

90 Hieronymus Bosch, *The Temptation of St Antony*, triptych, c.1510–16, Lisbon, Museu Nacional de Arte Antiga, detail. See R.-H. Marijnissen, ed., *Hieronymus Bosch*, Brussels, 1975, with extensive previous bibliography; J. Chailley, *Jérôme Bosch et ses symboles, Essai de décryptage*, Académie Royale de Belgique, Mémoires de la Classe des Beaux-Arts, 2nd series, vol. XV, no. 1, Brussels, 1978, pp. 209ff. No fewer than fifteen copies are known of the whole or of details.

91 Agostino dei Musi, called Agostino Veneziano (end fifteenth century–after 1536), *Anchora Inparo*, engraving, 1538; Bartsch, vol. XIV, p. 302, no. 400.

92 See A.B. Smith, "*Anchora imparo*", *The Art Quarterly*, XXX, 1967, pp. 119–25, for a free copy of 1558 attributed to the French engraver René Boyvin, with a nude putto, pushing a three-wheeled baby-walker, alongside the old man. Smith also refers to Giorgio Vasari's mention of the engraving of 'an old man in a *carruccio*', with the caption *ANCORA IMPARO*, made after a drawing by Domenico Giuntalochi, Vasari-Milanesi, Florence, 1906, vol. VI, *Life* of Niccolò Soggi, p. 27.

93 Horace (Quintus Horatius Flaccus) (65–8 BC), *Sermons* II.3, 247 ff; Erasmus, *Adages*, I, 437; see also *Praise of Folly*, 13. Seneca is also said to have contradicted his own dictum: '*Non bis pueri sumus, ut vulgo dicitur, sed semper . . .* ', 'We are not twice children, as is said by the common people, but always . . .', cited in Florentius Schoonhovius, *Emblemata partim Moralia partim etiam Civilia*, Gouda, 1618, emblem 27. See below, p. 145 and fig. 101.

94 The engraving was made as an illustration to Henry Fuseli's *Lectures on Painting, delivered at the Royal Academy, March 1801*, London, 1801, p. 151, the last page of the third lecture and of the text.

95 Goya, *Aun aprendo*, black crayon drawing, Bordeaux Album I, p. 54, c.1825–8, Madrid, Prado Museum. P. Gassier, *Les Dessins de Goya, les albums*, Paris, 1973, G.54 [411] p. 551, describes it as '*Cette figure de vieillard chenu, tout courbé par l'âge mais toujours jeune d'esprit, passe généralment pour être l'image idéale de Goya à la fin de sa vie . . . elle a la force des évocations allégoriques de la Vérité et de la Justice qu'il a tant aimées . . .*'. N. Glendinning, *The Burlington Magazine*, vol. 123, no. 934, January 1981, p. 57, in the review of an exhibition at the Hamburg Kunsthalle, refers to Goya's drawing 'which has so often been taken to be in some sense autobiographical, might equally well have been related to the Wise Man in search of self-knowledge in Otto van Veen's *Horatian Emblems*, which Goya certainly knew, or to Michelangelo's *Ancora Imparo* which Blake engraved for Fuseli's *Lectures on Painting* in 1801.' I can find no such figure in van Veen's *Horatian Emblems*; Blake's engraving is a portrait of

Michelangelo, not a copy of an image by him. See also Tom Lubbock, 'Holding Their Ground', in J. Wilson-Bareau, exh. cat. *Goya, drawings from his private albums*, London, 2001, pp. 27–8: 'But in the drawing where Goya seems most directly to imagine himself, he puts a good face on it . . . But it isn't a self-portrait, and it's about more than Goya. If this head reminds us of one of William Blake's ancients, that's not misleading. The image presents an oxymoron: in effect, God-on-sticks. A massive gravity combines with a rickety vigour . . . The caption is similarly ambiguous . . . 'I am still learning'. It may not be as inspirational as it first sounds . . . For lifelong learning is in one respect not an ideal, it's an inevitability . . . Still learning? Naturally! Learning to dodder.' For the character and history of the Bordeaux Albums, see J. Wilson-Bareau, pp. 19–23; pp. 145, 159.

96 Lubbock writes of 'the figure's steady eye-contact', but I do not think this is accurate; 'Holding Their Ground', p. 27.

97 Lubbock, 'Holding Their Ground', p. 28.

98 An epithet applied to himself by the 73-year-old Japanese artist best known to us as Hokusai (1760–1849). Although there is no connection between him and Goya, Hokusai's self-portraits in old age have much the same mocking edge as our fig. 89, and as his short autobiography makes clear, the motto 'I am still learning [in old age]' could have been coined by him. See, e.g. M. Forrer, exh. cat. *Hokusai, Prints and Drawings*, London, Munich, 1991, p. 29 and cat. no. 111.

99 Paige, *Nursery Slope*, *The Times*, London, 16 January 1978, illustrating what was then a regular column, '[Michael] Leapman in America'. The quote is from the column.

100 Erasmus of Rotterdam, *Praise of Folly* (1509), 13; transl. B. Radice, Harmondsworth, 1971, p. 80.

CHAPTER 6: 'BETTER TO KEEP STILL': PLAYFUL CHILDHOOD AND ADULT LAUGHTER

1 In the Greek text, the same noun, *kore*, is used to mean 'girl', 'virgin' and 'doll'.

2 Third century BC dedicatory verses; W.R. Paton, transl., *The Greek Anthology, Book VI (The Loeb Classical Library)*, London, 1919, vol. II, nos. 280, 309.

3 e.g. C.A. Hutton, *Greek Terracotta Statuettes*, London, 1899; see J. Neils, in Neils and Oakley, pp. 152–3; more generally, pp. 264–82, cat. nos. 68–94. For the most recent bibliography on rites at the shrine of Artemis, p. 161, note 42; for Hermes teaching youths how to spin a top, p. 216, cat. no. 16.

4 e.g. the Egyptian Predynastic site at Naqada (5500–3100 BC); Kahun and el-Lisht, Middle Kingdom (2055–1650 BC); Deir el-Bahri, from the early Middle Kingdom (2055–1650 BC) to the Ptolemaic (332–30 BC) period; R.M. and J.J. Janssen, *Growing up in Ancient Egypt*, London, 1990, pp. 44–9, and bibliography.

5 Neils and Oakley, *Coming of Age in Ancient Greece*, p. 143.

6 Some schemes of the Ages of Man, however, include the entire first decade or so of life under the rubric *Infantia* or its modern translations; see, e.g. Quarles's *Hieroglyphikes*, pp. 102–3, and de la Perrière's *Morosophie*, fig. 95 and note 9 below.

7 *The Ages of Man*, from Bartholomeus Anglicus, *Propriétaire des Choses*, Lyon, 1482; A.M. Hind, *An Introduction to the History of the Woodcut*, New York, 1935, repr. London and New York, 1963, vol. II, 605.353. Bartholomew the Englishman, a Franciscan friar, wrote a survey of creation, *De Proprietatibus Rerum*, 'On the Properties of Things', in the 1240s. This enduringly influential encyclopaedia was widely read in Latin and in translations well into the sixteenth century. I reproduce the famous woodcut from a French fifteenth-century edition; a woodcut in the first printed English edition of 1495

also pictures *pueritia* as a boy on a hobby-horse, holding a whirligig; N. Orme, *Medieval Children*, New Haven and London, 2001, pl. 3, p. 7; p. 15.

8 Nikolaus Solis (*c*.1544–85), *Childhood*, from David de Necker, *Ain Newes . . . Stamme oder Gesellen Büchlein*, Vienna, 1579, p. 66.

9 G. de la Perrière, *La Morosophie*, Lyon, 1553, pl. I; facsimile, with introduction by A. Saunders, Aldershot and Brookfield, Vermont, 1993.

10 See also Chapter 4, p. 103 and n. 46.

11 D. Erasmus, '*Ollas ostentare*', from the 1515 Basle edition of the *Adages*, M. Mann Phillips, ed. and transl., *Erasmus on his Times, A shortened version of the 'Adages' of Erasmus*, Cambridge, 1967, p. 142. *Encomium Moriae* mixes Latin and Greek; in ch.I-5, Erasmus refers to fools who would like to pass for wise men, 'so wouldn't the best name for them all be *morosophers*?'

12 Attr. to Giovanni Francesco Caroto (1480–1555), *Boy with drawing*, Verona, Museo Civico.

13 W.S. Gibson, *The Art of Laughter in the Age of Bosch and Bruegel*, 12th Gerson Lecture, Groningen, 2003, p. 5: 'Nowadays . . . we usually view Bruegel's art as anything but a laughing matter.'

14 Quintilian, *Institutio Oratoria*, Book VI, iii, 7–10; H.E. Butler, transl., *The Institutio Oratoria of Quintilian* (The Loeb Classical Library), vol. II, Cambridge, Mass., 1921, p. 441.

15 E.H. Gombrich, 'The Visual Image: Its Place in Communication', *The Image and the Eye*, Oxford, 1982, pp. 136–61.

16 In addition to already cited sources, see, e.g. J.Väterlein, *Roma ludens*, Amsterdam, 1976; A. Willemsen, *Kinder delijt, Middeleeuws speelgoed in de Nederlanden*, Nijmegen, 1998, both with comprehensive bibliographies.

17 Pliny, *Naturalis Historiae*, Book XXXV, xxxvii, 120; H. Rackham, transl., *Pliny, Natural History* (The Loeb Classical Library), vol. IX, Cambridge, Mass., 1952, p. 347. The painter referred to is Spurius Tadius, whose works included 'men tottering and staggering along carrying women on their shoulders for a bargain, and a number of humorous drawings of that sort besides, extremely wittily designed.'

18 See pp. 121–2.

19 *Girl with Toy Roller Chasing Bird*, Attic red-figure *chous*, *c*.420 BC, Worcester, Mass., Worcester Art Museum, 1931.56; G. van Hoorn, *Choes and Anthesteria*, Leiden, 1951, p. 193, cat. no. 994, fig. 272; Neils and Oakley, cat. no. 92.

20 e.g. Neils and Oakley, cat. nos. 92, 97, 101, 98, 99; p. 147, fig. 7.

21 Neils and Oakley, p. 275; cat. nos. 85 and 86; 79, 77, 16; 76, 15. By the seventeenth century, girls also played with hoops; by the nineteenth, they were often depicted with them: see Pierre-Auguste Renoir (1841–1919), *Les Parapluies*, *c*.1881–6, London, National Gallery, NG 3268, popular mainly for its portrayal of the seductively feminine little girl with hoop and stick en route to, or from, a Paris park.

22 See below pp. 160–2 and fig. 111.

23 J. Huskinson, *Roman Children's Sarcophagi: Their Decoration and Social Significance*, Oxford, 1996.

24 This attitude can, however, recur in later art. The English painter Frederick Daniel Hardy (1826–1911), a member of the Cranbrook [artists'] Colony interested in themes of rural life and childhood, specialised in scenes depicting children playing at their fathers' professions, e.g. *The Young Photographers*, 1862, or *Playing at Doctors*, 1863, both London, Victoria and Albert Museum; the children are comical, but not the professions *per se*. L. Lambourne, *An Introduction to 'Victorian' Genre Painting from Wilkie to Frith* [at the Victoria and Albert Museum], London, 1982, p. 25.

25 J. Onians, *Art and Thought in The Hellenistic Age; the Greek World View 350–50 BC*, London, 1979, pp. 38–40; 57–8; figs. 33, 55,

56; R. Garland, 'The Mockery of the Deformed and Disabled in Graeco-Roman Culture', in S. Jäkel and A. Timonen, eds., *Laughter down the Centuries*, vol. I, Turku, 1994, pp. 71–84.

26 It is surely one of the marks of the greatness and profundity of the art of Velázquez, painter at the Spanish court from 1623 until his death in 1660, that neither his portraits of royal children nor of the child-sized royal dwarfs robbed their sitters of dignity or their right to the viewer's empathy. See below, figs 139, 143.

27 Reproduced after a Greek vase painting of a boy riding a cane horse, now in Berlin, Daremberg, Saglio, Pottier *Dictionnaire*, Part 2, Vol. 3, Paris, 1904, p. 1358, fig. 4637; J.Väterlein, *Roma Ludens*, Amsterdam, 1976, p. 27, and fig. 7, p. 117, with previous bibliography; the anecdote about Socrates is cited from the first-century Roman historian, Valerius Maximus. This is the only ancient representation of a hobby-horse I have found listed in the relevant modern sources.

28 The earliest hobby-horse known to me is ridden by a monkey on a marginal drollery in a psalter from Ghent, *c*.1300–1320, now in the Royal Library, Copenhagen; Willemsen, cat. no. A 92, plate VIII. An unillustrated entry in Cesare Ripa's *Iconologia*, Rome, 1603, describes *Pueritia* as 'a little boy dressed in various colours, astride a reed. *Pueritia* is the first age of man, and lasts until the tenth year, in which man is unable to use reason . . . The variety of colours suits *pueritia*, as does the reed, because the latter and the former show variety and lightheartedness.'

29 The earliest rocking horse is believed to have been made *c*.1610 for Charles I when he was a boy; Sotheby's, exh. cat. *Childhood*, London, 1988, cat. no. 31; present whereabouts unspecified.

30 E.H. Gombrich, 'Meditations on a Hobby Horse', 1951, reprinted in *Meditations on a Hobby Horse and Other Essays on the Theory of Art*, London, 1963; p. 7.

31 For Jesus and the Holy Kindred as children with hobby-horses, see Willemsen, *Kinder delijt*, pp. 258–60. The boy Jesus also whips up his hobby-horse with gusto in an anonymous fifteenth-century German woodcut of *Saint Dorothy*; Schorsch, *Images of Childhood*, p. 78, ill. 46. For a survey of hobby-horses in art more generally, Willemsen, *Kinder delijt*, pp. 114–18, 338–41, cat. nos. A92–A139.

32 Hans von Metz, *The Road to Calvary*, middle panel of polyptych, 1445, Frankfurt am Main, Historisches Museum; L. Wüthrich, 'Windrädchenlanze und Steckenpferd, Kinderturnier und Kampfspielzeug um 1500', *Zeitschrift für Schweizerische Archäologie und Kunstgeschichte*, vol. 38, 1981, no. 4, pp. 279–89, cat. no. 41, pl. 22.

33 Translated from the Latin of the Vulgate by the Camaldolese monk Nicolò Malermi or Malerbi, published by Lucantonio di Giunta, Venice 1490, with 386 woodcuts, 210 of them in the Old Testament. Giunta would publish more than ten editions of the Malermi Bible in the next forty years, and use the same woodcuts for his 1511 Vulgate. J. Strachan, *Early Bible Illustrations*, Cambridge, 1957, pp. 27–31, fig. 34.

34 Hans Holbein the Younger (1497/9–1543) *The Godless Fool*, no. 69 in *Icones Historiarum Veteris Testamenti*, Lyon, 1538, 1547.

35 Israhel van Meckenem (*c*.1445–1503), *Children at Play*, Bartsch vol. VI part 2, p. 187, no. 274; Lehrs vol. IX, no. 479.

36 P. Parshall, in D. Landau and P. Parshall, *The Renaissance Print*, p. 62.

37 See above, pp. 102–3.

38 Cited in J. Manning, *The Emblem*, p. 142.

39 Florentius Schoonhovius (Florentin Schonhofius, 1594–1648) *Emblemata, partim Moralia partim etiam Civilia*, Gouda, 1618, *Semper pueri*, emblem 27.

40 Roemer Visscher (1547–1620), *Sinnepoppen*, Amsterdam, 1614, *Beter stil gestaen*, emblem XXI.

41 *Praestat otiosum esse quam nihil agere.*

42 The observation is from J. Manning, *The Emblem*, p. 158.

43 'Toen Maria Vos, mijn dochtertje, neevens andere kinderen, met de hoepel liep speelen.' 'Myn dochter slaat de hoep, die door de stoklag dreit: / Zy vindt geen endt, schoon zy haar aâm ten endt komt loopen. / Zoo toont een kindt ons, door haar hoepel, d'eeuwigheidt. / Het eeuwigh is door zeet en wakkerheidt te koopen.' *Alle de gedichten van den Poëet Jan Vos,* Amsterdam, 1662, p. 474. Cited in M.A. Schenkeveld, *Dutch Literature in the Age of Rembrandt, Themes and Ideas,* Amsterdam and Philadelphia, 1991, p. 86. I have slightly amended the translation of the Dutch original, credited to A.F. Harms.

44 See p. 125.

45 *A Choice of Emblemes, and other devises, For the moste parte gathered out of sundrie writers, Englished and Moralized. And divers newly devised, by Geffrey Whitney,* Leiden, 1586, Emblem 81. The title page promises 'A worke adorned with varieties of matter, both pleasant and profitable: wherein those that please, maye finde to fit their fancies: Bicause herein, by the office of the eie, and the eare, the minde maye reape dooble delight throughe holsome precepts, shadowed with pleasant devises: both fit for the vertuous, to their incoraging: and for the wicked, for their admonishing and amendment.'

46 *Alle de Wercken van Jacob Cats,* Zwolle, 1862, p. 334. *Houwelijk* describes six stages of a woman's life: Maid, Sweetheart, Bride, Wife, Mother and Widow.

47 An instance when the visual image is more specific than the word.

48 Woodcuts after Tobias Stimmer (1539–84), *The Ten Ages of Woman, The Ages of Man,* with verses by J. Fischart; A. Andresen, *Der deutsche Peintre-Graveur,* vol. III, Leipzig, 1872, pp. 39, nos. 45, 46; p. 40, no. 50. Stimmer delivered his first works to the printers of Strassburg in 1568–70.

49 Willemsen, *Kinder Delijt,* pp. 115–16, fig. 87, lists a single image of a girl straddling a hobby horse, in the margin drollery of a Book of Hours, *c.*1475, The Hague, Royal Library. The rocking horse does not seem to have had the hobby-horse's virtually exclusively male associations; an early eighteenth-century anonymous Dutch portrait depicts a small girl riding a rocking horse, probably side saddle; Sotheby's, exh. cat. *Childhood,* cat. no. 83, p. 62. The solid rockers of the horse resemble those of the Charles I toy, see above note 29.

50 Plato, *Laws* 643 B-C (trans. R.G. Bury), cited in Neils and Oakley, p. 264.

51 Hans Burgkmair (1473–1531), the *Teutsch Gestech,* woodcut 46 in *The Triumph of Maximilian I,* first published 1526, but projected in 1512, and the woodcuts designed *c.*1516–19; S. Appelbaum, ed. and transl., *The Triumph of Maximilian I, 137 Woodcuts by Hans Burgkmair and Others,* New York, 1964, p. iii. My account of the works executed for Maximilian, and of the German *Gestech,* is indebted to the Introduction and notes of this annotated translation of the descriptive text of the *Triumph* and facsimile of the woodcuts. The hobby-horse and windmill decorations are pointed out by Wüthrich, 'Windrädchenlanze und Steckenpferd', figs. 1 and 2, cat. no. 27.

52 According to V.A. Kolve, *The Play Called Corpus Christi,* London, 1966, p. 17, '[In the Middle Ages] as now, play or game could describe children's pastimes, adult sports, and elaborate jokes alike: elements of pleasure, diversion, or gratuitous action are always involved. Both words were used as antonyms of 'serious' . . . [an] example is the *Gawain* poet's description of his hero as he rides out to keep his promise in a Christmas "game" which may cost him his life.' Or, p. 19, 'the common medieval antithesis, "game" and "ernest" '. See also J. Huizinga, *Homo Ludens,* London, 1949, p. 13:

'Summing up the formal characteristics of play we might call it a free activity standing quite consciously outside "ordinary" life as being "not serious", but at the same time absorbing the player intensely and utterly . . . It promotes the formation of social groupings which tend to . . . stress their difference from the common world by disguise or other means.'

53 *June,* from Flemish Book of Hours, the so-called 'Golf Book', British Library, Add. MS. 24098, f.23 v. S. Hindman, 'Pieter Bruegel's *Children's Games,* Folly and Chance', *Art Bulletin,* vol. LXIII, 1981, no. 3, pp. 447–75; Appendix II, pp. 473–5, lists the late fifteenth- and early sixteenth-century manuscripts containing illustrations of children's games, and collates the months in which they are represented.

54 According to Hindman, 'Pieter Bruegel's *Children's Games',* note 68, p. 457, the games ascribed to individual months in the Ghent-Bruges calendars correspond to the calendars of games devised by modern Belgian and Dutch anthropologists and folklorists.

55 P. Ménard, 'Les illustrations marginales du *Roman d'Alexandre (Oxford, Bodleian Library, Bodley 264)*', in H. Braet, G. Latré, W. Verbeke, eds., *Risus Medievalis, Laughter in Medieval Literature and Art* (Mediaevalia Lovaniensia, Series 1, studia XXX) Leuven (Louvain), 2003, pp. 77–8. Ménard has calculated that in this richly historiated manuscript, only some fourteen out of some 186 marginal illustrations (i.e. under 8%) have any relationship whatever to either the text or the 191 main illustrations.

56 Pieter Bruegel the Elder (*c.*1524/30–69), *Children's Games,* 1560, Vienna, Kunsthistorisches Museum.

57 Karl van Mander, *Het Schilder-Boek,* Haarlem, 1604, fol. 233; cited by Hindman, note 3, p. 447.

58 Hindman, Appendix I, pp. 469–72, collating the systems of identifying the games of previous authors.

59 Hindman, pp. 458–60.

60 See Hindman for previous bibliography; the last item listed represents her own interpretation. See also E. Snow, *Inside Bruegel,* New York, 1997, for a more up-to-date bibliography.

61 Karel van Mander, *Het Schilder-Boek,* fol. 233; transl. H. Miedema, cited by Gibson, *The Art of Laughter in the Age of Bosch and Bruegel,* p. 5.

62 For a mainly literary survey, see D. Ménager, *La Renaissance et le rire,* Paris, 1995.

63 François Rabelais (1497?–1553?) physician and lapsed Benedictine monk, published *Gargantua* in 1534.

64 Pieter Balten (1525–98), *Village Kermis with the Klucht van Pleijerwater ('Phoney water' farce)* is a painting directly inspired by a *rederijker* farce; Gibson, *The Art of Laughter in the Age of Bosch and Bruegel,* fig. 2, pp. 11–12.

65 The theoretical basis for the depiction of the emotions, or *affetti,* is Leon Battista Alberti's treatise on painting, *De Pictura,* 1435 (translated into the vernacular by the author as *Della Pittura,* 1436) which treats only of such unambiguous passions as grief, anger or joy, suitable for the epic 'history painting' that according to Alberti is the noblest task of the artist. Jennifer Montagu points out that Leonardo da Vinci was more aware of 'the subtle differences . . . within . . . [what passes] for a single expression': J. Montagu, *The Expression of the Passions,* New Haven and London, 1994, pp. 65–6.

66 For Charles Le Brun's lectures at the French Royal Academy on depicting the passions, 1668 and 1678, and the schematic drawings illustrating them, see Montagu, *The Expression of the Passions.* For particularly interesting examples of the representation of the passions in French seventeenth-century art and music, see also E. Coquery, A. Piéjus, eds., *Figures de la passion,* exh. cat., Paris, 2001.

CHAPTER 7: 'JEAN QUI PLEURE ET JEAN QUI RIT', AND 'AS THE OLD HAVE SUNG SO PIPE THE YOUNG'

1 I have been unable to trace the origins of this French children's song; it may be eighteenth-century. Having established that 'John who weeps', is ugly, and 'John who laughs', handsome, the ditty nonetheless urges attractive but heartless laughing John not to mock weeping John, but rather to ask him why he's always sighing; 'let us not hasten to laugh at the miseries of this world.' The last stanza may be roughly translated as, 'To laugh like laughing John, to weep like weeping John, isn't very clever; everything in its time, let us laugh at the happiness of others, let us cry at others' sorrow.'

2 e.g. Frans Hals (1581/5–1666), *Laughing Boy with Wineglass*, and *Laughing Boy with Flute*, Schwerin, Staatliches Museum. Hals is also credited with inventing the motif of the laughing fisher children; for overview and interpretation, see Susan Koslow, 'Frans Hals's *Fisherboys*: Examplars of Idleness', *Art Bulletin*, vol. CXVII, no. 870, September 1975, pp. 418–32.

3 Jan Molenaer (c.1610–68), *Children making Music*, 1629, London, National Gallery, NG 5416.

4 N. MacLaren, C. Brown, *The Dutch School, 1600–1900*, *National Gallery Catalogues*, London, 1991, p. 272.

5 Dirck Hals (1591–1656), *A Boy and a Girl playing Cards*, 1631, Williamstown, Massachusetts, Sterling and Francine Clark Art Institute.

6 Late Hellenistic terracotta figurine, second to first century BC, Baltimore, The Walters Art Museum; Neils and Oakley, *Coming of Age in Ancient Greece*, p. 282, cat. no. 94.

7 Crispin de Passe the Elder (c.1565–1637), *Pueritia*, Hollstein, *Dutch and Flemish Etchings, Engravings and Woodcuts ca.1450–1700*, XV, no. 494.

8 M. Westermann, *The Amusements of Jan Steen, Comic Painting in the Seventeenth Century* (*Studies in Netherlandish Art and Cultural History, vol. I*), Zwolle, 1997, p. 212.

9 See also my discussion of the faun-child in Titian's *Bacchus and Ariadne*, fig. 133 and p. 189 below.

10 Now Dublin, National Gallery of Ireland.

11 See below, pp. 178–81, fig. 125.

12 Bartolomé Esteban Murillo (1618–82), *Invitation to a Game of Argolla*, (formerly known as *Invitation to a Game of Pelota*) c.1670, London, Dulwich Picture Gallery. Its companion painting (long treated as a pendant although the pictures were not painted as a pair) *Two Boys and a Negro Boy*, formerly called *The Poor Black Boy*, also at Dulwich, shows two street urchins about to eat a pie, with a third boy carrying a pitcher, probably a slave sent out to fetch water, asking for a share. In this case, the black child's longing expression is contrasted with the laughter of one of the street children, and the defiant mistrust of the other. Exh. Cat. *Bartolomé Esteban Murillo*, London, 1982, Pl. 67, cat. no. 67, 68, p. 191.

13 X. Brooke, 'Seville and Beyond: The Taste for Murillo's Genre Painting across Europe', in X. Brooke and P. Cherry, *Murillo, Scenes of Childhood*, exh. cat., London, 200l, pp. 51–75.

14 Thomas Gainsborough began to study Murillo's paintings of beggar children and infant saints in the late 1770s, and knew the *Invitation to the Game of Argolla*, then probably in the possession of the London-based art dealer Noel Desenfans. His own acclaimed first attempt in the genre, *A Shepherd Boy in a Storm*, 1781, drew the pose of the shepherd boy from the seated figure in the Murillo; the painting was destroyed by fire and is now known only through the mezzotint. See, e.g. M. Rosenthal and M. Myrone, eds., *Gainsborough*, exh. cat., London, 2002, cat. nos. 59, p. 140; pp. 212–15; cat. no. 122, p. 224; cat. nos. 124–6, p. 228. Reynolds's less numerous 'fancy pictures' of indigent children, dating from 1774–5, are with a few exceptions *en travesti*, more overtly playful and erotic; see N. Penny, ed., *Reynolds*, exh. cat., London, 1986, cat. nos. 92, 93, pp. 264–5. The fundamental discussion of these paintings is by P. Crown, 'Portraits and fancy pictures by Gainsborough and Reynolds: Contrasting images of childhood', *British Journal for Eighteenth-Century Studies*, vol. vii, no. 2, autumn 1984, pp. 159–67.

15 See below, pp. 181–3 and figs 128, 129.

16 Willem van Haecht II (1593–1637), *Albert and Isabella visiting the Collection of Cornelis van der Geest, 15 August 1615*, 1628, Antwerp, Rubenshuis.

17 I.M. Green, Secretary, The Torquay Pottery Collectors' Society, *Country Life*, 13 September 1979, 'Collectors' Questions', p. 750. The Sotheby's loan exhibition catalogue, *Childhood*, London, 1988, Cat. no. 361, p. 159, includes an entry for 'A Pair of Bronze Busts of Children, c.1860, one crying, the other smiling . . . $11\frac{1}{4}$ inches' (location unspecified).

18 See A. Tzeutschler Lurie, 'The Weeping Heraclitus by Hendrick Terbrugghen in the Cleveland Museum of Art', *The Burlington Magazine*, vol. cxxi, no. 914, May 1979, pp. 279–87, with full bibliography.

19 Donato Bramante, *Heraclitus and Democritus*, detached fresco, c.1485–90, Milan, Brera Gallery; A. Blankert, 'Heraclitus en Democritus bij Marsilio Ficino', *Simiolus*, vol. 1: 1966–7, pp. 128–35.

20 Tzeutschler Lurie, p. 280, note 16.

21 E. Wind, 'The Christian Democritus', *Journal of the Warburg Institute*, vol. 1, no. 2, 1937–8, pp. 180–2; see also E. de Jongh, 'Jan Steen, so near and yet so far', in H.P. Chapman, W.T. Kloek, and A.K. Wheelock Jr., eds., *Jan Steen, Painter and Storyteller*, exh. cat., Washington and Amsterdam, 1996–7, pp. 43–4.

22 '*Desperation/Pacification/Expectation/Acclamation/Realisation − it's Fry's*', Fry's Five Boys Chocolate advertisement, photographs by Messrs Poulton & Son, 1885.

23 Montagu, *The Expressions of the Passions*, pp. 63 and 203, note 53.

24 '*Esce di mano a lui, che la vagheggia/prima che sia, a guisa di fanciulla/che piangendo e ridendo pargoleggia,/L'anima semplicetta . . .*' Dante Aligheri (1265–1321), *Purgatorio*, XVI, lines 85–8, from the *Commedia*, or *Divine Comedy*, completed shortly before the poet's death. Dante's highly condensed verses may be translated very roughly as 'The soul, simple little thing, issues from the hand of him who watches her lovingly even before she comes into existence, in the guise of a girl who, crying and laughing, plays like a little child . . .'.

25 Giotto di Bondone (1267–1337), *The Expulsion of the Merchants from the Temple*, fresco, c.1305, Padua, Scrovegni Chapel. The decoration of this chapel consists mainly of a narrative cycle recounting the story of the Virgin Mary's parents, Joachim and Anna; the Virgin's own early life and the Annunciation; the Infancy, Ministry and Passion of Christ. It also includes allegories of the Virtues and Vices and, on the west wall, the Last Judgment.

26 Matthew 21:12; Mark 11:15; Luke 19:45; John 2:14–16.

27 Matthew 21:15 mentions 'the children crying in the temple, and saying Hosanna to the Son of David', but these children acclaiming Christ are quite different from the terrified children painted by Giotto. See L. Tintori and M. Meiss, 'Observations on the Arena Chapel and Santa Croce', in J.H. Stubblebine, ed., *Giotto, The Arena Chapel Frescoes*, (Critical Studies in Art History), London, 1969, pp. 203–14, esp. pp. 210–12. For the role of children in early fourteenth-century art more generally, see M. Meiss, *Painting in Florence and Siena after the Black Death*, Princeton, 1951, p. 61.

28 Briefly, painting in *buon fresco* uses pigments dissolved in lime water, that bind chemically with the layer of wet *intonaco*; in *a secco*, or 'dry' painting, the colours are superimposed over dry plaster, and are prone to flaking off over time.

29 Tintori and Meiss, in Stubblebine, p. 211.

30 Mark 11:18, Luke 19:47.

31 Proverbs 1:7

32 Mark 10:15.

33 '[Giotto] felt that the passage toward the left from the figure of Christ (lunging toward the right) to the columnar figure of St. Peter and the child near the frame was abrupt and insufficiently rhythmical. He decided, partly at least for this reason, to introduce a mediator . . . In this instance it was to be, largely for lack of space, a child.' Stubblebine, p. 210.

34 Cf. P. Cherry, 'Murillo's Genre Scenes and their Context', in X. Brooke and P. Cherry, *Murillo, Scenes of Childhood*, p. 13: 'Children have an important affective role in Murillo's religious narratives; in particular they act as vehicles for colloquy with the viewer . . . [they] guide the viewer's response to the action and set the mood of the paintings'; and M. Pointon, *Mulready*, exh. cat., London, 1986, pp. 111–12: 'In paintings which feature adult participants . . . the actions of the adults only become comprehensible by reference to the response of the child or children as recorded in facial expression and physical gesture. It is thus the child who is the mediator in the practice of signification'. Neither author, however, seems aware of precedents in earlier imagery.

35 Which already included satirical paintings, naturalistic in detail though highly grotesque and caricatural, by Hieronymus Bosch (recorded 1474–1516), see below fig. 120; the friend of Erasmus, Quinten Metsys (c.1465/6–1530), and his follower Marinus van Reymerswaele (active c.1509–67).

36 My discussion of Jordaens is heavily dependent on H. Devisscher and N. de Poorter, eds., *Jacob Jordaens (1593–1678), Tableaux et tapisseries*, exh. cat., Antwerp, 1993.

37 See C. Tümpel, 'Jacob Jordaens, a Protestant artist in a Catholic stronghold', Devisscher and de Poorter, *Jacob Jordaens*, pp. 31–7.

38 Jacob Jordaens (1593–1678), *Portrait of the Artist's Family*, c.1615–16, Saint Petersburg, The Hermitage, Inv. no. 484; Devisscher and de Poorter, *Jacob Jordaens*, cat. no. A5.

39 See above pp. 86–8.

40 Jacob Jordaens, *Pan and Syrinx*, c.1620, Brussels, Musées Royaux des Beaux-Arts de Belgique, Inv. no. 3292; Devisscher and de Poorter, *Jacob Jordaens*, cat. no. A18. The subject is from Ovid, *Metamorphoses*, Book I, lines 689–712. I am grateful to Elizabeth McGrath for calling this, and the work of Jordaens more generally, to my attention.

41 Jacob Jordaens, *Three Studies of a Child*, Saint Petersburg, The Hermitage.

42 Jacob Jordaens, *Apollo flaying Marsyas*, c.1625, private collection; Devisscher and de Poorter, *Jacob Jordaens*, cat. no. A33. The source is Ovid's *Metamorphoses*, VI, 382–97. The black Satyr is based on a sketch by Rubens, done from life.

43 Cited in Devisscher and de Poorter, p. 124, note 4.

44 Devisscher and de Poorter, *Jacob Jordaens*, p. 178; see also p. 204, cat. no. A64, and p. 218, cat. no. A69 for Jordaens's series, commissioned in 1644, of eight tapestry cartoons illustrating proverbs (including this one) mostly from Cats's collection.

45 Hollstein, III, no. 29; Hindman, 'Pieter Bruegel's *Children's Games*', p. 459, note 85.

46 The point is raised in relation to Jan Steen's c.1663–5 painting of the same subject, now in The Hague, Mauritshuis, in Chapman, Kloek and Wheelock, *Jan Steen*, cat. no. 23, p. 174.

47 Hindman, 'Pieter Bruegel's *Children's Games*', p. 460, note 86.

48 Hieronymus Bosch (recorded 1474–1516), *Gula*, detail from *Tabletop of the Seven Deadly Sins and the Four Last Things*, c.1490–1500, Madrid, Prado Museum.

49 Jacob Jordaens, *Soo d'oude Songen, Soo Pepen de Ionge (As the Old have sung, so pipe the Young)*, 1638, Antwerp, Koninklijk Museum

voor Schone Kunsten, Inv. no. 677. For other versions, see Devisscher and de Poorter, *Jacob Jordaens*, cat. no. A55, p. 180.

50 For bibliography on this topic, see Chapman, Kloek and Wheelock, *Jan Steen*, cat. no. 23, p. 175, note 2.

51 As suggested in Chapman, Kloek and Wheelock, *Jan Steen*, cat. no. 23, p. 174.

52 Jacob Jordaens, *Soo d'oude Songen, Soo Pepen de Ionge (As the Old have sung, so pipe the Young)*, Ottawa, National Gallery of Canada, inv. no. 15790.

53 e.g. Devisscher and de Poorter, *Jacob Jordaens*, cat. no. 64, p. 204.

54 Jan Steen, *The Cat Family*, c.1673–5, Budapest, Szépmüvészeti Múzeum.

55 *Chi di gatta nasce, sorci piglia.*

56 *The King drinks*, and *As the Old have sung so pipe the Young*, both c.1638–40, both Paris, Louvre Museum, on loan to Valenciennes, Musée des Beaux-Arts. See M. Westermann, *The Amusements of Jan Steen*, pp. 160–1, figs 83, 84.

57 Jacob Jordaens, *The King Drinks*, c.1640, Brussels, Musées Royaux des Beaux-Arts de Belgique, Inv. no. 3545.

58 Of the five senses, Touch has the least constant iconography, and may be pictured by a painful sensation, such as a lizard's bite or the pinch of a crayfish.

59 M. Westermann, *The Amusements of Jan Steen*, p. 163.

60 *Nil similius insano quam ebrius*; Jacob Jordaens, *The King Drinks*, Vienna, Kunsthistorisches Museum, Inv. no. 786.

61 Jordaens's *genre* paintings were available in the Dutch Republic; pendant pictures of *The King Drinks* and *As the Old sang so pipe the Young* were sold in Amsterdam in 1703. In 1649 and 1650, the Flemish artist was working on a commission for the Huis ten Bosch, the country residence near The Hague of Amalia van Solms, wife of Prince Frederik Hendrik of Orange.

62 E. de Jongh, 'Jan Steen, so near and yet so far' in Chapman, Kloek, and Wheelock, *Jan Steen, Painter and Storyteller*, pp. 42–51.

63 *Niet dat'er eenigh man in vrouwen hooger prijst, / Als dat haer rijpe sorg de kinders onderwijst.* Cited in C. Brown, *Scenes of Everyday Life, Dutch Genre Painting of the Seventeenth Century*, London, 1984, p. 143.

64 Jan Steen (1625/6–79) *The Effects of Intemperance*, c.1663–5, London, The National Gallery, NG 6442.

65 Jan Steen, *Bedurfve Huishow, (The Dissolute Household)*, c.1668, London, Wellington Museum, no. WM1541–1948.

66 Jan Steen, *In weelde Siet Toe, (Beware of Luxury)*, with below 'Soma op', (Sums up), 1663, Vienna, Kunsthistorisches Museum, Gemäldegalerie, inv. no. 791.

67 'Syt des slapend sot, vergeeten syt ge van Godt'; Formerly in Paris, Schloss Collection, present whereabouts unknown. See P.C. Sutton in *Masters of Seventeenth-Century Dutch Genre Painting*, exh. cat., Philadelphia, 1984, pp. 322–3.

68 Proverbs 20:1; 'De Wijn is een spotter'.

69 That is, *elle a chaud au cu(l)*. Hot or heated genitals are of course a signifier of sexual passion, a frequent reading of many Dutch seventeenth-century paintings of women seated with a footwarmer, such as, e.g., Jan Molenaer's *Young Man playing a Theorbo and a Young Woman playing a Cittern*, Steen's own *Man offering an Oyster to a Woman*, both London, National Gallery, or Samuel van Hoogstraten's *The Doctor's Visit*, Amsterdam, Rijksmuseum. Sutton, however, suggests caution on the strength of the widespread actual usage of the footwarmer, Sutton, *Masters of Seventeenth-Century Dutch Genre*, pp. 261–2.

70 Johan de Brune, *Emblemata of Zinne-Werck*, emblem 19.

71 *Jonge luiaard, oude bedelaars.*

72 For 'laughing prompt', see M. Westermann, *The Amusements of Jan Steen*, pp. 113–15.

73 E. de Jongh, 'To instruct and delight', (1976) reprinted in E. de Jongh, transl. M. Hoyle, *Questions of Meaning: Theme and Motif in Dutch Seventeenth-century Painting*, Leiden, 2000, p. 102.

74 Jan Steen, *As the Old Sing, so Pipe the Young*, *c.*1663–5, The Hague, Royal Cabinet of Paintings Mauritshuis.

75 Westermann, *The Amusements of Jan Steen*, p. 163.

76 For these identifications, see H.P. Chapman in Chapman, Kloek, and Wheelock, *Jan Steen*, pp. 172–5, cat. no. 23.

77 Gerard de Lairesse, *Groot schilderboek*, 1740, vol. I, pp. 53–4, scolded painters who with this inappropriate gesture turned their 'ill-mannered maidservant into a fancy salon lady', cited in Westermann, *The Amusements of Jan Steen*, p. 115.

78 *Liet/soo voer gesongen soo/na gepepen dat is al lang/g(e)bleken ick sing u vo(or)/so(o) volcht ons na(er)/van een tot hon(derd) jaar.*

79 As in the *Maid's* (i.e. young woman's) *Escutcheon (Maeghde-Wapen)* designed by Adriaen van de Venne for Jacob Cats's *Houwelick*, Haarlem, 1642, or Pieter Saenredam, *The Interior of the Buurkerk at Utrecht*, 1644, London, National Gallery.

80 See S. Schama, 'Wives and Wantons: Versions of Womanhood in 17th Century Dutch Art', *The Oxford Art Journal*, April 1980, pp. 5–13.

81 Chapman, in Chapman, Kloek and Wheelock, *Jan Steen*, p. 174.

82 By emphasising the maternal line that links the new mother and her baby with the old woman and her song; Westermann, *The Amusements of Jan Steen*, p. 164. If, however, the drunken woman in the foreground were not the children's mother but a sexy interloper, then the onus of bad parental example would fall on the 'Steen' figure.

83 Jan Steen, *The Feast of Saint Nicholas*, *c.*1665–8, Amsterdam, Rijksmuseum. Steen painted four variants of the theme, although the autograph version of two are missing; see Kloek in Chapman, Kloek, and Wheelock, *Jan Steen*, pp. 197, 199, cat. no. 30.

84 In 1087 Italian merchants stole the supposed relics of Saint Nicholas from Myra and brought them to Bari in Apulia, South East Italy, where they remain; consequently, he is often called Nicholas of Bari.

85 Cited by Westermann, *The Amusements of Jan Steen*, p. 156.

86 Respectively, Westermann, *The Amusements of Jan Steen*, p. 156; Kloek in Chapman, Kloek, and Wheelock, *Jan Steen*, pp. 197, cat. no. 30, who even writes, 'The complete absence of a father figure is in itself remarkable.'

87 Hendrick Avercamp (1585–1634) *A Scene on the Ice near a Town*, *c.*1615, London, National Gallery, NG 1479.

88 Westermann, *The Amusements of Jan Steen*, p. 155.

89 M. Pointon, exh. cat. *Mulready*, London, 1986, pp. 99–131, cat. nos. 98–121.

90 By Adriaen van Ostade, nos. 45, 98, 113, 115, and David Teniers II, nos. 31, 33, 49, 52, 76, 106, 110, 112, 142, 146; Jan Weenix, no. 47; Pilips Wouverman, nos. 77, 78, 79, 91, 92, 97, 182; see P. Murray, *Dulwich Picture Gallery, A Handlist*, London, 1980.

91 Fig. 113 and p. 163.

92 William Mulready (1786–1863), *The Butt: Shooting a Cherry*, 1847–8, London, Victoria and Albert Museum. Probably begun *c.*1822 and abandoned, it was finished in 1848 on the urging of a friend, John Linnell. The picture was on show in Paris at the Exposition Universelle of 1855, where Mulready's paintings were dismissed by French critics as 'wittily executed' but superficial, 'il ne pénètre pas le fond de l'âme', cited in Pointon, *Mulready*, p. 147, although the artist received the Legion d'Honneur for his painting *Train Up a Child . . .*, fig. 129.

93 Mulready's 1822 manuscript notes on colour in Old Master paintings attest his study of Murillo; K.M. Heleniak, *William Mulready*, New Haven and London, 1980, p. 134.

94 As stated by Pointon, *Mulready*, p. 160, referring to cat. no.

142, the watercolour of the same composition, Glasgow Museum and Art Gallery.

95 William Mulready, *Train Up a Child in the Way He Should Go and When He is Old He Will not Depart from It*, 1841, re-painted by the artist after a fire, 1853, New York, The Forbes Magazine Collection. My discussion of this painting relies heavily on Pointon, *Mulready*, pp. 121–6.

96 Despite Pointon's statement that the 'Christ-like child [who] could be a girl or a boy', the wide-legged stance of this figure categorically marks him as a boy, still wearing an infant's frock or 'coats'. The unisex garment was introduced into aristocratic and well-to-do European households in about the middle of the sixteenth century; before then toilet-trained children were dressed in clothes similar in cut to those of adults, which came to be criticised for being uncomfortable and hampering natural growth. See G. Buzzatti in *I principi bambini, Abbigliamento e infanzia nel Seicento*, p. 27. Until the early twentieth century, boys were normally breeched, i.e. dressed in trousers, between the ages of four and six.

97 Cited in Pointon, *Mulready*, p. 121.

98 Cited in Pointon, p. 126.

99 Although Frances Hodgson Burnett's *Little Lord Fauntleroy* was published in 1886, some forty-five years after *Train Up a Child . . .*, it is redolent of the ideals personified by this painting's English figures.

100 William Dyce (1806–64), *Titian's First Essay in Colour*, 1857, Aberdeen Art Gallery.

101 John Everett Millais (1829–96), *The Boyhood of Raleigh*, 1870, London, Tate Britain.

102 John Everett Millais, *Christ in the Carpenter's Shop (Christ in the House of His Parents)*, 1849–50, London, Tate Britain.

CHAPTER 8: CHILDREN'S DYNASTIC PORTRAITS

1 Francisco Goya (1746–1828), *Childish Rage*, black crayon drawing, *Bordeaux Album II*, *c.*1825–8, Madrid, Prado Museum (D4060); J. Wilson-Bareau, *Goya, drawings from his private albums*, exh. cat. London, 2001, cat. no. 107, pp. 200–1.

2 Wilson-Bareau points out his muscular arms and large hands, and the print's resemblance to no. 4 of Goya's *Caprichos*, whose Spanish caption, *El de la rollona*, sometimes Englished as 'The old spoilt child', she translates as 'Nanny's little boy'; *Goya, drawings*, p. 201.

3 e.g., in addition to the examples discussed in the text, Master of Moulins (Jean Hey, active by 1483–*c.*1500), attr., *Charles-Orlant, Dauphin of France*, now Paris, Louvre (R.F. 1942–28): portrait of the 26-month-old heir to the French throne painted in 1494 to be sent to his father, Charles VIII of France, then campaigning in Italy; Jan Gossaert (active 1503–32) *The Children of Christian II of Denmark*, *c.*1526, Hampton Court, Royal Collection (309): probably painted shortly after their mothers' death, the children's portrait seems to have been sent to England to Henry VIII's wife, Catherine of Aragon, their great-aunt; Juan Pantoja de la Cruz (1553–1608), *The Infanta Maria in her Coffin*, 1603, Madrid, Monasterio de las Descalzas Reales: daughter of Philip III of Spain, the Infanta Maria died at the age of one month on 1 March 1603; on 9 March and the following 12 May, the Spanish court painter Pantoja had delivered to her mother three portraits of the baby lying in her coffin, of which one was sent to Germany, another to Flanders, and a third remained in the palace in Madrid. By April 1607, a further three versions had been delivered to the Queen. See L. Campbell, *Renaissance Portraits*, New Haven and London, 1990, pl. 235, p. 214; pl. 128 and p. 196; pl. 180, p. 166.

4 As Titian – who, although receiving pensions from the

Emperor Charles V and his son Philip II King of Spain, resisted permanently residing at any court – promised to do for Pope Paul III Farnese's family; letter from Giovanni della Casa to Cardinal Alessandro Farnese, 30 September 1545, cited in Campbell, *Renaissance Portraits*, p. 266, note 99. I don't know of any state portraits with pet cats, but princes' dogs have frequently been commemorated, e.g. by Andrea Mantegna in the frescoes celebrating the Marquis Ludovico Gonzaga's family in the Camera Picta of the Palazzo Ducale at Mantua, 1465–74; Jacob Seisenegger's *The Emperor Charles V with a Dog*, 1532, Vienna, Kunsthistorisches Museum, later copied by Titian, Madrid, Prado (409), or Antonio Mor, *Cardinal Granvelle's Dwarf and Dog, c.*1550, Paris, Louvre (INV. 1538).

5 'Persona trattabile e dolce', as was said of him in 1542, in a letter to Cardinal Alessandro Farnese; cited by C. Hope, *Titian*, London, 1980, p. 86; see also J. Fletcher, in D. Jaffé, ed., *Titian*, exh. cat., London, 2003, p. 36 and note 52, p. 188.

6 Titian (Tiziano Vecellio, *c.*1488–1576), *The Vendramin Family venerating a Relic of the True Cross, c.*1540–5, London, National Gallery, NG 4452, detail of Federigo, b. 1535, youngest son of Andrea Vendramin. The youngest child depicted in this large group portrait, he cannot be more than about five, thus the painting must have been begun not much later than 1540.

7 Titian, *Bacchus and Ariadne*, 1520–3, London, National Gallery, NG 35; detail of faun-child.

8 Titian unwittingly reverses modern recapitulation theory, developed by Ernst Haeckel in 1866: that ontogeny [embryonic development of the individual] recapitulates phylogeny [evolutionary development of the species].

9 See below, pp. 208–14 and figs 149, 150.

10 Titian's 1548–9 portraits of the children of Ferdinand of Habsburg, King of the Romans, are lost; Hope, *Titian*, p. 116. Neither of his surviving child portraits – *Clarissa Strozzi*, and Pope Paul III's twelve-year-old grandson, *Ranuccio Farnese*, a painting commissioned for the boy's mother by his tutor, 1542, Washington, D.C., National Gallery – are dynastic portraits in the narrow sense of likenesses of hereditary rulers' children.

11 Titian, *Clarissa Strozzi*, 1542, Berlin, Staatliche Museen, Gemäldegalerie.

12 See below, figs 142, 143 for portraits of the daughters of Philip IV of Spain; fig. 19 for the portrait of Philip II's daughter Anne of Austria; fig. 18 from the copious series of portraits of children of the Medici grand-ducal family.

13 They may indeed have helped shape actual behaviour, since portraits of ancestors in princely collections are likely to have been shown to their descendents by nurses, tutors and mothers as exemplars of all the virtues.

14 Justus of Ghent (probably Joos van Wassenhove) (active 1460–*c.*1480) and 'Petrus Hispanicus', arguably Pedro Berruguete (d.1504) *Federico da Montefeltro and his son Guidobaldo*, 1476–7, Urbino, Galleria Nazionale delle Marche. Guidobaldo of Montefeltro (1472–1508) succeeded his father as Duke of Urbino in 1482, and married Elsabetta Gonzaga, sister of the Marquis of Mantua. They had no children, and in 1504 the sickly Guidobaldo adopted as his heir his nephew Francesco Maria della Rovere, who succeeded him.

15 Illegitimate son of Guidantonio, Count of Montefeltro and Urbino, Federico ruled Urbino from 1444, and was made Duke by Pope Sixtus IV in 1474 – perhaps the event celebrated in this painting.

16 'Well-behaved as a picture', the ambiguous French adage, implying also 'obedient' and 'still'; *sage* also means 'wise', 'prudent', 'moderate', 'restrained', even 'chaste'. There must be some significance, though I don't know what it might be, in the nearest English compliment being 'Pretty as a picture'.

17 Baldassare Castiglione, C.S. Singleton, transl., *The Book of the Courtier*, New York, 1959, p. 14. *Il Cortegiano* was completed by 1516, but not published until 1528. It rapidly achieved international renown, and was first translated into English as early as 1561.

18 Lucas Cranach the Elder (1472–1553), *Johann the Steadfast and Johann Friedrich the Magnanimous*, 1509, London, National Gallery, NG6538 and NG6539.

19 It is similar to the portrait of Johann the Steadfast in Cranach's Holy Kinship altarpiece at Frankfurt, also dated 1509; see S. Foister in *The National Gallery Report, April 1991–March 1992*, p. 16. Many drawings by Cranach of German nobles have survived.

20 Hans Holbein the Younger (1497/8–1543) *Edward, Prince of Wales, c.*1538, Washington, National Gallery of Art, Andrew W. Mellon Collection; S. Foister in K. Hearn, ed., *Dynasties, Painting in Tudor and Jacobean England 1530–1630*, exh. cat., London, 1995, cat. no. 6, pp. 41–2.

21 Alonso Sánchez Coello (1531/2–88) *The Infante Don Diego*, 1577, United Kingdom, private collection. The artist served King Philip II of Spain, chiefly as a portraitist. The Spanish tradition of dynastic portraits of royal children begins with Sánchez Coello, continues with his pupil and follower at court Juan Pantoja de la Cruz, see note 3, culminates in the reign of Philip IV with Velázquez, see figs. 135–40, continues with the latter's pupil and son-in-law, Juan Bautista Martínez del Mazo, followed by Juan Carreño de Miranda; and ends effectively with Claudio Coello under the last Spanish Habsburg king, Charles II, b. 1661, who died childless in 1700. It was momentarily revived in Goya's group portrait of *Charles IV and his Family, c.*1800, Madrid, Prado Museum.

22 I have not checked Spanish royal archives, but hobby-horses are lavishly recorded in the Medici grand-ducal household; Cosimo II, b.1590, asked for and received one before he was two years of age; R. Orsi Landini in *I principi bambini*, p. 19; notes 108–11, p. 24.

23 Don Diego's *ungherina* was inspired by the Hungarian male costume, that became fashionable throughout Europe as aristocratic dress for both sexes after the Hungarian crown was assumed by the child's great-uncle, Ferdinand of Habsburg, in 1526. The attached leading strings hanging from the shoulders formed part of many children's costumes until well after they could walk; G. Butazzi, *I principi bambini*, pp. 26–7.

24 Now Madrid, Prado Museum.

25 The point is stressed by Hope, *Titian*, pp. 110–12; most other authors entitle the picture *Charles V at Mühlberg*.

26 I cannot agree that this work, and similar portraits of royal children, 'burlesqued portraits of their elders', and that 'the humour of this [the reference back to Titian's equestrian portrait of Charles V] would have been obvious to courtiers in Madrid'; L. Campbell, *Renaissance Portraits*, p. 206. Philip II's first-born son by his first wife, Maria of Portugal, was the mentally unstable Don Carlos, whom his father barred from the succession, and who, having conspired with rebels in the Netherlands, died in prison in 1568 at the age of twenty-three. From that date until after 1570 and his fourth marriage, to his second-cousin Anna of Austria, the forty-three year-old Philip had no surviving male heir. Although Don Diego was the fourth son of this marriage, only his younger brother Philip survived to rule as Philip III. Philip II revered his father Charles V and admired Titian; this, together with the troubled question of the succession, seems to me utterly to preclude 'burlesque' and 'humour' in this portrait.

27 It is generally agreed that the visit of Peter Paul Rubens to the court of Madrid in 1628 was decisive in Velázquez 'discovering' Titian's colourism and daringly free brush work, and motivated him to seek permission to travel to Italy.

28 The first three children of Philip IV and Isabel were girls who died before reaching the age of one year; a fourth girl, Maria Teresa, was born in 1638 and survived to marry the future Louis XIV of France.

29 Velázquez (1599–1660), *Prince Baltasar Carlos with an Attendant Dwarf*, 1632, Boston, Museum of Fine Arts.

30 J. Brown and J.H. Elliott, *A Palace for a King, The Buen Retiro and the Court of Philip IV*, New Haven and London, 1980, pp. 253–4.

31 E.g. Argenta (Giacomo Vighi, recorded 1561–73), *Charles Emmanuel I of Savoy as a Child, accompanied by a Dwarf*, c.1573, Turin, Galleria Sabauda; Rodrigo de Villandrando (d. before 1628), *Philip IV and the Dwarf Soplillo*, Madrid, Prado Museum.

32 Baltasar Carlos had actually been carried down the nave of San Jerónimo by his uncles, who held him by the 'sleeves' – presumably the leading strings – of his costume, which Velázquez has suppressed in the portrait; Brown and Elliott, *A Palace for a King*, p. 254.

33 J. Gállego, in A.D. Ortiz, A.E. Pérez Sánchez, and J. Gállego, *Velázquez*, exh. cat., Madrid, 1990, cat. no. 33, pp. 202–7, suggests that the picture, dating from after 1634, represents the dwarf Francisco Lezcano who entered the Prince's service in that year, painted looking at a replica of an earlier portrait of Baltasar Carlos – i.e. a painting within the painting. Even if true, this would not substantially change the significance of the work.

34 Velázquez, *Prince Baltasar Carlos on Horseback*, 1634–5, Madrid, Prado Museum. Noble boys' horseriding lessons normally began at around six years of age; for contemporary Medici archives, see Landini in *I principi bambini*, p. 19, and notes 108–11, p. 24. Landini also cites a touching letter written c.1478 by Piero, son of Lorenzo the Magnificent, to his father, in which the little boy, pupil of the humanist Angelo Poliziano, expresses in excellent Latin his joy at his new pony, whose arrival, he assures his *magnifice pater*, will spur him on in his literary studies.

35 Antonio Palomino de Castro y Velasco, *El Museo Pictórico y escala Óptica*, vol. 3, *El Parnaso Español Pintoresco Laureado*, Madrid, 1724, transl. E. Harris, *Velázquez*, Oxford, 1982, p. 205.

36 Velázquez, *Prince Baltasar Carlos in the Riding School*, c.1636, The Grosvenor Estate. Palomino describes the picture in the collection of Olivares's nephew.

37 Both men were authors of treatises on the importance of horsemanship and the hunt in the education of a prince, as training for future wars; J. Gállego, in Ortiz, Pérez Sánchez, and Gállego, *Velázquez*, cat. no. 41, pp. 247–53. The hunt was not neglected in Baltasar Carlos's education: in the early 1630s Velázquez also painted individual likenesses of Philip IV, his brother Don Fernando of Austria, and little Baltasar Carlos in hunter's dress, for the royal hunting lodge the Torre de la Parada.

38 Gállego, in *Velázquez*, p. 253.

39 Velázquez, *The Infanta Margarita in Pink*, c.1653, Vienna, Kunsthistorisches Museum, 321.

40 J.B. Bedaux, in Bedaux and Ekkart, *Pride and Joy*, pp. 14–18, cites the naturalist Konrad Lorenz's list of features in the physiognomy of small children that elicit instinctive responses in adults – key stimuli often exaggerated in representational schemata such as those of *putti*. We find most of them suggested here: head large in proportion to body; protruding forehead large in proportion to rest of face [somewhat disguised by the hair]; large eyes below the midline of the head; short, fat extremities; rounded body shapes; soft, elastic body surfaces; round, protruding cheeks.

41 Cited in Harris, *Velázquez*, p. 170. Margarita is referred to as 'Empress' because of her marriage in 1666 to her cousin-uncle the Emperor Leopold I, see below, p. 200.

42 Velázquez, *Las Meninas* or *The Family of Philip IV*, 1656, Madrid, Prado Museum, 1174; Palomino, cited in Harris, *Velázquez*, p. 113.

43 Palomino also reports the reaction of the Italian painter Luca Giordano, c.1692: ' "This is the theology of painting", by which he meant to convey that just as theology is superior to all other branches of knowledge, so is this picture the greatest example of painting.' Palomino quotes cited in Harris, *Velázquez*, p. 214.

44 Cited by Gállego, in *Velázquez*, p. 420.

45 The idea for the mirror on the back wall, which draws spectators into the painting by seemingly reflecting two figures from their own space, may have been inspired by Jan van Eyck's '*Arnolfini Portrait*', 1434, now in London, National Gallery but in Velázquez's time in the Spanish Royal Collection.

46 This reading of the most likely occasion for the painting is Harris's, *Velázquez*, p. 174; she points out that Philip's only surviving child from his first marriage, the Infanta Maria Teresa, had to renounce the Spanish throne on her marriage to Louis XIV of France, which took place in 1660 but was proposed in 1656, the year of the painting. Maria Teresa is conspicuous in *Las Meninas* by her absence.

47 Velázquez, *Prince Philip Prosper*, 1659, Vienna, Kunsthistorisches Museum.

48 All these citations Harris, *Velázquez*, p. 219. Martial's reference is *Epigrams*, I, 109.

49 See D. Jaffé, 'New thoughts on Van Dyck's Italian sketchbook', *The Burlington Magazine*, vol. CXLIII, no. 1183, October 2001, pp. 614–624. By the time he himself had become famous, Van Dyck owned nineteen Titians, including some of the greatest now in England, e.g. *Perseus and Andromeda*, now London, Wallace Collection; *The Vendramin Family* and the *Portrait of a Man with a Blue Sleeve*, both now London, National Gallery.

50 E.g. in *The Lomellini Family*, now Edinburgh, National Gallery of Scotland; *Marchesa Brignole Sale and her Son*; *Paola Adorna with her Son*; *Filippo Cattaneo*, and *Clelia Cattaneo*, all Washington, National Gallery of Art; '*The Balbi Children*', London, National Gallery.

51 Anthony Van Dyck (1599–1641) *Three Children of Charles I*, 1635, Turin, Sabauda Gallery.

52 This literally means that he was 'angry with' Van Dyck 'for not [sic] having put on their apron [sic] as is the custom with little children'. Cited in O. Millar, *Van Dyck in England*, exh. cat. London, 1982, cat. no. 18, pp. 60–1.

53 A preparatory sketch, almost certainly from life, for the figure of Prince Charles in this painting is now in the British Museum; it shows leading strings on the child's dress, which Van Dyck has suppressed in the finished work. He has also moved the spaniel, not actually detailed in the drawing, from Charles's left to a more prominent position on his right. Both changes demonstrate that the artist was mindful of the need to depict the Prince of Wales with maximum dignity, though evidently less mindful than the King.

54 Anthony Van Dyck, *Three Children of Charles I*, 1635, Windsor Castle, Coll. H.M. the Queen.

55 Anthony Van Dyck, *Five Children of Charles I*, 1635, Windsor Castle, Coll. H.M. the Queen.

56 Millar, *Van Dyck in England*, cat. no. 27, p. 72.

57 C. Brown, *Van Dyck*, Oxford, 1982, p. 185.

58 Anthony Van Dyck, *Charles II as Prince of Wales*, c.1637, Windsor Castle, Coll. H.M. the Queen.

59 Anthony Van Dyck, *William II, Prince of Orange, with Mary Stuart, Princess Royal*, 1641, Amsterdam, Rijksmuseum (inv. no A102).

60 M. Webster, *Johan Zoffany, 1733–1810*, exh. cat., London, 1976, p. 8; my discussion of Zoffany is heavily indebted to this work.

61 Webster, *Zoffany*, cat. nos. 19, 20, 21, pp. 30–2.

62 Johan Zoffany (1733–1810), *George, Prince of Wales, and Frederick, later Duke of York*, 1764, Coll. H.M. the Queen.

63 Webster, *Zoffany*, cat. no. 24, p. 34.

64 As a result of the Act of Settlement of 1701 which secured the English throne for Protestants, George Louis, Elector of the former German state of Hanover and great-grandson of James I, acceded to the crown as George I in 1714, after the death of his aunt Queen Anne, bypassing her Roman Catholic brother, James Edward Stuart. George III was a great-grandson of George I.

65 Johan Zoffany, *Queen Charlotte with her Two Eldest Sons*, 1764, Coll. H. M. the Queen.

66 Webster, *Zoffany*, cat. no. 25, p. 34.

67 The painting was exhibited at the Royal Academy in 1770, and reproduced in a mezzotint by R. Earlom; Webster, *Zoffany*, cat. no. 61, p. 52.

68 Johan Zoffany, *Charlotte, Princess Royal, and Prince William, later Duke of Clarence and William IV*, c.1770, Coll. H.M. the Queen.

69 Johan Zoffany, *The Archduke Francis*, 1775, Vienna, Kunsthistorisches Museum.

70 Webster, *Zoffany*, cat. no. 77, p. 61.

71 In 1792 Francis succeeded his father as Emperor Francis II. His reign was marked by the French Revolution and the Napoleonic Wars. In 1806 he renouned the title of Holy Roman Emperor to become Francis I, first Emperor of Austria. His daughter Marie Louise, Duchess of Parma, became the second wife of Napoleon in 1810.

72 Johan Zoffany, *Four Grandchildren of Maria Theresa*, 1778, Vienna, Kunsthistorisches Museum. The letter on the table is inscribed, *A L'Imperatrice Reine Ma Dame, et Grand Mere*.

73 Webster, *Johan Zoffany*, p. 12.

74 Sir James Gunn (1893–1964), *Conversation Piece at the Royal Lodge, Windsor*, 1950, London, National Portrait Gallery, cat. no. 3778, showing George VI, Queen Elizabeth, Princess Elizabeth (later Elizabeth II) and Princess Margaret around the tea table.

75 Queen Victoria to Laurits Tuxen, cited in C. Lloyd, *The Queen's Pictures, Royal Collectors through the Centuries*, exh. cat., London, 1991, cat. no. 78, p. 208, also the source of later quotes about the painting.

76 Laurits Tuxen (1853–1927), *The Family of Queen Victoria in 1887*, 1887, Coll. H.M. the Queen.

CONCLUSION: BUBBLES

1 Jaan Kenbrovin and John William Kellette, *I'm Forever Blowing Bubbles*, 1919. Jaan Kenbrovin is the composite pseudonym of James Kendis, James Brockman and Nat Vincent, who all had separate contracts with music publishers.

2 John Everett Millais (1829–96), *'Bubbles'*, originally entitled *A Child's World*, portrait of Millais's grandson Willie James, later Admiral Sir William James, 1886, A. & F. Pears Ltd.

3 *Homo bulla*, 'man is a bubble' is cited as a proverb by the Roman polymath Marcus Terentius Varro in his treatise on farming, *De Re Rustica*, c.36 BC, elaborated by the second-century AD Greek writer Lucian in his dialogue on death, *Charon*, included c.1000 AD in the *Lexicon* by the Byzantine author Suida; Erasmus expands on the saying in a funeral speech for Philip the Handsome of Burgundy and a Venetian friend, Paolo Canal, both prematurely dead. See the classic article by W. Stechow, 'Homo Bulla', *The Art Bulletin*, vol. 20, no. 2, June, 1938, 227–8.

4 As I remember doing as a child in the 1930s: before the advent of paper or plastic straws and liquid detergents, the choosing and trimming with a pen knife of suitable stalks during summer walks in the country, and the alchemical mixing of 'strong' soap solutions, were pleasurable preludes to the actual blowing of the bubbles.

5 Cornelis Ketel (1548–1616), *A Man of the Wachendorff Family*; on the reverse side, *Homo Bulla*, 1574, Amsterdam, Rijksmuseum; see K. Hearn and T. Schulting in Hearn, *Dynasties*, cat. no. 55, pp. 104–105.

6 SERMO DEI AETERNUS CAETERA OMNIA CADUCA.

7 ΠΟΜΦΟΛΨΞ Ο ΑΝ ΘΡΩΠΟΣ

8 H.W. Janson, 'The Putto with the Death's Head', *The Art Bulletin*, vol. 19, no. 3, September 1937, pp. 423–49; for Boldù's medal, see pp. 429 and fig. 7; for Goltzius's *Quis Evadet?*, pp. 446–7, fig. 21; see also Stechow, 'Homo Bulla', p. 227, note 2.

9 Hendrick Goltzius (1558–1616), *Quis evadet?*, 1594, O. Hirschmann, *Verzeichnis des graphischen Werks von H. Goltzius*, Leipzig, 1921, no. 110.

10 '*Quis Evadet?/ Flos novus, et verna fragrans argenteus aura/ Marcescit subito, perit, alii, perit illa venustas./ Sic et vita hominum iam nunc nascentibus, eheu,/ Instar abit bullae vanique elapsa vaporis.*'

11 Forgotten after his death, Chardin was rediscovered in 1846 when works by him were first acquired by the Louvre, as part of a more general interest in Realism, and a catalogue of his oeuvre was published by Pierre Hédouin in *Bulletin de l'Alliance des Arts*, 10 November and 10 December, 1846. In 1860 over forty of his paintings were shown at the Galerie Martinet, in the first important exhibition devoted to French eighteenth-century art. The brothers Edmond and Jules de Goncourt 'consecrated' his reputation as a great French master in the *Gazette des Beaux-Arts*, vol. XV, December 1863, pp. 514–33, and vol. XVI, February 1864, pp. 144–67. For an overview of the nineteenth-century 'Chardin Revival', with bibliography, see G.P. Weisberg with W.S. Talbot, *Chardin and the Still-Life Tradition in France*, exh. cat., Cleveland, Ohio, 1979.

12 *As You Like It*, Act II, scene 7, line 152; see below, p. 230.

13 See E.H. Gombrich, 'The Visual Image: Its Place in Communication', pp. 137–61.

14 For the history of this painting I am especially indebted to *Childhood*, exh. cat., cat. no. 202, p. 104, and M. Warner in *Great Victorian Pictures*, exh. cat., London, 1978, cat. no. 37, p. 60.

15 *Cherry Ripe* was reproduced in *The Graphic*; an edition of 600,000 was exhausted in a few days, with demand still unsatisfied. A.L. Baldry, *Sir John Everett Millais, His Art and Influence*, London, 1899, p. 65.

16 Millais is said to have had a sphere of crystal especially made for him so that he could study the reflections and colours of a bubble; *Childhood*, p. 104.

17 'Skeleton' suits, 'so called because of their close fit and the fact that they had a kind of jointed continuity, the trousers buttoned to the upper garments.' D. Thomson, exh. cat., *Raeburn, The Art of Sir Henry Raeburn, 1756–1823*, Edinburgh, 1997, *The Macdonald Children*, cat. no. 34, p. 122; 'the more informal "skeleton" suits that had been in vogue since the 1770s.' *The Drummond Children*, cat. no. 37, p. 128; 'Such a garment would be worn until the child was about eleven, when he would graduate to more adult clothes. The suit is worn with a . . . white, open frilled collar', *Sir George Sinclair of Ulbster, as a child*, cat. no. 29, p. 112.

18 Millais had at least twice before, in *Autumn Leaves*, 1855–6, Manchester, City Art Galleries, and *Pot Pourri*, 1856, private collection, explicitly associated young children with emblems of transience and nostalgia. Young girls feature in the 'sequel' to *Autumn Leaves*, *Spring (Apple Blossoms)*, 1856–9, The Right Hon. The Viscount Leverhulme, which includes a scythe, that well-understood attribute of the Grim Reaper; conceived as a pendant to the latter picture, *The Vale of Rest*, 1858, London, Tate Gallery, is centred on the theme of mortality, with reference to youthful nuns rather than children. A later painting, however, *Little Speedwell's Darling Blue*, 1892, Port Sunlight, Lady Lever Art Gallery, portraying

Millais's granddaughter, Phyllis James, but with its title inspired by lines in Alfred Lord Tennyson's *In Memoriam AHH*, 1850, once again clearly associates childhood with notions of the brevity of life.

19 Thomas Couture (1815–79), *Les Bulles de Savon*, 1859, New York, Metropolitan Museum.

20 Edouard Manet (1832–83), *Bulles de Savon*, 1867/68, Lisbon, Calouste Gulbenkian Foundation; F. Cachin, C.S. Moffett, *Manet, 1832–1883*, exh. cat., Paris, New York, 1983, cat. no. 102, pp. 268–70.

21 Jean-Siméon Chardin (1699–1779), *Les Bulles de Savon*, *c*.1734, Washington, National Gallery of Art. The resemblance of Manet's painting to this picture, featured in the Laperlier sale in Paris, 11 April 1867, was pointed out by P. Rosenberg, *Chardin 1699–1779*, exh. cat., Paris, 1979, cat. no. 59, p. 205.

22 See especially D. de Chapeaurouge, 'Chardins Kinderbilder und die Emblematik', *Actes du XXIIe Congrès International d'Histoire de l'art, Budapest 1969, (Evolution générale et dévelopments régionaux)*, Budapest, 1972, vol. 2, 51–6; E. Snoep-Reitsma, 'Chardin and the Bourgeois Ideals of his Time', *Nederlands Kunsthistorisch Jaarboek*, 1973, no. 24, pp. 147–243; for the most recent and balanced account, K. Scott, 'Chardin Multiplied', in *Chardin*, exh. cat., London, New York, 2000, pp. 61–75.

23 'Contemple bien jeune Garçon, / Ces petits globes de savon, / Leur mouvement si variable / Et leur éclat si peu durable / Te feront dire avec raison, / Qu'en cela mainte Iris leur est assez semblable.' P. Rosenberg, Chardin, exh. cat., Paris, London, 2000, cat. no. 42, p. 208, for a summary of recent research on the relationship of Filloeul's engraving to the three versions of the composition known today (New York, Metropolitan Museum; Los Angeles, County Museum; Washington, National Gallery of Art).

24 Chapeaurouge, 'Chardin's Kinderbilder', p. 54, traces this interpretation to an image of Cupid having laid down his bow and blowing soap bubbles, by Jacob II de Gheyn, illustrating one of the erotic emblems of D. Heinsius, *Het Ambacht van Cupido*, Amsterdam, 1615. But the association of soap bubbles (as well as whirligigs and houses of cards) with youthful flirtation is found closer to home, in contemporary French pictures such as, e.g., Nicolas Lancret's *L'Air*, one of a series of the Elements, engraved in 1732. See C.B. Bailey, 'Anglo-Saxon Attitudes: Recent Writings on Chardin', in *Chardin*, exh. cat., 2000, fig. 10, p. 91.

25 A better-known version of *The Young Schoolmistress* is in London, The National Gallery, NG 4077.

26 The Latin translation of the first of the *Aphorisms*, or medical treatise, of Hippocrates, the fifth-century BC Greek physician – widely used out of its original medical context, and with *ars*, 'craft', normally understood as 'Art'.

27 Cachin, in Cachin and Moffett, *Manet*, p. 270, calls this 'a seductive idea'.

28 e.g. Edouard Manet, *The Child with Cherries*, 1858, Lisbon, Museu Calouste Gulbenkian; *Vase of Peonies on a Small Pedestal*, 1864, Paris, Musée d'Orsay.

29 Jean-Siméon Chardin, *La Blanchisseuse*, 1733, Stockholm, Nationalmuseum. For the painting's history and reproductions, see P. Rosenberg, *Chardin, 1699–1779*, cat. no. 56, pp. 199–200; *Chardin*, exh. cat., 2000, cat. no. 34, p. 192.

30 If Millais's child pictures were to be compared directly with a French, rather than English, eighteenth-century painter, it would not be Chardin but Jean-Baptiste Greuze (1725–1805), with his slick brush work, humbug sentimentality and covert eroticism; but I can find no example of the soap-bubble theme in Greuze's work. On the other hand, Chardin's *genre* compositions, whether through engravings or copies, were disseminated in England as early as 1738; see M. Levey in W. Graf Kalnein and M. Levey, *Art and Architecture of the Eighteenth Century in France*, Harmondsworth, 1972, p. 138 and note 91, p. 368.

31 Also in Stockholm, Nationalmuseum; a replica in London, National Gallery, NG 1664.

32 Perhaps more than any other artist's, Chardin's children at play embody Montaigne's observation: *Il faut noter, que les jeux d'enfants ne sont pas jeux, et les faut juger en eux comme leurs plus sérieuses actions* (It should be noted, that children's games are not games, but should be judged in them as their most serious actions). *Essais*, 1580, Book 1, chapter 23.

33 Caspar Netscher (1635/6(?)–84), *Two Boys blowing Bubbles ('Homo Bulla')*, *c*.1670, London, National Gallery, NG 843.

34 Now in Amsterdam, Rijksmuseum; N. MacLaren, revised and expanded by C. Brown, *The Dutch School, 1600–1900, (National Gallery Catalogues)*, London, 1991, vol. 1, cat. no. 843, p. 283 and note 2. Adam van Vianen's designs were available for use by painters because engravings after his work were published by his son Christian, *Modelles artificiels de divers vaisseaux d'argent, et autres Oeuvres capricieuzes et desseignées du renommé Sr. Adam de Viane; la plus part d'iceux battus d'une pièce d'argent*, Utrecht, 1650; A. Somers Cocks, 'Dutch Silver', in *Art in Seventeenth Century Holland*, exh. cat., London, 1976, pp. 7–9 and pp. 105–8 for the 'auricular' style of the *tazza*.

35 First published in 1565, and many times thereafter in various languages, by the Plantin Press in Antwerp. The seeming discrepancy between the locations of the Plantin Press are explained as follows: in 1549 Christophe Plantin established a Press in Antwerp; when the city was plundered by the Spaniards in 1576 he established a branch office in Paris and, in 1583, settled in Leiden, leaving his much-reduced business in Antwerp to his sons-in-law. In 1585 Plantin returned to Antwerp and his son-in-law Frans van Ravelinghen (Raphelengius) moved to Leiden. After Plantin's death the Antwerp business was carried on by his other son-in-law, Jan Moerentorf (Moretus).

36 See pp. 147–8.

37 'Cuncta complecti velle, stultum'; emblem 55b, Geoffrey Whitney, *A Choice of Emblemes, and other devises*, Leyden, 1586.

38 ET TUTTO ABBRACCIO ET NULLA STRINGO

39 Salvator Rosa (1615–73) *L'Umana Fragilità*, *c*.1657, Cambridge, Fitzwilliam Museum. The present title was used by Filippo Baldinucci (1624–96), Florentine art historian, in a lengthy description of the picture; a post-1658 inventory of the paintings in the collection of Cardinal Flavio Chigi, nephew of Pope Alexander VII Chigi, lists apparently the same work under the title *La Vita Umana*, 'Human Life'. The fundamental study, to which I am deeply indebted, is R.W. Wallace, 'Salvator Rosa's *Democritus* and *L'Umana Fragilità*', *The Art Bulletin*, vol. 50, no. 3, March 1968, pp. 21–32.

40 See p. 165.

41 *Democritus omnium derisor in omnium fine defigitur.*

42 In Italian, *rosa* signifies both the flower and the colour.

43 The description is Baldinucci's, see note 38.

44 See p. 115 and fig. 78.

45 For the glass orb as an attribute of the World, see E. de Jongh, transl. M. Hoyle, *Questions of Meaning, Theme and Motif in Dutch Seventeenth-century Painting*, Leiden, 2000, 'The Changing Face of Lady World', pp. 59–82. For Ripa see above, p. 34, n. 7; R.W. Wallace, 'Salvator Rosa's *Democritus* and *L'Umana Fragilità*', p. 31.

46 R.W. Wallace, 'Salvator Rosa's *Democritus* and *L'Umana Fragilità*', p. 31, note 79, points to a verse from Rosa's satire *Poesia*, 'Anzi havrà Cuna e tomba in un sol giorno', 'Indeed, he will have cradle and tomb in a single day'. Compare with the traditional iconography of the infant Christ, figs 63, 65.

47 'Humanae Vitae Conditio', Pierio Valeriano's *Hieroglyphica*, Basel, 1556, this image in turn based on Plutarch's *Moralia: Isis and Osiris*.

48 *Miseriae Humanae Ingressio* is the title of Crispin van de Passe's engraving of *Infantia*, the first of his Seven Ages of Man series, of which *Pueritia*, fig. 112, is the second.

49 Jan Steen, *The World as a Stage*, also known as *The Life of Man*, c.1665–1667, The Hague, Mauritshuis.

50 Cited by E. de Jongh, 'Jan Steen, so near and yet so far', in H. Chapman, W.T. Kloek, A.K. Wheelock Jr., *Jan Steen, Painter and Storyteller*, exh. cat., Washington D.C. and Amsterdam, 1996–7, p. 43.

51 *As You Like It*, 1599, Act II, scene 7, lines 139 ff.

Index

Photograph Credits